PREVIOUS BOOKS BY DONNA M. LUCEY

Archie and Amélie: Love and Madness in the Gilded Age

Photographing Montana 1894–1928:
The Life and Work of Evelyn Cameron

I Dwell in Possibility: Women Build a Nation, 1620–1920

National Geographic Guide to America's Great Houses (coauthor)

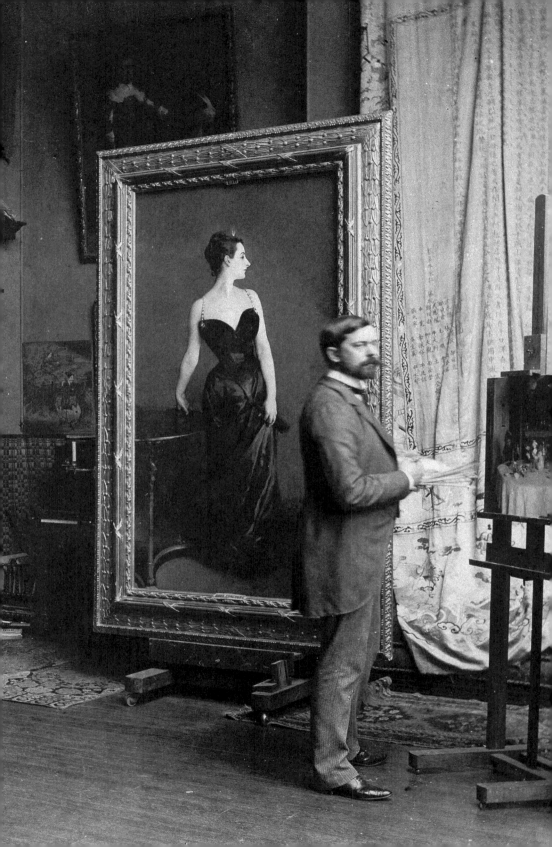

SARGENT'S WOMEN

Four Lives Behind the Canvas

DONNA M. LUCEY

W. W. NORTON & COMPANY
Independent Publishers Since 1923
New York • London

For information about permission to reproduce selections from this book,
write to Permissions, W. W. Norton & Company, Inc.,
500 Fifth Avenue, New York, NY 10110

For information about special discounts for bulk purchases, please contact
W. W. Norton Special Sales at specialsales@wwnorton.com or 800-233-4830

Manufacturing by Berryville Graphics
Book design by Ellen Cipriano Design
Production manager: Julia Druskin

ISBN 978-0-393-07903-6

W. W. Norton & Company, Inc.
500 Fifth Avenue, New York, N.Y. 10110
www.wwnorton.com

W. W. Norton & Company Ltd.
15 Carlisle Street, London W1D 3BS

1 2 3 4 5 6 7 8 9 0

For Henry the Next,
with all my love

His quarry was a suitable subject, his trophy
the creation of a thing of beauty.

—Sir Evan Charteris on his friend John Singer Sargent

CONTENTS

Four Women. Four Lives. Four Paintings.

BEAUTIFUL BUT HAUNTING, these women stop you cold, make you stand and wonder: Who *were* these women? Something in these canvasses guides the eye to detect rustling, restless souls. Elizabeth Chanler's mournful eyes and anxious hands; Sally Fairchild's enigmatically veiled features; Belle Gardner's broad shoulders and curving arms that seem to cradle something that's missing; and Elsie Palmer's utter strangeness, with her blunt bangs and blank stare. You cannot help but gaze, for these canvasses contain secrets. They are images from a remote age of extraordinary, vanished splendor and they have stories to tell. At this level of art, the artifice falls away and we make a human connection—direct, startling, unsettling. The master who created these images, John Singer Sargent, confided to an acolyte, "Portrait painting, don't you know, is very close quarters—a dangerous thing."

The late nineteenth century was the best and worst of times—times much like our own, floating on a financial boom, reveling in unprecedented excess, heading for panic. Mark Twain dubbed it, sarcastically, the Gilded Age, but in a way its greatest chronicler might have been Sargent. He defined the era in his portraits of the major players.

Massive, wall-filling works made the Sargent myth—that he merely

slathered on the glamour for ample fees. Indeed, he became the Tiffany of portraiture, a flatterer of Gilded Age vanities; but ever more famous and ever more a creature of the market, Sargent grew to detest portraiture. Still, he was an artist and some sitters truly engaged him. Their portraits leap from the walls, and when we learn their backstories we can see why—we don't get an art history lesson but a secret guide to their emotions. From their eyes, postures, gestures, and clothing Sargent divined their internal landscapes. He could be uncannily clairvoyant in portraits of young women.

During his lifetime Sargent created over nine hundred paintings and countless sketches. So why choose these particular four women? Their portraits captivated me with their aura of intrigue, their hints of deep layers of complexity that suggested fascinating stories behind the canvasses. All of these women inhabited the gilded world. But how did they navigate through it? What choices did they make? What storms did they endure? What passions? I tell the stories of these women in the order of age—beginning with an unformed teenager and ending with a commanding middle-aged woman who is painted again in old age. Their lives played out in different places, some of them expected: the drawing rooms in New York, Boston, London, and the behemoth "cottages" of Newport; some of them farther afield: a castle in the Rocky Mountains, a patrician beach on the Massachusetts coast, a haunted mansion in the Hudson Valley, a Bohemian art colony in New Hampshire, a medieval, moated manor house in the English countryside, a forbidding school on the cliffs of the Isle of Wight, an ancient hotel in the Cotswolds.

I visited all these places to see where the women lived and where Sargent worked. I clambered up the steep cliffs on the Isle of Wight in search of an old girls' school and explored the island's Undercliff. I rummaged through attics. I tracked down local experts who brought me to out-of-the-way places and unlocked doors to show me treasures not open to the public. I encountered a man haunted by living in the house once owned by one of the courageous, but tragic figures explored in the book.

Each story became its own rabbit hole, with unexpected twists and turns. Things got very curious indeed.

All these women left voluminous collections of papers—some in archives and libraries, others in private hands—which allow me to tell their stories from the inside out. I felt the joy of holding original letters and leather-bound journals and deciphering handwritten pages. Beautiful crisp stationery and travel journals illustrated by the diarist herself and datelined from exotic locales: the spa at Baden-Baden; the cities of Paris, London, Vienna, Moscow; tiny villages in Burma, India, and Japan; frontier outposts in the American West—it's a bit like Gilded Age porn to someone like myself. There's a tactile pleasure in opening envelopes with traces of sealing wax, and touching the engraved letterheads bearing the address of a grand hotel or a family crest from an ancestral mansion. The ink is sometimes smeared across a page; the handwriting is slanted, or florid, or, in some cases, practically unreadable. The letters and diaries kept by these particular women are an art form—written in longhand, with literary and artistic references that make modern correspondence pale. Their letters might go on for twenty pages or more, and they would write every day. It was their means of communication, their entertainment in an era before radio, television, and the nonstop cacophony of modern life. Absorbing all of their writing was not a task for the faint of heart, as it took me nearly eight years to read all of my subjects' papers and then to try and make sense of it all. Poring over someone's private writings is an extremely intimate act. Page after page of personal detail and the minutiae of daily life ushered me into the core of that person's world. And yet, there was always the sense that I was gazing into an inner theater where people were constructing their own characters, pursuing their own elusiveness.

Since any given scrap of paper could prove vital, my job became that of a detective, piecing together tiny bits of information from a variety of sources, not just from letters and diaries but from memoirs, from personal photographs, and ephemera of all sorts: receipts from dressmakers,

invitations to balls, menus from fancy dinners, a family's guestbook; and other, more bizarre remnants from a life: a photograph of a dead body, a vial of sand, an envelope marked "my curls" and inside it a huge clump of auburn hair. Everything offers evidence, clues, to each woman's character. Stories emerge; love affairs—some secret, some not—are revealed; intrigues and jealousies play out; rigid family dynamics come into view. These women were all very rich—or in one case, *had* been rich—so the drama was performed on an operatic scale, abetted by large fortunes and mansions, which doubled as showplaces and as stage sets for titanic family conflicts and tragedies.

Without exception, these women had a tremendous appetite for high culture. The music they experienced was performed live in their private drawing rooms, sometimes in Sargent's art studio—it elevated them to another realm. Wagner was all the rage among their peers, and they made pilgrimages to Bayreuth for performances of the Ring cycle. They considered theater, art, and literature essential to their very being. Isabella Stewart Gardner amassed a spectacular art collection and created her own museum. The portrait of the veiled Sally Fairchild inspired her sister to take up brush and follow the path of an artist. These women scribbled favorite verses into their diaries and letters, and carefully dissected the latest novels they were reading. Elizabeth Chanler wrote poetry. As a child, Elsie Palmer penned two stories that were published by her proud father in a leather-bound volume. One was a fairy tale about a brother and sister who received a magic wand and got their wish to explore under the sea. The other story concerned a real-life incident that occurred when Elsie was ten and en route across the Atlantic. One morning the ship turned abruptly and Elsie thought the boat was sinking; in fact, the crew was rescuing a man who had thrown himself overboard. Once safely back on the ship, the man tried to hurl himself into the water again.

Travel was a staple of restless, upper-class life—private rail cars; first-class trans-Atlantic steamer cabins; grand hotel suites in London, Paris, Venice, and other Old World cities; privately owned steam yachts

the size of small battleships. But John Sargent grew up with a different notion of restless travel. His mother, Mary Newbold Singer Sargent, had talked her husband into giving up his sedate medical practice in Philadelphia to live in Europe amid the glittering world of the wandering rich. Distraught after losing a child, she sought forgetfulness and relief in life abroad. She also harbored artistic dreams of her own. Dr. Sargent and his wife didn't have the financial means of the gilded expatriates, but the couple socialized at the edges of that class, with Sargent's mother cutting a slightly ridiculous figure as she tried to keep up.

John was born in Italy in 1856 and raised amid the glories of the classical and Renaissance worlds. His first memory was seeing a piece of porphyry, a purple-red stone prized by the ancients, in the gutter as he walked with his nurse in Florence. Its color remained with him always. He'd later say that the stone was one of the two most beautiful things he'd ever seen. The other was its polar opposite. In Egypt Sargent witnessed brilliantly colored mummies being exhumed and opened to the desert air; within minutes, their vibrant tones faded into dullness.

Young Sargent and his family moved about Europe like vagabonds. When funds grew short, they'd pick up and go to a new place in France or Italy or Germany and start over. They belonged nowhere, and Sargent was keenly aware of, and embarrassed by, their outsider status. His sister Emily, a year younger than he, suffered from a strange spinal disorder and for some years was bedridden and unable to walk. In the vain hope of finding some new climate or spa to cure her affliction, the wanderings of the family quickened. An artistic prodigy, the young Sargent became the family's shining star and his domineering mother's favorite cause. They went to Paris so John could study painting in one of the best ateliers. His stock rose to great heights in the City of Lights and then abruptly fell when his painting *Madame X* was unveiled in 1884 and scandalized the art establishment. Sargent depicted his subject, a well-known society figure in Paris, as a kind of courtesan—with her décolletage amply displayed, her pale skin casting a sickly bluish tone, and the strap of her

gown slipping seductively off her shoulder. An uproar ensued, hastening Sargent's departure to London.

Business in England was sluggish in 1887 when the thirty-one-year-old artist received a letter from a supremely rich New York financier and art collector. He asked the artist if he would come to Newport, Rhode Island, the summer playground for the robber baron set, and paint a portrait of his wife. Name your price. Three thousand dollars, Sargent shot back—triple his usual fee. The financier agreed and Sargent set off for America, where he soon fell into the social and professional arms of Stanford White, the fabled architect with the *Social Register* client list. White admired Sargent's extraordinary talent and arranged a small private dinner at a downtown studio to introduce Sargent to New York's top painters and architects. White also grasped how useful he and Sargent could be to each other. The architect was madly designing palaces for American potentates. Enormous walls required paintings—lush, beautiful paintings—and Sargent could provide them. At convivial dinner parties White dropped the name of the artist, whose work was *so* expensive, *so* exclusive, *so* sought-after. Sargent became *the* portraitist to New York's gilded set.

Sargent himself remains an enigma. The artist with the broad sensual brushstrokes, renowned for the rich texture and dreaminess of his canvasses, was a man of contradictions. He was an epicure who adored good food and fragrant handmade Turkish cigarettes; he made nightly appearances at the most fashionable parties and theatrical events; he loved earthy sports like wrestling and ice hockey, both of which enjoyed a vogue in London. He straddled the Bohemian and establishment art worlds, with a wide circle of friends among artists, actors, musicians, writers—perhaps the most famous being Henry James, another expatriate American.

On the wall of his dining room on Tite Street in London Sargent hung a portrait of a long-necked, handsome young man with an angular jaw and a square-necklined shirt to match. His eyes in shadow, he could be mistaken for an exquisite dancer, a youthful Nureyev-like figure fully

aware of his smoldering sensuality. He was Albert de Belleroche, a fellow art student in France. They shared studio space in Paris and London and traveled together. Sargent painted and sketched his friend repeatedly, with a romantic flair. He called Belleroche "Baby." Lovers? One can't jump to that conclusion. But past biographers have sometimes taken pains to depict Sargent as a robust masculine specimen who had no interest in sex, to preclude the possibility that he might be, in the coded language of the day, "not a marrying man." Indeed, Sargent never married, never appeared to have a serious romantic entanglement, though there were rampant rumors: He was a "frenzied bugger" according to one contemporary, others claimed a young woman had broken his heart. He produced a remarkable number of nude portraits at the turn of the twentieth century—the majority of them male, highly erotic, and carefully kept out of view.

One friend wrote that Sargent "seemed to protect himself in a network of repressions." His clothing was conservative and well tailored; his life was as orderly and regimented as a banker's: up at 7 a.m., breakfast by 8, followed by a bath, correspondence, and checking the list of social invitations he'd received. Then it was on to his sittings, to make use of the morning light. By turns he could be shy, voluble, overly opinionated, or charming. He was generous with other artists.

Sargent maintained that his paintings were not psychological studies—he merely painted what he saw. Yet he managed to peer into the souls of the women in this book. When Elizabeth Chanler limped into his studio, wounded by a debilitating illness not unlike Emily Sargent's, her melancholy eyes spoke to him. Elsie Palmer, and Sally and Lucia Fairchild, came to him not just as paying clients, but as the fascinating daughters of treasured friends. Isabella Stewart "Belle" Gardner was the toughest of the bunch. The first portrait he made of her was a battle and he muttered about her, and mimicked her, when she was out of earshot. She was narcissistic and impossible—"a lemon with a slit for a mouth," he said—but she grew on him. Over time she became his greatest patron

and friend. His final portrait of her, a watercolor, is regal and heartbreakingly beautiful.

These portraits reveal the carefully crafted paradox that lies at the heart of Sargent's work and gives it its tension. If you walk through museum galleries looking for Gilded Age spectacle you will find it, but you will miss Sargent's truth: He painted illusion that shared space with its own undoing. Sargent's well-wrought, deluxe surfaces create the dream of a perpetually placid world, but these canvasses hold clues that an elaborate illusion is being enacted. These women are about to do something we cannot see—to experience something they cannot predict. With his uncanny insight, Sargent has grasped that something is impending from within them. They present novellas in embryo: stories of forbidden sexual longings, byzantine family rivalries, tragic illness, the onset of shattering madness, and the transformative power of art. They illuminate a proud and troubled age, an era when financial panic and collapse threw some lives into turmoil and left others barely touched. And they illuminate their maker, whose reputation has waxed and waned, but whose works remain mysteriously seductive.

SARGENT'S WOMEN

The Pilgrim

Here is no home, here is but wilderness
Forth, pilgrim, forth! . . .

—Geoffrey Chaucer quoted by Elsie Palmer in her diary

T HE CROWD OF London aesthetes argued over the young woman's look. Some found her "lifeless" and "hard"; others were mesmerized by the intensity of her expression, the "almost crazy" directness of her eyes. The discerning audience—writers, critics, and designers among them—were seeing a new work by John Singer Sargent. Titled generically *A Portrait*, the six-foot-tall painting was on display in the spring of 1891 at an invitation-only viewing at the New Gallery in London. What most of the crowd didn't know was that Elsie Palmer, the subject, was there. The eighteen-year-old moved through the large crowd, hearing fragments of their sometimes-acid judgments while experiencing the strange sensation of being out of her body. "I sat sedately and unconsciously up in my frame; while people talked and fought about me down below," she wrote in her diary. The painting's surreal quality had a lingering effect. People were convinced, well into Elsie's old age, that

she was mad. Others that she was steely and cold. Virginia Woolf once referred to Elsie as "marmorial and mute."

It's true. She is utterly still and severe in the portrait. She's ice cold as she confronts the viewer with a forbidding stare. "I dare you," she seems to be saying. She's more like a character from Poe than the well-dressed elite we expect of Sargent as she sits alone on a low bench. She is in the chapel of a moated, medieval manor house and the mood is funereal. Her blunt dark bangs and long straight hair, her hooded eyes and thick eyebrows, the sharp creases in her white dress that mimic the linenfold paneling behind her—the entire composition is eerie. Sargent absorbs her into the very fabric of the house. Elsie appears utterly affectless. A pagan goddess perhaps, in a world of her own. And, really, she was in her own universe.

Sargent had a great deal of trouble with the commission; it took him over a year to complete the painting to his satisfaction. When the process began, Elsie had just turned seventeen, on the cusp of womanhood. It seems that Elsie was in the process of changing right before his eyes, for the early sketches that Sargent made are entirely different from the final canvas. The sittings dragged on and on as Elsie's character remained elusive. Initially he depicted her as childlike, gentle. In a pen-and-ink sketch, Elsie's lips are parted, her hair softly frames her face, and she glances away from the viewer. She is anything but confrontational; she appears dreamy, sympathetic. Sargent also made several preliminary oil sketches—something he rarely did—to find just the right pose, just the right look for his subject. He painted her standing in the Great Hall of the manor house, with a fireplace and a Gothic arch in the background, a collie resting at her feet. She is distant and unformed, her features blurred. In an entirely different composition Elsie poses in the garden, bathed in yellow light, surrounded by roses, her head cocked slightly in a charming manner, a hint of a smile on her lips. She's flirtatious but innocent.

The finished portrait, however, dispenses with charm. Elsie seems to be in a state of hyperfocus. One contemporary critic wrote that the portrait was a "merciless analysis of character." Except for the single dainty

slipper that appears from underneath her dress, and the soft shawl (perhaps cashmere) partially draped across her lap, Elsie is all hard edges. Humorless. She is otherworldly.

On October 31, 1889, the day after Elsie's seventeenth birthday, Sargent came to paint her. Elsie's mother had just visited the artist at his country retreat; while there, she probably finalized the arrangements for the portrait. Elsie, her two younger sisters, ages eight and nine, and her mother were then living in the English countryside in Kent. They were American expatriates. (Elsie's father, General William Palmer, a railroad baron from Colorado, footed the bill but made only infrequent visits.) For the past three years the Palmers had been living in a medieval fantasy of a house called Ightham (pronounced "Item") Mote, a sprawling half-timbered manor house surrounded by water, with a central cobblestoned courtyard, a bell tower with a one-handed clock that rang on the hour, and a ghost that supposedly paced the staircase hall at night. The ghost, Dame Dorothy, had died a gruesome death in 1641 after pricking her finger while sewing on a Sunday. As if her nightly footsteps were not reminder enough of the ill-fated dame, her portrait in Elizabethan dress hung above the fireplace in the dining hall.

Elsie's mother was called "Queen," an apt nickname given that she presided over an ancient estate with a cast of courtiers who came regularly by train from London, some thirty-five miles away. Queen, a rich, charming American with a gorgeous mezzo-soprano voice and a taste for entertaining, had the perfect property to gather like-minded lovers of art and music and literature. Who could resist visiting one of the great historic treasures of England? London tastemakers flocked there for the atmospherics and for the august company: the famous novelists Henry James and George Meredith; John Singer Sargent and his friend, the musically inclined Alma Strettell (she and Sargent played such incessant

duets in the Cotswolds one summer they were dubbed "co-maniacs");
Alma's sister, Alice, an inspired costume designer; and Alice's husband,
Joseph Carr, a well-known art critic, theater director/impresario, and the
founder of the New Gallery, where Elsie's portrait would hang.

The biggest personality to frequent Ightham Mote was Ellen Terry,
the greatest stage actress and celebrity of the day—"Aunt Nell" to Elsie
and her sisters. Born into a theatrical family, Terry made her stage debut
at the age of nine. She married three times, had a series of lovers—
including a rumored relationship with Elsie's German governess—and
gave birth to two children out of wedlock. This sort of behavior by a
woman did not generally go over well in Victorian England, but in her
case, it added to her fame. (She was eventually appointed a dame of the
British Empire.) Sargent had painted the forty-two-year-old actress the
previous winter. She was then starring as Lady Macbeth in a controver-
sial London production. Sargent, an avid theater fan, took in the open-
ing performance on December 27, 1888, and audibly gasped upon the
actress's first entrance. That dress! It shimmered like "the scales of a ser-
pent," and hugged Terry's figure like "soft chain armour." That had been
the intent of the costume designer, Alice Strettell Carr, a friend of both
Sargent and Terry, and among the inner circle at Ightham Mote. But the
dress hadn't come easily. Carr couldn't find any fabric in England to cre-
ate the sensuous yet metallic look she had in mind. She imported fine yarn
from Bohemia—strands of green silk twisted with blue tinsel—and then
crocheted the yarn into a dress based on a thirteenth-century design. It
was floor length with large sweeping sleeves, but still lacked the theatri-
cal brilliance to project to the final row of the theater. Inspiration came in
the form of luminous insects. Carr had countless iridescent beetle wings
sewn all over the dress. In a finishing touch, she arranged rubies and
diamonds along the edges of the costume to create Celtic-style patterns.

Upon seeing Terry in that fabulous dress with her hair hanging to
her knees—"magenta hair!" Sargent exulted in a letter to the art collec-
tor Isabella Stewart Gardner in Boston—Sargent knew that he had to

paint her in full costume. It took some arm-twisting, but Terry finally relented and arrived by carriage to Sargent's Tite Street studio one soggy morning. (Across the road, Oscar Wilde was riveted as he looked out his library window to witness "the vision of Lady Macbeth in full regalia magnificently seated in a four-wheeler." Such "wonderful possibilities" the street now possessed, Wilde mused.)

The year had been an emotional roller coaster for Sargent. Winter sittings with the sublime Ellen Terry (among others) and the spring unveiling of his finished portrait, *Ellen Terry as Lady Macbeth*. The painting caused an enormous sensation; it was adored and reviled in equal measure and made Terry and Sargent the talk of the town. The artist created a tableau that did not appear in the production, but one that evokes the heart of the tragedy: the moment—simultaneously horrific and triumphant—when Lady Macbeth becomes queen of Scotland after having goaded her husband into committing murder. Dressed in her costume of beetle wings, she lifts a golden crown onto her head; her face, ghostly white, is stricken with overwhelming emotion, half steely ambition and half hysteria at the realization of the evil she has wrought. Henry Irving, who played Macbeth opposite Terry, purchased the painting and hung it in an alcove of the Beefsteak Room at the Lyceum Theater, a cozy gathering spot for the posttheater Bohemian set. A celebratory dinner was held there in March when the painting had its first private viewing among friends.

Just a month after Sargent's triumph, his father, FitzWilliam, died in the village of Bournemouth on the southern coast of England. FitzWilliam Sargent had grown to hate the expatriate life with its incessant travels through Europe, but he bowed to the demands of his wife. Decades earlier he wrote: "I am tired of this nomadic sort of life:—the Spring comes, and we strike our tents and migrate for the summer: the Autumn returns, and we must again pack up. . . . I wish there were some prospect of our going home and settling down among our own people and taking permanent root."

Permanent root—there had been no such thing in John Sargent's

early life, as his family roamed around Europe always in search of something that seemed just out of reach. As an adult, Sargent had become not quite a man without a country but one who straddled two lands. He laid claim to being an *American* artist, yet lived full time in England.

With the death of his father, Sargent became head of the family. The artist was accustomed to painting aristocrats who fell heir to vast estates and fortunes. Sargent's father didn't leave much in the way of a financial legacy. The family had long-since depended upon Mary Sargent's fortune—the bequest she had received years earlier—and they had expended much of that capital with their nonstop travels. The painter now inherited the care of his demanding mother and his two siblings: Emily who could still, at age thirty-two, burst into tears at any moment, in humiliation over her spinal deformity; and headstrong twenty-year-old Violet.

When Sargent arrived at Ightham Mote on the last day of October in 1889 he must have experienced a twinge of recognition. Here was another nomadic American family with a mother hungry to mix with the leading cultural lights of the day. Unlike Sargent's mother, who had been driven abroad by a combination of grief and artistic ambition, Elsie's mother was fleeing illness. Nine years earlier, Queen—then only thirty years old—had suffered a heart attack near her home in the Colorado Rockies. Doctors warned that the thin air could be fatal for her.

Queen had not grown up in the pioneer West. She'd been raised in pampered style on Long Island. Her father, William Proctor Mellen, was a prosperous, well-connected lawyer and a former partner of Salmon P. Chase, the chief justice of the Supreme Court. Seeking investment possibilities in the post-Civil War boom, Mellen met William Jackson Palmer, an ambitious and bright young man who understood the western railroad business. A former Civil War general, Palmer had political clout and financial savvy. A number of Union generals parlayed their high military

rank into postwar railroad riches. Palmer also had a thorough knowledge of railroad technology and a grandiose scheme: he'd build a railroad line from Denver south to El Paso, Texas, and connect it with a railroad that he would simultaneously build north from Mexico City. In the steep Rocky Mountain regions rich in coal, gold, and silver, he would cleverly make use of narrow-gauge rail lines. The system of railroad lines he created—and the ancillary real estate and mining investments that rippled out from them—eventually turned into a bonanza.

While promoting his business plans to Mellen on a train heading west, thirty-two-year-old Palmer had a chance meeting with Mellen's traveling partner, his diminutive, curly-haired, eighteen-year-old daughter, Queen. Instantly smitten, Palmer began to court her. One of his first invitations was an impressive one: he asked Queen if she would accompany him to President Ulysses S. Grant's inaugural ball in Washington. Shortly thereafter, they were engaged. Palmer, constantly on the move on business matters, wrote her long affectionate letters. He painted a romantic vision of their life in the West: he'd build a "Castle" for her in a spectacularly beautiful setting he'd come upon in Colorado "where life would be poetry—an idyll of blue sky, clear, intense atmosphere, fantastic rock, dancing water, green meadow, graceful hillside, high mountain, rugged cañon, and distant view—of the kind that gives wing to the imagination." Queen loved this adventurous dream, though wished that Palmer would stop working long enough to come see her every now and then. "I may as well get used to these sudden moves of yours and accept my fate with mild resignation," she wrote him on May 30, 1869. She also had to get used to the idea of being intimate with a man so much older and more experienced than she. The awestruck bride-to-be continued to address her fiancé as "General," until Palmer insisted she call him by his first name.

They married in November 1870 and honeymooned in England, where the workaholic groom drummed up investors for his railroad and for a resort town he envisioned along the route. The town, Colorado Springs, would feature pure mountain air and no alcohol—though residents would

soon find creative ways to circumvent that particular proscription. Known variously as the "Newport of the Rockies" and "Little London" for the number of Britons it attracted, Colorado Springs eventually became a refuge for well-heeled invalids—patients suffering from consumption (now known as tuberculosis), who were referred to as "lungers."

With Queen offering architectural advice from afar, Palmer oversaw the creation of a rambling country home about seven miles from the town, in a canyon of spectacular red rocks beneath Pikes Peak. Called Glen Eyrie, their home was on the edge of the "Garden of the Gods," a geological wonderland that featured sculpturelike rock formations of every conceivable shape scattered haphazardly about—pinnacles and spires, mushroomlike effusions and boulders that appeared to be teetering en pointe. The novelist Helen Hunt Jackson, among those drawn to Colorado Springs for her health, described this surreal red landscape as "all motionless and silent," as if at "the very climax of some supernatural catastrophe."

As a new bride in Colorado, Queen embraced the frontier, giving the rock formations around Glen Eyrie fanciful names: "Major Domo," "King Arthur's Seat," "Abraham Lincoln," and "Montezuma," among others. As Colorado Springs emerged from the wilderness, she also christened the town's new streets, naming them Cache de Poudre, Tejon, Cascade, and Pikes Peak, after rivers and mountains. She eagerly embarked on town projects: hosting a Christmas party for the local children that became an annual event; arranging and singing at a concert to raise money to build a library. She endured blizzards in their remote canyon perch, and witnessed snow rising from avalanches sliding down the surrounding mountaintops. She accompanied her husband on a strenuous overland trip to Mexico City to survey railroad possibilities. En route, the group was attacked by bandits but managed to escape. Queen soon realized that she was pregnant and grew increasingly sick from the incessant jostling of the carriage. She left the traveling party for New York, where she gave birth to Elsie on October 30,

1872. Then, Queen brought their infant back to the wilderness kingdom of Glen Eyrie.

Native Americans considered the landscape sacred and Elsie, who grew up there as a child, found it magical. As a young girl, she wrote a fan letter to the children's fantasy author George MacDonald, asking him for his autograph. "Our home is in Colorado in the midst of the mountains, and a long way off from houses, and I love it more than any place in the world," Elsie wrote. "Some of the descriptions [in your books] . . . remind me very much of it; and when I am there I go far away almost inside of the beautiful red rocks, and read them, and they help me to understand them." She signed her note, "Your little friend Elsa Palmer." She felt a kinship to MacDonald's characters, particularly the eight-year-old heroine of *The Princess and the Goblin* who lives in a remote mountain landscape, her mother dead and her father away much of the time. Left to her own devices, the princess finds an evil world of goblins in the nearby mines, and a beautiful ghostly forebear who protects her.

Queen's heart seizure in 1880 changed everything. The thin mountain air—which Colorado Springs touted as such a tonic for good health—was deadly for her. On October 29, 1880, Queen gave birth in Colorado to her second daughter, Dorothy; but when she got pregnant again the following year, the family retreated to a seaside resort in southwestern England, where a third daughter, Marjory, was born on November 12, 1881.

Queen stayed on in England with her three daughters, ages nine and under, while the General returned to America to attend to his all-consuming railroad business. That didn't prevent him, however, from giving long-distance child-rearing instructions. He was worried when, in 1882, Queen wrote that Elsie appeared "dull-eyed and wan." Is her schedule too strenuous, he wondered? "Is the discipline too much and are the rules too exacting for a rather delicate constitution?" He knew what that felt like. As a boy, he had been pushed too hard until he fell ill and

nearly died. He didn't want the same thing to happen to his dear Elsie. "I suppose the nearer to little kittens children can actually be kept during infancy the better, so as to give the animal part of their natures full swing and development," he wrote to his wife. He went on to complain about a "hot-house tendency" in child rearing at that time, "as if the competitions of the business and social world had entered the nursery and the school-house." He worried that perhaps they, as parents, were too ambitious for Elsie, and "that we may have driven her too much, in our anxious zeal, and made a little machine of her." He did, however, want Elsie to work on her equestrian skills in England. "I am perfectly enchanted to learn of the way Elsie jumps," her father wrote in a subsequent letter. "She has succeeded beyond even my sanguine hopes."

In the summer of 1882, the General went to London and brought them all back to Colorado. But within a year Queen's heart grew weak, her spirit restless. She worried that eleven-year-old Elsie needed a proper education, and not just the one-room schoolhouse at their rock-strewn estate, miles of barren unpaved wasteland away from Colorado Springs. Queen brought her daughters to Newport and then, in 1884, to New York City, where Elsie enrolled at Brearley, a serious private school for young girls that had just been founded by a Harvard graduate of the same name. There, Elsie had the chance to make friends in a school setting with girls her own age. She became lifelong friends with the Dunhams, a brood of a half-dozen sisters—four of whom Sargent would eventually draw or paint—who were sought-after guests in the drawing rooms of New York's cultural elite.

While in New York the Palmers lived for two years at the Dakota, the city's first luxury apartment building, a delightful confection of French Renaissance, German Gothic, and Victorian English design that had just been built on the then barely inhabited far reaches of the Upper West Side. (At Central Park West and 72nd Street, the Dakota has been home to the rich and famous for generations and was made ghoulishly famous as the setting for the film *Rosemary's Baby* and the real-life murder of

John Lennon, who lived there.) Central Park lay just outside their door, so Elsie had ample opportunities to ride. And the Dakota had its own adjoining tennis and croquet courts, so there was no end of fresh air and activity. But the bitter winter weather took its toll on Queen's health. In 1886, they pulled up stakes once more, moved back to London, and then on to Ightham Mote.

The Mote is a giant puzzle, or more precisely, a geometric sequence of squares. It is a square within a square within a square—the central square cobblestone courtyard, surrounded by buildings, all protected by a moat fed by a lake. The house, in a wooded hideaway, is completely enclosed upon itself. Impregnable, solid, and self-sufficient, it feels as if it's hermetically sealed. The walls of the house fall precipitously into the water surrounding it. At the main entrance, a two-arched stone bridge delivers visitors to an oak door studded with nails. One expects knights in armor to emerge.

The exterior of the Mote is a marvel of irregular gables, chimneys, and staggered rooflines, the accretions of many centuries; there are mullioned windows and a stone tower topped by a brick parapet. The interior is just as quirky. The fourteenth-century Great Hall has an arched roof that rises nearly forty feet above the ground; in a humorous touch, crouching carved figures in the wall appear to hold up the arches. Coats of arms and mythical beasts are carved into the wooden paneling.

For Elsie, an imaginative child who grew up reading romantic stories while curled up in the cleft of a rock, the house must have been mysterious and fascinating—but not without its terrors. There was no electricity, so family and guests wandered the corridors with candles, the flickering light casting long shadows. Rats scurried across the floors at night. Turning a corner, Elsie would come face to face with the frightening head of a Saracen carved into the newel post of the Jacobean staircase. Up the stairs

were the bedrooms, one created out of the "Old Chapel" where services
had been held from the Middle Ages until at least 1585, when authorities
raided the Mote to search for relics and to accuse the owner, whose wife
was Catholic, of keeping "a vile and papistical house." There was still a
"squint," or opening on one wall, so that family members not inclined to
attend the chapel service could listen without entering the room. Elsie's
own bedroom had a small window looking out onto the stone court-
yard; she wrote in her diary of moonlit evenings when she could see the
shadow of the tower on the illuminated cobblestones and the dark fir
trees beyond.

Down the hall there was another chapel—the "New Chapel," prob-
ably consecrated in 1633—with a barrel-vaulted ceiling celebrating
Henry VIII with images of the Tudor rose, the castle of Castile com-
memorating Henry's first wife, and other royal images laboriously
painted on the curving ceiling boards. The room was somber. The
wooden pews, and pulpit; the linenfold paneling, so named because the
carved wooden walls look like folded linen; the angelic figures carved
onto the end of the church stalls. The only light filtered in through
sixteenth-century stained glass windows from Germany. A claviorga-
num, a hybrid of harpsichord and organ—Henry VIII owned such an
instrument—stood at one end of the chapel. This seems a gloomy spot
for a portrait, but Sargent got to know Elsie well, and this is where he
eventually decided she belonged.

A photograph taken during Sargent's stay at Ightham Mote shows Elsie
and her mother as he might have first encountered them after crossing the
moat to enter the house. They are in the stone courtyard. Queen wears
a fancy dress, an elaborate broad-rimmed hat, and a full-length cape
draped over her shoulders. Her arm is raised and her finger is pointed
toward her daughter, as if giving instructions. Elsie is looking the other

way, directly at the camera. She wears a billowing dress, a tall soft dark
hat, and has a blank, impenetrable look. She appears to inhabit a world of
stone ruled by her powerful, domineering mother. Elsie holds on to her
new dog, a sad-eyed St. Bernard named Leo.

Elsie had recently returned from a nearly two-month trip with her
father. They had traveled through France, Germany, and Switzerland.
In Paris they ascended the Eiffel Tower that had just been built as the
entrance to the world's fair being held there. They hiked in the Swiss Alps
and spent a night at the Hospice, or monastery, of St. Bernard, where
monks had first bred the mountain rescue dogs. Elsie's father bought two
St. Bernards and gave the bigger one, "who is a perfect beauty," to his
daughter. Elsie went back to the Mote with her dog; not long after, her
father returned to New York with his dog on the *City of Paris*, the fastest
steamer then plying the Atlantic.

Elsie's mother spent most of her married life apart from her husband
and she confided in her eldest daughter as if she were a peer. The threat
of death always hung over "Motherling," as her children affectionately
called her. Queen made it clear to Elsie that *she* was to take over in her
place if something should happen to her. In July 1886, Queen had just
moved her children to England. She feared she was about to die; her
children's father was nowhere in sight. She entrusted a letter to thirteen-
year-old Elsie.

> Mother wants to be very sure that you have some words from her—
> for "God-speed"—in case she should be called away suddenly on
> a long journey—without time to <u>speak</u> . . . to you before she goes.
> . . . My big darling—my white little maid—my gentle snow drop—
> Elsie—you know how much we have talked of your being the little
> mother of the other two. Think of that, now—my first born—my

precious daughter—I need say no more to your loving soul than
that—<u>never forget</u>—that Motherling is near you blessing you—
always—forever—helping you, comforting you—and waiting for
you and your baby sisters. . . . Make them brave and good—<u>Kind</u>
and true . . . and let them know how "Mutterlein" is loving them—
and near them. You will read these words to them—so that they
will remember what Mother said to them—and you will show them
by your own sweet love how Mother loved them . . . better than all
the world besides—You will not be sad—but bright and happy with
them—Mother is resting (you know how tired she often was—my
darling) and happy—and glad in your joys—and goodness—and
waiting till your work is done too—

This was a heavy burden for Elsie. She had a special bond with her
mother, but it was always clouded with impending doom. Queen traveled
to the Continent without her children on at least one occasion while they
were living at the Mote, and Elsie hated the separation. She wrote plain-
tively to her mother:

After supper at 8 o'clock here I am, writing to you, <u>my</u> Mother,
in your morning room which shows a tiny bit of your spirit to me
. . . loving you dearly, dearly, and wondering what you may be doing
just now at this very minute . . . I love The Mote better than any other
place in the world . . . [and] when I am away from it I always long to
get back to it, just the way with Glen Eyrie. I am sure this will be a
real second home some day; I love it too much, and you love it too
much . . . that it shouldn't be, even if only in our thoughts . . ."

Ightham Mote became a touchstone for Elsie. On returning from Swit-
zerland in 1889, she wrote in her diary that she was "bewildering[ly]
happy" to see "Motherling" and "<u>Our</u> Mote." The General made only
occasional visits to the manor house, where he faded into the medieval

furnishings. Queen, who charmed her guests with delightful, animated conversation, was the star of the household; her introverted, business-obsessed husband became the butt of some joking among the artistic crowd—even though he was the one paying the bills. At Christmas 1887, Henry James wrote sarcastically of the patriarch's arrival, "The good General Palmer arrived from Mexico, with the mud of his railway-making still on his boots."

James and assorted other guests were spending the holiday season with the Palmers, an episode the novelist described as the "drollest amalgam of American and Western characteristics . . . in the rarest old English setting." The rich Americans, with "characteristically Coloradoish, generosity," laid out a Christmas feast for the estate's seventy "lean tenants," whose English landlords had been so poor and closefisted for so many generations that the "rustics" were unaccustomed to such largesse. The tenants devoured the dozens of turkeys and roast beefs and plum pies set out for them in the Great Hall. The room was warmed by a Yule log and a band provided music. A Christmas tree added to the festivities, and the young people—Elsie and her sisters and the other children who were houseguests—performed a dance in costume.

The local innkeeper, who helped organize the event, was most competent in James's estimation. Why would Queen, who "now lives in a country boasting the perfection of domestic service," look elsewhere for help? After a trip to Italy, she had returned with an Italian butler who was merely "a picturesque boatman who doesn't even wash his hands," and she employed as her "major-domo a helpless German-American governess from the Rocky Mountains."

That being said, the household was still exceedingly English, with its ancient furnishings, in James's words, in "a state of almost perilous decrepitude." The place was also freezing. Frances Wolcott, an American guest, once wrote that the dining hall was so drafty that screens had to be placed around every chair. "Our spines were chilled," she wrote. "I felt that a woman's best friend was a hot water bottle and that to jump into bed

and pull up the coverlets . . . was but the part of wisdom." A member of the House of Commons had warned her about how frigid English country houses could be. He told her that on visiting such places he wore "perforated chamois skin next [to] my body." Not quite able to picture herself with chamois peeking out of her low-cut dress, Wolcott had to endure the cold, "sitting at [the] table looking black and blue from lack of circulation, with my toes turned under the arch of my foot."

James didn't focus on the cold during his Christmas visit, but he did report that he shared his tower bedroom with both a ghost and a secret dungeon, though "fortunately the former remained in the latter." The author added to the decidedly spooky atmosphere by sitting next to a huge fireplace and spinning out gruesome ghost stories—leaving the assembled adults, and doubtless the cringing children, hanging on every word. But the guests, both young and old, also sang Christmas carols and danced merrily to music provided by a fellow reveler.

The Mote was a paradise for children, and Queen saw to it that her grown-up friends brought along their young ones. "The children were always the frame to the picture in that lovable household," one guest reminisced. There were formal gardens and dark woods to explore, there was bowling on the large greensward known as the "Pleasaunce." The children dangled fishing lines off the stone bridges over the moat or stood on window seats in the library—each child claiming his or her own cubicle—and then cast their lines out the window to the water below.

The house yielded its secrets to curious children. A scouting party once turned up an unknown room that hadn't been used for over two hundred years. Ellen Terry's son found it when he nearly fell through rotted floorboards into the hidden chamber that had been used as a temporary jail for Roundhead troops who'd attacked the Royalist stronghold of Ightham Mote during the English Civil War of the seventeenth century.

The guests who frequented the house were an unconventional sort who mixed easily with the next generation, treating them as equals. The theatrical impresario Joseph Carr insisted the children call him by his first

name. George Meredith, a literary eminence in declining health, would park himself beneath the spreading cedar tree next to the bowling green and ponder the future careers of all the children by studying their heads as if they were crystal balls. Joe Carr's daughter had such a remarkably shaped head that Meredith advised, "Always let her pursue whatever walk in life she chooses." Elsie found Meredith full of lively talk, though his stories and reminiscences tended to ramble on. He once told her that she looked "like a nun in a rose garden."

Dress-up was a major component of entertaining at the Mote. Queen loved wearing outfits that were in keeping with the medieval surroundings. Guests followed suit. At Queen's insistence, Ellen Terry would bring her theatrical or fancy dress costumes when she came for a weekend. (While at her own country house, Terry preferred doffing her clothes, and dancing outside in gossamer nightgowns.) Elsie watched this world of make-believe with her mother at the center of it.

During her sittings with Sargent, Elsie kept a diary. The artist was very particular. He would decide upon the manner and the mood in which his subject would be presented. The socialites and dowagers he painted would bring out an array of their finest gowns and Sargent would look through them, rejecting this one, choosing that one. Or, he might just take some luxe fabric and drape it around the sitter in the way he wanted. The accoutrements were crucial—perhaps a hat, a rose in a hand, a pair of oversized Asian vases to tower over a group of children, a costume covered in beetle wings.

With Elsie, in contrast, Sargent stripped everything down. The dress he chose is simplicity itself: smocked on top, a sash at the waist, the crisp vertical folds of the fabric echoing the background. It is an aesthetic-style dress, a fashion then in vogue, that harkened back to the Middle Ages. Elsie is almost entirely covered: Her inner sleeves stretch to her wrists,

her dress reaches to her neck. She wears a modest, barely visible necklace. She looks chaste. The artist abstained from using bright colors. He made it largely a study in white, muting the rest of the colors. He matched Elsie's brown hair and eyes with the linenfold paneling. He gave her pale pink lips and a subtle mauve shawl wrapped partially around her waist. That was all the contrast he cared to show. He used the severe wooden background of the chapel wall, coupled with Elsie's blank but haunted stare, to make it seem as if she were in a liturgical trance, or had just emerged from the confessional.

Sargent needed activity, conversation, and music during his painting sessions. He'd encourage his subjects to invite friends. He'd puff on a cigarette, sit at a piano and play when he hit a dull patch. Sargent was a brilliant pianist and could just as easily have pursued music as a career, but whether he would dare touch the claviorganum in the chapel is another matter.

"Hardly doing any-thing but sitting still with my hands in my lap, having my portrait painted," Elsie wrote in her diary on December 1, 1889. The sittings at the Mote had been going on for a month, and Sargent was still seeking something. The artist was a virtuoso of technique and was well-known for being able to turn out portraits quickly. Critics accused him of being facile; fellow artists gnashed their teeth with jealousy. A full-length portrait usually took Sargent no more than about a dozen sittings. But Elsie was giving him fits. He couldn't quite get a handle on her—and the weather complicated the matter. Sargent needed light to illuminate Elsie's features inside the chapel and a stretch of gray days delayed the process. On one gloomy, dank day Sargent abandoned the indoors altogether. He went outside and sketched a group playing a game of bowls next to the manor house— five women in long cloaks, Queen and Elsie among them, and one tall, thin, bearded man.

The more time Sargent spent at the Mote, the better he got to know Elsie—and the harder it became to paint this complicated creature. He

and she conversed over dinners and on evening strolls. On November 5, while Queen was in London, Sargent and Elsie walked several miles with the dogs to the village of Shipbourne. It was Guy Fawkes Day and there was a bonfire on the green, a great conflagration with a tower of smoke, flames shooting up and sparks flying above and onto the crowd. The groups of boys carousing around the fire unnerved Elsie, who thought they looked "strange and weird." Leo, the St. Bernard, was frightened by the chaotic scene so Elsie and Sargent ambled home.

As November turned to December, Sargent had to put aside the painting. On December 4 the artist was leaving for America with his sister Violet. Commissions awaited Sargent on the other side of the Atlantic. Elsie went up to London to see him and his sister off, and then stayed in town for several days in a flat that Queen had been leasing. Elsie did her Christmas shopping, attended a concert, and then returned to the Mote in moonlight with the countryside covered in snow. The sight enchanted her.

Life would soon be different. The Palmers' lease for the Mote was coming to an end, and a new owner, Sir Thomas Colyer-Fergusson, had given them notice that he would be moving into the house himself. Queen and Elsie had already spent months seeking a new country home, and they settled on Blackdown, a stone Elizabethan manor house in West Sussex set against a steep hill and looking out onto wonderful vistas. Lord Tennyson lived nearby.

Leaving the Mote was wrenching. Queen's fortieth birthday fell just a few days before their departure. Elsie's sister Dorothy ("Dos") played some Schumann for her mother, and a magnificent array of spring flowers—daffodils, violets, primroses, and daisies—brightened the table. Nonetheless, the birthday celebration was melancholy. At the end of March 30, 1890, their last full day at the Mote, Elsie lingered

at the window, savoring her final view of the courtyard and the lawn. "Tonight: <u>this is the Mote;</u> tomorrow: <u>that was the Mote</u>," she wrote. The next day the family bid good-bye to the tenants on the estate, one of whom presented a hazelwood cane to Queen, and blue jay feathers to Elsie.

Mother and daughters caught the morning train and began yet another new chapter. But they had barely settled into Blackdown when they got word that *that* estate had also been sold, and they'd have to find another place to live. They shuttled between London and a cottage in the ancient village of Frant, until they could find something grander.

Sargent meanwhile was deluged with commissions in the United States in 1890; nonetheless, his sister Emily wrote, "Elsie Palmer's unfinished portrait in England is weighing very much on his mind." The fact that Sargent was even thinking about her portrait *at all* is rather astonishing. Sargent was then frantically finishing a series of commissions on the East Coast, and about to embark on mammoth wall decorations for the new Boston Public Library designed by the prestigious architectural firm McKim, Mead & White. Sargent's architect friend Stanford White and his benefactor, Isabella Stewart Gardner, had played key roles in securing this coveted commission for Sargent.

Sargent briefly returned to London in November. Busy as he was, the artist was intent on finishing Elsie's portrait. On November 18, 1890, three days after his arrival, Elsie visited his Tite Street studio and was amazed to see the "wonderful change" he'd made to her painting since she'd last seen it. That being said, he still seemed to be having some trouble with her hair. "Hair is probably coming down," she noted. There was, she said, a "state of quiet" in the studio.

To those who didn't know him well, Sargent appeared shy and awkward, his speech interrupted by long pauses and nervous half coughs,

his feet jiggling. He despised public speaking, which he avoided at all costs. *Repressed* was a word that often came to acquaintances' minds, but with friends he was gregarious and charming. He also held strong opinions and loved to debate matters of art and literature. He did so with Elsie, keeping up a steady stream of good-natured arguments as she sat for him in his studio over the course of a week. "Same spirit of rebellion against Scott," she wrote, after he presumably expressed his old distaste for the historical novelist Sir Walter Scott. On other days they argued over Schubert's symphony, actors and actresses, his picture of Ellen Terry as Lady Macbeth. Elsie either ate lunch with the artist at his studio, or went off with his sister Violet to catch up on the latest news. In the evenings, Queen and Elsie often dined with Sargent. Yet the portrait still remained unfinished.

By mid-December, the skies were so dark in London that Elsie suggested that Sargent come to their country cottage in Frant. He did so the next day, and he was rewarded with a bright sunny day. While Elsie posed, Queen read aloud the speeches of Charles Parnell, the Parliament member who fiercely supported Home Rule in Ireland. The political chatter seemed to propel him. "Portrait got on fast and well," Elsie wrote, "and is so <u>beautiful</u>; it will be finished tomorrow." The next day he came down early from London; but though there was lots of continuing discussion of Parnell, the light wasn't good. A friend in attendance expressed her sympathy. Oh, the trials of posing!

Within weeks, Sargent left London for the Near East and wouldn't be back for the best part of a year. (Elsie's painting would be unveiled in his absence, though he still wasn't entirely satisfied with it.) The artist was going abroad on a research trip for his Boston Library murals that were to be based on the Bible and the ancient world. By contrast, Elsie's life was circumscribed. She spent New Year's Eve with her mother and, in her

diary, reflected on how quickly the year had gone by. She added, "I can't express my feelings."

At eighteen, Elsie was understandably confused. In a sense she was trapped between her mother—whose health she worried about constantly—and her father, who worried about *Elsie's* health and well-being. As the family reluctantly left the Mote at the end of March 1890, Queen wrote to her eldest daughter on stationery from the manor house. She directed that the letter be opened only in the event of her death. It was a sequel to her previous letter containing her death instructions. Queen looked over the old letter and wrote:

> There is not much to add. If I should write farewell words to you now they would be the same. . . . Perhaps you will never see the words I have written, for I <u>am</u> stronger, not so tired any more, and even though we are on the eve of leaving our beloved Mote, I am happy. . . . It is a comfort always, to know that even if I should go to sleep tonight, not to wake again in this world, I have been able to go so far on your journey with you and the little ones. <u>What a joy it is</u>—you will not forget sweetheart? even when you miss your own Motherling <u>who is near you</u>—whether you see her or not—forever.
>
> Good by—my Heart—my little ones—<u>our</u> Mote—Your Mother

Elsie suffered from worry and from headaches. Doctors in England prescribed coffee, but her father sent contradictory instructions from Colorado. He opposed the use of caffeine and advocated a daily regimen of fresh air and exercise. As if he were commanding troops or running a railroad, the General drew up a schedule for her. If she lived up to it, she'd earn a larger allowance, but if she failed to fulfill her duties, he would reduce it. Though he began the letter with "My darling chick," he quickly adopted an authoritarian tone as he dictated a plan "of great advantage to [your] health, nerves, temper, spirits, & morale."

As I merely want compliance, & not promises . . . I have thought to adopt a plan which may present a continuing inducement—No compliance—No instalment [*sic*]. You can cease when you like— only I might not be inclined to renew when once broken . . .

The present requirements are

no tea or coffee or stimulants

To be out & take a 10 minutes walk at 10 minutes before 8

To take a walk or ride in the forenoon—before lunch & after breakfast

Ditto—between lunch & dinner—the two together to be not less than 3 miles of walk every day unless weather should absolutely prohibit (which means an American not the usual English storm)

Off to bed at 10—or earlier without fail except when theatres, concerts or parties are at hand.

This will do for the present. If you wish to start on that, the check will be sent you weekly or monthly.

You [are] to notify me of any default.

Your Papa

Elsie knew her father was a stickler for detail and would demand strict adherence to his regimen, so she responded with some questions of her own. Could she try the regimen for perhaps a month before committing to it? She also inquired about specific situations that might require bending the rules. For instance, if evening events kept her up beyond 10 p.m., could she push back her morning schedule the following day? She promised to tell him if she did not stick to the plan.

When it came to Elsie, the General and Queen had differing priorities. For her father, physical exercise trumped all; for her mother, an immersion in the arts was paramount. Queen saw to it that Elsie had a steady

diet of theater and concerts and ongoing piano lessons from a professional musician. Queen was well-known to the artists in London, and welcome to visit them. One winter day in 1891, Elsie and her mother visited Alfred Parsons's studio where, courtesy of his paintings, they enjoyed the spectacle of English gardens in bloom.

Elsie and her mother went alone to Paris in March 1891. It was art at the Louvre in the morning and the music of Richard Wagner, the German composer, in the afternoon. "The end of the Gotterdammerung, carried one off one's feet—it was as though I were hearing the soul of music." Wagner was an absolute obsession at the time, and the theater he built in Bayreuth, Germany, to stage mammoth productions of his work was a mecca for music lovers. En route to Bayreuth later that summer—the "most sacred spot," in Elsie's words—she and her mother passed through forests of "great solemn silent pines! they almost speak to one; and mean strength and everlastingness." The first performance they saw at the Bayreuth Festival was almost more than Elsie could bear and beyond her ability to convey in language.

Surrounded by some of the most talented and creative souls in England, Elsie felt an emptiness at her core. Who was she exactly? On January 21, 1891, she confided in her diary:

> there is . . . a <u>something</u> strangely lacking in me. . . . I feel that the lack of it (whatever it is) must be at the root of my clumsiness, forgetfulness, shyness, vagueness, and it makes me feel—well, not very happy. How nice if some kind powerful person would present me with it, and I could safely install it into that lacking void of my brain. Good-night, feelings, happy, sad and complicated! I have had quite enough of you.

When her portrait—her very character—was scrutinized at the New Gallery in April, neither her father, nor the artist himself, was there. The General visited London later that year, and, being a practical man, he wanted to look at his daughter's portrait close-up, to examine what he had paid for. He and Elsie went to the artist's Tite Street studio in December 1891, but Sargent wasn't there and they couldn't find the painting themselves. The artist had decamped for larger quarters in the village of Fairford, where he was working on his enormous library decorations. Upon learning that Elsie had been to his studio, Sargent wrote a letter of apology for any inconvenience he'd caused, saying that he'd moved her portrait from its accustomed spot in order to reuse the easel it had been resting on. He also asked a favor. Please don't have the painting photographed just yet, he requested. "I want to do something more to your portrait." What revision Sargent had in mind is unknown, but clearly Elsie continued to mystify and intrigue the artist.

Sargent, too, remained something of a sphinx. In trying to describe him, Elsie wrote: "It is too difficult a task, too complicated and queer . . . to attempt; all I will say is that one feels great trust in him, and sure of sympathy in trouble." Elsie wrote her assessment in the spring of 1892, when Sargent was staying with the Palmers at Loseley Manor, the mansion they were then leasing, one of the great Tudor houses of England. Queen Elizabeth I had visited the manor house three times.

The current woman in residence, Queen Palmer, was entertaining a number of guests, among them, Sargent and Madame Haas, Elsie's talented piano teacher who played Chopin, Beethoven, and Schumann with a level of artistry that amazed her pupil. The assembled guests, both adults and children, played bowls outside, went to a nearby garden that was "like an ideal fairy-garden," and visited an old gallery that had a magnificent tapestry. After dinner there were the requisite parlor games and more music. When Sargent left the grand premises he took with him an old wooden box that he'd found in the house. It would

be perfect, he said, for one of his subjects to stand on while posing. (Elsie noted in her diary that Sargent's studio certainly lacked practical necessities.)

Elsie would know. That spring she was spending a good deal of time in his Tite Street studio, watching as he painted Helen Dunham, her dear friend from New York and sister of her closest friend, Katie. The artist chose a graceful, red chair with a curving back and a plush cushion for Helen to sit on, though she leans slightly forward, away from the chair rather than sinking back into the upholstery. Sargent has her wear a gown of fine white silk, her arms and neck exposed, her head in profile, her features soft—the exact opposite of how he portrayed Elsie. The artist began the painting with a distinct disadvantage—he'd scorched his fingers several days earlier in a freak accident. Elsie described the event in her diary on May 5, 1892:

> After having wandered through the New Gallery and Academy
> . . . [Sargent] went into some café to refresh himself with beer and
> cheese and bread and butter. He was quietly enjoying himself when
> suddenly he felt a sting and then flames shot out from his pocket,
> and he discovered that his match-box had caught fire; people looked
> at him suspiciously as they would at an anarchist, until at last the
> waiter had pity and put the fire out. His hands were burned, and I'm
> afraid he found it difficult to paint.

Sargent's studio was full of paintings at the time—so many, in fact, that he asked if Queen would take the charming painting he'd made of the group playing bowls at Ightham Mote. "Put it away in some nursery [or] on a stairway." He had no space for it, he insisted. And so the painting eventually went to Elsie.

Helen Dunham remained in London during the sittings, but Katie stayed with Elsie at Loseley Manor and the two of them would travel to town to spend mornings at Sargent's studio, watching the portrait unfold.

One day Katie sang a song by the Hungarian-born composer Francis Korbay to inspire the artist as he worked. In less than a month and a half, Sargent finished Helen's portrait. He then moved on to Lady Agnew of Lochnaw, a close friend of the Dunham family, and completed her portrait after a mere six sittings. Sargent's speed in executing these two portraits was in stark contrast to the way he approached—and avoided—finishing Elsie's painting. As for the two portraits he created so quickly, there were similarities yet profound differences in the personalities he evoked. Sargent chose nearly identical white silk dresses for Helen Dunham and Lady Agnew to wear—though Lady Agnew's has an elaborate, long, purple sash around her waist—and each one is posed in an elegant curved chair. But Lady Agnew, with her dark, bedroom eyes, slouches sensually onto one side of the chair, places an arm seductively around the outside of it, and is a magnificent seductress. In contrast, Helen, though beautiful, appears stiff and guarded. She looks away from the viewer and clasps her hands as if to protect herself. (Upon seeing the painting, the pianist Ignacy Paderewski described her fingers as "saignant," or bleeding.)

While Katie Dunham was visiting, the two friends went to see Ellen Terry. After going to the actress's home, Elsie reported how delightful and down-to-earth Terry was, despite her celebrity. That evening Elsie and Katie went to see her playing Queen Katherine in Shakespeare's *Henry VIII*, and the actress had a special treat in store for them. Before the end of the play, "a white finger appeared through a little hole" in the curtain. It was clearly directed at them. "Beckoning!" Elsie wrote. Katie Dunham leapt up immediately, but Elsie waited for the end of the performance before seeing Lady Nell in her dressing room.

Approaching twenty years old, Elsie had no romantic prospects and spent much of her time in the company of people decades older. Social activity revolved around the electric cultural figures drawn to her mother. It's

strange that Queen took no active role in encouraging Elsie to marry. After all, in that era and in that rarefied social class, the ultimate goal for a mother was to arrange an appropriate marriage for her daughter. A pedigreed British aristocrat was especially coveted by Americans— and vice versa. An impoverished earl or duke would bestow a prestigious title upon a wealthy American wife, who, in turn, would provide the necessary cash to keep up his ancestral estate. Queen had orchestrated the perfect backdrops—Ightham Mote, Loseley Manor—to entice a suitor for Elsie. Yet it seemed that she wanted to keep her eldest daughter for herself—as a friend she could confide in, and as a second parent who would help take care of the younger sisters, who were always considered "the children," and therefore separate. Queen even looked beyond her own death, when Elsie would have to take charge of raising her siblings. In effect, Elsie became Queen's handmaiden.

Elsie spent little time cultivating friends of her own. Even an occasion with someone her own age inevitably devolved into an event dominated by older, famous personages. A birthday party in Surrey for Marie Meredith, the daughter of George Meredith, attracted several of London's greatest theater luminaries who were almost a generation older: Johnston Forbes-Robertson, considered the greatest Hamlet of the Victorian era, and Arthur Cecil, a famous comic actor and playwright. Cecil led the group in humorous songs. After supper some of the guests, Elsie included, rode donkeys up a hill only to come down it dancing and singing the traditional English song *What Cheer.* George Meredith doted on Elsie while she stayed at the family's country home, Box Hill. He even permitted her to read in his "chalet," the cottage in the garden where he wrote many of his famous books. One day she pulled a volume of classic Arabic poetry from his bookcase and pointed out a poem she particularly liked. Thereafter, the elder Meredith playfully teased her. He dubbed her the "Poetess, who turns her back to Venus and faces the moon." She loved the attention. "That evening we watched the sun set and moon-rise, outside his chalet door, and one enjoyed it the more for his presence," she wrote.

Elsie left Box Hill and its intellectual pleasures and went directly to London to see her father on June 11, 1892. As was often the case, Elsie saw her father alone, and, as usual, the General wanted his daughter to get more physical exercise. He had been dismayed to learn that she'd already given up on the daily health regimen he'd prescribed. For their day together in London the General had arranged a lesson at a stud farm just outside of town. Elsie was learning how to drive horses in tandem. The lesson went well. The stud master who tutored her was a wonderfully patient teacher and devoted to his animals, but he was an endless talker. Relief came when the baroness who owned the estate invited Elsie and her father in to lunch.

Elsie's diaries reveal a life of almost unimaginable privilege in England: accompanying Sargent to a concert by the virtuoso pianist Ignacy Jan Paderewski, and being tutored in piano by the composer Korbay while she played a piece by Bach for him. But on at least one occasion she had the opportunity to learn how the poor lived. A month after Elsie saw her father, a group of about one hundred residents from a settlement house in the East End of London came to visit Loseley Manor. In an act of social service, Queen opened the grounds of the estate to "Men and women of all kinds. . . . It was interesting beyond words," Elsie wrote. "They were all full of enjoyment and grateful and appreciative, and kind." It was a beautiful summer day and the city dwellers took particular delight in the gardens and the beehives. Each one of them got a rose to take home. Lunch was served under a tent and the woman next to Elsie, a widow, spoke of her dead husband. She was now superstitious about the month of July because "he had been born in July, become shipmate in July, . . . and been drowned in July." She said she was always relieved when the month was over. After lunch there was tug of war and a game of cricket that pitted the ladies against the men. Most of the men pretended they were playing in earnest, preferring to let the women triumph. There was tea and singing and speechifying and "Madame Haas played Chopin's Funeral March, which touched the people very much." They all gradually left,

issuing invitations to their hosts to visit them in their urban quarters—an invitation that was apparently never taken up.

Queen's health was, and remained, the determining factor in the Palmer family's peregrinations. It's why she lived in England with her daughters, even at the expense of her marriage. For much of their married lives, Queen and the General lived thousands of miles apart, with only occasional visits. Their courtship had begun with such romance and adventure, but Queen's health—and Palmer's absolute devotion to his work—kept them apart. Moldy old manor houses seem scarcely a prescription for good health, but Queen clung to the belief that she could survive only in England. In an undated letter to the General she reminded him that the three doctors who best understood her heart condition believed that even living in New York was out of the question. Of course the city was at sea level, she told him, but the weather there could prove fatal. "The very thing in this English climate which is called relaxing to some people is the quality most favorable for my condition." Queen offered Elsie as a kind of pawn to placate his loneliness: "I will not let you be so homeless any more—if you cannot come to us, Elsie must make a home for you there. You know how decidedly fond of you she is." Queen also begged him to consider delegating some of his responsibilities, or giving them up altogether, even if it meant a smaller income. Come to England, and "be happy with your little family here."

But duty—not just to his immediate family, but to the large circle that depended upon him—was paramount to the General. In developing his railroad lines, he had surrounded himself with his wartime comrades, men he trusted implicitly, and he considered it his responsibility to maintain their good fortune. He was also supporting Queen's extended family. After her mother died, Queen's father, William Mellen, remarried and had a large second family, all of whom moved to Colorado Springs.

When the Mellen patriarch died unexpectedly, the General stepped in as surrogate father to the second family—none of whom were particularly eager to work—and took over their financial support.

The General was decisive and, especially as he got older, generally not given to introspection. He loved business. "There is some *music* in the inception of large enterprises," he said. But in an uncharacteristic moment of regret, the General once apologized to his wife for their long-term separation: "And you my dear wife whom I have so often cruelly distressed & whose young affections I allowed to be Estranged because I was hard & cold & blind and stupid & wretchedly wrong altogether, and Reckless . . . [What] a heaven would life seem now, if with vigorous health, one had nothing to do but start without a penny to make a home for this beloved flock."

Palmer would never relocate to England, but in 1894 the General brought Elsie back to the United States. He wanted her to see her native country. She was thirteen when she left America. Now almost twenty-two, she was more British than American. On March 5 they boarded Palmer's private rail car, the "Nomad," in New York and set off on a tour of the States. Their rail accommodations included several servants and a marvelous cook. The train headed south, first to Washington, D.C., and then on through the hanging moss, palmettos, and cypress trees of Georgia and Florida. Father and daughter ate fresh oranges and took a glass-bottom boat tour. One of the Dunham sisters was in Florida, so she and Elsie sailed and traveled about together for a time. Then the train reversed course and headed north through Cumberland Island, Georgia ("Mrs. Carnegie's place"), to Savannah and on to "George Vanderbilt's place"—the French Renaissance-inspired chateau then being completed in the North Carolina wilderness near Asheville.

From there, the Nomad headed west, with stops along the prairie so

they could have "stately little walks in the wind." Finally, on the after-
noon of March 29 they reached Glen Eyrie. "The green rock wall looked
as it always used to—as if it were the case to rich things," Elsie wrote. A
flood of memories rushed back: "Mothers love"; "Mother in a silk dress";
the smell of the piñon fires in the tower room, where Queen used to pre-
side; "Motherling's path." Queen was everywhere.

Two days after their arrival at Glen Eyrie, it snowed. When the sun
peeked out, Elsie escaped to the private refuge she had used as a child:
a seat in a corner of the estate near a gooseberry bush. The bush had
grown, but everything else was unchanged. She listened to the call of an
owl and the song of the "chromatic scale bird," the sprightly house finch.
Visitors came and went to Glen Eyrie and Elsie would frequently retreat
to her perch in the wilderness in search of solitude.

Colorado Springs's transient population of invalids came in like the
tide—and, oftentimes, never left. Among the latest arrivals was a literary
celebrity from New York, Mariana Griswold Van Rensselaer, a writer and
landscape critic with a patrician lineage who had brought her nineteen-
year-old son, Gris, to Colorado Springs for his health. Van Rensselaer
was astonished by the weather extremes and the sudden fluctuations in
temperature, but took it in stride. "Even what seems bad weather here
is good for throat and lung people," she wrote. "It is always dry, and
they say the cold and the wind are what brace people up best." But as for
the town itself, Van Rensselaer wrote dismissively that it was a "barbaric
place where there is nothing to balance one's mind or keep one's pen in
serious paths." As the founding father's daughter, Elsie was at the top
of the social pecking order in Colorado Springs. So, despite her disdain
for the town, Van Rensselaer dined with Elsie on the evening of April
19, 1894. Mariana's fair-haired son joined them. That very day Mariana
had written to a friend back East that her son was so well they would be
returning home within a month. Only two days later he died. Death was
a commonplace in Colorado Springs.

The country Elsie had returned to was in the midst of an economic

meltdown set off by the Panic of 1893, one of the worst financial crises in U.S. history. Unemployment was rampant. There were violent strikes. "Almost like a civil war going on in parts," Elsie wrote while traveling in luxury on the Nomad with her father. They were back on the road again, traveling to the west coast. They stopped at mines en route to San Francisco, where they attended the World's Fair at Golden Gate Park. For Elsie, the highlights of the exhibition were a chanting group of South Sea Islanders and a person claiming to be a vampire. In Salt Lake City the president of the Church of Jesus Christ of Latter-Day Saints personally greeted them, though the Palmers did not share his religious beliefs. In the same city, they also witnessed an encampment of angry unemployed workers who marched through the streets chanting and demanding jobs. When a strike broke out at the Cripple Creek mine in Colorado, the General—experienced in the art of guerrilla warfare from the Civil War—was summoned by telegram to return immediately from Utah to take over the fight. Rumors reached them that six people had been killed; by the time Palmer got back, the state militia had restored order.

Within six months Elsie was heading back to England, the place she considered home. She had a joyful reunion with her mother at Waterloo station, but as the autumn unfolded "black shadows were assembling like conspirators, in the orchards and under the spreading elms by the roadside." It seemed an omen.

In late October of 1894, Elsie received a "questionable letter" from Peter Harrison, the husband of her mother's closest friend, Alma Strettell Harrison. Peter and Alma Harrison—constant guests and traveling companions of the Palmers—were practically family. Alma and Queen were the same age and had befriended each other when Alma visited Colorado Springs several times in the 1880s. Alma was a writer, and, like Queen, her interests revolved around music, literature, and the arts. She was part

of the Sargent/Henry James/Ellen Terry set in London. (Alma's sister designed the famous beetle-wing costume for the actress.) In December 1890, "Auntie Alma," as Elsie called her, married the tall, thin, debonair Lawrence Alexander "Peter" Harrison. He was fifteen years younger than the bride, and only six years older than Elsie. On their marriage certificate Peter cited "gentleman" as his profession. Elsie attended the wedding with her mother and reported that the bride "looked sweetly interesting" in a "silver-grey poplin dress with yellow ribbons."

Peter was an artist who did more talking about his work than actual painting. He suffered equally from depression and from procrastination, and he exhibited few works in his lifetime. He was extremely jealous of his friend Sargent—the "Juggernaut," as he called him—for his nonstop productivity. At Sargent's Tite Street studio one day, Peter saw "heaps of watercolours lying about like cards," which he dismissed as "all hopelessly clever but utterly without any thought." He felt that Sargent was personally withholding secrets, "creeping away into inner rooms," and didn't have "the vitality to face things in himself."

"If he really faced things," Harrison wrote, "he might be wiser and less exuberant." Henry James once chided Peter about his attitude toward Sargent, saying that he hoped he'd "be converted to think more of John." But Harrison also understood his own shortcomings and the manner in which a "strong man" such as Sargent would view him: "I feel every minute I am just the sort of man [Sargent] most despises—dilettante—dreamer & do-nothing."

Ironically, Peter Harrison is primarily known today as the subject of a series of informal paintings by Sargent, some of them "hopelessly clever." A sensuous oil titled *Group with Parasols* shows Harrison napping in an alpine meadow with a group of friends, among them, Elsie's sister Dos. And if you look carefully at Sargent's wall decorations at the Boston Public Library, you'll also see Peter's face as a biblical prophet. Saintliness was not exactly Peter's strong suit. He had a roving eye for younger women. His "questionable letter" to Elsie was surely romantic—an inap-

propriate overture to the daughter of his wife's best friend—for their relationship would later blossom into a torrid love affair.

In mid-December 1894, Queen became ill with a bad cold—an "asthmatic attack," Elsie called it—and cloistered herself in her room. On Christmas Eve, Alma and Peter Harrison arrived, songs were sung, and presents exchanged. But Queen remained upstairs. On Christmas Day, Elsie resorted to writing to "my own darling Motherling" since her mother was too ill to have any visitors, even her eldest daughter. Elsie assured her mother that she loved her Xmas stocking, the dress she had been given fit perfectly, and that all were having a marvelous day. "We feel your presence with us every second. It's wonderful how you do that! And all your little thoughts for people's pleasure come showering downstairs to every one . . . almost as if you were there." Queen's condition rapidly worsened and on December 27 Elsie cabled her father that he should come immediately. Queen died at sunrise the next morning of heart failure. She was forty-four years old.

It took the General two weeks to reach his family. In the meantime, Elsie looked to Peter for comfort and support. The General had his wife cremated and her ashes buried in England, and declared his decision to bring his daughters back to Colorado. Elsie did not resist. How could she? Peter gave Elsie a gift, a small case containing a tintype of Motherling. Before leaving, the Palmers visited the Mote once more. Elsie wandered through the hallways and the gardens that held so many sweet memories. She had a long talk that day with Peter, who seemed to understand the depths of her misery. The loss of Motherling and their adopted home—the separation from Peter—it was all hard to comprehend. Peter, his wife, and a few other friends saw the Palmers off at the train station. Sargent, from London, sent Elsie his best wishes and his fervent hope that he would see her again in New York. The Palmers boarded the steam-

ship and left Southampton on March 16, 1895. After the ship pulled out of the dock, Elsie, her father, and her two sisters remained on the deck and watched as the sun set and England disappeared from view.

After nearly a decade of genteel British country life, Elsie—sporting an English accent and manners, and accustomed to a vibrant social life— was abruptly plunged back into the rough-hewn American West. Her two sisters, fourteen-year-old Dos and thirteen-year-old Marjory, had scarcely any memory of Glen Eyrie, a twenty-two-room clapboard house with the décor of a hunting lodge—buffalo, elk, and deer heads; animal skins; stuffed birds; bear robes; and Native American weapons. There could hardly be a greater contrast from the ancient manor houses the Palmer sisters had grown up in, where the walls were hung with Elizabethan portraits, tapestries, and other trappings of English aristocratic life. And the otherworldly landscape in Colorado bore no resemblance to the gentle hills and meadows of Sussex and Kent. A British friend of the sisters wrote that the wild countryside en route to Glen Eyrie "looks like the end of the world," and "cannot be [the] same world that holds England!"

In the 1870s the General had hired the Scottish-born landscape architect John Blair to design gardens and lay out pathways amid the fantastical obelisks and needles of red rock surrounding Glen Eyrie. Blair created ponds, rustic walkways with gnarled wooden benches, and arched bridges of local stone. Among the first things the sisters did upon their return in the spring of 1895 was to plant some flowers of their own, but the General's pack of Great Danes dug up the seeds before they could sprout. Undeterred, the sisters created a "Sky Garden" in an all but inaccessible spot—perhaps in a rocky crevice above the ground—that could be reached only by ropes.

Following Queen's instructions, Elsie took on the role of substitute mother to her younger sisters, and helpmate and hostess for her father.

Close upon arrival, Elsie moved into her mother's private quarters at Glen Eyrie, had the room scrubbed clean, and the woodwork freshened with cedar oil. The spring mountain air blew in through a window that opened onto a tree. That very day a lost watch of her mother's arrived mysteriously and without any note attached. It seemed to Elsie as if her mother were still with them.

Elsie's relationship with her father was entirely different from the deep spiritual bond she shared with her mother. Her first memory of him was as a rather forbidding figure: He was riding in the Colorado wilderness atop his steed, Señor, and she recalled his stern expression, his prickly mustache, his weather-beaten face, and his large hands, "freckled and a little awkward." She also vividly remembered his leather riding boots, well-worn and misshapen after years of hard use. (The ones that Henry James would later scoff at in England.) The boots were stored in a cabinet in his bedroom. She'd been locked in that cabinet once as a child, a punishment for some long-forgotten infraction, and had sat in the dark with the boots as her companions.

She looked up to her father—as all did—as "The General." Though of only middling height, he possessed an aura of command and was widely admired in Colorado. Urged to run for governor, he declined. He was a man of principle, an empire builder, and a splendid rider and outdoorsman. The extensive network of rail lines that he built and the thousands of acres of real estate he acquired along the way made him exceedingly rich and powerful. The General would regale guests on his private rail car with stories of how he and his associates had arbitrarily created towns as they lay track through the West: "They would arrive with a town on the train & just plant it down anywhere that seemed convenient at the moment & call it whatever came into their head: if they wanted it further on afterwards they just took it up & again put it down elsewhere." Thus little towns cropped up, one a "little forlorner" than the next.

In his Colorado castle the "charming tyrant," as one acquaintance called him, took command of Elsie's and her sisters' schedule. He planned

every day in detail. A fitness fanatic, he believed that women should exercise regularly by raising their arms, doing deep-knee bends, and breathing deeply, all the while wearing "loose or no undergarments, in private with good ventilation." The General organized picnics, riding expeditions, and vigorous wilderness hikes, always in the company of his pack of dogs and puppies, that could trip up hikers in the narrow mountain passes. The rugged and strange country made one English visitor yearn to float in a hot air balloon high above the landscape to get a proper perspective. The panorama didn't make any sense to her. She pronounced that the mountains and valleys of Switzerland looked like a landscaped garden compared with the jagged outcroppings of Colorado.

Elsie served as the hostess at Glen Eyrie for a constant procession of guests, many of them eager to discuss business with the General: railroad men and land speculators, well-born Britons with money to invest, governors and other political figures. Visitors would sign the guestbook at the house. Most of those who came and went were interested in the General only. They wanted to strike deals with him, or ask favors of the powerful magnate, or reminisce about the Civil War. These men paid little attention to Elsie, and, in turn, she surely found them deadly boring. She was used to artists and spirited intellectual conversation; at Glen Eyrie the talk was mainly taken up with railroads, mining, and money. But on December 30, 1901, a decidedly unconventional pair from England arrived at Glen Eyrie and penned their names: Eveleen Tennant Myers and her twenty-year-old son, Leo Myers. Eveleen, dressed entirely in black, was in mourning for her recently deceased husband, Frederic W. H. Myers, a renowned figure in the Spiritualist movement that had taken hold in Britain and the United States. Eveleen and Leo were in the United States on a bizarre mission: they believed they were going to have a posthumous meeting with their dead husband/father. One of the founders of the Society for Psychical Research, Frederic Myers had been convinced that he would be able to reach out from beyond the grave. He had spent his life exploring all manner of occult and paranormal practices; he had

taken part in hundreds of séances; he had coined the terms *supernormal* and *telepathy*. Before he died, Frederic instructed his wife as to where and when they would meet in America. She followed his directives—but he failed to turn up. Leo, however, underwent his own spiritual transformation in a Chicago hotel room, where he was convinced he had a mystical experience and touched the "Infinite."

Mother and son made a long detour to Colorado to visit the Palmers, whom they'd known in England. The Myerses were at the center of intellectual and artistic life in Cambridge—just the sort of aesthetes that appealed to Queen, and appalled the General. In the midst of their psychic quest in America, Leo and his mother experienced a different kind of reality in Colorado: a camping trip organized by the General in which Spiritualism played no role whatsoever. Like a commanding general, Palmer controlled every aspect of his camping expeditions. A "platoon" of servants accompanied the treks, cooking up steaks from Denver, and pouring fine wines for the guests every evening. By day, there was no idling around the campsite. Rain or shine, the party would set off on a tour, with the General issuing directives.

Elsie accompanied the group and apparently struck up more than just a friendship with Leo. Given how rich she was, Elsie, at twenty-nine, should long since have been married. Such was the custom in the Gilded Age. But Colorado Springs, where people came to die, did not offer much in the way of marriage partners. Peter Harrison remained her romantic, idealized soulmate, but he had a wife and he was on the other side of the Atlantic. Elsie considered Leo a boy—he was nine years younger—and rather delicate, but he had a sweetly handsome face, with curly hair parted in the middle. A cerebral soul drawn to the mysteries of the occult, Leo was the polar opposite of her father. Perhaps over the campfire, or when out of earshot of the General, Elsie and Leo exchanged confidences. Elsie, who felt the rustlings of her mother from the beyond, was doubtless eager to hear details of Leo's otherworldly encounter in Chicago.

Though raised in entirely different circumstances, Elsie's and Leo's

childhoods bore uncanny similarities. Both had famous fathers: Elsie's, a celebrated war hero and business tycoon; Leo's, a magnetic Spiritualist who presided over a decidedly odd household where psychic experiments regularly took place. Young Leo—both mesmerized and terrified—would find himself in the middle of séances and other paranormal events. The two fathers were also authoritarian and distant: Frederic Myers, lost in his mystic realms, and the General often on another continent. In contrast, the two mothers doted on their children. Queen enveloped Elsie in a world of costumed pageantry. Eveleen took up photography, had a darkroom built, and absorbed Leo into her new undertaking. As a young boy, he became a subject for her camera. In two images titled *The Compassionate Cherub*, he poses shirtless, with wings attached to his shoulders. (In truth, he looks more forlorn than compassionate.) Leo would watch as his mother photographed some of the most eminent figures in Victorian society, among them, William Gladstone, the prime minister of England.

Eveleen had brought her camera with her to Colorado and she photographed the camping party in front of a tent. The General stands with his daughters and other members of the group, but Elsie has defiantly turned her back to the camera. Why she refused to show her face is unknown, but it is indicative of a steely resolve she exhibited only rarely. For the most part, she was the ever-dutiful daughter and helpmate.

At some point during the excursion in Colorado, Leo abruptly asked Elsie to marry him. She declined. Perhaps her father—whose feet were solidly planted on terra firma—objected to the very idea of his daughter marrying a psychic explorer. Or maybe Elsie's thoughts floated back to the idyllic, though inaccessible, Peter Harrison. Leo and his mother returned to England, but Leo would appear again later in Elsie's life.

The following year another interesting English visitor came to Glen Eyrie: twenty-four-year-old Doll Carr, whose mother had fashioned

Ellen Terry's dress of beetle wings. She stayed for nine months. Doll arrived just in time for Christmas 1902 and kept a diary of the extraordinary world out West and daily life at Glen Eyrie, where a dozen or more guests around the dining table were not uncommon. After dinner, they would play charades, or the General would narrate his adventures in the Civil War—an event they called "Battleground." It was "a war of boys," he explained, and at the age of twenty-five he was a colonel and the oldest man in his cavalry regiment; by twenty-eight he'd earned the brevet rank of brigadier general. He was captured as a spy, briefly imprisoned in Richmond, and was later awarded the Medal of Honor. Ironically, he and his family were devout Quakers from Philadelphia. After the war, the Philadelphia Quakers sought a formal apology from Palmer for having fought. Refusing to apologize, he wrote a letter passionately defending his actions.

Until her early twenties Elsie had lived under the wing of her mother. Art, not war, was discussed at her dinners. With the General at the helm, the conversation was much rougher: talk about mountain lions and bears roaming in the canyon behind the house, about stagecoach robberies and lynchings. Doll was horrified at the lynching of African Americans and how commonplace it seemed to be—"probably 50 or 60 since I have been in America," she wrote after having been in the country for only about three months. A lynching had even taken place near Glen Eyrie. "Only 2 years ago they burnt a negro outside Colorado Springs & everyone concerned kept a bit to testify to their having been there." The idea of taking a souvenir—a singed piece of flesh from another human being—revealed a darkness beneath the civilized surface of American society, she wrote. The General was appalled by the gross mistreatment of African Americans, and, despite his own military background, he hated the brand of American imperialism that resulted in the Spanish-American War. One evening after dinner the General insisted that Doll read aloud a graphic account of wartime atrocities recently committed by American soldiers. She burst into tears at the horror of it.

Languishing in the Rocky Mountains, her social life practically nonexistent, Elsie couldn't help but think of her former life in England. With no notion that his daughter had a long-distance crush on Peter Harrison, Palmer unwittingly delivered Elsie to the arms of her seducer in the summer of 1902. The General brought his daughters to the Swiss Alps for a reunion with their old friends Sargent and Harrison. At the end of the trip Elsie, who had just turned thirty, remained in England with her sister Marjory for nearly six unchaperoned months. Harrison, though still married, happily volunteered to escort the sisters from London all the way back to Colorado. In mid-May 1903, they arrived in New York and the love-struck Elsie and Peter spent two glorious days together in the city, what Peter would call "that burning time" when "I touched the sky . . . and lost myself in you."

What Elsie and Peter didn't know was that there was a double agent in their midst: twenty-one-year-old Marjory had been instructed by her sister Dos to keep her eyes open and to let her know all that Elsie and Peter did.

A keen student of emotions, Peter found a Shakespearean complexity in the shifting, ambiguous role-playing of the Palmers. He compared the General and his offspring with King Lear and his daughters. Brusque, efficient commander of all external events, the General seemed blind to his daughters' emotional lives. Queen had controlled the heart and soul of the family and had forged an intimate, almost secretive connection with Elsie. Perhaps as a result, Elsie—driven by duty to her mother, then her father and sisters—developed an introspective, subdued personality. In contrast, Dos and Marjory were always more carefree and social. Dos, the most vivacious and beautiful of the sisters, looked upon Marjory as her soulmate. "My Marje you are a part of me," Dos wrote when recruiting Marjory as her spy—an adroit maneuver worthy of the Elizabethan

stage. Always aloof from her younger sisters, Elsie seemed unaware that they were conspiring.

After Elsie and Peter left New York—with Marjory watching in the background—they all proceeded to Colorado. Peter stayed at Glen Eyrie for about four romantic months. There were furtive walks with Elsie in the dark, and secret meetings in the wild, rocky landscape. "Oh! For a day on the wolf trail with you, little Elsie." Meanwhile, the General was apparently oblivious to the reality under his roof: that his eldest daughter was involved with a married man.

It turned out that the mysterious young woman on Sargent's canvas with the blank expression—the one who seemed to be attached to her mother to an almost unhealthy degree, or else under the thumb of an overbearing father—had fiery passions bubbling beneath her serene surface. Perhaps Sargent posed Elsie, consciously or not, in front of that dun-colored linen-fold paneling in an ancient chapel because he sensed that she harbored an interior world that was almost religious in its intensity. The narrowness of those wooden linenfold strips seem to echo the restrained and duti-ful role the Palmers had imposed upon Elsie. But Sargent's painting also suggests that there were mysterious layers beneath that flat surface—and Peter tapped into those. In a letter to Elsie, Peter wrote that he and Sar-gent had discussed her portrait and that they both liked "that very calm expression" of hers. "Do wear it," Peter urged. "When it comes on your face, your lips seem like folded hands & I love it & rest in it. My dearest, I love & love you—let me say it." As for his wife, "I am with her & yet far away at the same time, for I belong to you."

After Peter left Colorado, their romance continued to burn in sen-sual, impassioned letters. Peter wrote nearly every day, pages and pages. The exchange of letters had distinct phases. There was the excruciating wait as the letters traveled by boat and then by train from England to

Glen Eyrie. Would one arrive that day? Elsie never knew for sure. And then—utter joy—when an envelope from him was among the day's mail. Elsie would seek out a secret place to read his letters, to savor each phrase, as he did with hers. He wrote that the torrent of letters "is life to me & without it the waters would close over me." She counseled patience—one day they would physically be together. Yet at times Elsie wondered if it was right to be following one's heart in this way. But signs of ambivalence seemed to only heighten Peter's fervor, and his need for her. Increasingly brazen, Peter set out photographs of Elsie at his home in England, where his wife and visitors could see them.

In the Colorado wilderness the younger sisters whispered, and probably counted the letters as they arrived in their crisp cream-colored envelopes with Peter's distinctive script. Dos cast her net. Saying nothing to Elsie, she wrote to Peter—<u>I see what you're doing</u>.

Dos knows about us, Peter wrote to Elsie, and she understands the depth of our feelings toward each other. A new plot line was launched. Peter struck up his own parallel correspondence with Dos, and made no secret of it to Elsie.

In his letters to Elsie, Peter frequently invoked Dos: her beautiful voice (like a "meadowlark"), her vivid and expressive letters. "Tell me of Dos: <u>always</u>," Peter wrote to Elsie. When Elsie threatened to break off their relationship, he reminded her of the promises they had made to each other in New York, and he claimed that he had a presentiment he was going to die soon. From afar he stirred a rivalry between the sisters, telling Elsie how much love he had received from Dos. "For plain love I could not love you more than I do her," but he assured Elsie, "the affinities between you & me are the wonderful extra bond."

Affecting a brotherly tone, Peter expressed worry over Dos's future. Was she wasting her youth in a remote wilderness? Living in Colorado might ruin her chance to marry well, and prevent her from forging a happy life. Can you imagine "that Dos has only been 2 months in Eng-

land in the last four years!!" Another snare was being set out. He begged
Elsie to convince her father to send Dos abroad. "I believe you can do
anything . . . with your 'quiet way.'"

In the spring of 1904 the General took his daughters on an extended
tour of Europe, a shopping spree while renovations were taking place at
Glen Eyrie. Peter could barely contain his excitement as Elsie crossed the
Atlantic. His letters simmered with a renewed erotic charge. After the
Palmers arrived, Peter went to Paris to set eyes on Elsie once again. He
had to mask his ardor while in the presence of her family, but he secretly
wrote to her while he was there, telling her how lucky he was just to be
near her. "I am walking on the clouds & worshipping you . . . I feel such
tenderness for you that at times I can hardly hold myself. . . . I can't always
'show' tho' I quiver with the desire to." Elsie apparently shared his pas-
sion, for after a day alone with her, Peter called her a "poetess: for every-
thing shared with you is true poetry. . . . Dear lovely Elsie, you scarcely
seem of earth now: [you are] a wonderful pervading spirit." He signed
the letter "yr Señor who worships you." (The same name—intentional
or not—as the General's favorite horse.)

And yet within days there were signs that Peter's gaze was straying.
In another letter he referred to twenty-three-year-old Dos as his "stan-
dard," and Elsie took offense. Peter tried to be jocular, but an undeniable
note of jealousy crept into the correspondence. Did Peter, though thirty-
seven (and married), prefer Dos's youth to Elsie's relative maturity? He
adored seeing Elsie in Paris; but Elsie and Dos seemed to be on two dif-
ferent trajectories. Elsie, an unmarried woman in her early thirties, was
losing her girlish charm. But Dos, so young, beautiful, and full of life,
seemed to have an extra sparkle. Peter urged Elsie to send Dos from Paris
to England.

Elsie sent her. Dos stayed with the Harrisons one night in London
with Peter stopping by her room to say goodnight. She was lying in bed
with the window open and the moonlight flooding in. Peter wrote to

Elsie, with knifelike cruelty, of how beautiful and happy Dos looked and how he noticed her "delicious lines of throat and neck. Ah! Elsie you haven't got her now . . ."

Soon, Peter's letters to Elsie ceased.

Elsie returned to Glen Eyrie aware that her sister—younger, livelier, and more beautiful—had betrayed her. Peter was now passionately attached to Dos, who traveled quite openly with him and his wife, Alma. It became common knowledge that Dos was his mistress. In a way, Sargent put his stamp of approval, or at least nondisapproval, on the round robin of relationships when he painted a languorous oil of Dos, Peter, and two other friends nestled together, asleep, in an alpine meadow in Italy in 1905. Alma, though on the trip with them, was conspicuously absent from the painting.

From 1904 to 1906, the General was busily transforming Glen Eyrie's original clapboard house into a sixty-seven-room stone mansion, the Colorado stone specially chosen for its rich patina. The General ordered limestone from Indiana for the doorways and window casings. The Great Hall had twenty-five-foot ceilings, and a balcony large enough for an orchestra to entertain three hundred guests below. The General loved technology and had electricity in the original house as early as 1882. He continued to install the most up-to-date improvements in his new castle: fire doors as a safety measure, smoke removal and central vacuum systems, an elevator, and telephones, among the first ones in the West. He built a modern creamery with pasteurization equipment he acquired from Louis Pasteur and imported a staff of dairy experts from Switzerland. The castle featured Turkish baths, a bowling alley, and a billiard room. Outside there was a tennis court and a pool for swimming in the summer, skating in the winter. The General built greenhouses where a

team of gardeners raised rare flowers, fruits, and vegetables year-round.
A rose arbor, a peaceful haven for Elsie and her sisters, was created in
front of a backdrop of spectacular rock formations. The castle itself rose
up amid towering pinnacles, as if it were an integral part of that landscape.
Atop the castle's stone tower the Palmers could survey their domain from
a roof garden, featuring an enormous German bell that could be heard
for six miles in the thin Colorado air. The General wrote of Glen Eyrie,
"It seems to be a sort of paradise to which only the elect can be permit-
ted to go."

Elsie seemed destined to be like some fairy-tale princess imprisoned in
her Rocky Mountain castle. Like Queen before him, the General made
no discernable effort to marry off his eldest child. He needed her. Her job
was to welcome his business associates and old military comrades who
might stop by, and to look after her younger sisters. His idea of intro-
ducing adventure into Elsie's life was to bring her down a mine shaft. A
woman inside a mine was practically unheard of out West. Miners were
an extremely superstitious lot, and they believed that a female in their
subterranean world meant impending doom; some miners would even
refuse to go back into a mine if a woman had entered it. But the General,
who had a financial interest in a number of mining operations, did what
he liked. He was in charge. Elsie, who once led a cosmopolitan life with
world-renowned artists and aesthetes, was now set in a world of min-
ers and consumptives. The occasional social events and dances in town
catered to a younger crowd—women in their teens and early twenties,
like Dos and Marjory. By the time Elsie settled into the new stone cas-
tle with her father, she was practically considered too old for marriage.
She'd missed her chance, wasting her time besotted with Peter.

Old friends like Katie Dunham from New York visited Glen Eyrie,

but that was a rare treat. In 1906, Elsie had to maintain a cheerful demeanor when Peter Harrison—without his wife, Alma—came for a lengthy stay and lavished his attention on Dos. The General organized one of his patented camping trips, and Elsie joined the party with Peter and Dos. What torture it must have been for her to watch as forty-year-old Peter glanced longingly at her young sister, or whispered to her behind a pine tree. Perhaps as a way to deflect suspicion over why he was staying at Glen Eyrie so long, Harrison created individual portraits of the three sisters while he was there. The artist, ever flirtatious and charming, managed to convince Elsie to sit for him; but she knew she had lost her place in his heart. The portraits were hung side by side in the mansion.

The year ended tragically. On October 28, the General suffered a freak accident that changed his life—and Elsie's. The seventy-year-old General, on one of his daily horseback rides, was thrown by his horse and landed headfirst. In an instant, he was paralyzed, all four of his limbs frozen and useless. The General ordered that the horse be shot.

Elsie had to step in and organize a household totally dedicated to the round-the-clock care of her father. A battery of doctors and nurses came and went. An X-ray machine was hauled to Glen Eyrie from Colorado Springs by a horse-drawn wagon, and the newly renovated castle became a virtual hospital. Surgery was ruled out as being too dangerous. The General was a man who craved activity and depended upon it. He became deeply depressed. Elsie grew so concerned about her father's mental health that she summoned Dr. Silas Weir Mitchell from Philadelphia, a neurologist famous for his treatment of nervous disorders and "hysteria" of varying kinds. At first the General was furious that Elsie had invited Dr. Mitchell to Glen Eyrie and refused to see him. I'm not insane, he told his daughter. But as the days passed—and as Mitchell's fees continued to pile up while he did nothing—the General finally relented and allowed Dr. Mitchell to treat him.

The General grew resigned to his condition, but, with the help of

Elsie, he refused to give up an active life. He ordered a "Stanley Steamer," a white steam-driven car with a flashy red leather interior. The ritual of getting him into and out of the car was an ordeal, but the General insisted upon a regular schedule of drives. Servants carried him out of the castle in a kind of sling, put him on a stretcher or wheelchair, and then carefully fitted him into the backseat that was constructed of feathers and hair and contoured to fit him perfectly. With a chauffeur at the wheel and the top down, Palmer enjoyed drives all over the countryside at high speed.

Novelist Hamlin Garland came to visit and recalled being greeted by Elsie in the Great Hall. The doors burst open and Palmer was wheeled in atop a couch, with two servants and two gigantic wolfhounds at his side. "On this couch lay the old soldier, his head propped by pillows," Garland wrote. "He had the stern dignity of a disabled duke in the days of Elizabeth."

Like a duke of old, Palmer assembled his knights for a grand gathering, with Elsie at his side. In August 1907 nearly 280 members of the 15th Pennsylvania Cavalry, his old Civil War regiment, convened in Colorado Springs for an all-expenses-paid reunion. It was nine days of revelry at the Antler's Hotel, the fanciest hotel in town. The bottles of champagne and liquor piled to the stockroom ceiling were happily consumed. (So much for Colorado Springs as a "dry" town.) There were dinners, toasts, speeches, and a grand parade through town with the General leading the way in his Stanley Steamer. Palmer spent well over a million dollars in today's money to celebrate his old comrades in arms. A photograph taken at Glen Eyrie shows the General in his wheelchair surrounded by his regiment—and Elsie in a fancy hat.

Elsie's role in life seemed set. She would forever be the caretaker for her family: first, for her sickly mother; then her quadriplegic father; and finally her sister Marjory, who contracted consumption about the same time her father was injured. She, too, had to be cared for at Glen Eyrie. As time went on, the General grew more demanding and cranky, and Marjory's lungs grew weaker.

At the moment when it seemed that Elsie would never be able to claim a separate life of her own, she did something remarkable. She stood up to her father and announced that she was going to marry and leave Glen Eyrie. The meek, mild, and dutiful Elsie revealed a streak of courage and determination that must have shocked the General. She also unveiled a secret. Over the years, she had made occasional trips back to England, where she felt so at home. While there, she apparently renewed her relationship with Leo Myers, the young man who had come to America in search of his dead father years earlier. Out of the blue, Elsie announced she was engaged to Leo. Close friends had no idea they even knew each other. Leo had his private papers burned after his death, so it's impossible to discern exactly what drove their relationship. One thing is certain: He was not after Elsie's money, as he had inherited his own substantial legacy in 1906, and was already known in England as a generous donor to the arts. Was it love? Perhaps. But it seems more likely that Elsie saw Leo as her escape; the only way she could break free from her father's smothering demands.

On the evening of January 20, 1908, Elsie, then thirty-five, married twenty-six-year-old Leo at Glen Eyrie. Her father and sisters were presumably in attendance. Guests arrived from New York and London. Elsie emerged in a wedding dress that not even Sargent could have conjured: a long, brown wrap covered with huge metal buckles. Cords holding tiny bronze figures of animals of all kinds—a thousand of them—crisscrossed her outfit. It was like a medieval coat of mail, more a piece of body armor than a dress. One can imagine the tinkling sound as she moved, with a thousand metal figures swaying and colliding in the Colorado stillness. The *New York Times* covered the event on the front page of its January 21, 1908, edition. The headline read, "Bride's Wrap of Bronze."

After the wedding, Elsie bid farewell to her bedridden father, and the newlyweds began a new life together in London on the Chelsea Embankment overlooking the Thames—and just down the road from her former lover, Peter Harrison. Not long after returning to England, Elsie brought Leo to visit Peter. (Dos was apparently not there.) Perhaps Elsie felt the need to close that chapter of her life once and for all—and to prove to him that she could survive and prosper without him. Peter acknowledged that Leo was beaming with happiness. But, manipulative as ever, he wrote to Elsie that seeing her again "was like dew after a hot baking day."

On November 4, 1908, Elsie gave birth to a daughter named Elsie Queen ("EQ"). A rumor spread that the General had given EQ, his first grandchild, a million dollars as a Christmas gift. Under the headline "Not a $1,000,000 Baby," the New York Times reported that Palmer's business manager denied such a gift. When Elsie received news that the General's health was failing, she and Leo rushed from London to Glen Eyrie with the newborn. Elsie wanted her father to meet his granddaughter. A photograph shows the General immobile in his hospital bed with the infant lying on his chest. The General died on March 13, 1909, while Elsie, Leo, and EQ were in Colorado. Elsie oversaw the funeral. Over seven thousand mourners lined the procession route to the cemetery in Colorado Springs where her father's ashes were buried. The New York Times immediately began to speculate as to how much the General had left his daughters, with estimates ranging from $6 to $15 million.

Elsie cabled Peter Harrison, who had recently been at Glen Eyrie with Dos, to break the news of her father's death. Peter wrote back saying that the end was probably merciful, for living in such a diminished state was intolerable for a man like the General. But Peter, ever the cad, couldn't resist an opportunity to attempt seduction once again. Speaking of the secret "bond" he still shared with Elsie, he said that their relationship was beyond anything felt by mere mortals. He expected nothing from her, he said, except knowing that she loved their bond as much as he did. As the years went on, he wrote Elsie occasionally and always

expressed his undying love for her—while maintaining his relationship with Dos. Elsie didn't take the bait. She was beyond that.

As for Dos, she moved to London after the General's death and lived openly with Peter. She moved to Cheyne Walk in Chelsea—conveniently, on the same street as Peter's wife. Peter and Alma never divorced, but remained neighbors. Sargent's mother and sister also resided on Cheyne Walk, and, for a time, Elsie and Leo were just a short stroll away. Dos became a social worker in London, served with great distinction during World War I, and lived in England for the rest of her life.

Elsie and Leo forged their own life together in England, moving from one place to the next. Elsie had a second daughter—Eveleen Myers, named after Leo's mother—in 1910. Leo became a writer and maintained a tenuous connection with the Bloomsbury Set of intellectuals that included Virginia Woolf and E. M. Forster, but he was so high strung and argumentative in that competitive orbit that he was considered impossibly difficult. Elsie had achieved her freedom but it came at a cost. Her marriage to Leo was unhappy. A tortured soul, he recognized his own contradictory nature and resented it. He declared himself a communist, but had a passion for expensive car racing and a taste for fine food. (He was part owner of a very chic and costly French restaurant.) When Leo and Elsie moved to Cambridge in the late 1920s, he had the walls in his study painted a shiny black.

Life with Leo was turbulent, and at times they lived apart. Elsie focused her attention on her daughters, much as Queen had done a generation earlier. Over the years Elsie also remained devoted to the memory of her father—but at a distance, never returning to Colorado. Not long after the General's death, she wrote to Sargent asking him which American artist he'd recommend to create a monumental sculpture of her father. From Corfu, Greece, where he was on a painting holiday, Sargent wrote back that he was at a loss. Augustus Saint-Gaudens, who had died several years earlier, would have been his choice. An equestrian statue of the General that stands in the center of Colorado Springs was eventually

completed in 1929, and, much to Elsie's delight, a World War II Liberty Ship was christened the SS *William J. Palmer* in 1943.

Despite his personal demons, Leo gained renown for writing *The Root and the Flower*, a trilogy set in sixteenth-century India that was published between 1929 and 1935. His work became all the rage in the 1930s, but his literary success brought him no solace. Leo once wrote that living was "a very over-rated pleasure," and in 1944 he took his own life. He wanted to usher himself into that other world that intrigued him so.

Elsie survived for another decade, dying in England on September 17, 1955, when she was nearly eighty-three years old. She was helped in her final years by a man who'd worked in the stables at Glen Eyrie for her father. He served as her chauffeur and gardener, and took her on long afternoon walks through the serene English landscape—as her father would have approved—during which they could reminisce about the old days in the Garden of the Gods.

The Sorcerer's Apprentice

It is the greatest thing in the world to paint, so far as
one's own joy goes, isn't it?

—Lucia Fairchild Fuller to her husband, June 18, 1898

THE BOSTON ATHENAEUM, the grand old private library and museum, is essentially an enormous vault where Beacon Hill and Back Bay families have deposited their heirlooms, books, paintings, and prints for over two centuries. Located at the whimsical address of 10½ Beacon Street, the Athenaeum permits well-behaved dogs into its hushed and atmospheric precincts. The galleries and library spaces are full of comfy chairs and gorgeous artwork, Sargent paintings among them; huge windows look out onto the leafy seventeenth-century Granary Burying Ground where Paul Revere and other Revolutionary heroes rest.

The librarian there had never seen the uncatalogued artifact before, so he watched nervously as the fragile two-foot-tall scrapbook was opened, its hand-sewn binding barely holding the brittle pages in place. The scrapbook, entirely dedicated to Sargent and his career, had been compiled by the artist's devoted second cousin. The book is a hodge-podge of photos, newspaper and magazine clippings, and reproductions

of his paintings. There is no particular order or chronology, but the book begins and ends with photographs taken on the beach at Nahant, Massachusetts, a craggy summer colony on the North Shore. There Sargent vacationed with the extraordinary Fairchild family. The snapshots are not in the usual square format but round, and draw the eye right into the scene, as if looking through a telescope, so in an instant one feels privy to an intimate circle.

By God, here's Sargent winking at the camera, his mouth half open, perhaps smiling (hard to tell with that bushy beard and mustache), as he shares a jovial moment with the unseen person behind the Kodak. That newly invented box camera had become the gadget of the moment, just the thing for a seaside holiday. On that bright summer day, thirty-four-year-old Sargent—riding the high tide of fame, fresh from a triumphant painting tour in New York City, sought after by some of the richest and most powerful potentates on earth—appears to be enjoying himself in the sunshine on a rocky cove, even if he is a tad overdressed in dark suit and cravat and watch chain. Behind him, in the distance, can be seen palatial summer houses, one of which rises up above the water like a medieval cathedral.

Sargent shared a series of languid summer days from 1889 to 1891 with the Fairchilds in England, Paris, and Nahant. They commissioned work from him, and Charles Fairchild, a Boston banker, advised Sargent on his finances. The relationship grew much deeper than a professional one. Sargent chose the "ever-hospitable Fairchilds," as one friend called them, to take in his twenty-year-old sister Violet when she was besotted with a Swiss charmer whom Sargent viewed dimly. Violet had befriended one of the Fairchild girls, Sally, in England; so when Violet seemed determined to leap into an unsuitable marriage, Sargent whisked her away to the New England household of the "wonderfully decent and understanding people with a grand home life." After a frenetic stretch of painting in New York, Sargent chose to relax and refresh himself among the Fairchilds. Of course, he never really stopped working. On a sum-

mer afternoon on the beach at Nahant, inspiration seized him, and he produced one of his most enigmatic portraits—vastly different from his usual work, as if the seaside sun and breezes had released him from invisible coils.

Years later, Sally Fairchild, the oldest daughter, recalled details of the great man's visit—the excitement that swirled around the Fairchild household that summer of 1890 when she was twenty-one—Sargent's nonstop activity, painting, playing the piano, puffing furiously on his cigarettes, expounding on the beauty of his current favorite color, magenta. Sally enchanted the artist, as she did seemingly everyone. One smitten contemporary—and there were many of them—described Sally as a "legend," with a face "so outgiving—so generous . . . it strikes me as a sunburst!" Sargent brought Sally outside to paint her. She remembered that he set her against the shadowy stone cliffs. Wild vegetation—beach grasses, evening primrose, and staghorn sumac—covered the steep granite inclines on the far eastern end of the island where they were staying, and in deft strokes he captured several layers of that tangled plant life. Yellowish, pod-like shapes can be seen on one side of Sally, and slashes of his favorite magenta on the other. The young woman, dressed in stark virginal white, pops out of the dark verdant background. It's as if she is illuminated from within, an ethereal presence emerging out of nature.

And then the stroke of genius. Sargent covers that beautiful face— the one that everyone adored—with a long, translucent turquoise-blue veil that he wraps sinuously around her neck in thick curves of paint. He obscures Sally's features except for a commanding eyebrow, a purplish magenta splotch of eye, and the barest hint of a nose and ear. Her cheek has a healthy rosy hue—here's a young woman unafraid of the sunshine and sea air. The veiled Sally is in profile, and a jaunty straw hat sits atop her auburn-colored hair. Her dress is iridescent, though tan shadows fall across part of it—a passing cloud perhaps. One can almost hear the crash of the waves in the background.

The portrait feels like a frame from a film of that Nahant summer.

In the movement of the brushstrokes we can see a gust of wind blowing in. The breeze must be strong because the netting cleaves tightly to Sally's face. The edge of her veil lifts aloft and she gathers the sheer fabric with her hand, pulling it back against her neck. In a few deft strokes Sargent—a genius at making hands—creates her fingers, so tapered and well-groomed, the hand of someone very well tended. A blue ring sparkles with the same color as the veil. And beneath the veil, a curving and imperious eyebrow. "One look at that eyebrow and you *know* who she is," the owner of the painting notes. Indeed. Sally was an imperial presence, a diva.

Here is the forthright and vibrant presence of youth, yet wrapped in netting, like an art installation by Christo. Sally's beauty and strength of character seep right through the fabric that caresses her face. A veiled woman—what could be more exotic and alluring? Who was she? With a veil she could be anyone—like an actress taking on a role. But which persona was it? Sargent had a fondness for the theater, for artifice. And what of the artist himself, a man who carefully kept his own personal life under wraps, unwilling to share his world, his secrets. He was no stranger to veils.

The previous summer the Fairchild family had vacationed near Sargent in England. The Fairchilds were staying in the picturesque village of Broadway, an outpost in the Cotswolds favored by artists, including Sargent and Henry James. Indeed, James might have conjured up this spirited American family traveling around Europe, collecting art with a discerning eye, and mixing easily with creative spirits. The rock-solid father (banker, stockbroker, and Civil War veteran), poet mother, and their seven red-headed children formed a cultured, literate, exquisitely refined clan that brimmed with that American self-confidence and energy so admired by Sargent.

Broadway and its surrounding landscape evoked Elizabethan times, a well-preserved backdrop for tragedy or comedy—honey-colored limestone buildings, gabled houses with mullioned windows, picture-perfect

cottage gardens, hedgerows and country lanes, and meadows full of sheep. Everything was ancient and redolent of historical drama. The Fairchilds stayed at the Lygon Arms where Cromwell had stayed in 1651, when the Lygon was already a venerable establishment. The Bostonians traversed the inn's stone floors through somber wood-paneled rooms with enormous stone fireplaces. It was at once gloomy and majestic. Sally's memory of it revolved around herself: she talked the inn's coachman into teaching her how to drive a tandem of horses, a daunting trial that the daring young woman relished.

Sargent was ensconced with his sisters and mother ten miles away in the tiny village of Fladbury. They, too, were in an atmospheric perch—a large, stately parsonage on a steep bank overlooking the River Avon in Shakespeare country. From his back windows Sargent could admire a scenic brick mill on the other side of the swiftly moving river. In the waning light at the end of day, he could see the mill's perfect reflection in the water. Next door was a twelfth-century stone church with a walled-in graveyard that tumbled down to the river. There were thatched-roof cottages but not much else in town. In that rural outpost, the Sargents entertained a succession of guests, including some of the most famous artists of the day. The Fairchilds became enveloped in Sargent's world that summer, and Sally immediately befriended Violet Sargent. They were kindred, free-spirited souls—one hanging around with the hotel help, the other intent on pursuing a love affair with a forbidden suitor. Months later, while in America, Violet went off to rejoin her friend in Boston and settle in with the prosperous Fairchild clan.

Charles Fairchild was a Midwesterner—an outsider in parochial Boston society—but he was a Harvard man, class of 1858. He married the daughter of a prominent Boston judge; he had fought for the Union—a

definite plus in a city still consumed by the Civil War. In late-nineteenth-century Boston the miasma of the war, and the memory of its patrician sons lost during the conflict, continued to haunt the drawing rooms of the Brahmins who prided themselves on their abolitionist and patriotic fervor. The wounds were still fresh, the war heroes still celebrated.

During the postwar financial boom, Charles Fairchild worked his way up the ranks in a paper manufacturing company in Boston; he was also astutely managing the profits rolling in from the Fairchild family's substantial real estate holdings. His father had been the first mayor of Madison, Wisconsin, where the family owned valuable commercial downtown property. Charles seemed to have a golden touch and his investments in real estate, railroads, banks, typewriter and knitting companies prospered. (Interestingly, one of his brothers missed a bonanza when he declined to join George Westinghouse in forming an electric light company, opting instead to invest in gas light.) In the boom years, Charles Fairchild became a financial eminence in Boston.

But Fairchild also had a hankering to mingle with the literati. A drinking pal of Mark Twain's and other "knights of the quill," Charles helped finance the *Atlantic Monthly* in the 1870s. He bought up land atop Belmont hill west of Boston, and developed it with the dream of creating a kind of high-brow commune centered around the Fairchild family. Fairchild built a house for William Dean Howells, editor of the *Atlantic Monthly*, a writer, and one of the titans of the literary world. Famous authors gathered there. Henry James described Howells's house as a "fairy abode of light and beauty" and its airy, hilltop location as nothing less than inspiring: "When I looked from within outwards and over that incomparable landscape . . . I said to myself, 'Well, good fortune can no further go. Let silence muse the amount of it!'"

In 1880, Charles became a partner in the patrician investment firm of Lee, Higginson & Company and was ushered into the inner sanctum of the Brahmin financial world—in fact, right into its draw-

ing room. The Fairchilds lived in one half of an enormous six-story double house in Back Bay with Henry Lee Higginson, head of the firm—and one of the bluest blue bloods in town. Music, art, and brilliant conversation were staples of the grand household. In 1881, Higginson created the Boston Symphony Orchestra as a gift to the city, bearing virtually the entire cost himself for decades.

The gods had lavished every advantage on the Fairchilds, and life never seemed sweeter, better, or more ennobling than when Sargent came to visit that summer of 1890. The artist's evocation of Sally captures a self-assured, beautiful, and privileged young woman with an independent streak. She became the first woman permitted to attend a lecture at Harvard—a psychology lecture by family friend William James (though Harvard insisted she stand behind a screen for propriety's sake). Over the years, she casually batted away endless proposals of marriage, finding none of her suitors right for her. Apparently content, she stayed at home, caring for her mother. Perhaps sensing that time was passing her by, she grew increasingly resentful as her younger sister—plain, plump Lucia, whom she'd bossed around since childhood—stepped out of the shadow and took center stage. She, too, had been touched by Sargent's magic.

If you look closely, you can see Lucia in one of the snapshots on the beach at Nahant. She's lurking in the background like a spy. Sargent is front and center sitting on the grass, a look of sheer pleasure on his face, a rambling, shingle-style beach house on the bluff behind him. But in the middistance is the shadowy figure of Lucia, a rather pudgy young woman, sitting upright, looking vigilantly in Sargent's direction. Reading through hundreds of Fairchild family letters one is drawn inexorably to Lucia, the ugly duckling sister, because *her* story, *her* character is so riveting. Sally, the chosen one, pales in comparison. Perhaps Sargent painted the wrong sister. As it turns out, his painting transformed *Lucia*, not Sally. The veiled portrait points to the story of a hidden sister who formed her own connection to Sargent, and opens up a tale of sibling rivalry, passionate but misbegotten love, and the power of art.

Lucia was nearly eighteen when Sargent painted Sally. She watched him intently that summer, following him around, noting his every mannerism and brushstroke. Lucia wasn't surprised that Sargent wanted to paint her sister. He'd shown his preference for Sally before, and had already painted her several times. She was clearly resigned to her second-class status. Sally was so graceful and magnetic, "the goddess of my childhood," Lucia would later write. But, it still must have hurt to be passed over. Lucia wrote in her diary: "Things I must learn not to care about: That I am so ugly." And on the facing page: "Things I must learn—Courage . . ." Lucia was touched, inspired—who knows?—perhaps even ruined by Sargent. He was her idol. "He is so great," she wrote and later tried to erase in her diary. He helped inflame her passion for art.

When Lucia first announced to her parents that she wanted to go to art school they were not thrilled—this despite the fact that they collected art, commissioned it, and surrounded themselves with artists and writers. Several years earlier Charles Fairchild had hired Sargent to paint Robert Louis Stevenson, already world famous, as a gift for his wife Lily, who was a devoted fan. Why buy just a book when a painting by John Singer Sargent would bring the author to life? In fact, even bring him to their doorstep.

The eccentric author of *Treasure Island* spent part of one summer on the Fairchilds's couch in Newport, lying ill after a rough ocean crossing on a ship with a cargo full of apes. His skeletal frame wrapped in a scarlet dressing gown, he smoked nonstop and unspooled a stream of stories. The children were enthralled. Stevenson and Lily hit it off right away—he found her handsome and "very intense." They became long-term correspondents and he later invited her to visit him in Samoa where he'd taken final refuge. You'd love it here, he assured her—the simplicity and purity and happiness of the natives. "You are quite right," he wrote

to her, "our civilisation is a hollow fraud, all the fun of life is lost by it." Ah, but Samoa was different. "It will be the salvation of your souls, and make you willing to die."

Art made life worth living, in Lily's estimation. She published poetry under the pseudonym C. A. Price, or "Caprice" (in deference to her husband's starchy sense of propriety that a married woman should not publish under her real name), and she surrounded herself with a cast of literary heavyweights. In addition to Mark Twain and Henry James, other celebrated figures drifted through the household, among them Walt Whitman and Julia Ward Howe, who'd written *The Battle Hymn of the Republic*. Conventional people did not appeal to Lily. So why the reluctance to permit her daughter Lucia to study painting? Art was one thing, but economic reality was another. The Fairchild brand of bohemianism required money—lots of it. So her father made a deal with Lucia: if she'd agree to endure the yearlong pageantry of being a debutante in Boston society—and, with luck, snag a suitably deep-pocketed spouse—she would be allowed to pursue her art.

Lucia began her studies at Cowles Art School in Back Bay, a private academy that employed Parisian modes of instruction. Under the Impressionist painter Dennis Miller Bunker, a friend of Sargent's, she learned how to draw figures, studying anatomy and composition. Her next step was New York and the fabled Art Students League, to work under the tutelage of William Merritt Chase, another friend of Sargent's. But Lucia's education was enhanced by her intimate connection with the master portraitist himself. She was the student who had dinners with John Singer Sargent. When Sargent took refuge with the Fairchilds in Boston and abroad, the famous artist chatted with young Lucia—the acolyte. She took notes of his unguarded observations on celebrity, art, his clients, literature, and music. He thrilled to the "grand cubic chords" in Wagner, but had little use for Hawthorne's *Scarlet Letter* ("dreadfully morbid, and the whole thing seems so unnecessary"). He grumbled about his high-

paying clients, among them the exasperating Isabella Stewart Gardner, whose face he described to Lucia as "a lemon with a slit for a mouth."

But more importantly, Lucia's diary records conversations when the master imparted the arcane alchemy of painting. In the summer of 1891, Lucia visited him in the English countryside at Fairford. There, she began a landscape. One afternoon Sargent found her at her easel. "Very green, those trees," he said. "You're under the impression that trees in England are green—whereas they aren't." Not green? No, to him they had to be "much *blacker* and duller . . . grey—or purple, or whatever along the edge." And while others might see the inky silhouettes of fishermen on the horizon as black, Sargent saw them as brilliant yellow, the sunset reflecting in their eyes.

Lucia listened intently as he discussed the role of the artist in society—in his view, art and politics should never mix—and commented on his own work. He feared sentimentality in his paintings, admitted that an "interesting" face outweighed a beautiful one, but also spoke of the hazards of his profession. "Portrait painting, don't you know, is very close quarters—a dangerous thing"—an intense, claustrophobic experience, dangerous for both artist and subject—the danger of coming too close to the person, or to the truth; or straying too far away, or unveiling oneself. Lucia, the sorcerer's apprentice, avidly took notes.

In Paris, Sargent gave Lucia and her family a tour of the Louvre. Lucia thought he looked "wonderfully handsome & tanned & rather thin, with the Legion of Honor ribbon in his button hole," as he led the way through galleries he knew by heart. Sargent had been appointed a Chevalier of the Légion d'Honneur—the highest honor awarded in France—after having won a *grand prix* for six paintings he exhibited at the Exposition Universelle in Paris in the spring of 1889. Having once been denounced by the art establishment in France for his *Madame X*, Sargent must have felt triumphant as he strutted through the museum wearing his badge of knighthood. Perhaps puffed up by his exalted status,

Sargent took exception with the placement of the art. The Louvre had erred, he said, in the way it positioned the *Venus de Milo*—it should be turned so that the light would strike her more dramatically; he approached a museum guard about doing just that, but was rebuffed. He lingered for the longest time over the headless *Winged Victory*, admiring it from every angle—something, he said, he had to do every time he saw it. He darted from painting to painting, pointing out his favorite ones, and highlighting details of color, line, and texture.

En route home, the conversation turned to love and marriage—another burning subject for Lucia, who had fallen in love with a fellow art student, a young man named Henry Brown Fuller, of whom her parents disapproved. Henry had the proper breeding, descended as he was from a distinguished old New England family, but he had no prospect of making any real money from his art, and Lucia's father took financial independence seriously. (Apparently, the debutante festivities hadn't produced the desired result.) Lucia announced that one should marry only for love and Sargent laughed. He warned her that one had a better chance for happiness without all that intense passion; he told her that "*Terrific* love" might lead to bitter disappointment and "*Terrific* hate."

Henry Fuller was boyishly handsome with his seductive eyes, thick eyebrows and mustache, and fringe of brown hair falling on his forehead. Five years older than Lucia, Henry—or "Harry" as she called him—was tall, well-read, and charming. To her, he was irresistible, radiant with talent. Everyone agreed he was going to be a star in the art world. His father, George Fuller, had also been a painter. One Boston newspaper, with hometown hyperbole, announced the elder Fuller's death in 1884 with the front page headline: "THE LEADING ARTIST OF AMERICA PASSES AWAY." The Fairchilds moved in the same social circles as George Fuller and his wife, Agnes, who was a Higginson. Charles and Lily had even commissioned a painting by George Fuller. Nonetheless, they did not view his son as proper marriage material.

Despite her father's best efforts to squelch the romance, Lucia carried

on a furtive love affair with Harry for several years. They met secretly and wrote passionate letters to each other. Harry's talent was yoked to bleak depressions. He craved the praise and encouragement Lucia provided. Enamored with Symbolism, a new movement that had taken hold among some Parisian artists, Harry conjured bold, universal ideas. He eventually created large allegorical paintings using figures out of mythology and fiction, whose titles—*Illusions* and *The Triumph of Truth over Error*—give an inkling of the philosophical issues he tried to convey on canvas. Portraiture bored him, and he blanched at the very idea that he would kowtow to the rich to secure commissions. According to family lore, he had the dubious distinction of never actually finishing a commission.

Lucia found his ambitions pure, godlike even. "Don't you think I know the difference, King, between you and me?" she wrote. "You are a God—Jupiter or maybe sometimes Apollo and Kali and Botticelli and Marcus Aurelius and I am your humble servant." Lucia may have felt unworthy, but it was *her* career that was in ascendance, not his. Perhaps inspired by the sheer size of Sargent's canvasses, Lucia painted on a grand scale. Murals became her specialty. At the age of just twenty, she leaped to the upper tier of artists when she was commissioned to create a mural for the Woman's Building in the fabled "White City" at the 1893 World's Columbian Exposition in Chicago. She was one of six women artists—the famous Impressionist Mary Cassatt among them—to provide murals for the building's Hall of Honor.

While Cassatt painted *Modern Woman*, Lucia evoked the New England past with a mural titled *Women of Plymouth*. It is an all-female colonial world that Lucia created: More than a dozen women, on an eleven-by-twelve-foot canvas, are spinning, washing, teaching the young, and caring for infants amid a wintry landscape. The women appear saintly, devoted, and dutiful, though the central figure also seems slightly shell-shocked as she washes out a pot. (A thought bubble over her head might read "Is *this* my future?")

Lucia's mural in the White City promised a bright professional

career. The leading American artists of the day exhibited at the expo-sition, among them the monumental sculptor Augustus Saint-Gaudens who mused, "Do you realize that this is the greatest gathering of artists since the fifteenth century?" And here was Lucia taking her place among the luminaries. All seemed possible.

Perhaps buoyed by her triumph, Lucia defied her parents' objec-tions and Sargent's advice to opt for *terrific* love. In the fall of 1893, Lucia announced her engagement. She wanted a simple wedding—the sooner the better—with only the immediate families present. Her oldest brother protested that she should at least have the decency to wait until after the Yale–Harvard game. The bride- and-groom-to-be were presented tick-ets to the game in the hope they would postpone their nuptials. They didn't. Lucia and Harry were married in Boston on October 25, 1893.

The newlyweds hatched a romantic plan: They'd be itinerant art-ists, painting portraits as they moved from one New England town to another in a "caravan"—a horse-drawn house on wheels custom-built by the groom, with a special compartment beneath it for their cat. They didn't get very far, as Harry's carriage was an ill-conceived mess: It was at once too low-slung for the rutted roads to the Green Mountains of New Hampshire where they were headed, and too tall to pass through covered bridges. They meandered on back roads.

Lucia got pregnant, and then in the cramped confines of their fantas-tical caravan, she began suffering from an ailment that had first appeared in her adolescence, a strange, recurring weakness that would leave her bedridden for weeks. Over the years, she had gotten varying diagno-ses, followed by just as varied treatments—nothing helped. Leaving Harry in the caravan, Lucia sought refuge at her family's summer place in Newport, "Bel' Napoli," in late August 1894. She was told to lie down and rest—she was not even to *think* about bathing in the ocean or fresh water ponds. Meanwhile, she watched enviously as her healthy brothers played tennis and swam all afternoon. Her grandmother had no sympa-thy, storming into Lucia's room one morning to command, "Luddy, you

lazy girl . . . get right up." But Lucia's weakness persisted. Her doctor advised "fleshing up"—gaining weight being considered a healthy antidote for women suffering from "hysteria" and just about any other mysterious illness.

August turned to September and then to October. Confined to Newport, Lucia missed Harry dreadfully and spent her days writing love letter after love letter to him, filled with news of life in the resort: the bicycling craze that had taken hold among the socialites (a millionaire's sister offered to teach Lucia, but she wasn't able to take her up on it) and the closely followed exploits of the deep-sea divers searching for a lost torpedo in the harbor. "They look like hob-goblins, with huge helmets on their heads, and little glass windows set in, a complete rubber suit, and long rubber tubes through which the air is pumped to them."

She had such yearning for Harry. "Dearest dearest Harry I am longing to get your letter . . . I think of you all the time. My dear little Harry, don't take any risks will you, and write me right away if you want me." Her own health seemed insignificant; it was Harry she worried about. She fretted over his not sleeping well in the caravan ("Rigolo" was her name for it), suggested he have curtains made to keep out the morning light, and sent him a specially ordered hammock, and wicks to light the stove so he'd be warm in the September chill.

Harry's extant letters seem to dwell on his own complaints and money worries. Always money. It would be the preoccupation of their lives, and he seemed incapable of making any. He disdained commercial work. It was beneath him.

Lucia began to think of practical moneymaking schemes; someone had to. Yet she feared her husband would hate her for looking to the marketplace: "Harry you make me so afraid that I shall turn out . . . exactly [like] one of the artists that you despise. You know I haven't the jeu sacre like you, and I don't believe I shall ever want to do anything more than literally copy things that I literally love—Principally you." She wrote him that fall, "It makes me respect you awfully to see how entirely you

live up to your principles." Meanwhile, still suffering from her undefined illness, she went to New York City to consult with yet another specialist ("Dearest little Harry . . . I write thee of nothing but Doctors, medicine and ailments. What would Emerson say!") and to recast her own artistic career in order to generate some income.

The giddy free-spending days of the Gilded Age had been at least momentarily derailed. Even Lucia's father suffered devastating losses during the financial free fall of 1893. She couldn't turn to him for help, nor did she want to, as it would be an admission that perhaps she'd made a mistake in marrying Harry after all.

Lucia had an idea. Miniatures—watercolors on ivory ranging in size from about 1½" × 1" to 6" × 4"—were an old-fashioned art form not much in vogue at the time, but she saw a possibility in them. She could paint them quickly and, with luck, in great quantity. They were afford-able, yet carried with them a particular charm; you could hold one in your hand. Lucia believed there would always be a demand for family heirlooms that could be passed down from generation to generation. In an article touting the tiny art form Lucia noted, "a miniature brings the vanished personality before us more vividly than any photograph can do." She argued that the "extreme finish of detail which so small a scale demands" created works of unequaled intimacy.

Producing a miniature was a painstaking process that demanded patience and talent—to say nothing of excellent eyesight. Lucia couldn't employ the broad brushstrokes she'd grown accustomed to with her murals. Miniatures demanded tiny, carefully controlled brushwork in a technique known as stippling—basically making a series of small dots to create a kind of pointillist painting on an extraordinarily small scale. Lucia had been schooled in art, but not in this technique. She needed a teacher.

While attending an exhibition of miniatures in New York in the fall of 1894, Lucia tracked down the addresses of two of the artists in the show. Unannounced, she knocked at the Fifth Avenue address of the first

miniaturist, who brightened immediately at the sight of Lucia, assuming she was a potential customer. "There she is, and powder dropped off her as she talked," Lucia narrated in a letter to Harry. The artist was literally swaying with excitement at the prospect of showing Lucia her work. She pulled aside a heavy curtain to reveal forty or fifty of her miniatures— "all very pink, very finished, and very well framed"—affixed to a large velvet-covered board. As soon as Lucia explained why she was there, the artist lost all interest in her. It wouldn't be worth her while to teach her, she explained coldly—and in fact, one lesson would be worthless anyway. The doorbell rang, the artist perked up at the possibility of a paying client, and abruptly ushered Lucia out the door. "I found myself, very crushed, in the street," Lucia wrote.

Pregnant and sick, Lucia, nevertheless, pressed on. Helped by a postman, she tracked down the second artist in the Bronx. She knocked and heard a faint "Come in." There, at an easel, sat an elderly, white-haired woman with a kindly expression on her face, surrounded by her "dreadful" miniatures. She agreed to give Lucia a lesson, perhaps even two if necessary, but added "I hope you find it pays better than I do." On that dismal note, Lucia embarked on her new career.

Here was Lucia, alone and terrified in New York City. She implored Harry to send money as soon as possible so she could pay her bills. Lucia explained—as if she needed to apologize to her husband—that she had spent all she had on medicine and ivory and the other art supplies she needed to make miniatures. She was miserable, she'd caught a cold, and she wanted to come home. Accustomed to life in grand Back Bay mansions and gilded seaside resorts, Lucia now occupied grim lodgings on Union Square—an interior room with a window opening onto an elevator shaft. The gaslight fixture was so high up on the wall she couldn't reach it, even standing on a chair, so she spent much of her time in darkness. The room lacked a washstand or towels, and she had to share a bathroom with a stranger. The walls were paper-thin. Sitting by herself in her spartan lodgings, Lucia could hear a woman sobbing in the room next

door. "Release me," she begged Harry. He wrote back and made it clear that she should not count on any help from him. He suggested that she borrow money from the William Dean Howells family—her childhood friends from that propitious hilltop in Belmont—who were now living in New York. She would have to fend for herself.

Lucia became skilled in the art of miniatures, turning out commissions for patrons in New York and Boston; she also became the primary breadwinner in their growing family. She gave birth to a daughter, Clara, in the spring of 1895, and nearly died when she gave birth in New York to a son, Charles, less than two years later. (The doctor warned her not to risk having another child.) Harry generally remained rooted in his studio in New Hampshire while she followed the money. Sometimes she had the children with her, but more often she pined for them from afar. "I think of that fat porpoise Clara til my arms ache to hold her," she wrote of her year-old daughter. She fretted about her babies—"the dear birds" as she called them—ever fearful of accidents and illness. What would she do if something happened to them? She begged Harry to take good care of them. He dutifully reported that the children missed her, and that one morning two-year-old Clara announced, "mama all gone."

Lucia meanwhile attracted a stellar roster of clients—Whitneys and Morgans and even the famous actress Ellen Terry when she was touring in New York; Cabots and Curtises in Boston. Her subjects could be infuriating and demanding, but the bills for Lucia's young family were mounting, so she had no choice—she *had* to be accommodating. Price was always a delicate issue to negotiate and proved to be especially so when painting Dr. Carroll Dunham at his country home at Irvington-on-Hudson in the summer of 1896. Sargent had painted Dunham a few years earlier—a "very florid and very strong" image that was apparently destroyed by the family because the colors were considered too brash. That painting had been commissioned by a friend, and it's doubtful that Dunham haggled with Sargent over a fee—the

artist was much too famous and in too much demand to put up with such nonsense. But twenty-six-year-old Lucia, a young mother in need of money, did not have that kind of clout.

Lucia was at the doctor's home, ready to embark on portraits of him and his wife, when news broke that populist William Jennings Bryan had won the Democratic presidential nomination. That's it, Dunham told her, now I'm going to have to "economize"—a euphemism for *Your fee will be cut*. Meanwhile, he insisted that all the servants and guests in the household, including Lucia, attend a family religious service he presided over. They all had to sing hymns and canticles, get down on their knees to pray, and listen as the doctor preached on the topic of how material comforts were a reward for having pleased the Lord. Lucia seethed over his holier-than-thou hypocrisy. Here he was equating his own prosperity with goodness, while chiseling Lucia at the same time. It was positively "materialistic" and "impious," she wrote to Harry. Afterward, Dunham's wife refused to pose for her portrait as it was a Sunday, and then the doctor announced it would be another ten days before he could sit. Harry, meanwhile, dashed back a note to his wife saying that he was thrilled by the selection of William Jennings Bryan and urged her to stand up to Dunham and demand a hefty fee. Easy to say from afar.

Lucia produced miniature after miniature. Her Boston Brahmin clientele were no better than Dunham—they turned out to be just as cheap and difficult. In June 1898, when Lucia presented Mrs. Cabot with her finished portrait she rejected it. "I don't like the way my hair looks," she told the artist, and "I want to be presented as if seated on a cushion." Lucia dutifully redid the ivory portrait. Mr. Cabot was impressed with the result, saying it was the best image he'd ever seen of his wife and a hundred times better than what he'd expected—a rather backhanded compliment. But worse, they still haven't paid me, Lucia noted. A common refrain. While juggling portraits for several wealthy Bostonians that summer, she wrote forlornly that for all the work she had produced, and

for all the time she had spent on the miniatures, she had yet to receive a single penny from her clients. In the next sentence she was asking Harry how much money they had left in the bank. There wasn't much.

In 1897 they'd purchased an old farmhouse in the village of Plainfield, New Hampshire, and they were in the midst of renovations. For Lucia and Harry, Plainfield was Nirvana, the fulfillment of an aesthetic dream: they became full-fledged members of the so-called Cornish Arts Colony, a gathering of artists, writers, musicians, and theatrical sorts who had gravitated around a picturesque section of the Connecticut River Valley. The area boasted covered bridges, sparkling tributaries with colorful names like Blow-Me-Down Brook, and rolling hillsides that culminated in the three-thousand-plus-foot Mount Ascutney that ruled like a kind of Mount Olympus over the gifted creatures assembled below. Art was the official religion, and the chief priest was sculptor Augustus Saint-Gaudens.

The son of a shoemaker, Saint-Gaudens had risen to become one of the titans of the Gilded Age. Today it's hard to imagine just how famous Saint-Gaudens was, as even the art forms he perfected—bas-relief sculptures of exquisite detail, monumental bronzes for public spaces, cameos, medals, and probably the most beautiful American coin ever created—have long since faded from popularity. Massive postwar urban monuments to Union heroes were being commissioned at that time and Saint-Gaudens created the greatest of them. They were brooding, powerful works of art. Saint-Gaudens redefined the sculptural depiction of American heroism in that era.

In part, it was a commission to create a monumental sculpture of Lincoln that first drew the artist to Cornish. A wealthy New York lawyer named Charles Beaman had a country place in the area, and he convinced his friend Saint-Gaudens to move up to Cornish for the summer of 1885: There are lots of Lincolnesque types in that New England back-

water, he assured the artist. (In fact, Saint-Gaudens did find a lean six-foot-four-inch local farmer by the name of Langdon Morse.) The lawyer had been gobbling up huge tracts of land for a pittance from dirt-poor farmers and he sensed a real estate bonanza if only he could attract the right kind of people—artists like Saint-Gaudens. Among the properties Beaman owned was a brick inn that dated back to around 1800. The place was so out of the way it had been a complete bust—what travelers would ever be wandering by? Locals referred to it as "Huggins' Folly," after the brothers who'd built it. Saint-Gaudens preferred to remember that it had also been a whorehouse. He bought the place and eventually moved in full time.

Saint-Gaudens renamed the estate Aspet, after the French town where his father had been born. Now a historic site overseen by the National Park Service, it's set on a hill with a magnificent view of Mount Ascutney, and the grounds and studios are littered with plaster casts and full-scale bronzes of Saint-Gaudens's works. There, his colossal sculptures are displayed away from the cacophony of their usual urban settings—the commanding figure of Civil War admiral David Farragut; a brooding seated Abraham Lincoln; and a rather arrogant Puritan in midstride, his cape billowing around him in royal fashion. Looking up at these works one feels awed by the power of their presence—even diminished by them. Yet, wandering amid the cozy hedges and birch trees on the estate, a different set of emotions are stirred by two of Saint-Gaudens's greatest works: the heart-rending Shaw Memorial dedicated to the ill-fated Colonel Robert Gould Shaw and his regiment of black soldiers who were killed during the Civil War (the film *Glory* was based on their story), and the funerary sculpture of Clover Adams, the brilliant but unstable intellect, wife of the writer Henry Adams, and photographer who took her own life in 1885 by drinking her photographic chemicals. Both of those sculptures are set apart, in meditative isolation, each one in a leafy cul-de-sac.

Saint-Gaudens employed a small army of assistants to help with his commissions, and a steady stream of artistic spirits followed in his

wake—Lucia and Harry among them. At some point, Lucia's mural
Women of Plymouth was installed above a stage at the quaint Blow-Me-
Down Grange in the center of Plainfield, where they lived. The Cornish
Colony was more a "state of mind" than a municipality; its borders were
fluid and the burg of Plainfield was a northern outpost of that enclave
of "high thinking and perfection." (Just so there'd be no mistake about
it, one Plainfield resident had calling cards that read "Geographically
in Plainfield, Socially in Cornish.") The colony spilled across the Con-
necticut River to the town of Windsor, Vermont, which was linked by
a covered bridge (as it happens, the longest such bridge in the country).
Windsor was where Cornish residents picked up their mail, and where
they boarded trains for the approximately six-hour trip to Boston, nine
to New York.

Maxfield Parrish, famous for the supersaturated, Technicolor qual-
ity of his paintings and illustrations (intense cobalt blue is sometimes
referred to as "Parrish blue"), was part of that hallowed congregation
of artists. Like Lucia and Harry, he lived in Plainfield and, like Lucia,
he left behind a treasure for the town. Practically a stone's throw from
the Grange, Plainfield Town Hall features another stage used for official
ceremonies and plays. In 1916, Parrish designed a backdrop that includes
six wings and three overhead drapes. It depicts a woodland scene with
a brilliant display of painted leaves in autumnal shades, and sculptural,
white birch trees surrounding a large body of water. Mount Ascutney is
at the far end of the scene, overseeing all. When lit properly, the land-
scape backdrop can be transformed into any moment of the day, from
daybreak to twilight.

In the fantastical paradise that Parrish and his cohorts created in
flinty old New England, what better gift than a stage set? In the Cornish
Colony, pageants, plays, masques, *tableaux vivants*, dramatic readings,
and energetic evenings of charades were part of its very soul. Every-
thing about the colony had a theatrical element. There was a kind of a
Midsummer Night's Dream aura to the entire enterprise. Photos of Lucia's

children and their friends show them in one costumed drama after the next. Ethel Barrymore—considered the greatest American actress of her era—coached the children in William Thackeray's comedy *The Rose and the Ring* in the summer of 1906. In her memoir, Barrymore made special note of Clara Fuller's marvelous performance as the queen. Lucia created the scenery for the production, which was covered by a New York theater magazine. Modern dancer and choreographer Isadora Duncan visited Cornish and performed one evening, though her knees creaked while dancing as she was well past her prime.

The families that stayed year-round—among them the Parrishes, the Fullers, and, by 1900, the Saint-Gaudenses—proudly called themselves the "Chickadees," for like those small birds, they remained behind during the long winter. Considering themselves a special breed, the artists snidely dismissed the rich hangers-on who wanted to be part of their rarified world—the patrons who actually purchased their work—as "Philistines." *They* didn't have the creative gift. Even worse were the "natives," whom they looked down upon as rubes. (Though they *did* need the farmers to clean their houses and do their yard work.) In turn, the locals thought these free-spirited artists were slightly nuts—flouncing about in Grecian robes, spouting poetry, allowing their boys and girls to swim naked together in the summer, and generally encouraging them to act like forest nymphs. Lucia reveled in the freedom of their country life—and hated those bleak periods when commissions tore her away. She permitted her children Clara and Charley to pose nude for their father, which was not uncommon in that milieu. Lucia, too, posed for Harry and other artists in the colony. There was lots of model swapping, and lots of live-in-models-who-soon-became-mistresses, and eventually lots of fractured marriages. The farmers watched all the drinking and partying and theatrical goings-on and shook their heads. Protocol in their households was much more conventional.

Real life—at least the kind the natives were used to—rarely intruded, though some of the colonists liked to populate the countryside with live-

stock of various sorts. One member of the colony preferred bison, which he trained to pull his cart. Such quaint touches added to the Arcadian idyll. Though herds, of whatever sort, were charming to look at from a distance, the noise could be bothersome. Artist Kenyon Cox enjoyed his view of cows on the landscape, but implored his novelist neighbor to quiet their bells, on the excuse they woke the women in the house too early. Another colonist found that the lowing of cows in a nearby pasture interfered with his tennis game and he succeeded in having the offending herd removed.

The well-traveled colonists hated New England farmhouses, considering them much too severe and boring. They found the rolling hills reminiscent of Italy and wanted to re-create a style of life that evoked classical civilization. Terraces, pergolas, formal gardens, tiled roofs, stucco walls, and columns suddenly sprouted up all over the landscape. Lucia and Harry remodeled their house in Roman fashion: a three-sided structure facing out onto a central courtyard. A colonnaded portico completed the scene. Renovations went on and on, with Harry filing reports to Lucia on the status of the studio as it was being built, and on the size of the courtyard ("too small," he pronounced). As Harry lounged in the country, Lucia endured long stretches in New York and Boston to pay for it all.

In the meanwhile, Lucia's father was faring badly. On March 31, 1894, a small item appeared in the *New York Times*:

NOTICE—
 Mr. Charles Fairchild retires from our firm this day.
 Lee, Higginson & Co.

Charles had guessed wrong in the stock market. In the collapse of 1893 his favored investments—western railroads and real estate—had gone bust, and he was unceremoniously cut loose from Higginson's firm. Just like that, Fairchild's gilded career in Boston was over.

The war veteran had grit and started over in new territory. Charles, now fifty-six, launched an investment firm at 29 Wall Street, and man-

aged to purchase seats on the New York Stock Exchange and the Corn Exchange, but his business never really flourished. Family members later blamed the eldest son, Charles Jr., for squandering a million dollars of the family fortune. The family began a slow descent, while trying to maintain appearances: They socialized with the same old families (though the Henry Lee Higginsons surely must have kept a healthy distance), went to the same clubs and schools (Harvard, naturally, for Lucia's younger brothers), still attended the Boston Symphony (until they couldn't afford even the cheapest seats), maintained their servants and their cottage in Newport, and lived amidst their books and art collection. But the paintings began to slowly disappear from the walls, one by one—works by Winslow Homer, Thomas Gainsborough, and Sargent—to pay the bills for residences in Boston, Newport, and now, New York.

The family's arrival in New York became a trial for Lucia. Her sister Sally ("Satty") was impossible: "I will whisper to you that I wish Satty would marry and go to Europe. . . . It would suit me better than to have her in New York," Lucia wrote to Harry. Sally surely had her chances at marriage. Lord Bertrand Russell, mathematician, philosopher, and member of one of the most prominent aristocratic families in England, sounded like a smitten schoolboy when describing Sally in his *Autobiography*. She spent a long visit with him and his first wife at his estate in England in the summer of 1899. "Her movements," he wrote "were the most graceful that I have ever seen." He talked longingly of their walks together in the twilight, though confessed that he never dared kiss her. She had the same effect on his eccentric cousin, St George Pitt-Rivers, who would propose marriage. She declined—perhaps a wise move on her part. A confirmed Buddhist who wandered about Tibet visiting the Mahatmas, Pitt-Rivers was convinced that *he* had invented the electric light, not Edison, and he squandered his fortune in a series of futile lawsuits. Russell's memoir notes that many others lined up for Sally's hand—"She used to say that you could always tell when an Englishman was going to propose, because he began: 'The governor's a rum sort of chap, but I think you'd get on with him.'"

Sally remained single and devoted to her mother. Even Sally would later admit that she might have taken filial devotion too seriously. Like a guard dog, she sometimes lashed out at people, barking at them to protect her dear mother from harm or hurt. She felt no such protective instinct toward her sister. From childhood on, she lorded over Lucia and resented any attention her younger sibling might receive. As children, the brothers and sisters all engaged in dares and contests, some of them dangerous. One day Lucia jumped from their high stoop on Commonwealth Avenue and severely injured her back. For a time she was restricted to a wheelchair, and when she didn't improve, the doctor prescribed an extended stay at the spa town of Baden-Baden in Germany. Lucia went there, received daily mud baths for a month—and got lots of personal attention. Sally was livid, convinced that her sister was just faking it.

Sally's jealousy only worsened as they got older. She never failed to scold Lucia about minor things, and she surely seethed at the spotlight being cast on her younger sister who, by the late 1890s, was a respected presence in the art world. Why was *Lucia* gaining fame, and not she? After all, *she* had always been considered the beautiful sister, the one chosen by Sargent. And yet, by her late twenties the five-foot-one-inch Lucia had changed in looks. She'd lost her baby fat and, in fact, was growing thinner and thinner. She was quite lovely, with her brown eyes, and her hair parted in the middle, pulled back, and braided into a figure-eight pattern at the back of her neck. Lucia's daughter would remember the precise way her mother had arranged her hair, and in the 1970s she described it in a letter addressed to "All Lucia Fairchild Fuller's Grandchildren and Great-Grandchildren." She wanted her descendants to know all about Lucia: what she looked like, how courageous and sensitive she was, how talented and beloved she was. Also how bold. During her lifetime many people told Lucia that she "thought like a man," which was quite a statement back then.

Lucia also smoked like a man, having taken it up after her father offered her a cigarette in Boston. (Yet another sore point with Sally: Her

father let Lucia smoke, but not her.) Smoking seemed to confirm Lucia's nonconformist, self-confident persona. Her letters to Harry, however, reveal another side to her character: her insecurities and her neediness, all of which she had to camouflage in order to forge ahead in her career. "If it had not been for marrying you I see that I should have suffocated," she wrote to Harry in May of 1898.

> I am too weak to stand up to my guns. I can't analyze and make epigrams and I'm terrified and abashed before the critical attitude. I needed love and kindness to develop at all, and . . . to make me feel at all competent in meeting other people, and you give it all to me Dear. I wish my nature were more open and that I was contented to be what I am without caring what people thought, but I'm not. And the consequence is I'm paralyzed unless I'm met with gentleness and tolerance. . . . I realize how much I owe to you, and I shall try to help you more in the future as you have helped me.

She trusted and loved Harry. She had to. It was part of her armor.

Lucia spent most of that hot summer of 1898 in New York and Boston, painting, giving art lessons, and sending checks to Harry as soon as she got them, despite being short of cash and unable to pay her own boarding house charges. Somehow Harry couldn't even manage to get the checks into their bank account in a timely fashion. She occasionally grew exasperated with the way he'd leave her hanging by a thread, but she tried to remain optimistic. Surprisingly so. On June 18 she wrote that a three hundred dollar check from the Cabots would soon be arriving at the post office in Windsor: deposit it *immediately*, she instructed him sternly. "I have so little faith in your doing things promptly since you have so cheerfully let me be here, without any money. . . . It has really been very painful to me." She was so exhausted, she told Harry, that she didn't even know how she had found the strength to finish the Cabot order. But by the end of her letter, she'd already softened toward him.

How could she stay mad at him? *Terrific* love, and art, defined her. "After all, it is the greatest thing in the world to paint, so far as one's own joy goes, isn't it? . . . Goodbye bad little boy."

The renovations on the Cornish house and studio soaked up a lot of money, and so did Lucia's medical bills. Her health was failing once again—her nerves were frayed, her back ached, at times her right arm failed her. The doctor in New York visited daily, complained about not being paid, and suggested surgery. Exactly what kind, Lucia doesn't say. She endured an operation all alone at the end of June—no Harry to hold her hand—and then had to spend ten days recuperating in bed. The New York heat was so brutal that the city's poor children were dying in their tenements. She describes conditions in 1898 New York as if from the lowest circle of Hell: "It is simply burning here. Everything you touch is heated through. The air steams in through the blinds in hot puffs. . . . I hear the babies crying and my heart aches. . . . It is cruel to hear them, to read of their deaths. It is not the rich who are responsible, but everyone with a vote and a heart, who might help. They let water run in the streets late in the afternoon, and the children roll in it, and that is said to save many lives."

By the middle of the month she was up and about, her stitches removed, but her spirits low. Her back still ached and she felt on the verge of tears at any given moment. She was convinced that the surgery had been useless, that she was never going to get better. Her mood only darkened when her father stopped by one day, giddy over having made some quick money buying and selling stocks after getting an inside tip about the Spanish-American War. At least we don't have to do that sort of thing, stepping all over other people to get ahead, she confided to Harry. "Artists have a more fortunate life."

More fortunate for Harry, perhaps, who could cloister himself in his New Hampshire studio. Lucia, meanwhile, had to cajole and please her clients. Desperate for money, she was grateful for the steady stream of commissions that came her way, but they held her pinned down, far from her family, lonesome and sick in New York.

Lucia looked upon her rich and mighty patrons with a jaundiced eye. Her dealings with the J. P. Morgan family were instructive. Jane "Jessie" Norton Grew, Lucia's childhood friend from Boston, brought the artist into the midst of that über-banking family, one of the brand names of Gilded Age excess. In 1890, Jessie had married John "Jack" Pierpont Morgan Jr., son and namesake of J. P. Morgan, the bulbous-nosed financier who would be characterized alternately as "the financial Moses of the New World" or as "a beefy, red-faced, thick-necked financial bully, drunk with wealth and power." A man of huge appetites, Morgan Sr. stockpiled steam yachts and mistresses, as well as priceless cultural treasures—paintings, drawings, artifacts, manuscripts, musical scores, and books of the rarest quality. His private preserve would be turned into the Morgan Library & Museum after his death.

A portrait of the financier/collector hangs above the mantel in his study—it's a heavily edited version of the real man, his grotesquely oversized and reddened nose (he suffered from a skin condition known as rhinophyma) reduced to normal size. It took sheer willpower not to stare at that unsightly protuberance when in the great man's presence. (Further proof that money and power are surely aphrodisiacs, for Morgan never lacked lovers.) The painting is an act of imagination on the part of the artist Frank Holl, who clearly wanted to get paid for his work. Delighted by the painting—perhaps even convinced that it looked like him—Morgan had photographs of it sent to friends. Some years later Morgan wanted John Singer Sargent to do yet another portrait of him. At first Sargent agreed, but then couldn't bring himself to do it. He'd grown weary of portraiture by that time, and there were limits to what he'd endure, even if offered a king's ransom.

Sargent did, however, paint Morgan's daughter-in-law, Jessie, in 1905. It took thirteen sittings in his studio, and the artist arranged a mirror so she could watch him as he summoned up her image in paint. As usual, he chose her clothing from an assortment that she'd brought with her—he settled on a gown of white satin with a floral pattern, a volumi-

nous fur of white fox that he draped around her, a single long gold chain, and an unopened fan in one hand. She appears quite elegant and demure.

Morgan Sr. wasn't terribly fond of his daughter-in-law, whose frosty manner made it evident that she didn't approve of his flagrant extramarital affairs. The financial titan deemed her prim and judgmental, and made fun of her in private, referring to her as "cold roast Boston."

Jessie may have been testy with the old man, but she had a soft spot for Lucia, despite her unconventional life, and understood her friend's plight. A commission was arranged for Lucia to paint Jessie. This, in turn, led other members of the Morgan family to request miniatures. In October of 1898, Lucia was summoned to Cragston, J. P. Morgan Sr.'s estate—or rather his "barony"—on the Hudson River near the village of Highland Falls, not far from West Point. Cragston was set on the decidedly less fashionable western shore of the Hudson; the eastern side of the river was populated by Livingstons, Astors, Chanlers, and other eminences.

Morgan had purchased Cragston in 1872 when it was still a working dairy farm of 368 acres, with a wooden farmhouse set on a bluff overlooking the Hudson. He nearly doubled the acreage by buying adjacent lots, had huge wings added to the house, and relandscaped the grounds in the manner of an English country house. He built greenhouses, tennis courts, kennels for his prize-winning collies (the kennels alone cost over a quarter million dollars in today's money), and stables for the finest horses he could buy. He constructed an L-shaped dock to accommodate his enormous steam yacht—the favorite plaything of the Gilded Age rich and a source of endless jockeying over who had the biggest one. Morgan generally did—and if not, he'd build a new one, always named *Corsair*. The yacht served as a kind of clubhouse for Morgan's male friends and assorted mistresses, and a refuge from his wife. It also made a huge impression when closing business deals.

Lucia was not bowled over by either Cragston or its occupants. Though an article in the *New York Times* had gushed over the estate's

grounds and the "charming and artistic" thirty-room house with its "many gables and harmonious lines," Lucia found little charm and less artistic spirit. "The house is one of the regular Deadly Bores," she wrote to Harry, describing a warren of "endless rooms covered with big chintzy flowered papers."

Lucia had wandered into a country-house comedy, by turns hilarious or boorish. Jack Morgan and others would enter her workspace unannounced, criticize her work, and exclaim, "Lunch!" Aghast to find that Lucia subsisted on cold potatoes, the Morgans insisted she join them en famille for their gargantuan midday meal that consisted of soup, a beef entrée accompanied by corn, potatoes, and eggplant, all washed down with wine. Next came pie, fruit, and coffee. No wonder the Morgans are all extremely fat, Lucia wrote. Table conversation revolved around money. They discussed how much interest they were getting from their bank accounts. When Jack, who earned a conservative 2 percent on his account, learned that another family member was earning 3.5 percent, he was nearly apoplectic—not with envy, but with fear that such a high interest rate was dangerous. He advised closing the account immediately. Lucia, who didn't have two cents to rub together, could only listen with incredulity as they recounted the shocking tale of the friend who'd died broke, leaving to his wife and daughters only a life insurance policy of $350,000. How could they live on such a pitiful amount?

Lucia, of course, couldn't even imagine such a windfall. Mrs. Morgan knew all too well about the Fairchilds' financial collapse and she suddenly remembered her luncheon guest. "Well," she said to Lucia, "we aren't all talented like you, Mrs. Fuller, to be able to earn a living, when we lose our money." And then, as if to embrace an egalitarian tone, she pronounced, "I think we all ought to have a trade." Turning to her daughter she went on, "I think Annie could be an accountant." Annie, the independent, defiantly unmarried youngest daughter, countered to her mother that she'd rather be a manicurist. Then someone told a story of a manicurist who'd

saved $25,000. Lucia wrote with amusement that the two butlers serv-
ing silently at the table bore "a discreet air of promising not to remember
what we said."

The Morgan commissions added up to a thousand dollars worth of
work—some $26,000 in present-day money—a huge payday for Lucia.
That is, if they'd ever pay. Extremely reluctant to part with money, the
Morgans decided to delay payment until *all* the portraits were done, which
left Lucia in a hole. (Her brother Charley advised Lucia not to press the
Morgan family, and he offered her one hundred dollars to tide her over.)
This slight wasn't entirely because she was a woman or a young artist. J. P.
Morgan Jr. also nickel-and-dimed Sargent over money due for a portrait of
his wife. The painting had been made in London, where Sargent lived and
worked full time; thus the canvas had to be shipped abroad, making it liable
for duty fees. Irked at this relatively small surcharge, Morgan argued that
he shouldn't have to pay it since the artist was American. He urged Sargent
to get an exemption at the American consulate.

After the long siege of work in New York, Lucia was finally able
to go home to Cornish to their newly renovated house. Bliss. The chil-
dren could scarcely believe their good fortune, for they adored their
mother. But for about six months Lucia remained bedridden with what
they believed was rheumatism. She'd barely regained her strength when
disaster struck. On a chilly December night in 1899, a fire started in the
attic. Bells in the village rang out and volunteers quickly arrived to fight
the blaze. As the house burned, Lucia calmly oversaw the removal of
every stick of furniture and every piece of china. Young Clara and Char-
ley were carried across the way to a neighboring house. Years later Clara
remembered standing frozen at the window, staring across the way as
their home burned to the ground, terrified that her mother would be con-
sumed by flames. Lucia survived unscathed, but she wasn't able to save
her wedding dress, locked away in a trunk in the attic. Harry's where-
abouts during this emergency goes unmentioned.

Their home had to be completely rebuilt. The family moved into an

empty house nearby and watched as a new Italian villa rose up atop the bones of the old place. The desolate, charred classical columns that had survived the fire became the foundation for a pergola, covered in grape vines, which surrounded the central open courtyard. An even grander transformation took place. At the extravagant cost of two hundred dollars, workers excavated a large portion of the courtyard (seven feet at its deepest point), placed a foot of stone at the bottom of the open pit, installed pipes, and constructed sidewalls. The result: a pool, twenty-eight-feet long and twelve-feet wide. The courtyard was enclosed on four sides making the pool entirely private. Spring fed, and deliciously cold on a warm summer day, the pool became the centerpiece of life among the children of the Cornish colony. They gathered there and learned how to swim, and practiced diving off the deep end. The children swam naked. It was utter freedom floating in the water beneath that blue, blue sky. (Ethel Barrymore rented the house in the summer of 1906 and famously hosted pool parties of a much more mature nature. A neighboring poet said the twenty-seven-year-old actress had a penchant for diving into the pool from atop one of the columns. And if one should feel the need for a bathing suit? Well, they were arrayed on pegs, "and the fit shall be as God wills.")

A question was posed among Clara and Charley's friends one day when they had assembled for a swim: "If you couldn't have your real mother, whose mother would you like to have?" At once, the children exclaimed, "Mrs. Fuller!" (The only holdout was little Mabel Churchill, daughter of best-selling novelist Winston Churchill, who piped up, "If I couldn't have my real mother, I'd like my father to be my mother.") Lucia was a special favorite among the children. She paid attention to them, took them seriously. She encouraged their imaginative and theatrical spirits. She designed costumes for their staged productions. Clara remembered how beautifully her mother read aloud to them—it might be Dickens or James Fenimore Cooper or Thackeray. On the day when the children agreed that they'd want Lucia as their mother, she joined

them in a game of planchette, an early kind of Ouija board. The Fullers had four new kittens and the children asked the planchette to name them. The children and Lucia put their fingers on the saucer that served as the pointer. It circled furiously and spelled out without hesitation: "Drat it, Dash it, Damn it, and Drown it."

The Fairchild-Fuller family papers are housed at Dartmouth College, not far from Cornish. The papers include thousands of Lucia's items— handwritten diaries, letters, photographs, calling cards, bills (always bills), a list of wedding gifts, receipts, bits of poetry, sketches, her childrens' report cards, and assorted oddities. Lucia saved clippings about unsolved crimes and murders from all over the country with headlines like "BLOODY HARLAN. A STORY OF CRIME IN THE KENTUCKY MOUNTAINS" and "DOOMED TO DIE ON ONE SCAFFOLD . . . THREE BROTHERS AND THEIR TWO COUSINS SENTENCED TO SWING TOGETHER FOR MURDER"; accounts of stabbings involving domestic disputes; and reports about H. H. Holmes, the notorious serial killer who stalked the Chicago Exhibition where Lucia's *Women of Plymouth* had been exhibited. Lucia's seemingly bizarre obsession had a professional purpose—among the papers is a draft of a murder mystery she was writing.

Lucia also collected articles about strange, unexplained disappearances, hypnosis, ghosts, and other supernatural occurrences. Drawn to the world of the occult, she was also frightened by it. When she was twenty she had visited a well-known palm reader in London. The woman looked at Lucia's hand and immediately detected a sign that Lucia, too, was psychic. She warned her never to reveal that fact to anyone who didn't share the same gift. Lucia believed she had extrasensory abilities. She sometimes saw things or knew things for no explicable reason. She was once chatting with people she had never met before. After

they talked about their children and various pets Lucia burst out, "But you forgot the parrot." Indeed they had one. On another occasion she saw more than she wanted. She told her mother that after looking down at a particular man's hand she realized it was the hand of a dead man. The next day he drowned. Lucia told these stories to her daughter. True or not, Clara believed them. Her mother seemed to be touched with a gift—or perhaps a curse—that made her sensitive to others, empathic. But even Lucia, with her second sight, might not have been able to fore-see the tragedies still ahead.

The Fullers' marriage began to crumble. As Sargent had predicted, *ter-rific*, intense love could turn poisonous. The free and easy society at Cornish—the boozy dinner parties and nude modeling, and the ideal of beauty and art above all else—led to diverse couplings and uncou-plings. Unconvention was the rule. The worldly Maxfield Parrish hired a fifteen-year-old country girl to take care of his first son; in short order she became his favorite model, and eventually his lover, moving into his studio where she lived with him for decades. His wife remained in the big house, but everyone knew of his double life. Augustus Saint-Gaudens had his own shadow family, conceiving a child with model Davida Clark, his vision of ethereal beauty who posed for several of his most famous works: the scandalous nude statue of Diana that twirled atop Stanford White's pleasure palace, Madison Square Garden; and his winged bronze angel *Amor Caritas*, meaning "love is charity"—though Gussie, the artist's deaf and cranky wife, might not have thought so. Saint-Gaudens's affections were quite clear. He frequently visited Davida and his son in Connecticut, and, to his wife's disgust, he removed the bas-relief of their son, Homer, from their home in Cornish, and replaced it with a bas-relief of his illegitimate son. When the Saint-Gaudenses

showed dinner guests around the house, Gussie would pause in front of
this hated image, turn to her husband and say, her voice dripping with
anger: "Now tell us all about this one."

Rumors abounded about Lucia and Harry. She posed for several
paintings by fellow Cornisher Thomas Dewing in the spring and sum-
mer of 1901, and before long, word spread around the artists' colony that
they were having an affair. Harry, suspicious and angry over her stray-
ing affection, had already written her a scathing letter accusing her of
being unfaithful. Their marriage had long been teetering, largely because
of Harry's sexual dalliances. The strong-willed Lucia was furious that
she should be judged by *him*. In a bitter handwritten poem she recounted
their marriage:

> *You said that you must marry now,*
> *'Twas time for you to settle down—*
> *You had another maid I know,*
> *Almost before you left the town.*

> *And I, who had given you everything,*
> *Who had put myself beneath the ban*
> *For when you were the Lord & King,*
> *—I've never known another man. . . .*

> *I think I see you turn away,*
> *Your face, once tender, now is cold,*
> *You very very humbly pray*
> *Forgiveness for your sins of old. . . .*

> *Did you forget our nine long years,*
> *The time when I was all in all—*
> *Our laughter, & our common tears,*
> *The hour that you heard your "Call"?*

Oh Harry Harry let me cry,
For I am deep distressed.
And gladly gladly would I die
To know a moment's rest.

You said you loved me long ago
And now it is not so.

The poem comes to its abrupt end, the stanza unfinished and abandoned. Lucia had worked tirelessly for their children, for their marriage. She was ill and exhausted. Her doctors were discussing yet another operation in which they'd break all of her joints. (Fortunately they decided against it, urging rest instead.) Meantime, she was making portrait after portrait in order to support them. In 1903, at the age of thirty-one, she took note of the fact that she'd just finished her 191st commission. Harry had yet to complete one.

The only portraits Harry had produced by that time were a handful he did for himself—no pay involved—of friends from Cornish, and, in 1905, a painting of the Fullers' live-in Swedish model, Ebba Bohm. (Lucia found models for Harry in New York and sent them up to Cornish—perhaps part of her undoing.) The Bohm portrait, now owned by the de Young Museum in San Francisco, practically reeks of sex. Bohm appears to have hastily covered herself with a silk dressing gown, her breasts clearly visible; she stares dreamily at a vase of irises, and reaches out to touch the stem of one of the flowers. It feels like a contemplative postcoital moment.

In 1900–1901, Harry produced one of the two large works that would define his career: a roughly six-foot-by-four-foot allegorical painting titled *Illusions*. A beautiful woman is covered only by a see-through Grecian gown. (Keeping women clothed seemed to be a problem for Harry.) In her arms she holds a crystal orb up high, out of the grasp of the eager outstretched arms of a naked, young girl. Here is innocence reaching for knowledge, for the secrets of the adult world. The ball appears to be a glorious bauble, a future full of promise and fulfillment. Its shiny surface

enchants the child, who wants to grab it. But the grown woman knows better. She understands the world and sees the orb for what it really is: an illusion that will destroy the child's innocence. Better to delay the knowledge, to keep the glistening orb out of reach.

Was Harry alluding to the reality of their lives in that canvas? Saying something about their marriage, which would soon come crashing down into a thousand pieces? It was Lucia and their five-year-old daughter Clara who posed for the painting. Amidst the Fairchild-Fuller papers is a strip of rough fabric with a series of photographs mounted on it—three photos of a naked Clara, her arms outstretched, standing poolside next to one of the classical columns in their courtyard. Tiny pinholes are visible at the top of the fabric—Harry must have hung these nude photos of his daughter near his canvas as he worked. The finished painting includes a backdrop of Mount Ascutney and a glimpse of the Connecticut River. Art imitating life in Symbolist fashion. The painting won a bronze medal at the 1901 Pan-American Exposition in Buffalo, New York.

Lucia's sight began to dim, and creating miniatures became more and more difficult for her. She needed a break. During the summer of 1904 she devoted herself entirely to the children of Cornish. She adapted *Ivanhoe* for the stage, creating a romantic costume drama full of swashbuckling action, and then directed it. Over a hundred people attended the performance that September, and Maxfield Parrish's wife gushed over it. "Lucia Fuller," Parrish wrote in her diary, "was a marvel and the enthusiasm of the audience must have repaid her for the vast amount of care and thought she had put in the performance." Her work on the play was more than just a frivolous diversion for Lucia. She said it had been "her salvation" that summer, as she was nearly blind.

The following January, Lucia, with not-quite-ten-year-old Clara in tow, visited Boston and then New York in search of a cure. In Boston

she ran into Dr. Wadsworth, a distinguished ophthalmologist and family friend who assured her, "I'm <u>sure</u> you'll get well." Lucia wasn't so sure. She went on to New York, to visit fellow Cornisher Clara Potter Davidge at her Washington Square winter quarters. Davidge was a well-known interior decorator from a socially prominent family—her father, Henry Codman Potter, was the Episcopal bishop of New York and ministered to the Astors of the world—but even by Bohemian standards she stood out. The decorator was once described as "animated, eccentric, rattle-brained Clara! Always dressed like the doll of any little girl of ten who has had recourse to the family ragbag and secured bits of gay silk, fur and lace. . . . She collected old furniture and promising artists."

Davidge took an interest in, or perhaps took pity on, Lucia, and provided lodgings for the thirty-two-year-old artist and her daughter. Lucia had despaired of the medical establishment ever helping her. She became interested in Christian Science and began consulting with mental healers on the Upper West Side, dragging young Clara with her on the subway to and from her appointments. Clara would nestle in with a book during the sessions. Afterward it would be roller skating in the park or learning how to make Native American–style baskets from Davidge. For Clara it was an adventure. She was thrilled to be with her mother, and probably just as delighted to be away from her distant, moody father, who spent long hours absorbed in his allegorical paintings, forgetting about his children.

Come spring it was Charley's turn to accompany his mother to a hotel in New York. "I feast my eyes on this great city!" the eight-year-old announced dramatically on his arrival. He visited relatives, roller-skated, and was generally awestruck by New York. Lucia, meanwhile, scurried around town gathering commissions and setting to work on them. Still, she was painting the miniatures as if through a fog because her eyesight was so poor. But then a piece of good news came: New York socialite Grace Dunham Luling enlisted Lucia to paint her children as a surprise for her husband. To Lucia's vast relief, Grace wanted

an oil portrait substantially larger than a miniature, which would be much easier to paint.

Lucia had to hand her children off to friends and relatives while she raced about town executing her commissions. The Luling painting required her to be especially careful about her comings and goings at their household, lest she ruin the surprise. No such luck. On her first day at work on the portrait of the son, Saster, his father arrived unannounced—and he wasn't very pleased: "the door jerked open and a tall man appeared. 'Dam,' said he and went out. 'That was my father' said Saster. 'He's a very cross man, you see.'" Grace then walked into the room on the verge of tears. The commission continued nonetheless.

As usual, money was an ongoing concern and Harry was worse than useless. By today's standards it may be hard to fathom why Lucia continued to put up with him—his narcissism, his philandering, his drinking, and his bouts of depression. But divorce in the early 1900s was almost unthinkable, and Lucia clung to the idea that she needed Harry. Yet his indifference—his cruelty—to her was nothing short of loathsome during that spring of 1905.

Young Clara had been having problems with her throat and a doctor in New York strongly recommended that she have her tonsils removed—and while he was at it, why not take out her brother Charley's as well. Instead of racing down from New Hampshire to be at his children's side during the surgeries, Harry just complained about the cost. Lucia had to convince Harry that the procedures were necessary—the doctor had been vehement about it—and she promised to take on more work to pay for it. Such surgery generally meant a three-day stay in a hospital, an impossible expense. Lucia told the doctor to perform the operations in her apartment. A nurse arrived early to help Lucia fix up the room, arrange the tables, and hang sheets all over the walls, remarking, "You don't want to get the walls splashed, you know. It's a very bloody operation." The two of them covered the carpets with thick layers of sheets and newspapers, and then Lucia had to stand by as her children were

operated on, one after the other. On May 11, 1905, she reported on the procedures to Harry:

> Clarky [Clara] got on the table, all smiles and politeness and took the chloroform like a lamb. . . . In 40 minutes Clarky was in bed and pretty well out from under the chloroform, her poor little lips quivering with pain and her eyes suffused with tears, but so gentle and brave and polite that it was touching to see her. She kept motioning for me to kiss her and then moaning "My throat, Oh my throat!" I told her how proud I felt that she was so brave. "I tried my level best to behave well," she said gravely. She is a wonderful child. Charles fought under the chloroform like a man—objected to it in a loud voice, and at intervals I could hear his little feet kicking the table madly. However, there was much less to be done to him, only one tonsil and one adenoid, whereas Clara had both tonsils and a group of adenoids and the uvula all cut away.

Before the operation Clara had asked the doctor to save all of the removed tissue for her, which he did. Lucia must have felt as if she were undergoing the knife herself, as she listened to her children's groans and cries, and saw all that blood and mucus—half a pail-full while they were still on the table, with more coming up after they emerged from the chloroform. Clara, especially, was in terrible pain after the surgery, and her mother gently soothed her and read to her until she finally dozed off.

And where exactly was Harry? Was he too absorbed in his work— or a new model—to take time to help his wife? Or, an unlikely scenario, did he actually disapprove on moral grounds? Inspired by the writings of Mary Baker Eddy, Harry had embraced Christian Science along with Lucia—though clearly, neither of them were totally committed to the belief system, as they both opted for doctors when they felt the need. Around that time Harry began painting an eight-and-a-half by eleven-and-a-half-foot work titled *The Triumph of Truth over Error*, based on the

tenets of Christian Science. In it, a winged symbol of Truth—a beautiful woman (model Ebba Bohm) dressed in white flowing robes, one breast exposed—vanquishes the dark force of Error, portrayed as a figure shrouded in black with one hand shielding his eyes, unable to meet Truth's steady gaze. In defeating Error, Truth has cast aside the illusion of illness and disease. Mary Baker Eddy loved the painting and gave it a rave review; the work even garnered a five hundred dollar art prize in New York, though the headline announcing the award in the *New York Times* on December 12, 1908—CARNEGIE PRIZE MISPLACED—dismissed the work as lightweight and undeserving. Critics piled on when Harry admitted he'd had some help with the painting from other Cornish artists, Saint-Gaudens and Everett Shinn among them. One journalist noted sarcastically, "This hypothetical MR. FULLER is said to have embodied the thoughts of so many artists in his work that if he were to make full acknowledgement their names would cover the canvas." Nonetheless, the work remained popular and over the years Harry made cheap reproductions of the painting and sold them, mainly to devotees of Christian Science. Finally, a money-making scheme, though it came too late for Lucia.

While her children recuperated from their operations in New York in the spring of 1905, Lucia followed the news coming out of Cornish. A huge theatrical event, one that would eclipse all others, was being planned. It was twenty years since Augustus Saint-Gaudens had arrived in Cornish, and word leaked out that the guiding spirit of the colony had cancer. Treatments proved worthless; his time was short. A pagan ritual was in order. The colonists plotted a surprise gift for the sculptor: a pageant in his honor that would take place on the evening of the summer solstice, amid a grove of old-growth pine trees in a far corner of the grounds at Aspet. Delayed one day because of rain, the joyous fête took place on June 22,

1905, and it became the high point, the defining moment for that idyllic artistic community. Basing the event on Florentine entertainments from the Renaissance, the Cornishers put on a masque—the first such performance in the United States—that involved dance, music, poetry, elaborate costumes, and sets. The artists and writers of the colony took the roles of Greek gods and goddesses, not a far cry from how they perceived themselves. Lucia, back in Cornish with the children, became Proserpina, goddess of the underworld. Harry was Apollo, the son of Zeus and the patron of music, poetry, prophecy, and truth—the god revered as a healer. Clara and Charley and the other children of the colony, costumed in Greek robes with wreaths on their heads, played forest nymphs and followers of Bacchus.

Printed invitations went out to friends and special guests. This was decidedly not a public event and the press was intentionally excluded. (No matter, reporters managed to worm their way into the crowd.) By late afternoon on the 22nd the invitees, several hundred of them, began assembling, some arriving on horseback, others by train from New York for the theatrical event titled *A Masque of "Ours."* Among the celebrities in attendance were the secretary of state, John Hay, and novelist Henry James; they sat on benches facing the woodland stage. When the playwright, Louis Shipman, learned that Henry James would be in the audience, he changed the subtitle of the play to *The Gods and the Golden Bowl*, riffing on James's recently published novel *The Golden Bowl*, and substituted a gold-colored bowl for a sundial that was to be offered at the climax of the play. Musician and fellow Cornisher Arthur Whiting composed incidental music and imported members of the Boston Symphony Orchestra to perform it. The atmosphere was festive. Maxfield Parrish created two large gilded comic masks, their stylized faces frozen in permanent smiles, which were hung from trees. Parrish naturally devised his own costume. For his role as the kindly centaur, Chiron, Parrish strapped himself into an elaborate papier-mâché horse's body, complete with hoofs on wooden rollers.

Saint-Gaudens and his wife, Gussie, were ushered into special chairs in front. The curtain parted and the stage set designed by Lucia and Harry was revealed: a classical temple with an altar and wreathed Ionic columns.

Then the play, dedicated to the beloved Saint-Gaudens, began. It is set in the Cornish Hills, a kingdom ruled by the classical gods and goddesses who are dumbstruck by the arrival of mortals. Jupiter, the chief diety, dispatches Hermes to summon all the gods from Mount Olympus to convene at Aspet. Jupiter wants to learn more about these humans and perhaps find one among them worthy to take over as ruler. A "countryman" carrying a tin dinner pail (acted by Harry, who also appears later in the production as Apollo) enters the stage, sits down on the altar, pulls out a corncob pipe, and begins to smoke. Jupiter, intoxicated by the smell, is drawn to this common man and asks, "What people are these you live among?" The countryman replies:

> *Well, they're a crazy bunch take 'em large and small*
> *None of 'em do any work just play*
> *though hanged if they don't seem to make it pay.*
> *Paintin' pictures, writin' books*
> *Makin' statues, hirin' cooks,*
> *Fussin' with flowers, buildin' pools,*
> *You never see such a lot of fools.*

The countryman goes on to describe the music and art that permeated life in the Colony and Jupiter is moved:

> *Ah, now I begin to understand*
> *This is a sort of promised land*
> *Come true. A group of perfect mortals found,*
> *In mutual admiration bound.*
> *With ideals high, and free from strife*
> *They all pursue the simple life.*

One by one, the gods and goddesses arrive to meet in council. Once assembled, Jupiter announces that he plans to abdicate, for "The Gods are not what they're cracked up to be / No mortals take us seriously." Neptune and Pluto step forward and each one, in turn, claims that *he* would be the best. Jupiter asks Minerva, the goddess of wisdom, to choose between the two. She selects neither. She orders Neptune to be content "to rule the tides" and Pluto to get "back to the Earth's insides." The candidate she chooses is "from amongst the mortals, / One who's never passed Olympus' portals." Jupiter asks, "Is he painter, poet, sage?" and Minerva responds:

> *He's all in one.*
> *The maker of a new Augustan Age."*

It is Saint-Gaudens.

An emotional Saint-Gaudens—the new king of the gods—was escorted onstage, surrounded by the cast members, and presented with a bowl embellished with mythological figures and engraved with both his name and that of his wife. He and Gussie were placed on a chariot designed and painted by Lucia and Harry—with Gussie somewhat denting the magical moment by memorably shouting at her husband that the paint was still wet. Cast members then carried them off. (The chariot remains at the historic site, a relic of that remarkable evening.) Saint-Gaudens later recalled the transcendent moment: "As the play ended and the performers followed the chariot up to the house in their classic dresses, all bathed in a wonderful sunset, it was a spectacle and a recall of Greece of which I have dreamed, but have never thought actually to see in Nature." Dinner on Saint-Gaudens's colonnaded porch followed, and then dancing and more revelry in his studio.

Saint-Gaudens was so touched by the Colony's tribute to him that he created a bas-relief bronze sculpture to celebrate the event. He reproduced the pagan scene: Parrish's grinning masks hang from pine trees flanking the temple-like stage set; a fire burns on the altar above the motto "Amor Vincit" ("Love Conquers All"); to the right of the altar, the figure of Amor, the ancient god of love, plays Apollo's harp. The sculpture is topped with a classical pediment embellished with a golden bowl; at the bottom is the chariot. The names of all the participants in the masque, eighty-six of them, including Lucia and Harry and their two children and even Ebba Bohm, are memorialized in it. Saint-Gaudens had three-inch tall medals of silver and bronze—minisculptures known as "plaquettes"—cast from the larger original he'd made. He had two editions produced—one in Paris by Janvier & Duval, and the other by Tiffany in New York—and distributed the plaquettes to all the colonists who had taken part in the pageant. Though the keepsakes celebrated the notion that "love conquers all," the medal didn't save Lucia and Harry's marriage.

Not long after the grand celebration, Harry decamped for his mother's farm in Deerfield; she had an inheritance and could support him. Lucia would be relieved of the burden of carrying him financially and enduring his depressions. Around the same time, Lucia painted a six-inch-by-four-inch miniature self-portrait. *In the Looking Glass* depicts Lucia at her easel in midcreation, looking into a mirror. (The viewers are in effect the mirror, with Lucia staring directly at them.) Dressed in a shapeless brown dress with a prim lace collar, looking wan and joyless, she almost appears to be a nun or one of her colonial-era Plymouth women. She portrays herself as an artist, and she doesn't sugarcoat it. It's hard work. She's now on her own, left with the care and support of their two children.

She and Harry had parted amicably and she insisted in her letters to him that he needn't worry about trying to provide for them financially. (She was surely a realist when it came to that.) Nor did she bad-mouth him to her children. Just the opposite. As her daughter later wrote, "Lucia

firmly told us that he was a much better painter than she, and that we should love and respect him." The following summer they rented their house and pool in Cornish, the center of their dreams, to Ethel Barrymore. Lucia and the children took a more modest place nearby.

During subsequent summers Harry would sometimes reappear in Cornish as if the family were whole once again, but in short order they'd go their separate ways. They were better off apart. Lucia's health was growing worse, and she surely didn't need Harry around. And yet, narcissistically, he believed that he was the victim. After Lucia rejected his attempt at a rapprochement in 1909, he wrote angrily to her: "Whereas the pain I cause you brings you nothing but pain, the pain you glory in causing me is immeasurably greater. . . . I am myself degraded in your degradation, not because you affect me egotistically, but because while I live with you I am zero." And then, the final rebuke: "I am no more a part of your psychological existence than a chair." It would be better for her to be free of that particular chair.

One thing was clear: Lucia could not look to her own family for help. Over the years Sally had made certain of that. In hectoring letters to her younger sister, Sally repeatedly reminded Lucia of the pledge she'd made that she would never ask the Fairchilds for money. "If you had a husband who could support you," Sally lectured Lucia, there wouldn't be a problem. And as for the family's post-1893 financial losses, well, things were becoming "quite desperate" by Sally's standards: "We cannot even afford the cheapest seats at Symphony this season." Yet, Sally and her mother made at least two trips abroad, to Paris and London, in the mid-to-late 1890s. Sargent wrote to the art collector Isabella Stewart Gardner in 1894, proposing a dinner in London with a small guest list that included Sally. Paterfamilias Charles was left behind during these excursions, and he began a slow descent into senility. Lily confided in a letter that his

speech was becoming nonsensical and the once-savvy financier no longer read his business correspondence. He'd tear it up instead.

It was expected that the Fairchild sons would join their father in the family business on Wall Street. They were well-bred Harvard grads who'd rubbed shoulders with the most privileged young men in the country. But misfortune and tragedy—and plain failure to thrive—haunted all of the brothers. The only exception was Blair, who shrewdly married for money. He wed Edith Cushing of Boston, whose disfigured leg had discouraged suitors despite her handsome bank balance. One family account speculated that Blair was homosexual, but this marriage of convenience turned out to be a happy one. After a brief stint in business he entered the diplomatic service, with posts in Turkey and Persia (present-day Iran). Then, thanks to his wife's income, he turned to composing music. The couple had no children. They lived in Paris and summered in Saint-Jean-de-Luz. Blair artfully fended off requests for money from his siblings, claiming that he got by on "an allowance from Edith." Though Blair felt especially close to Lucia—"my angel sister!" he called her—he did not do much to ease her travail.

Reading the letters and the accounts of the brothers, one is struck by the spectacular way they imploded. They were all handsome, athletic, well-liked members of the right clubs. Every one of them was an expert sailor, having spent blissful summers on Narragansett Bay in Newport in a house that a family friend described as having "its back to the world and its face to the Infinite." They all lived in an uneasy borderland between the world and the Infinite—and, deeply troubled, they seemed drawn inexorably to death. In contrast, Lucia's Infinite was art. And Sally focused her considerable energies on clinging to her place in society.

None of the brothers inherited their father's business acumen. The most incompetent of all was the oldest son, Charles Jr. Unfortunately, he took over the helm for his sick father and made a complete hash of the business. By 1905, he had squandered the family fortune—and then,

to make matters worse, he sold his father's seats on the New York Stock Exchange and Corn Exchange, apparently for his own gain. Blair, insulated as he was by the Cushing money, attributed his eldest brother's misbehavior to mental illness. Charles was an alcoholic and, at times, apparently homeless. He'd dart into the best New York hotels and pinch stationery to write to his siblings, saying things like "[I'm] staying alert for any opportunity that may present itself." Meanwhile his frantic wife, May, who, like Lucia, was a miniature artist, was moving from town to town in New England and writing pathetic letters to her in-laws begging for money so that she could buy warm clothing for her children. She was so desperate she even approached Lucia.

The Fairchilds had been brought up to believe that one had the right to take one's own life—to choose the Infinite, so to speak—and, unfortunately, the brothers took that philosophy to heart. In 1906, the charming Nelson, who'd been a member of the fencing and Hasty Pudding clubs at Harvard and who was noted by his classmates for his special ability to cultivate long-lasting friendships, was appointed vice-consul to Mukden, Manchuria—the first American mission in that remote corner. He wrote enthusiastic and colorful letters to his mother of the sights and smells he encountered en route to Manchuria on the Trans-Siberian railroad. He seemed happily engaged at his new post—that is, until he put a gun to his head and pulled the trigger. He was twenty-seven years old. His mother, devastated, refused to believe it was suicide. The Boston newspapers called the death a tragic accident. Lily collected the letters Nelson had written to her during his foreign adventure and published them privately. A copy of the book, with a long sunny summation of his life, remains at the Boston Athenaeum. Lucia painted a posthumous miniature of Nelson, based on the last photograph taken of him in Mukden.

None of the brothers survived middle age. Charles Jr., the financial miscreant, took his own life in his fifties. Jack, the second oldest son and a star at Harvard—class president, head of the Hasty Pudding club, mem-

ber of the crew team, and all-round football player (he played variously as quarterback, fullback, kicker, and punt returner)—never made it to fifty, dying of some mysterious cause. He had several disastrous marriages— the first one in 1898 to Charlotte Houston, a Bohemian art collector and photographer who shed Jack when it became clear he had insufficient money to indulge her interests. Charlotte had her own intriguing story. She moved to New York with their three children and became a prominent performing arts photographer, shooting modern dancers and actresses, Ethel Barrymore among them.

Gordon, the sweet youngest brother, would become ensnared in scandal. When Sargent visited the Fairchilds in Nahant in 1890, he watched eight-year-old Gordon playing by the seaside, clambering over some rocks. The artist determined that he had to paint the boy. And so he did. The canvas depicts Gordon sitting cross-legged, nearly enveloped in a wicker chair, looking as if he is about to nod off to sleep after an active day at the beach; dreamy-eyed, he clutches his pet guinea pig. By the time Gordon graduated from Harvard Law School in 1907, the family was in free fall. Money gone. Father incapacitated. Brothers scattered, incompetent, or dead. Gordon moved to the other side of the world—to Manila, where he worked as a legal attaché for the governor-general of the Philippines.

In August 1909, Lucia visited her parents in Newport and was shocked at her father's pathetic condition—slack-jawed and wandering aimlessly about looking for something he couldn't remember. (Oddly, he repeated over and over again how grateful he was to Harry.) Lily, in need of money, was forced to sell the gift her husband had once given her—Sargent's portrait of Robert Louis Stevenson. She had an American offer, but wanted to get the highest price possible. In the spring of 1910, she corresponded with Sargent, asking if she might find a more lucrative bid in England. Forget the English market, he told her, as budgets here are very tight. He ended the note by saying how sorry he was

to hear of her husband's "melancholy" state; he also sent his love to Sally and Gordon.

Charles died later that year. Sixty-five-year-old Lily and forty-one-year-old Sally decided to join Gordon in Manila. "Change is relief," William Dean Howells wrote to the widow, "even if you must come back to the loss you try to fly." While in Asia, mother and daughter also visited Japan. A photo of Lily in a Japanese rickshaw survives, as do complaints from Sally about local hygiene: "They are so clean in some ways & so disgusting in others. The best dressed ladies all use their hair pins to pick their teeth & I am sorry to say clean their ears & nails—& they spit raucously into bits of paper which they put in their sleeves until next time!" she wrote to Lucia.

After a few years Gordon gave up on the law and moved back to the States with Lily and Sally. In 1912 he considered taking a job at the Museum of Fine Arts in Boston. A friend on the staff had suggested Gordon to the director, who was in search of an assistant. The director's eyes lit up at the possibility of a Fairchild working for him. Gordon was just the sort of blue blood he wanted—a man of the world who understood the subtleties of the Cabot set and was "a more or less certain fork chooser." Yes, Gordon knew all about forks and Cabots. But then his friend had second thoughts. He warned Gordon that the job would entail working with "a lot of women and hermaphrodites who wished they were women. God would hate you." Better to go to the Metropolitan Museum in New York or "to some fresh water museum which is building up," his friend advised him. The Museum of Fine Arts had changed for the worse: "The old . . . days of sacrifices to the Muses are gone and we have strange new gods the smoke from whose altar goes up in shapes like $."

Perhaps heeding his friend's caution, Gordon instead became a master at St. Paul's School, the all-boys aristocratic breeding ground in New Hampshire. His mother and sister moved in with him at the boarding school. Sally served as Gordon's hostess, entertaining homesick boys on

Sunday afternoons with tea and goodies served on fine, bird-patterned china, and doubtless offering up advice.

Lucia, meanwhile, fought her increasing disability and achieved great professional success: she helped found the American Society of Miniature Painters in 1899; she was elected to the American Society of Painters that same year; she won medals at expositions in Paris, Buffalo, and St. Louis; she became an associate of the National Academy of Design in 1906, and eventually president of the American Society of Miniature Painters in 1913. A 1910 exhibition at the Royal Academy of Arts in London included Lucia's miniature of a sweet young girl in a nightgown holding her doll. Clara had been her model. (The Metropolitan Museum purchased the painting five years later.) Sargent probably saw Lucia's miniature on display, as he, too, exhibited at the show. A wealthy Viennese woman so admired Lucia's portrait of Clara that she commissioned her to come to Austria and paint a posthumous portrait of her dead daughter.

At sixteen, Clara accompanied her mother on the trip. Their departure in 1911 was delayed for a month when Lucia became ill with what seemed to be a bad cold. By force of will, Lucia managed to travel to Vienna and complete the portrait. But Clara remembered this as the beginning of the steep deterioration in her mother's health. After their return to New York, Lucia went to the Neurological Institute for the Study and Treatment of Nervous and Mental Diseases on East 67th Street. Finally, a diagnosis: sclerosis of the spinal cord, what we know today as multiple sclerosis. At that time the disease was almost completely misunderstood, and the doctors believed that Lucia's case stemmed from the childhood mishap when she jumped off the steps of their Back Bay mansion and hurt her back, the injury that her sister Sally thought she was faking.

In 1914 her doctor recommended an immediate five-week stay in the hospital for daily electrical treatments and massage. After that, she

would require a period of rest for at least several months. Work was out of the question until they could arrest the spread of the disease. If she followed the prescribed regimen, there was hope that she'd have many more years producing art. Lucia was frantic. She couldn't afford to stop working. She had rent and medical bills to pay. And then there were her children's school expenses—nineteen-year-old Clara in college, and seventeen-year-old Charley at boarding school. Lucia insisted on the best schools—Brearley and Bryn Mawr for Clara, Groton and Harvard for Charley—believing it was her children's birthright to have an elite education. This was the world to which she had been brought up, and she wanted them to enjoy the same privileges, even if she lacked the financial wherewithal. Tuition money depended on scholarships and the generosity of others. When Charley enrolled at Harvard in 1915, Lucia's childhood friend Jessie Morgan covered four thousand dollars of Charley's expenses. Lucia's brother Blair, thanks to his wife's fortune, contributed another thousand dollars.

But Lucia's overtures to her mother-in-law fell on a hard-hearted soul. Agnes Higginson Fuller had access to ample funds: as part of her Higginson inheritance there was a pot of money set aside for use in family emergencies. Surely Lucia's hospitalization would qualify. Lucia wrote to Agnes in desperation in 1914 and received no answer. She wrote again in April, listing her anticipated expenses before October—the total bill for rent, school, taxes, doctor, and hospital would come to $1,750; she didn't even include food. "It is the list I am going to <u>beg</u> you to take off my hands," she pleaded. "Dear Mrs. Fuller, stop and think it over! If you do this for me now you will probably be spared further demands from me and my children . . . if you do not do it, probably what will have to be done in the end will amount to greatly more."

Lucia appealed to Agnes's sense of justice: Don't you think you owe it to me? And to your own grandchildren? Surely, if other Higginson family members (who had even more money) knew of Lucia's predicament, they'd be willing to help. "If you explained to them that I had always

supported the children, even to earning the money for the doctors' and
nurses' bills when they were born; and that for seventeen years you did
not even have to pay anything toward Harry's support." And what of the
emergency fund for family members? Couldn't money from that be used
in the name of the children? Lucia pointed out that Harry had dipped into
that fund once before, supposedly to cover medical bills for the children,
but truth be told, Lucia had already paid those bills, and Harry used the
money instead for a rather pricey studio for himself. Not that she wanted
to point an accusatory finger at Harry. In fact, Lucia went out of her way
to absolve him of any responsibility for their pathetic plight: "This letter
does not mean in <u>any</u> <u>way</u> to be blaming of Harry. . . . I realize that his one
preoccupation is his work, and that the reason that he has never helped
toward the support of his children is not in the least because he does not
care for them, but quite simply because he is an idealist, wrapped up in
his vision, without what is called worldly sense." And as for the chil-
dren, "they don't criticize him at all, as they did at first when they began
to notice that 'other mothers didn't have to work all the time.' They are
fond of him, and admire his talent and wit. But they feel, and [my physi-
cian] Dr. Dana feels keenly, that I need help now, and ought to have it.
Much help." She begged Agnes: "I <u>hate</u> to ask it of you. But it seems that
my strength is really at an end. And it seems better to patch me up while
I <u>can</u> be patched, doesn't it, then to leave me to go ahead until I become
a thing in a wheeled chair, with the children who are so splendid and so
promising—not yet able to support themselves."

Agnes was unmoved by Lucia's plight. She went directly to New
York to confront Dr. Dana, and told him that Lucia's illness was her own
fault—it was because she smoked. The doctor strenuously disagreed,
but Agnes had already made up her mind, and she was damned if she
was going to help. Agnes wrote to Lucia with the following advice: sell
your place in Plainfield (Lucia had already tried and failed, and the house
was so heavily mortgaged it would never earn anything anyway), and
"put the children to work at once." Lucia was stunned. She couldn't even

respond to Agnes's letter. "I feel too bitterly her eager readiness to sacrifice my children," she wrote to a family friend.

Within several years Lucia had to give up painting altogether because of her failing eyesight. She resorted to working for an interior decorator in New York, dashing about town picking up paint, wallpaper, and fabric samples. She was treated "like a slave," according to her daughter, and her condition worsened.

Worn out, Lucia yielded to Clara's entreaties to move in with her family in Madison, Wisconsin. Twenty-three-year-old Clara had left Bryn Mawr for the University of Wisconsin, where she married an English professor. They welcomed Lucia into their household in November 1918. After a time, Jessie Morgan, Lucia's very rich and very devoted childhood friend, bought her a house in Madison. Clara's friends, much like the children of Cornish, embraced Lucia, charmed as they were by her good nature and warmth. They called her "M. F." (Mrs. Fuller), and Clara's own friendships seemed to improve because of her mother. Lucia had that way with people.

In January 1924, while living in Madison, Lucia received news that her mother had died unexpectedly at St. Paul's. It's unlikely that Lucia, now unable to see or to walk without crutches, could attend the funeral. Sally wrote to Lucia that their mother had passed away peacefully. "Mama looked so beautiful & just asleep." Sally took solace in the fact that their mother's most ardent wish had been granted: that she would die before another one of her children did. Lily had cherished the memory of her travels in Japan, so Sally laid a Japanese iris in her casket. She also put into her mother's hand a postcard from the Temple of Heaven in China that Nelson had sent to her before his suicide. (Lily had specifically told Sally that, in death, she wanted to clutch his card.) Sally put other meaningful items next to her mother: a bronze Gizo statue from Japan, a glass cross from Rheims, and a small silk American flag she brought with her wherever she traveled and kept by her bedside when at home. Sally cut off pieces of her mother's hair and encased them in

lockets for family members. She also sent her sister other items that had belonged to their mother: a diamond pin and ring, an Egyptian necklace, and a picture of Mount Fuji that Lily had kept on her dressing table mirror. Sally and Gordon both agreed that Lucia, who suffered so, should have the watercolor of Christ carrying his cross by John La Farge.

In the wake of their mother's death, Sally's letters to Lucia—once prickly and demanding—turned introspective and apologetic. Now middle-aged at fifty-five, Sally admitted that her entire life had been about caring for her mother. She didn't regret it, as from the age of fourteen that was all she had wanted to do. "My whole inner life has been in reference to her," she wrote, and even since her death, "I have felt no sense of separation." Yet, Sally confessed that she had been too rough in dealing with others. She had created a tiny universe around her mother and tried to keep everyone else at bay. In the process she had been "too hard, or intolerant, or impatient," and her behavior had hurt many. Lily herself had been wounded by Sally's conduct, wishing her eldest daughter would be more gracious and sympathetic toward others. Sally acknowledged her faults to Lucia, the sister she had always treated so shabbily.

At first, Sally worried over her future. She couldn't imagine being alive when her mother wasn't. Life goes on, she wrote—"I sleep and eat just as usual"—but it was hard to put up a good front. The day-to-day commotion around her at St. Paul's—students rushing about and playing their phonographs, parents visiting their sons—was a welcome distraction. But if a friend approached Sally to comfort her, "I find how little self control I have." Feeling in control, and superior, and more privileged and beautiful than others, had always been essential to Sally. She recognized that Gordon had loved their mother as much as she, but "far more sensitively." Now she had a new role. Gordon would become the central being in her life. She would care for him, support him. He had plunged right back into the daily activities, saying grace at supper for the assembled

students within days of Lily's death. Sally expected that she would spend the rest of her life on St. Paul's bucolic campus.

Among Lucia's papers is a handwritten note that begins, "This evening I had a revelation." No longer "strong and proud and able to work," she had nonetheless found peace: "My knockout is the chance for my children. All the world will see the beauty and the splendor of their goodness." People will say, "'How good they are to their mother,' 'Did you ever see anything finer than Clara and Charley and the way they take care of their mother?' 'Aren't they fine about it!' 'Aren't they splendid!' 'Aren't they unselfish and noble and superb!' Oh, happy heart, remember this," Lucia wrote, "and cease to grieve at the burden you have become." At last Lucia had found the *terrific* love she'd always sought—love unmarred by hate.

Lucia died of pneumonia on May 20, 1924, not yet fifty-two years old. Notices in the Boston papers reported on the passing of the well-known miniaturist. Though Lucia had always thought of herself as an agnostic, in the last year of her life she was drawn to Catholicism and converted. She was buried in Madison after a Catholic funeral service. Even Harry came to mourn his brave wife. Lucia left behind a note for Clara saying that, if she could, she would return to her after her death.

In mourning, Sally and Gordon went abroad, staying at their brother Blair's apartment in Paris. They then continued on to the fashionable Pointe-au-Pic in Quebec province, where their mother had planned a family reunion for that summer. The rustic outpost on Murray Bay, a place they'd often visited as children, inspired "healing and blessed memories," according to Sally. On July 7, 1924, Sally wrote to a friend how grateful she was that her mother had been spared the sadness of Lucia's death. To Sally, the loss of Lucia seemed even more real than the

loss of her mother, but at least her sister had been released from suffering. Lucia had died believing that her work on this earth was finished, as both of her "adoring children" were settled into their own lives. Sally, once such a critic, wrote of Lucia's "wonderful courage" and her "generous heart & mind."

But Clara, still protective of her dead mother, continued to nurse a grudge against the arrogant and autocratic Sally, who had clashed so often with Lucia. When Sally traveled to Madison in 1928 to meet Clara's new baby, named after her mother, Clara confronted her aunt, demanding to know if she still thought that Lucia had only been feigning illness and if her death had been merely a "hysterical gesture."

Sally returned East to her brother, but by 1930 they were no longer in New Hampshire. Gordon, discovered in the arms of a young boy, had been booted out of St. Paul's. Sally and the disgraced Gordon slunk back to Back Bay. Heaven knows how they had the money for that—more paintings sold, perhaps, along with contributions from brother Blair's wife. Like his father, Gordon became a stockbroker, but life had turned bitter for him. His portrait by Sargent as an adorable little boy clutching his pet guinea pig must have felt like a dream from a distant, unrecognizable past. Leaving Boston behind in 1932, Gordon set out on a long sea voyage. He jumped overboard as the ship crossed the equator. That made three out of five brothers dead by suicide—a fourth under puzzling circumstances. Gordon's death was the hardest of all for Sally to forgive. How could he do that to her? She knew he had the right to take his own life, yet "his wanting to escape almost breaks my heart," Sally wrote to Lucia's daughter. It was, she said, "a real betrayal of our understanding and affection."

The litany of tragedy that befell the Fairchild family is bewildering. The siblings had grown up in a cocoon of privilege, money, and influence.

As their wealth vanished, the scrambling survivors didn't put up much of a fight. Except Lucia. She always believed art was her salvation. "Eat, drink, paint and be merry," she had written to Harry early in their marriage. Yet she also understood the need to temper her aesthetic idealism with commercial reality—something Harry never learned. Lucia took Sargent's grand view and distilled it into miniature portions. She worked tirelessly until, ravaged by her baffling disease, she could no longer see to paint her ivory portraits. Sargent had his enormous talent; Lucia had talent and raw courage.

And what became of Harry after abandoning Lucia? When he'd taken refuge with his mother at the family farm, Lucia was grateful. He needed an oasis of calm to soothe his troubled soul.

Harry's mother died the same month that Lucia did. The year before, Agnes sent Harry off to Paris to rekindle his practically nonexistent career. Though she had refused to help her grandchildren and daughter-in-law, she had no such misgivings about spending money to set up her son in Paris. He established a studio in Montparnasse. The change of scene didn't do much for Harry's art, but it improved his social life, as it was much more exciting in France than in rural New England. Harry became a fixture in the bars and cafés of Paris that were frequented by a who's who of famous artists and writers: Ernest Hemingway, James Joyce, Man Ray, Jean Cocteau, Joan Miró.

The death of his mother finally gave Harry his independence—the income from her estate left him well-fixed in Paris. "Was ever a man more suited to its artistic atmosphere than you are?" the executor of his mother's estate asked Harry. "Your beautiful and lifelong devotion to your mother entitles you to whatever freedom you can enjoy for the rest of your life." Freedom. Money. If anything, it led Harry even farther off the artistic path. He roamed from Paris to the Riviera to Saint-Jean-de-Luz.

He took up with a hard-drinking coterie that included Lady Duff Twys-den, a beautiful Englishwoman who ditched her baronet husband but kept the title. Tall, slender, and unconventional, she kept her hair closely cropped, her face beautifully made up and alluring. She could drink like a man—in fact, could drink most of them under the table. There were lots of men sniffing around her, including a besotted, but married, Heming-way. She did have one rule: no sleeping with married men. Hemingway based his character Lady Brett Ashley, the ultra modern heroine of *The Sun Also Rises*, on Duff.

Letters from Harry to his son Charley in the fall of 1925 recount dis-solute nights of drinking and gambling with Duff and her lover in Saint-Jean-de-Luz. Duff proposed a winter plan: she'd move with Harry to the Riviera without her lover. Charley was alarmed at this turn of events, and begged his father not to take up with her, saying that Duff would destroy him, wreck whatever was left of his career. Harry, instead, took a ship to Algiers, and made his way back to Paris where, on an impulse, he mar-ried his extremely young model. She was so young, in fact, that before deciding to marry her, he had tried to legally adopt her. As he explained in a letter to his bewildered children, he was trying to protect this young woman from her cruel mother. The middle-aged man came back to New York with his child bride, moved into a Greenwich Village apartment, and then asked the executor of his mother's estate to sell all the stocks and bonds he owned. "It is a life and death matter." Clearly, his debts were overwhelming him. And soon his bride was gone back to France, likely because of those debts.

Thereafter, Harry moved from place to place. In 1932, in his mid-sixties, he drifted south in search of a warmer climate. At a diner some-where in the Carolinas he met a young blond waitress named Susie and took her along with him. He wrote to his children that she was to be his assistant and apprentice—he'd teach her everything he knew about arts and crafts. Adventures and misadventures followed them on their

journey. In Savannah, Harry got quite ill and went to a local doctor who told him that he should limit his drinking to only four whiskeys a day—this during Prohibition. The doctor also warned that it would be considered scandalous for Harry and young Susie to share a cottage alone without a chaperone. Enough of Savannah. They pulled up stakes and moved on.

Around that time a bit of good news came for Harry: unexpectedly, he was named the beneficiary of a Higginson trust fund. He and Susie moved to a cottage in Sarasota, Florida, where no one seemed to care about their sleeping arrangements, but he soon grew restless. Debts were still following Harry, and the lawyers up North, taking their own healthy fees from his new assets, were slow in sending checks. Rather than wait patiently for funds and pay his bills, Henry came up with another crackpot scheme, circling back to his original dream of being an itinerant artist living out of a caravan. Forty years earlier he and Lucia had their disastrous horse-drawn contraption; now he invested in the modern version: a 1929 seven-passenger Buick that could pull two trailers behind. He shelled out $450 for the car.

Harry began spending his money faster than he got it. He ordered a customized trailer, wired for electricity, from a factory in Dayton, Ohio. It would be his mobile workshop. Though it was, in his words, "only a shell," the trailer cost an extravagant sixteen hundred dollars. And then there was the expensive equipment he needed, from electrical tools for making furniture to a complete photographic outfit including a Graflex camera and enlarger, though he didn't have the slightest experience in photography. He envisioned himself and Susie making a handsome profit as they traveled across the country selling their arts and crafts: paintings and etchings, photographs, even sea shells that they collected. He was so sure of success, he planned to take along a maid to clean and wash.

Harry, who had so little time for his daughter, Clara, when she was a child, now sent her one thousand dollars for a car and trailer, with

detailed instructions on exactly what she'd need to outfit it properly. He wanted her to join them on the road. He was distressed when Clara wrote back to say that, rather than investing in a trailer, she'd used his money to pay off some debts. He wouldn't do that, arguing it was better for him *not* to pay off his debts. "Trailering," as he called it, would cut his living costs and surely give him a better chance to make money: "even in these hard times" during the Depression, art could be profitable. Harry spent several more months in Florida, buying gear, and preparing for the trip.

Harry and Susie arrived in New Orleans in mid-March 1934, and ended up in the crowded, unkempt Dixie Tourist camp. The manager of the trailer park moonlighted as a high-wire entertainer. Their campmates were a rough bunch. One night the manager had to come to the rescue of a woman being beaten by her husband. Bonnie and Clyde checked into the camp. The celebrity outlaws were recognized, sneaked out, but then returned again in the morning to retrieve a cushion they'd left behind in the cabin. Later that day the outlaws were ambushed and killed by a posse on a country road in Louisiana.

Harry had been working on a new painting for months and it was going nowhere. He was waiting for inspiration to kick in. Harry longed to get on the road again. As for income, Susie had taken up woodworking and she was making frames for reproductions of Harry's Christian Science painting. There were Mary Baker Eddy true believers everywhere, some of them eager to buy such an image. Susie was also learning to make wooden lawn ornaments—ducks, and that sort of thing—which they would paint and sell. Harry saw this particular business as a sure-fire moneymaker. So this was the final apotheosis of Harry, the aesthete: reduced to making lawn ornaments in a trailer park. (This from the man who deemed his wife déclassé for doing commissioned portraits.) It was a far cry from John Singer Sargent and the life of the artist that Lucia had imagined so many years before. Quoting from Montaigne, Harry wrote to his daughter in March 1934, "We must make ourselves comfortable with the faults we have." Not long after, he died of cardiac arrest.

By Harry's death in 1934, all of the Fairchilds were dead except Sally, who soldiered on for several more decades. Sally was a tough old bird. Her great nephew Blair Fuller visited her in Boston in the 1930s, and she made a deep impression—a daunting, lordly personage, tended by a liveried Japanese manservant and flanked by snappish Pekinese dogs. The bookplates in her library—many of them now at the Boston Athenaeum— featured her favorite canine, "Tug," the name of the Fairchild dog that she claimed as her own as a child. Sally maintained her patrician Old World hauteur, a reminder of the long-dead Gilded Age. Not everyone was taken in by her pose, however. Lord Bertrand Russell, once smitten with the young Sally, was less than enraptured when he saw her in her elder years, long after her money, beauty, and youth had faded. In his *Autobiography* he wrote that when he encountered Sally in 1940 he wondered what it was that he had ever seen in her. (Of course, his dismissal of an older woman may say even more about Russell, who enjoyed a string of much younger wives and mistresses.)

But what stories Sally could tell of the places she'd been, the great artists and literary figures she'd known: John Singer Sargent, Robert Louis Stevenson, Henry James, George Bernard Shaw, and other eminences. Even H. G. Wells had sought out Sally when he visited New York in 1905, having heard so much about her in England. As an old woman she still had the ability to seduce. At eighty she took up with a man nearly fifty years her junior. His wife sued for divorce, but Sally expressed no remorse whatsoever, saying instead, "If that young woman can't hold her husband that's her lookout." The man remained devoted to Sally until she died in 1960 at the age of ninety-one.

As the years went on, even Clara softened in her feelings toward her aunt, though she couldn't resist reporting that, since Sally outlived her sister by many years, it was Lucia who triumphed in the end. She had the

"last laugh," Clara wrote, referring to the peace of the afterlife. "She had thirty-six years of undisturbed peace with [her mother] Miss Lily" before the annoying ghost of Aunt Sally "joined them on the other side."

Sargent kept his painting of Sally—that effusion of veiled youth and beauty on the shores of Nahant—for the rest of his life. It was not a commission; he had done it for himself. At one point Charles Fairchild wanted to buy a portrait of his daughter from the artist, perhaps this one, but Sargent refused. In fact, they got into an argument over it. Since Sargent never gave up this painting, it clearly was meaningful to him. Perhaps the portrait brought back memories of that summer day at the beach and the happy family whose lives seemed so filled with promise. After Sargent's death in 1925, the auction house Christie Manson & Woods in London held an estate sale of the artist's studio work. The printed catalogue did not include a listing of *Lady with a Blue Veil*, as Sally's painting is called, since it was a late addition to the sale. Someone at the auction house added an annotation in pencil to the catalogue: "Lot 149A," and her portrait was described as "Girl veiled with sailor hat poor unfinished." Sargent obviously thought otherwise.

The social world they all moved in was a very small one, so Sargent surely knew of the Fairchilds' fading fortunes, of Lucia's success as an artist and her tragic decline, and of Sally's life as it unfolded. Sally cared deeply for her mother, traveled widely, entranced some of the extraordinary artists and intellects of the era, dealt with the loss of money, the deaths of siblings, and finally ended up being loved by a much younger man. It was an eventful life, but compared with Lucia's accomplishments and heroism, it pales. Looking back upon his choice of sisters, one wonders if Sargent regretted his decision. He had once counseled Lucia that an "interesting" face, an interesting person, was a better subject for art

than one who was merely beautiful. Perhaps he should have taken his own advice.

Sargent's portrait of Sally, now in private hands, remains as fresh and mysterious as the day it was painted. Yet it is Lucia—the "other sister," who watched as the painting emerged—whose story continues to resonate. Lucia seems to have cast a spell over the current owner of her house in the old Cornish Colony. He says that living there has been a kind of fantasy come true. And he means that literally. Before he'd ever seen the place, he made a freehand pencil sketch of his dream house: U-shaped, with a courtyard and garden in the middle, and an overhanging roof on all sides. Around the same time he happened to see an ad for Lucia's house, and he was amazed that it looked exactly like his drawing. It seemed fate had drawn him to the house so he bought it, even though it was well beyond his means. With the taxes, the cost of heating it in a New Hampshire winter, and other expenses, it is a continual struggle to hang on to the place, but, like Lucia before him, he economizes as best as he can. Inspired by Lucia, he has taken up painting, and has methodically transcribed her letters. He speaks of feeling an affinity with her, as if she were still alive. Her courageous spirit and determination inspire him. "Each time I turn a door knob, I know that Lucia has turned it with her own hand before me," he says, "and I feel her presence everywhere." As for her husband, Harry, he feels no such empathy. "Harry, well, he is where he is."

The Madonna

The bud is so beautiful one wonders what the open flower is to be.

—Margaret Astor Chanler, speaking of her infant daughter Elizabeth

BOTH THE WOMAN and her portrait were deeply loved. In a family of operatic passions and conflicts this woman, Elizabeth Chanler, and her image, by Sargent, offered points of repose. Such beauty! Elizabeth's sister Margaret so loved the portrait that she could not bear to be away from it. For half the year the portrait hung at Rokeby, the Chanler family's country estate on the Hudson River. A semiannual ritual took place for six decades. Come late autumn, the four-foot-by-three-foot portrait (not counting the elaborate scallop shell frame chosen by Sargent) was taken off the wall at Rokeby, carefully packed, and brought to the Upper West Side of Manhattan, where Margaret relocated for the winter. The painting would then be ceremoniously hung above the fireplace in the drawing room of her townhouse at 317 West 74th Street, the residence that had been personally selected for her and renovated by über-architect Stanford White, friend to both her and Sargent. When the weather warmed, the reverse commute took place, and the prized family possession returned to Rokeby like a migrating bird.

Sargent had painted twenty-seven-year-old Elizabeth Winthrop Chanler in June of 1893, in his studio in London. She was in England for a happy occasion—the marriage of her brother Robert. The artist described Elizabeth as a woman with "the face of the Madonna and the eyes of a child" and there's a saintly, even somber quality to the painting. Over her shoulder, on the wall, hangs a religious scene that appears to be the Virgin and child encased in a Florentine frame. Elizabeth's black satin dress with its puffy, leg-of-mutton sleeves is elegant but old-fashioned. The strands of pearls and frothy jewels that adorn some of Sargent's women are absent here. Instead, an antique pendant hangs around her neck—though it might as well be a cross. She is beautiful but hard to fathom, with her brown, deep-set, impenetrable eyes. Sargent may have described those eyes as childlike, but they are neither carefree nor joyous. Elizabeth stares directly at the viewer, so hard in fact that you wish she'd blink. Curators at the Smithsonian American Art Museum, where the portrait now hangs, point out the tension in the portrait—the utter stillness of her face versus the jumble in the bottom half of the painting where her clasped hands try to keep a colorful "restless" pillow under control. Chaos is not far from the serene surface, with Elizabeth doing everything she can to keep it tamped down.

How is it that Sargent intuited the storms—past and future—that swirled around a seemingly guileless, innocent soul? Sargent knew her story. She was one of the famous "Astor orphans," set adrift at an early age. The artist was aware of the terrible illness she had endured. She limped just as his own sister Emily did, from inscrutable childhood diseases. Unable to walk then, they both spent a good part of their young lives carried about on portable beds. The similarity was uncanny, and it couldn't help but give Sargent a special empathy for this woman.

Elizabeth's fragile health convinced her she'd never marry. Her family felt equally certain of that. She was to be brave, but virginal. Long-suffering and self-abnegating. And ever cheerful, no matter what tragedies befell her—and there were lots of them.

At six years old, Elizabeth stood by as her sister, two years older than she, died from scarlet fever. Three years later her great-grandfather, William B. Astor, the richest man in America, passed away at the ripe old age of eighty-three. Her mother, Margaret, reportedly caught a cold during the funeral procession. Within weeks, the Astor heiress—just thirty-seven years old and pregnant with her twelfth child—was dead from pneumonia, the unborn child perishing with her. Elizabeth was, at nine years old, the eldest daughter of ten surviving children, and she took on the role of surrogate mother.

The grief-stricken father, John Winthrop Chanler, a lawyer and former three-term U.S. congressman from New York, was unable to cope with his huge brood. At Rokeby, about six miles north of Rhinebeck, New York, the children were overseen by a succession of governesses and tutors and a house full of servants, but it was Elizabeth, a mere child herself, who provided the emotional ballast. Her father spent much of his time tending to financial matters in New York. He recruited Mary Marshall, his sternly Calvinist, unmarried cousin from South Carolina, to take charge of the overactive and combative children, who ranged in age from thirteen-year-old John Armstrong "Archie" to Egerton, who was barely a year old.

Despite the ample staff and the elegant surroundings, the children were largely unsupervised and sometimes their world seemed more *Lord of the Flies* than Peter Pan's Neverland. Visitors were shocked by the scenes of bedlam that played out at Rokeby. Years later, Elizabeth's sister confessed in a memoir that their playmates found the Chanler children "formidable" and the family brand of humor "grim in every sense." The children were either sick, fighting, or recovering from an accident of some sort. The household featured a menagerie of pets—ponies and rabbits, raccoons and snakes. One brother yoked an ox to his wagon for fun. There were dogs of varying breeds: fox terriers, a bulldog, a setter. One fierce dog fight in the parlor ended only after Elizabeth's brother Robert bit the dogs' tails. Pets regularly foraged under the table at dinner and on

at least one occasion, a goat made an appearance in the dining room. At that, Mary Marshall leaped out of her chair and bolted from the room. Dinner provided an opportunity for arguing at high volume. Natural orators, the Chanlers prided themselves on their commanding voices and on their debating skills. They all shouted at once, but when words failed they'd sometimes resort to stronger measures. Knife slashes can still be seen on the family dining table.

The children were daredevils, determined to best one another in death-defying feats—a competitive streak that would continue their entire lives. Mary, dark-eyed and gentle, could barely contain her charges. She did a lot of praying. A telling photograph shows the children surrounding their seated cousin. Poor Marshall has an exhausted look on her face, dark circles around her eyes; she sits slumped in her chair, one of the children firmly pressing a hand on her shoulder as if holding her down.

Elizabeth—known also as Bess, Bessie, or even Queen Bess—served as a kind of maternal presence, parceling out advice to her older brothers, Archie and Winthrop "Wintie," who were at boarding school at St. John's Military Academy in Sing Sing (now Ossining), New York. In an 1876 letter, Elizabeth counseled them to work hard and earn good grades. She also offered tidbits of life at Rokeby in their absence. "Dear boys," she began, as if a grown-up, though her childish handwriting, misspellings, and ink blots on the page reveal her true age of not quite ten. She went on to describe a "grand dinner party" she held with the help of her governess Miss Tisdale. She and her coconspirator kept the party a secret until the last moment, and Elizabeth felt very proud of her hostessing skills: "I had my little table brought up to the dineing room and the leavs put in. We had sherry glasses for goblets, we ate off my dinner set that aunt Margaret gave me. I inviteed all the children as far down as Margaret [who was five years old; the three younger children didn't make the invitation list] and we dined at the little table. We had soup, beef steak, & quail for chicken, mashed potato, cranberry, and pie. . . ."

She wrote dutifully to her brothers, reporting on the status of the

puppies; on younger brother Willie's mumps, which then spread to Lewis and Marion; and on baby Egerton—too little to know that he had no mother—taking his first steps. Amid the chaos, servants came and went. "Nanie and Mary, have both left with out saying good bye to any one," she wrote. Small wonder.

Elizabeth missed her father as much as she missed her brothers, and she'd write to him in New York, where he remained sequestered at their Madison Avenue residence. "The children at home are very well," and "Bob is getting on very nicely," she reported in one letter. She also included news about a pony and the arrival of a carriage— "carriedg" in her youthful misspelling. She eagerly anticipated her father's visits to Rokeby, even if she did have to remind him of his social obligations. Don't forget to let the neighbors know if you're going to dine with them, she lectured him in one note. It was as if Elizabeth were the mistress of the household, or his social secretary, the practical one making arrangements. "I would have gone to meet you but there is only one seat in the sleigh," she wrote to her "Dear Papa" on mourning stationery with thick bands of black around the edges. The stationery told its own grim tale.

It was a strange household. Remote. Old-fashioned. Like a world unto itself, with its own rules of behavior, and brutally clannish. The children clung to one another and to Rokeby itself. The house was vast, with multiple levels, long hallways, a looming tower with a winding stairway that led to the rooftop. The children could browse through William B. Astor's original library of books that still remain in the octagonal-shaped library; family treasures throughout the house reminded them always of their exalted position in the world. But many of the rooms were frigid in winter, and everywhere there were deep shadows relieved only by the dim flickering of kerosene lamps. There was an emptiness beneath the grandeur—their mother gone, their father deeply distracted.

The boys were tended by Jane Cross, a former slave who'd been working as a laborer at the Navy Yard in Washington when their mother hired her as a nurse. She moved with the family to New York after Con-

gressman Chanler finished his final term. She never learned to read or write despite the best efforts of the children, who took turns trying to teach her, but she was a beloved peacekeeper in a household in need of one. She settled disputes among the staff and scolded the boys well into adulthood when they got out of line. She even took it upon herself to lecture fifteen-year-old Margaret about her poor posture, telling her how un-Chanler-like it was. Cross swept the boys' rooms and kept their clothing immaculate into her old age. She died at Rokeby and her ghost haunts the house. On the anniversary of her death, one of the brothers heard "Old Black Jane" sweeping the billiard room above him, the room where she'd caught the cold that killed her. She had told the children it was her "death cold." Years later, a guest experienced the same ghostly phenomenon on the anniversary of Jane's death.

Besides Cousin Mary and Jane Cross, their upbringing was mainly in the hands of servants whom the children summoned with bell pulls. The servants created their own minidramas. One butler borrowed money the sisters had saved for the poor and collected in a mite box—and then refused to repay them. A housekeeper who lived on the third floor kept up a melancholy vigil for her brother, long since lost at sea. She expected his return any day, her hopes raised and then dashed whenever a visitor approached. The children were, of course, well aware of her misery. In a letter to her brother in Sing Sing, Elizabeth announced the arrival of yet another new nurse—and this one stayed for thirty years. She walked "like an empress," was very English, and lorded over the other servants.

The majority of the servants were Irish, most of them fresh off the boat, and they treated the children like little English lords and ladies. They bowed to the children's superior rank, but they also taught them jigs and reels, and bewitched them with strange stories. The servants were country people, steeped in old ways and superstitions. Sunday was their day off, and after the requisite churchgoing, the boys would sometimes wander to the servants' porch for blood sports like dogfighting. Irish wakes were held in the house. One winter a young boy living on the

estate was murdered in his family's cabin. The drinking and the keening went on all night, the sounds from the wake echoing throughout the dark hallways. The children watched the next day as the funeral sleighs wound through the snow outside their windows.

Unsettling spirits hover over the house. Even Mary Marshall, the soul of sobriety and common sense, had a ghostly premonition. In the middle of the night, a cousin came to her bedside. Marshall was not at all surprised when she later received the news that her relative had died that very night.

The Chanlers' rustic ways were incomprehensible to their grand relations. And *grand* is the only word to describe a lineage that melded the best of colonial and old Knickerbocker society—descended as they were from Winthrops, Livingstons, Beekmans, even Peter Stuyvesant himself— with the immense Astor fortune. It was an unbeatable combination of blue blood and greenbacks. The Chanlers were perched atop the highest rung of society; they knew or were related to every important family in New York, but they seemed to studiously avoid the pageantry expected of their class. Their great "Aunt Lina"—a.k.a. Caroline Schermerhorn Astor, wife of William B. Astor Jr., but known simply as "*the* Mrs. Astor" to anyone who mattered—became, without question, the most power-ful personage in all of society. She and her minion Ward McAllister (also a Chanler relation) sifted and selected the elite members of society, the so-called "Four Hundred." According to legend, that was the number of grandees who could cozily fit into Mrs. Astor's ballroom. The Chan-lers were among the elect. (In 1968, *Life* magazine featured a photo essay of "America's 'Grandes Dames.'" Among them was ninety-five-year-old Alida Chanler Emmet, the youngest Chanler sister, and the only sibling then still alive. Posing in a ball gown, Alida was identified as the last sur-viving member of the "Four Hundred.")

Aunt Lina ruled from her Fifth Avenue mansion, which was just around the corner from the Chanlers' handsome brick house on Madison Avenue between 34th and 35th Streets. After Elizabeth's birth in 1866, Aunt Lina was chosen to be her godmother. She presented the infant with a beautifully engraved set of christening silver. (You can see it today, prominently displayed at the Smithsonian American Art Museum next to Elizabeth's portrait.) Life at Rokeby surely did not conform to Aunt Lina's idea of a proper upbringing.

At Rokeby, Elizabeth and her sisters had a makeshift education. Governesses taught them French, music, and drawing; dancing and cards were also part of the curriculum. (When playing whist they learned early on to "Lead from a king and remember the small cards.") Mainly, they read. The library of books that once belonged to their great-grandfather was their lifeblood. "Books, books, books," Elizabeth's sister Margaret later wrote in a memoir. "Did they not line the tower, twenty shelves high, many of their old bindings out of reach?" The children managed to grab them anyway. Books were not just an ornament, or an idle amusement, in the Chanler household; they were an integral part of it. Jane Austen, *The Arabian Nights*, history by Macaulay, Victor Hugo's memoirs in the original French. They read all of it. Elizabeth was particularly enamored with Robert Browning, and devoured his poetry as a young girl. After evening prayers the children were routinely read to, the assumption being that "reading aloud was human nature's daily food." Mary Marshall read to them, as did visiting cousins. Even their "disconsolate" father was "persuaded to stop looking at his wife's portrait and read straight through" the long narrative poem by Sir Walter Scott titled *Rokeby*, after which their house had been named.

Life took an abrupt twist for Elizabeth in 1877. Her father pulled her two brothers out of St. John's boarding school in the middle of the spring

term so they could be educated in England. They were lackluster students, and the Gilded Age set loved anything that reeked of the Old World. An immersion in an English public school—Archie to Rugby and Wintie to Eton—was meant to give them the manners, accents, and education of British aristocrats. J. Winthrop Chanler booked passage on a transatlantic steamer for himself, his two sons, and eleven-year-old Elizabeth. He'd brought his daughter to England with the idea of placing her in a tiny, elite school for girls—a school that several cousins had previously attended. It was located across the English Channel on the Isle of Wight and run by Miss Elizabeth Sewell, a renowned author and educator. Every year she would take a handful of young female students, all of them rich and well connected, into the home that she shared with her two unmarried sisters, Ellen and Emma. The Sewells hated the term *school*—it sounded much too institutional. They preferred to call their enterprise a "family home." The students fondly referred to the Sewell sisters as their "aunts." Aunt Elizabeth and Aunt Ellen taught the girls; Aunt Emma was an invalid who never left her couch—her "prison sofa" as one student called it—but she was a warm presence, and the one the girls could confide their secrets to.

After they'd arrived in London, Chanler seemed to have second thoughts about leaving Elizabeth behind. She was so young. For all of her adult posturing, Elizabeth was still playing with dolls. He eventually made up his mind. Elizabeth's mother had expressed an interest in having her daughter attend the school. How could he refuse to carry out his dead wife's wishes? There may also have been an element of mercy on Chanler's part—an attempt to relieve some of the parental burden that young Elizabeth had prematurely taken upon herself. She worried so about her siblings. This would be her chance to free herself from those responsibilities. One relative described the school as "a perfect haven of rest." With luck, it would be that for his daughter. And it would also provide her with a serious education.

Chanler made the necessary arrangements for his daughter—the

boarding fees involved, how vacations would be spent, the possibility of Elizabeth's brothers joining her during holidays. He then returned to America, to the Chanlers' summerhouse in Newport with the rest of the children. "What horses have you taken to Newport, and what dogs?" Elizabeth wrote her father. She inquired after the health of the animals and asked him to "Please give lots of love to the little ones, and keep some for yourself." She described her first impression of the isle and her new school: there were many beautiful plants and flowers, she liked the Sewell sisters "very much," and she found their house, called Ashcliff, "very pretty." But she ended her description with the plaintive, "Please come soon."

Not long after, a telegram arrived at Ashcliff. Miss Sewell delivered the tragic news: Elizabeth's father was dead. Eleven-year-old Elizabeth tried to comprehend the unfathomable. A sudden case of pneumonia. A chill caught while her father was playing croquet on a soggy field. Elizabeth was now an orphan, left among strangers to grieve. She'd only been at the school for a month. Elizabeth was told she must be brave, it was God's will. She'd heard that before.

What is it about orphans and English boarding schools, and even poor-little-rich girls, which resonate with a Grimms-fairy-tale quality? Terror combined with an I-can't-avert-my-eyes-from-this-particular-horror-story—that is the feeling evoked when reading through the scores of handwritten letters addressed to Elizabeth on the Isle of Wight, a young American girl far from her homeland.

Elizabeth was not permitted to return for the funeral, not allowed to clutch her orphaned brothers and sisters. "My dear sweet little Bessie," a cousin wrote. She assured Elizabeth that her father had looked beatific and happy in death, "a most glorious smile on his face." The cousin enclosed a lock of his hair that she had cut off herself. Another relative wrote to say that she looked forward to the day when the youngster could return to Rokeby and be "Mother Bess" to her siblings. In the meantime, she instructed the orphan to "learn all you can from the dear

Aunts" and not to be lonesome. Elizabeth had to tough it out alone, in an unfamiliar place, in a foreign country. She was marooned in the tiny village of Bonchurch, on the far southern reaches of the Isle of Wight. That distant island outpost remained the locale of one of the most formative periods of her life. For the rest of her days it served as both an inspiration (she remained devoted to her Aunt Sewells) and as a reminder of the cruel turn her life had taken.

The Sewells' stone house, sited high above the sea in Bonchurch, still stands. No longer a school, it is now in private hands. Bonchurch earns its reputation as the most picturesque village on the entire island. Its houses of local stone are set on ascending terraces on a steep hillside overlooking the English Channel. Vertiginous, curving stone stairs, slick with mud, lead from one level of the town to the next. The village nestles against chalk cliffs, known as St Boniface Down, that rise nearly eight hundred feet above the sea. The Down serves as a kind of wall that traps the sun's heat to create a unique microclimate—a paradise of subtropical vegetation—in the so-called Undercliff that stretches for roughly seven miles along the coast. It's a bit of the Mediterranean in the United Kingdom, nicknamed the "Madeira of England" and touted as the sunniest place in all of Great Britain. Even Miss Elizabeth Sewell, an exemplar of Victorian restraint, could not resist exclaiming that "heaven itself can scarcely be more beautiful."

Once the province of poor fishermen and smugglers, the Undercliff became fashionable in the mid-nineteenth century after Queen Victoria and Prince Albert built Osborne House, their grand rural retreat on the other side of the island. The queen loved her Italianate-style hideaway and could scarcely be budged from the place after the death of her husband. (She died at Osborne House in 1901.) When the royal family moved to the island, the entire court converged on the Isle of Wight and one of Victoria's ladies-in-waiting settled in Bonchurch. The queen herself came to the village. All who did were amazed. The miraculous Undercliff boasted palm trees and all manner of exotic plant life; lizards basked in

the December sunshine; wild cyclamen, geranium, primroses, and vio-
lets thrived at Christmastime; and masses of rare butterflies got positively
drunk on the abundant nectar.

With its sea air, warm winters, and cool summers, the area soon
became renowned for its healthful properties. Invalids, especially those
suffering from lung diseases, arrived. In neighboring Ventnor, the Royal
National Hospital for Consumption and Diseases of the Chest (its motto,
"While I breathe I hope") was built on a bluff overlooking the sea.
Donkey-drawn carriages carried invalids through the streets. Wheeled
bathing machines (some dedicated strictly for use by women, others for
men only) lined the beach, as soaking in seawater was considered cura-
tive. The place became a destination for both foreign royalty and wealthy
Brits—though Karl Marx also spent two winters there convalescing. (It
was no miracle cure for him: he died within weeks of leaving Ventnor.)

Bonchurch, next door, attracted literary celebrities. Charles Dickens
came for the summer season in 1849 and rented a villa named Winter-
bourne. He was especially pleased by a waterfall on the property; he hired
a carpenter to build an enclosure around it so that he could use it as "a per-
petual shower-bath." He exulted in the sea air, daily strenuous walks to
the top of St Boniface Down, games of rounders on the beach, and visits
from such luminaries as Thomas Carlyle, William Thackeray, and Alfred
Lord Tennyson. There were amiable picnics, garden parties, and amateur
theatricals.

Dickens wrote a chunk of *David Copperfield* in Bonchurch but his bois-
terous and rather blunt manner did not sit well with some of the local gen-
try, especially straitlaced sorts like Miss Sewell. She claimed to have seen
him only once because she and her sisters "did not go into society" much.
(That's putting it mildly: though formal entertainments were an integral
part of her social set, Miss Sewell could recall attending only half a dozen
balls in her entire life.) There were doubtless other reasons to avoid a per-
son like Dickens, who lived a stone's throw from her house. Miss Sewell
had a positive horror of what she termed "irreligious society"—she said

that she found it hard to breathe in such company. Most Londoners, alas, fell into that category for Miss Sewell: she found them generally "distasteful" since "religion seemed entirely out of their thoughts." Hardly surprising then that she would avoid at all costs a clever man like Dickens, who threw satirical poison darts at organized religion.

The offending author didn't last too long in Bonchurch. His initial enthusiasm for the climate transformed into a positive hatred of it. By August he was complaining of being depressed, bilious, sleepy by day, and sleepless by night. He blamed it all on the weather. "I am quite convinced that I should die here in a year," Dickens wrote. The equinox's high winds took its toll. A close friend was seriously injured in late September after the wind had whipped up—he suffered "congestion of the brain" after being flattened by an enormous wave. Dickens hypnotized his friend to help cure him; not long after, the author bid good-bye to the island.

The Sewells had been just across the way from Dickens. Their manor house is located atop "The Pitts," the site of an old quarry as rock solid as the discipline and rigor inside the house. "In that little world there was never any doubt about belief or duty," one of Elizabeth's cousins, who preceded her at the school, wrote in a memoir. "The religion was Anglican and thorough; . . . the language pointed and pure, and the morals so high and honourable that during all my stay under that kindly roof I cannot remember one case of deception or fibbing on the part of the girls, or one expression of suspicion or disbelief, or a single act of injustice, on the part of the authorities."

Well, maybe one. The author recalled the sad fate of a fellow student named Rosie, who had the audacity to peek at a proscribed bit of text. One evening Aunt Elizabeth was reading aloud in the drawing room to the seven assembled students—the usual nighttime ritual—when she came to an abrupt stop. She was midway through *Cranford*, the quaint novel by Elizabeth Gaskill about English country life, when something in the text struck her as objectionable. Something about a baby. "I will leave

this out," Miss Sewell said ominously, and moved on to the next page. The girls were naturally riveted. What juicy bit had been excised? The book, left behind in the parlor for anyone to look at, was like an occasion of sin, a trap laid by the aunts. Rosie was found "devouring the forbidden page" the following morning. Despite the tears and entreaties of the other students, Rosie was expelled.

Moral judgment hung heavily in the air. The aunts kept a running tally of the students' daily performance in large bound books. Every evening each girl had to carry up her register and wait for the verdict on how she had done on her lessons that day: "Very good," "Good," or the dreaded "Tolerable," which was considered a "foul disgrace!" If, heaven forbid, a girl had broken a rule of any kind, she was expected to own up to the infraction—that too, would factor into the grading. There were no overt punishments. There was no need. On Saturday evenings every girl had a private audience with Aunt Ellen— a kind of weekly confession— during which the student's register was examined. A frown from Aunt Ellen was more than enough punishment; a smile from her was a cherished reward.

The school was a bastion of Victorian rectitude. Queen, country, religion—of the right Anglican sort—that was the credo. Photographs from the era show the Sewells dressed in acres of dark fabric, with gloves and heavy bonnets, only their faces visible. And yet, for all of their resolutely old-fashioned beliefs, Elizabeth and Ellen Sewell were also quite revolutionary. After their father died leaving huge debts in his wake, the pair earned money to help stave off creditors, a bold move by women of their refined, and usually idle, class. They did not look to marriage as a fallback; they looked to themselves. The sisters took in pupils, beginning with their widowed brother's children, who'd been left motherless. Soon word spread among the wellborn, and places in the Sewells' school became sought after years in advance.

Much of this was due to Elizabeth Sewell's growing literary fame. Her first novel, *Amy Herbert*, mirrored her own life. The plot concerned

the travails of a well-bred young woman, deeply Christian, who was thrust into the role of governess and educator of young children. Published in 1844, the book was hugely popular in both England and the United States. Scores of novels and educational texts followed, and the titles of them reveal the class-conscious, religious, and classical focus of her brand of pedagogy: *The Earl's Daughter, The Child's First History of Rome, Private Devotions for Young Persons*, and *Principles of Education, Drawn from Nature and Revelation, and Applied to Female Education in the Upper Classes*.

The school boasted a rigorous curriculum: logic and history, math and science, literature and grammar—all of it imbued with a heavy dose of Scripture. On occasion, a male expert was brought into the girls' school, among them a university lecturer who introduced the students to political economy. Ellen Sewell had the artistic gift in the family, and she tutored the girls in music, singing, and drawing. The minutiae of social etiquette were also drilled into the students. The art of letter writing had to be mastered: how to accept and decline invitations, how to properly inquire after an invalid, how to check references for servants, how to address a tradesman ("rigid third person" was the rule on that one). A dancing instructor taught them to move gracefully: "Be willowy, young ladies, for heaven's sake be willowy!" Aunt Ellen would sometimes play the role of hostess as the girls were taught to navigate a room properly—entering it with confidence and style, engaging the eye of the hostess before glancing at anyone else, moving a teacup or opening a window soundlessly, and always with a smile on one's face.

Unlike the free-for-all at Rokeby, days at Miss Sewell's were carefully structured, from morning till night. To the schoolroom by 7:30 for bread and butter. An hour of prayer and study before a hearty breakfast. Lessons all morning, with a playtime break in the gardens surrounding the house. A large midday meal followed by a two-hour walk, with or without a friend. Afternoon tea. More hours of study. Yet more tea—"the highest of high teas, where everybody chattered all the time and the girls

cut the vast cakes to suit themselves." Evening in the drawing room, a fire blazing, Aunt Elizabeth reading aloud, Aunt Ellen on the piano. Bed at 9:30. The next day, as Elizabeth woke to the maids carrying hot water for her bath, the cycle would begin anew.

The surroundings were homey: chintz furnishings, large windows looking out to the sea, watercolor paintings by Aunt Ellen on the wall. But the discipline was ironclad. Even Aunt Elizabeth's spelling exercises bore moral instruction. Sentences were read aloud and students had to copy them, with special emphasis on learning the italicized words. A typical dictation: "The child is a *homeless* wanderer, brought up in *careless* and *shameful* habits, and it is *truly* sad to see how *rudely* she behaves. In my judgment her case is *wholly hopeless*; but it is *awful* to be brought to such an *acknowledgment*." Pretty sobering sentiments for an eleven-year-old orphan.

Elizabeth spent her free time riding horseback or tending a garden plot. She could clamber up the steep steps to the very top of the Down where the world was reduced to the simplest elements—wind, sky, sea, cliffs—or wend her way down toward the wooded path that led to the beach. Past the villa once inhabited by Dickens, and past the grand stone mansion where decadent poet Algernon Swinburne had grown up. (The aunts banned the work of both authors.) The old Swinburne place, with its aura of corruption, held a certain frisson for the girls. Without even reading his poems, they knew there was something very powerful about them. The redheaded poet—the poster child for godlessness and debauchery, sensual pleasure and alcoholism—was an ongoing trial for his aristocratic mother. "Poor dear Lady Jane," the aunts would say. "Algernon has broken her heart!"

It was unusually cold and stormy during Elizabeth's first winter in Bonchurch. So on one of the first nice days, a sunny Sunday in late March 1878, people all across the island were drawn outdoors to bask in the sunlight. From Ashcliff, Aunt Ellen sketched a lovely sight: a beautiful three-masted ship passing under full sail through a "green and purple

sea." The ship was the HMS *Eurydice*, named after the Greek mytho-logical figure—the doomed lover who could not escape the underworld (a rather macabre choice of name for a ship). Speedy and maneuverable when built, by the 1870s she had grown obsolete. Refitted as a train-ing ship for young seamen, the *Eurydice* was returning from the West Indies. As they approached home, the sailors were in a festive mood and the captain let them enjoy the fine weather after a successful four months at sea. Rum was passed about. Many of the young men lounged in their hammocks or rested on the main deck. The gunports were open to ven-tilate the ship.

Soon after 3:30 p.m., a freak blizzard blew in from the northwest. The *Eurydice* was rounding a point and the eight-hundred-foot cliffs of St Boniface Down obscured the black clouds about to envelop them. Fero-cious winds and blinding snow rousted the men from their languor, but it was too late. The *Eurydice*'s sails immediately filled with heavy snow, two of the topgallant masts snapped off, and the ship was helpless as it spun around in the swells. Icy water poured through the open gunports and the ship plunged into the depths. The blizzard continued for forty-five minutes, and then—as if the storm had never happened—the sun reap-peared. Bodies littered the now calm water. The crewmen, all capable swimmers, never had a chance. Some got sucked down into the sea with the ship; others quickly froze to death in the frigid water. Of 360 men, only two survived.

The entire nation mourned the loss of the young men, with such promise. The incident was seared into Winston Churchill's memory. Four years old at the time, he was walking along a nearby cliff with his nanny when he saw the ship just before it sank. Days later, he stood again on the cliffs now lined with fellow Britons who doffed their hats as a pro-cession of boats slowly carried the corpses ashore. Gerard Manley Hop-kins later memorialized the event in a long narrative poem, *The Loss of the Eurydice* ("Too late; lost; gone with the gale. . . ."). Elizabeth and

the other girls at Miss Sewell's witnessed firsthand the capriciousness of fate: one moment a vessel upright and triumphant—Aunt Ellen painted that picturesque moment—and in an instant all lost. So many ifs. If only the cliff hadn't obscured their view, if only the sailors' senses hadn't been dulled with drink, if only they'd had some warning, if only the gunports had been closed.

Curiously, a photograph of Elizabeth survives from this time period: she is wearing a sailor suit and high-button shoes and is standing against a studio backdrop of sharp rocks. Her hair is cut boyishly short, her forehead is covered with bangs. She's in semiprofile, a sprig of flowers in her hand. She looks quite serious, her brow knitted, not an ounce of jollity evident.

Death and tragedy seemed to stalk Elizabeth. Perhaps that's why she was so sympathetic, why she had such compassion for others. People were naturally drawn to her. They confided in her. A classmate referred to Elizabeth as reflecting "the spirit of God" and being "a very powerful medium of good." Even the Sewells melted in the young girl's presence, Aunt Elizabeth writing, "she is so attractive that every one pets her." Of course, that was just the sort of thing that Sewell worried about—too much petting.

American girls baffled Elizabeth Sewell—their frankness, their self-assured air, their buoyancy and good humor. And above all, their sense of entitlement. They rendered opinions as they pleased, and spoke to their superiors as if they were their equals. In contrast, English girls were "morbid, self-conscious, anxious, uncertain." Sewell was in a quandary. Which characteristics were preferable? "The shy unobtrusiveness of the English girl, or the self-possession and decision of tone of the American girl." Sewell threw up her hands. "I do not pretend to

decide," she wrote. But she did do her best to instill a steely sense of duty and religious fervor—and even a bit of old-fashioned guilt—into her American charges.

By the spring of 1878, young Elizabeth had been away from home for a year. In the interim she'd mourned her father's death and celebrated her twelfth birthday without family. She yearned to see Rokeby, her siblings, and her pets. Could she come home for the summer? She was at the mercy of the guardians—the eight relatives who'd been named in her father's will to make all decisions concerning the children's education and upbringing. (Chanler had drawn up his will only six months before his death, never dreaming that his life would end so soon.) The guardians were influential members of society—among them, John Jacob Astor III and William Waldorf Astor (later, Viscount Astor)—who had little time to sit and ponder the children's future. In addition, most of the guardians had no children of their own and were largely clueless about child-rearing.

Amid the family papers at Rokeby is a leather-bound volume containing the minutes of the monthly meetings of the guardians in New York City. It reads like something out of Dickens, with much of the discussion concerning money and ways to save it, rather than the welfare of the children. The boys in England were permitted allowances, "but not extravagant" ones; the children would make their "usual" Christmas presents to the servants; cousin Mary Marshall, who did the only real parenting at Rokeby, was commended for her "good management & economy"; permissions were sought for boxing lessons and drawing lessons, for ribbons and sleighs, for entrance fees to various "societies" for Archie (the guardians agreed to pay the fees with the proviso that Archie reimburse the family account when he gained his inheritance at age twenty-one). Every penny was counted.

A special meeting was held in March of 1878 to decide if the three siblings left in England—Archie, Wintie, and Elizabeth—would be permitted to come home for the summer. Only Elizabeth was allowed to do

so; her brothers had to remain behind. Elizabeth was doubtless ecstatic over the prospect of being reunited with her family. But Miss Sewell had some reservations that she confided to one of the guardians in a letter: "My fear is that the Uncles and Aunts and Guardians will make so much of the child that her little head will be turned, for it is very hard, even when one puts on one's most severe spectacles not to feel that she is one of the most winning little creatures imaginable." There were other matters the schoolmistress wanted to address as well. Sewell thought it advisable to have Elizabeth examined at the Orthopedic Hospital in London before she boarded the ship. The young girl had developed a limp so pronounced it appeared as if one of her legs might be shorter than the other. Though Sewell considered it a "very small matter," she thought it best not to ignore the abnormality.

With a physical ailment compounding the sorrow Elizabeth had endured that year, you'd think Miss Sewell might have suggested a carefree summer. But she didn't. She packed Elizabeth off with lessons she should attend to regularly, a less-than-scintillating reading list, and a warning not to fall into careless penmanship. Miss Sewell also sent word to Mary Marshall that Elizabeth's failings should not be allowed to grow. The schoolmistress had already lectured Elizabeth on her sins: "Pride— Temper—Curiosity—and a disregard of the pleasure of her companions when her own amusement is concerned & carelessness in her lessons . . . I think I could have added vanity to the list of faults. . . . She must learn also to sit quiet in Church & not look around her." Elizabeth had promised to mend her ways, but Miss Sewell feared she would be ruined. No worries in that regard. The "small matter" of Elizabeth's limp was just the beginning of years of misery.

By midsummer it was unclear whether Elizabeth would be able to return to Miss Sewell's. Doctors suspected she was suffering from a hip disease,

and her lameness made travel difficult. Should she stay home where she could recuperate surrounded by family? The Guardians had all escaped New York City during the summer season, off on their yachts, or away to some cool watering spot. Thus, no emergency meeting could be convened to decide Elizabeth's fate.

One guardian did interrupt her stay at a spa in Germany to express her strong opinion on the subject. This was twenty-four-year-old Margaret Stuyvesant "Daisy" Rutherfurd, a first cousin of the orphans and the youngest member of the guardians. (J. Winthrop Chanler had selected her because he wanted at least one of the guardians to be relatively close in age to his children.) Daisy had gone to Miss Sewell's, adored the place, and argued strenuously that Elizabeth—short of being a complete invalid—should return there. She pointed out that her own roommate at Miss Sewell's had also suffered from hip disease and she'd been royally treated. Daisy stressed that Elizabeth would be better off away from the chaos of Rokeby. The rigid routine at Miss Sewell's would be far preferable. And even the medical care she could receive on the Isle of Wight was considered superior to what was available at Rokeby. As for moving Elizabeth to New York City to live with Daisy's family—well, that would be quite impossible, what with their busy schedules. No, Elizabeth should go back to the aunts despite her diminished condition—even if climbing those cliffside terraces required the agility of a mountain goat. And so Elizabeth returned to Miss Sewell's and got worse and worse.

The young girl was finally brought to London in December 1879 to be examined by Dr. James Paget, a well-known surgeon near Hanover Square. He was clearly baffled by her case. Even Elizabeth could sense his confusion. Staying in the ultraproper Brown's Hotel in Mayfair added to Elizabeth's boredom and depression. Then, as if by magic, her charismatic grandfather Sam Ward appeared. He was a wonderful, colorful character—a bon vivant who had long since been ostracized by the Astor family and prevented from seeing his grandchildren. (The guardians per-

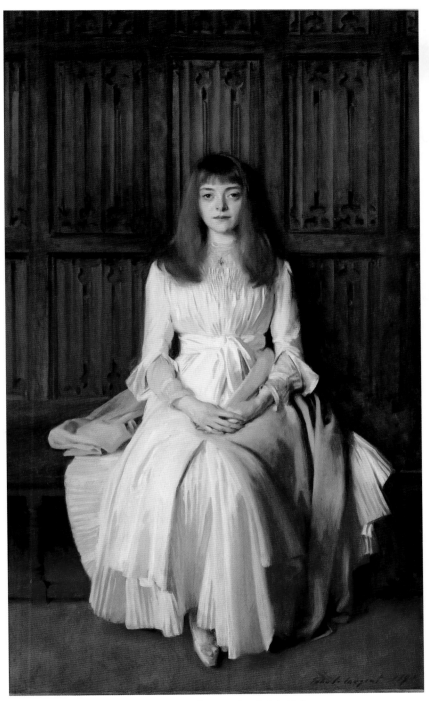

John Singer Sargent's portrait of Elsie Palmer at
Ightham Mote in Kent, England, 1889–1890.

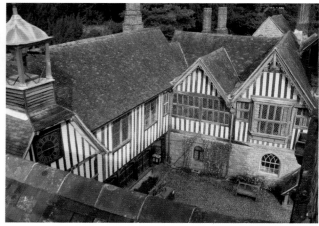

The interior courtyard at
Ightham Mote.

(Photograph by the author)

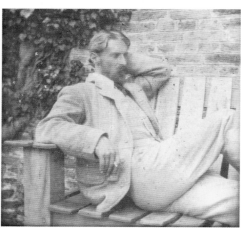

Peter Harrison lounges in a chair at
Glen Eyrie near Colorado Springs.

(Colorado Springs Pioneers Museum)

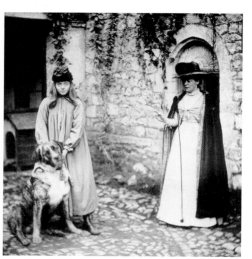

Dos Palmer poses for artist Peter Harrison in
a studio he set up at Glen Eyrie.

(Colorado Springs Pioneers Museum)

Queen Palmer, her daughter Elsie, and their dog
Kelpie in the cobblestone courtyard at Ightham
Mote during a visit by John Singer Sargent in 1889.

((@National Trust/Ightham Mote)

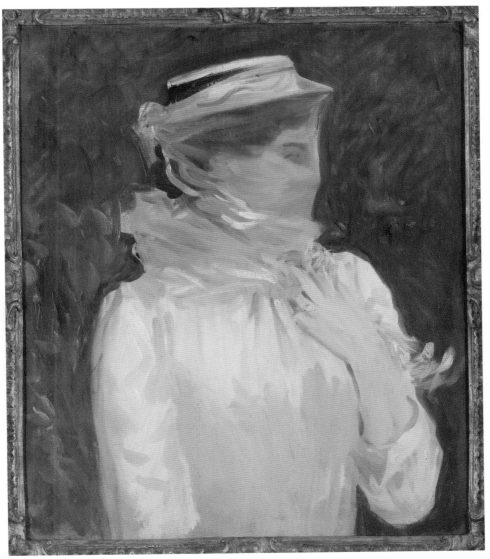

John Singer Sargent's *Lady with a Blue Veil (Sally Fairchild)*,
Nahant, Massachusetts, 1890.

(Private collection)

Lucia Fairchild Fuller (upper right) clutches a black cat; her husband, Harry Fuller, stands beside her; her mother-in-law, Agnes Higginson Fuller, sits beneath the couple, holding their baby Clara; and Harry's sister, Violet Fuller, is at bottom right. This 1895 photograph was taken at the Fuller family farm in Deerfield, Massachusetts.

(Pocumtuck Valley Memorial Association, Memorial Hall Museum, Deerfield, Massachusetts)

Sally Fairchild poses with her dog.

(Pocumtuck Valley Memorial Association, Memorial Hall Museum, Deerfield, Massachusetts)

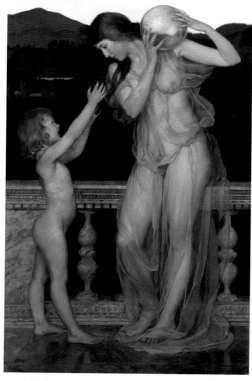

Illusions by Henry "Harry" Brown Fuller, created before 1901. Harry's wife, Lucia, and his daughter, Clara, posed for this painting. Mount Ascutney is visible in the background.

(Smithsonian American Art Museum)

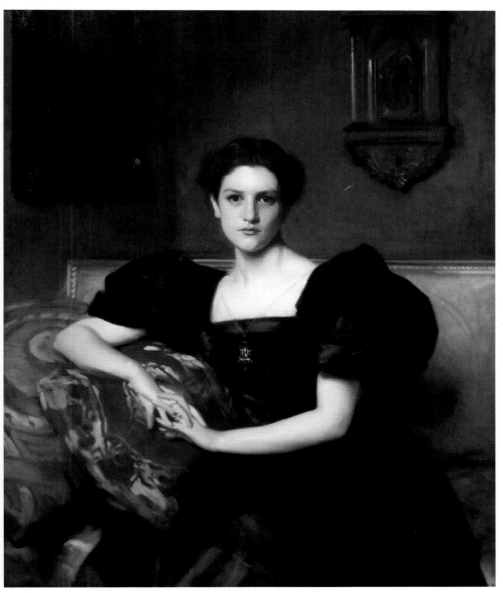

Elizabeth Chanler by John Singer Sargent, 1893.

(*Smithsonian American Art Museum*)

John Jay Chapman as a young man, seated on his grandfather's porch in Katonah, New York.

(Rokeby Collection)

Elizabeth Chanler in Taormina, Sicily, 1891.

(Rokeby Collection)

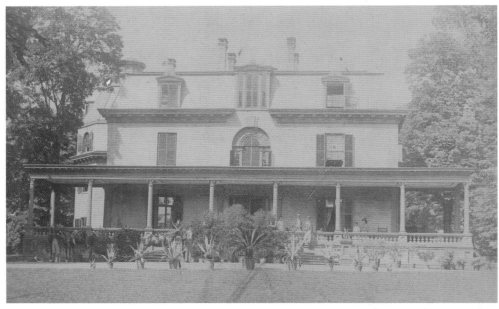

The exterior of Rokeby, the Chanler mansion in the Hudson Valley, circa 1888.

(Rokeby Collection)

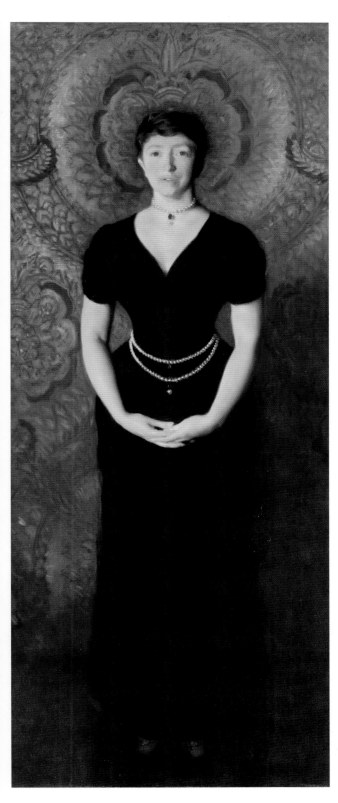

Isabella Stewart Gardner by
John Singer Sargent, 1888.

*(Isabella Stewart Gardner
Museum, Boston)*

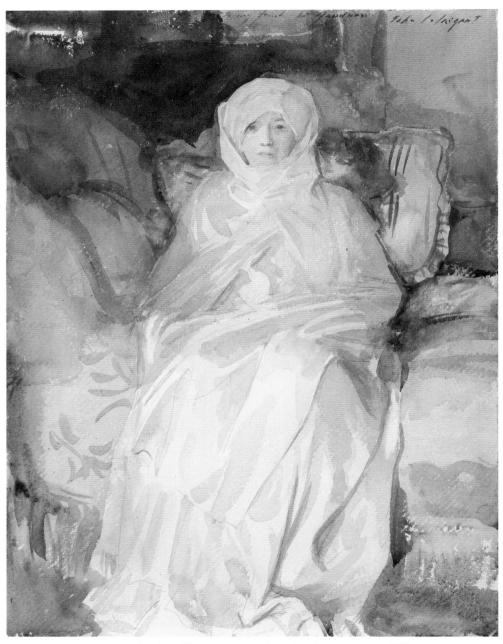

Mrs. Gardner in White, a watercolor by John Singer Sargent, 1922.

(Isabella Stewart Gardner Museum, Boston)

mitted this surprise visit only because they believed Elizabeth was dying.) Ward arrived like Father Christmas, laden with wonderful gifts: a ruby ring surrounded by diamonds, a robe of camel's hair, and a traveling case lined with maroon silk that cradled cut-glass flasks. Such a rascal Ward was, encouraging his teenage invalid to enjoy herself.

Elizabeth made almost immediate use of her new traveling case. She and Wintie, then at Eton, were to spend the coming Christmas season in Paris with family friends. One of the guardians advised her that while she was there she should always speak French. A tutor had been hired to give Elizabeth and Wintie daily French lessons for an hour and a half; there would also be music lessons three times a week. Elizabeth also had in hand a recommendation for a local doctor in case her pain increased or she became more disabled.

While in Paris, Elizabeth did need medical help. Fearing that her illness would leave her permanently crippled with curvature of the spine, the doctors prescribed a radical treatment: Elizabeth was to be kept immobile by being strapped to a board—for two years. In their monthly meeting on February 17, 1880, a week before Elizabeth's fourteenth birthday, the guardians noted that their young charge would not be returning to school on the Isle of Wight. (They also expressed concern over getting the prepaid tuition back from Miss Sewell, and were relieved to find out they would.) Elizabeth, by then a complete invalid, was staying with an exceedingly social Astor cousin—a baroness married to the Dutch envoy to Paris. It's hard to imagine that amid the swirl of Paris diplomatic life the baroness spent many quiet evenings by the fire with her sick cousin. From afar the guardians made provisions for Elizabeth's illness, sending money for a private nurse, as well as for the "surgeon's fees . . . hiring a landau & other luxuries & comforts incidental to Miss Chanler's invalidism."

Relatives came and went but Elizabeth was left, in her words, "strapped down in a machine flat on my back." For a long stretch she wasn't even permitted to write letters. In the summer she was transported from Paris to Trouville-sur-Mer, a village on the coast of Normandy. The

trip was an ordeal. She was slung in a hammock from the ceiling of the railroad carriage to prevent her spine from being jolted during the journey. She was then carried off the train and placed into a horse-drawn carriage. With the long machinelike board she was lying on, there was no room in the wagonette for anyone else. Elizabeth could hear the clatter of wheels and horse hooves, and look up at the sky, and try to imagine a time when she would be freed from her prison-like restraint. In Normandy she was surrounded by lots of cousins, but she remained on the porch as activity swirled around her. Occasionally, she'd be carried outside to watch family members play lawn tennis. An older gentleman sweetly read the newspaper to the invalid.

Elizabeth became an object of pity. Her family shuttled her from one locale to the next: from a fancy hostelery in lower Manhattan (where Grandfather Sam Ward, a habitué of the place, came calling with more gifts), to a mansion on the corner of Second Avenue and 15th Street, home of Rutherford Stuyvesant, her extremely rich cousin and guardian. Heir to the original Peter Stuyvesant fortune, "Cousin Stuyve" spent much of his time hunting game and bagging art: Old World Italian masters and medieval and Renaissance suits of armor. Amid the display of broadswords and faceless steel knights, Elizabeth languished.

Elizabeth was sick, bored, and lonesome for her family. But the guardians and the children's anxious caretaker, Mary Marshall, wouldn't permit her to return home. The utter confusion at Rokeby, even the summer heat, were cited as reasons to stay away. Despite the reality that wealthy New Yorkers *always* fled the sizzling city streets come summer, Mary Marshall insisted that Rokeby's airy perch above the Hudson was hotter in June than the city was, since they were farther away from the sea breezes. "What is best will be made plain Bessie dear, if we ask God's direction & we need this about everything great or small," Marshall wrote.

Lengthy letters kept Elizabeth abreast of the latest from Rokeby, as one season led to the next: the thick coating of snow that made sleighing

perfect in February; sister Margaret's new pet bullfinch that she'd trained to sing and to snatch seeds out of her lips; the mud pies the children made in soggy April. Cousin Marshall sent Elizabeth pressed violets, the first of the season. She also urged the young invalid to think of others less fortunate. On her sickbed Elizabeth dutifully made a flannel petticoat for a helpless old woman near Rokeby. Elizabeth was the soul of generosity and patience, always good-humored in spite of her own condition. "Queen Bess" they came to call her during that time period, for her dignity and restraint were nothing short of regal.

News also arrived from her old classmates on the Isle of Wight (one letter to Elizabeth was signed "Your loving old school fellow/That sometime sinner"). And her Aunt Sewells corresponded with their former pupil for many years, sending their love and reminding the sick teenager "to take all the suffering & privation cheerfully" since it came from God. They had lots of questions for her: Have you grown tall from lying down so much? Who takes care of you? Has the pain decreased? They begged her for a photograph so they could look upon her "dear little face again!" The photographs Elizabeth sent to Bonchurch delighted the Sewells. They wrote back and said how unchanged she was—and yet, how sad she looked. Despite Elizabeth's disabling illness, the aunts cautioned her that she should not think of herself; rather, she should look after her siblings. "I hope my dear Bessie all your own home circle are well—and that you have no more sad anxieties about any of them."

Heaven knows, she had endured enough.

But near the end of 1882, Elizabeth's brother Egerton died of a brain tumor at Rokeby. He was eight years old. Elizabeth spent Christmas at Rokeby with her bereaved siblings. Unstrapped from her board, Elizabeth now hobbled about on crutches. After the holidays she returned to Cousin Stuyve's care in New York. And then a fresh blow. Fourteen-year-old brother Marion, off at St. Paul's boarding school in New Hampshire, died suddenly in February 1883, after winning a competition with a fellow student over who could eat the most Turkish delight at one sit-

ting. Though victorious, Marion vomited all night in the frigid dormitory. Days later he died of pneumonia. Elizabeth was not allowed to join her siblings in mourning this time. Mary Marshall considered it unwise for Elizabeth to travel to Rokeby. "I am so afraid that you might suffer from a journey taken just now while you are more or less run down & are necessarily under excitement," Marshall wrote to Elizabeth. "God alone can support us under this heavy sorrow & my constant prayer is that He will." The orphans were now down to eight.

Elizabeth came of age in 1887 and gained the considerable fortune her father had left her in his will. No more governesses or guardians need watch over her. She was free to travel as she liked and she did. Her limp didn't stop her. Hundreds of letters squirreled away for decades in boxes and stored willy-nilly at Rokeby—in the attic, or the tack room, or any spare corner of the ancestral home—chronicle Elizabeth's nearly incessant movements. Letters addressed to her in New York or Rokeby couldn't keep up with her and they'd be redirected to her latest stopping point: glamorous places like Paris, London, Monaco; or spots more off the beaten track, like Taormina in Sicily, which, at the time, was overrun with bandits. Elizabeth's brother Willie—an adventurer much admired by Theodore Roosevelt—brought her to Sicily in the vain hope they would run into some desperados. After several weeks they took off like bandits themselves: having run through their cash they were unable to pay the hotel bill. Another sibling would settle up.

Such was life for the orphans. The Chanlers wandered all over the globe. Brother Willie spent a fortune on several harrowing expeditions in East Africa, nearly fomenting war during one of them, but having the wherewithal—to say nothing of the ego—to name a waterfall after himself before making a hasty exit. The youngest brother, Robert, announced to Elizabeth, his dearest confidante, that his goal in life was "To roam & see & learn to be quiet & steady, to be energetic & firm. In fact like a bit of wood on the mother sea." Bobbing about aimlessly, like driftwood on the ocean, seemed to be the fate of the orphans.

But expectations for a woman of Elizabeth's status were rigid and clear. She had one job, and one job only: finding a suitably rich, blue-blooded husband. Love played little part in the equation. For Elizabeth, it did not seem she'd have much choice in the selection as her fragile health and limp would be seen as a burden by many men. Elizabeth bore the scars of her illness. (Her symptoms indicate that she probably suffered from tuberculosis of the hip, a bacterial disease, in an era that predated antibiotics. Her years strapped to a board didn't help a bit.) Thanks to her father's largesse, Elizabeth had plenty of money so marriage was not a financial necessity, but she did need to find her place in society. And that itself posed a problem. Elizabeth had little interest in the nonstop procession of balls, entertainments, and social seasons that consumed her class. All of it struck her as vapid. Literature and art were what appealed to her. She wrote poetry and studied painting in Paris.

Elizabeth's cousin and former guardian, Daisy Rutherfurd (by that time married to Henry "Harry" White, an American diplomat in London), was a woman of steely social ambition. She decided to take Elizabeth in hand, and Daisy did not take on projects lightly. Previously, she had remade her rather lighthearted groom, who at age twenty-nine had been perfectly content to pursue a life of sport and easy camaraderie. That wouldn't do for Daisy. Deciding that Harry needed to do something useful, she nudged him into the diplomatic service, and her beauty and charm helped him ascend the ranks quickly. She *made* Harry's career, and he admitted as much. She also helped launch Sargent in London. In 1883, before he had become a brand name, Daisy sought out the up-and-coming artist in his disheveled fifth-floor walk-up studio in Paris. She wanted Sargent to paint her portrait. (In contrast, her husband Harry had his own portrait painted by Léon Bonnat, a far safer, known quantity.) Sargent's imposing portrayal of Daisy, over seven feet tall and every inch of it stately, became the focal point of the Whites' dining room in their London home. The aristocrats and members of Parliament who dined around their table marveled at the elegance of the composi-

tion. Word spread and Sargent's reputation soared in England. A star was born, helped in part by Daisy.

Elizabeth stayed for long stretches with the Whites in London and Daisy introduced her unmarried cousin to all the best sorts of people—among them, members of the "Souls." The Whites were part of that set, the first Americans to be accepted into that very high-toned political/artistic/literary group (though Edith Wharton and Henry James did not make the cut), which was composed of the bright young things of London. Members included Arthur Balfour, a future prime minister who would be raised to the rank of earl (the Whites affectionately referred to him as "Ah Bah"), and George Curzon, who would go on to become the viceroy of India and the marquess of Kedleston. The group met at one another's grand country houses where they spent weekends playing word games, charades, and generally looking into one another's souls—thus they were christened the "Souls"—and sometimes into each other's bedrooms. Illicit love affairs among the members added high drama, though Daisy herself was much too puritanical for that sort of thing and doubtless shielded Elizabeth.

The Whites glided in the highest social circles. When a robber made off with Daisy's valuable jewels at their country estate, Ramsdale, the Duke and Duchess of Westminster sent one of their own jewels to console her. The Whites occasionally dined with the Prince of Wales—later, Edward VII—and even spent a memorable evening with Queen Victoria at her Scottish castle, Balmoral. After dinner the queen had a private conversation with Daisy about poetry and other matters. Daisy was later pleased to learn that the queen had been impressed by her "pleasant voice and speech (I suppose this she does not expect from Americans) and that she thinks me very pretty!"

Elizabeth's own meeting with Queen Victoria did not play out quite so smoothly. Daisy and Harry had arranged for Elizabeth to be presented at the royal court in the spring of 1889. Elizabeth wore the prescribed costume for a young unmarried woman: a long white dress with an enor-

mous train, a white veil, gloves, and a fan in one hand. Photographs of Elizabeth show the beautiful young woman in what looks like a wedding gown.

The presentation ceremony was a grand spectacle from start to finish. Hours before the afternoon event, carriages queued up near Buckingham Palace and throngs of curiosity seekers peered into the equipages to get a look at Elizabeth and the other debutantes. The nervous young women were then ushered into a crowded, stuffy antechamber to wait their turn in line. Elizabeth, like all the other sifted few, had spent weeks envisioning and rehearsing how the event would proceed when her time came: she would gracefully carry the train of her gown as she headed toward the Throne Room; one of the lords-in-waiting would then unfurl her train; and when her name was announced she would stride across the room and kiss the queen's hand as she curtsied deeply, nearly touching the floor with her knee. But something went askew. Being jostled in the line unnerved Elizabeth. Perhaps it was her difficulty in walking, or her distaste for being poked and touched (something she'd been subjected to during her years of confinement). For whatever reason, when a court official urged her forward with a gentle push and the command "Hurry!" Elizabeth recoiled. She walked across the room, but in her agitated state she completely forgot to curtsy when she reached the queen. This would have been considered a great international slight, if fate hadn't intervened. Just as Elizabeth approached Queen Victoria, the monarch's veil became dislodged and revealed her pigtail beneath it. Courtiers immediately surrounded the queen so that Elizabeth's break with protocol was not widely seen. Her social gaffe did, however, cause enough of a stir that it was reported upon in New York's society gossip sheet, *Town Topics*.

In 1893, Elizabeth was twenty-seven years old, unmarried, and dangerously close to being considered over the hill. This was the year John Singer Sargent painted her. She'd come to London that spring for the wedding of her youngest brother, Robert, now a twenty-one-year-old artist with an unstable, manic personality. (He was the one who'd professed his

life's ambition as bobbing about on the sea.) The ceremony came off in such a rush that not all the siblings could attend, but among those in the pews at St. George's Church in Hanover Square were celebrity architect Stanford White and his wife, who'd come from Paris for the event.

Stanford White's presence guaranteed that London society would take notice. With his bushy mustache and red hair in a distinctive buzz cut—one of Elizabeth's brothers affectionately called him "old Fuzz Buzz"—White commanded attention. According to a contemporary, he'd stride into view "like a Triton," both the name of a Greek god and the largest moon of Saturn. A dazzling presence in the Gilded Age firmament, White helped invent the look of the era with his Beaux Arts architecture. He was a man of feverish passions and over-the-top appetites. The Chanlers were not only clients but friends. White admired everything about them: their money (which the architect knew how to use), their impressive lineage, their eccentricity, and their devotion to art. A plaque pronouncing the family's undying friendship with Stanford White remains in the front hall at Rokeby. Over the years White caroused with the brothers, remodeled Rokeby, helped decorate their other various homes, and got deeply enmeshed in one of the brothers' projects to build a mill town in North Carolina (a disastrous miscalculation on White's part). White was thirteen years older than Elizabeth, and he took a paternal interest in her and her two sisters.

Elizabeth, twenty-two-year-old Margaret, and nineteen-year-old Alida rented a place in London so they could stay on after their brother's April wedding. The middle sister, Margaret, having recently come into her own inheritance, decided that she wanted a portrait of Elizabeth. Getting the world-famous Sargent to agree to a commission was not easy, but the Chanlers had clout. Elizabeth herself may have known the artist. It is believed that she purchased his oil painting *Street in Venice* on January 1, 1888, at the St. Botolph Club Exhibition in Boston, the artist's first one-man show. The painting depicts a young girl, wrapped in a black shawl, her eyes downcast, as she hurries past several men in shadows;

two men are talking, but one of the men can't take his eyes off of her. There's something disquieting about the scene, about the man's lingering, not-entirely innocent stare. Elizabeth purportedly gave the painting to Stanford White—a man who also could not take his eyes off a pretty woman—in return for some architectural work.

If Sargent needed any more convincing to paint Elizabeth, Stanford White surely would have weighed in. He was as devoted to the Chanlers as he was to Sargent. Thanks in large measure to Stanford White, Sargent had recently signed a contract to create vast murals and wall decorations— more than fifty thousand feet of artwork—for the Renaissance-style Boston Public Library designed by White's architectural firm, McKim, Mead & White. Sargent's brain was already deeply absorbed in the project and had been for several years. He'd traveled throughout the Near East to soak in the ancient world—pagan gods and goddesses, hieroglyphics, mummy tombs—as well as the iconography of early Christianity and Judaism. The subject of his murals would be nothing less than the entire history of religion over the millennia. He truly believed this would be the capstone of his life's work, his Sistine Chapel.

Before and after he painted Elizabeth, Sargent was spending most of his time in the village of Fairford in Gloucestershire, working in an oversized, barnlike studio to accommodate his large-scale library project. He was applying relief casts to enormous painted canvasses to create unusual Byzantine-like sculptural effects. To relax he rode horseback. He was within a short distance of the only landmark in the village: a glorious fifteenth-century church that possesses the most complete set of medieval stained glass windows in the entire country. The richly colored windows chronicle the Bible stories, beginning with the serpent tempting Eve and ending with the Resurrection and Ascension of Christ. There are visions of sinners, saints, martyrs, and even a grotesque figure of Satan devouring the damned.

Sargent returned to his studio in London to paint Elizabeth in June 1893. He lived and worked in the same building at 33 Tite Street, an artis-

tic enclave in Chelsea. James Whistler (whose credo was "Art for art's sake") had previously used the same studio; Oscar Wilde lived across the street. Elizabeth, an aspiring artist and writer herself, doubtless loved the slightly Bohemian setting—sturdy brick buildings lining the narrow street with real artists at work in them. She was ushered into Sargent's studio with its charming jumble of French furnishings, an upright piano, and marble busts. Morning light streamed through a huge window on the wall facing east.

When Elizabeth limped into the studio a saintly quality hovered over her. The artist said she possessed "the face of the Madonna," and he wanted to capture that look—the beautiful dark-eyed Madonna, pure, good-hearted, and virginal. To Sargent, her eyes were those of a child, radiating innocence.

Painting for Sargent was practically an athletic performance. Back and forth he would go, viewing Elizabeth, from different angles, different distances. And then when he had an idea he'd strike quickly, lunging at the canvas, his brush in one hand, his palette in the other, a cigarette dangling from his mouth when he wasn't humming or whistling. While he painted, Sargent talked to her. He learned that he and Elizabeth had a close mutual friend in Sally Fairchild of Boston, and he wrote to the Fairchilds to let them know of the serendipitous connection. He always encouraged outsiders—friends or family of his subjects—to be present while he painted, so that his sitters would be animated. Elizabeth's sister Margaret, who'd commissioned the painting, was instructed by the artist to keep the conversation moving. But when she suggested aloud that Rudyard Kipling should fill the then-vacant position of poet laureate in England, Sargent bellowed: "What an unpleasant American idea!" Another guest at the sitting reported that Elizabeth was "talking hard" while he painted her; yet Sargent somehow managed to make her look remarkably still and voiceless. She doesn't seem to be moving a muscle. There is complete calm. And yet those entwined nerve-wracking fingers and that busy pillow inject another whole level of what? Anxiety? Pent-

up emotions ready to explode? The portrait is dark and funereal in the background, but the light illuminating Elizabeth's face and hands makes her appear angelic.

The portrait didn't take long. Sargent was so sure of his approach that he repainted her face only once. After he'd finished the canvas he seemed to regret how deadly serious he'd made her. "Miss Chanler," he told Elizabeth, "I have painted you *la penserosa*, I should like to begin all over again, and paint you *l'allegra*." Indeed, Elizabeth is pensive in the portrait, and there's an underlying tension to the image. But she also appears poised, steady, and determined, her eyes staring at the viewer. It's as if she's ready to step off the canvas on her own path, as if she's on the cusp of some great change—and she was.

Despite everyone's belief that she would never do so, Elizabeth fell in love. Madly and deeply. But it was with her best friend's husband. In the 1890s, Elizabeth had embarked on an intense friendship with Minna Timmins Chapman and her husband, John Jay "Jack" Chapman, a young couple that had moved to New York from Boston. Minna, a tall, dark-haired half Italian/half Bostonian raised on Beacon Street, had a fiery temperament. She was as impulsive as she was generous. She took one look at Elizabeth's room at Rokeby and declared it bleak. Minna went off and purchased yards and yards of beautiful poppy-colored Italian silk that she hung on the walls of the room, transforming it from a monkish cell to an exuberant refuge. Gesturing dramatically around the room, Minna told Elizabeth, "you must have <u>flames</u> & <u>roses</u> about you." Minna's vibrance was the perfect counterweight to Elizabeth's deep reserves of seriousness and sadness—the traits that Sargent captured so brilliantly.

Elizabeth, Minna, and Jack shared a devotion to literature and a belief in its transforming power. In fact, Minna and Jack had fallen in love while reading Dante together in the Boston Athenaeum library. Chap-

man was then a student at Harvard and a member of the Porcellian Club, the university's most elite club. (One of Elizabeth's brothers was Chapman's classmate and a fellow club member.) Chapman's background was suitably august, descended as he was from Chief Justice John Jay. His family's reform-minded credentials were equally formidable: his grandmother Maria Weston Chapman had worked hand in hand with William Lloyd Garrison, the abolitionist editor celebrated in Boston.

Nearly six feet tall, handsome, dark haired with a mustache and stylish sideburns, Chapman was a commanding figure. He spoke in spellbinding paragraphs. He was charismatic, witty, charming, opinionated, and brilliant. But he was also gloomy and tormented. "Be fearfully afraid," he wrote on the ceiling of his room at Harvard.

Perhaps the one he had to fear most was himself. In a jealous rage over Minna, he beat another student whom he mistakenly believed had offended her. When Chapman realized his error, he felt he had to atone for his sin. He put his left arm in the fireplace in his room—and held it there. He later wrote of this almost incomprehensible act in a matter-of-fact tone:

At that time I was rooming alone in a desolate side-street in Cambridge. It was a small, dark, horrid little room. I sat down. There was a hard-coal fire burning brightly. I took off my coat and waistcoat, wrapped a pair of suspenders tightly on my left forearm above the wrist, plunged the left hand deep in the blaze and held it down with my right hand for some minutes. When I took it out, the charred knuckles and finger bones were exposed. I said to myself, "This will never do." I took an old coat, wrapped it about my left hand and arm, slipped my right arm into an overcoat, held the coat about me and started for Boston in the horsecars. On arriving at the Massachusetts General Hospital I showed the trouble to a surgeon, was put under ether, and the next morning waked up without the hand and very calm in my spirits.

From his hospital room he wrote to his mother in New York and lied to her. She was a difficult, domineering woman and he didn't want her by his bedside. "Please don't be scared by telegram from hospital," he wrote, "I had my left hand run over yesterday and taken off. I am perfectly well and happy. Don't mind it a bit—it shall not make the least difference in my life. If you can help it don't come on. I shall be here at the Massachusetts Hospital [for a] week or so with all science and comfort." While hospitalized, he was visited by a well-known *alienist*—the term for a psychiatrist in those pioneering days of the profession—who asked Chapman whether he was insane. "That is for you to find out," Chapman answered. The doctor pronounced him sane.

Oddly, it was that grotesque act of self-mutilation that sealed Jack's bond with Minna. She took it as proof of his utter devotion, their love forged in flames. But her family was understandably alarmed. They did everything they could to keep the lovers apart. They sent Minna to Colorado Springs, then farther off to England, Europe, and Egypt, in the hope she'd find a more suitable husband. To defy their meddling, Minna chopped off her beautiful hair while cruising on the Nile. She would look like a penitent and her sacrifice would be an offering to her lover. A glittering dinner party in London was arranged so she could meet an attractive, eligible Englishman named Renshaw. "Imagine my horror," the hostess later recalled, "when the door opened and Minna entered, wearing a shabby blue silk frock . . . her cropped hair straggling from an insufficient number of hairpins. She paid no heed to handsome Renshaw. . . . It was the form of her loyalty to the man she loved in the United States, which demanded that she should in nowise either adorn her person or make herself fascinatingly agreeable."

Minna and Jack would not be denied. They married in July 1889 at the evocatively named Prides Crossing in Massachusetts. Nine months later they had a son, Victor Emmanuel Chapman; a second son arrived three years later in November 1893. Jack worked on Wall Street as a lawyer and was left alone in New York for long stretches while Minna and the

babies stayed with family in Italy or Massachusetts. He loathed the law and preferred philosophy, politics, and literature—all of which appealed to the Chanler sisters. He became a staple at their dinner parties in New York and Rokeby, a brilliant addition to their table. And then, inexorably, as if brought together by forces beyond their control, he and Elizabeth drifted into a passionate romance. They recognized something in each other: they were kindred, damaged souls. They were survivors. "I have played chess with the powers of darkness steadily day & night and beaten them," he wrote to Elizabeth on June 25, 1895. "I have suffered vivisection—& not flinched." Having both passed through dark torments of body and soul, they shared a bond. He could see into her heart. After a dinner party one winter night in 1895 during which Elizabeth was clearly depressed—"way down in Hades and could scarcely make conversation"—he penned her a note. "There is a certain cut fate has for us—against which there is no defence—namely the misfortunes and unhappiness of other people," Chapman wrote.

Their dozens and dozens of letters, some of them twenty pages long, grow ever more intimate. The "My dear Miss Chanler" eventually morphs into "Elizabeth darling" and "my beautiful Elizabeth."

"I love you & am with you in spirit," Jack blurts out just after Christmas in 1894. He counts the days when he will see her next and fears missing any opportunity he has to visit. Sunday noon on February 17, 1895, he writes as if to prepare himself for disappointment:

My dear Miss Chanler

What is going to happen is this—I leave a card at 2:40 at your house & shall be told you do not receive till 5 & as I have to go downtown I shall not see you for a week. . . . But you are here always & forever. We will have no partings & deathbed scenes & attempts to sum up & deliver the whole treasury of human thoughts & feeling which the word parting suggests—You are to be always here—And you will ask me to Rokeby will you not.

Their letters simmer with desire and frustration, volleying back and forth like "a sort of electric wire." One moment Jack says they have no need to see each other physically as their connection is of a higher metaphysical order: "The air is full of spirits—shuttlings through the universe & riding on the spider filaments of reminiscence." But sometimes those filaments don't suffice and he has an animal craving to *see* her, to *be* with her. In the evening he often went to the Century Association on 43rd Street, the grand, all-male club in Manhattan. There, fellow members like Stanford White—whose firm had designed the grand Renaissance Revival clubhouse—gathered for drinks and blustery talk. Jack sat at a remove, huddled over a table with paper and pen, scribbling pages to his beloved. Perhaps he was fueled by a few stiff drinks, as the handwriting sometimes deteriorates and the letters begin to ramble. Still, there is no doubting the depths of his feelings. On the night of October 3, 1895, he writes from the club that in her absence he feels as if he is "gasping for air or water." She is in Paris at the time, impossibly far away.

For all the passion and love in the letters, there is also a strong spiritual current. Jack writes to Elizabeth that when he first set eyes upon her he felt a "blessedness" in her existence and saw "all the Light Life shining out of you." Elizabeth had been schooled to bend to God's will, no matter how unfair or inscrutable the events in her life had been. All those lectures she'd heard from cousin Mary Marshall at Rokeby, and the Sewell sisters on the Isle of Wight telling her over and over again that life's sorrows were all part of God's plan. Perhaps her relationship with Jack was also the work of God. If so, she and Jack were helpless to resist. Elizabeth experienced a joy and an awakening she'd never known before.

In an impetuous moment in 1895, Jack sent Elizabeth the sonnets he had written for his wife. Minna was in Italy at the time, off with the children, but upon her return she asked her husband for the poems. Jack wrote to Elizabeth, then in Paris, begging her to return the sonnets. Elizabeth was enraged. She burned all of his recent letters. When Jack received her "big letter with death in it," he was beside himself. How

could she do such a thing? The letters were "holy things . . . a part of my soul. . . . Those letters were my memorial and part of me—the veins in the body—you have burnt them—" He begged for an explanation and prayed that she'd at least kept the ashes. In a single day he wrote her three separate letters from his Wall Street firm and the Century Club, alternating between professions of love and anger. When he got home that night there was a cable from Elizabeth saying "so sorry." He was incensed. That was all she could say? Your cable "sounded like cracked china," he wrote back. "You are a shallow pan . . . a flighty shallow girl." Letters and cables flew back and forth across the Atlantic. Where is my Elizabeth? Jack wanted to know.

The drama and accusations led to a long-distance reconciliation. By the time Elizabeth headed back to the States in October 1895, she and Jack were desperate to see each other and more passionate than ever. It would take six long days by ship from Liverpool to New York. Jack wrote in care of the Cunard office on Bowling Green so that Elizabeth would be handed his letter the instant the boat arrived, saying he'd try to meet her at the dock.

Minna, conveniently, was in Massachusetts with the children. She was often away. That held risk, as there were women, among them Elizabeth, who found Jack's smoldering good looks and intellectual intensity appealing. "How is it you dare to go off to Europe and leave every woman in New York ready to fall on my neck?" Jack wrote supposedly in jest to Minna in January 1895, when she and the children were in Italy. "Knowing my weakness of highly organized and contemptible flirtations, you don't think I'll indulge in them?" Clearly she didn't think he would, and the least likely candidate for a love affair was the saintly Elizabeth, her dearest friend. Nonetheless, Elizabeth and Jack's furtive relationship remained secret until suspicions arose at a Chanler family event.

On October 27, 1896, the youngest Chanler sister, twenty-three-year-old Alida, married the dashing Temple Emmet. (Like most of his set, Emmet was a gentleman lawyer/sportsman, with the emphasis firmly

on the latter.) Two hundred family and guests boarded a special train from New York City, which converged on Rokeby for the celebration. It was a Tuesday. Stanford White (referred to as "a kind, gay pagan" by a Chanler in-law) served as impresario, orchestrating the event to the tiniest detail. The morning wedding ceremony was co-officiated by Henry Potter, Bishop of the Episcopal Diocese of New York, in the picturesque church near Rokeby that had been built by an Astor forebear. Entering the Carpenter Gothic church, guests passed beneath an archway of evergreens and brightly colored autumn leaves. The local country folk, who more or less served as dutiful peasants in Hudson Valley's feudal society, had erected the wedding archway in honor of Alida.

A grand wedding breakfast and reception followed at Rokeby. The festivities went on all day. Tapestries festooned the exterior of the mansion, Neapolitan mandolin players strolled among the guests, and a popular Hungarian orchestra provided dance music. Revelers danced in a canvas-covered pavilion that Stanford White had built for the occasion.

Jack had written Elizabeth weeks before the wedding, telling her that he was coming solo, as Minna was pregnant and due to give birth in just a few months. Rather than rush home after the reception, Jack asked if he could stay on for an extra night at Rokeby to spend some time with her.

Anticipating her sister's marriage—and her reunion with Jack— Elizabeth had gone to the very fashionable Mme. Macheret's shop on East 23rd Street and purchased a "crimson chiffon dinner gown and blue silk blouse waist." (*Crimson!* The Sewell aunts would have been appalled.) Her purchase amounted to $150—over $4,000 in today's money. The brilliantly colored dress would match the autumnal landscape and would surely be noticed by Jack. During the reception, or in the dark hallways that night, Margaret Chanler came to the shocking realization that her older sister—the one supposedly destined for spinsterhood and fated never to experience sexual passion—had found love after all. But it was a forbidden love that Margaret determined to destroy, because it defied all conventions of society and religion.

Margaret confronted her sister and convinced her to pack up. They would leave together for a long voyage to Ceylon (present-day Sri Lanka), India, and Japan, so that Elizabeth would forget Jack. The Chanler sisters stopped in London to pick up letters of introduction from their influential friends before traveling to the British colonies in South Asia. They received entrees to the leading tea estates in Ceylon; to experts on the education of Indian women (a subject of particular interest to both Elizabeth and Margaret); to the head gardener at the Taj Mahal who would give them a personal tour. Aboard the steamship RMS *Valetta* they sailed through the Mediterranean, traversed the Suez Canal, suffered from seasickness, and celebrated Christmas dinner with their fellow passengers by holding hands and singing "Auld Lang Syne." The regular voyage from London to Ceylon, the tropical island off the southern coast of India, took roughly a month. After landing in the capital city of Colombo, the sisters soon went to a Buddhist monastery where Elizabeth conversed with monks through an interpreter. They attended an exhibition of Buddha's tooth, and made an arduous trip through dense jungle to reach the ancient holy city of Anuradhapura, where a cutting from Buddha's "tree of enlightenment" has grown for several thousand years. An ancient order of high priests protects the leaves from monkeys eager to eat them.

Limp or no limp, Elizabeth wanted to go off the beaten track. In India, a British general plotted an itinerary for them from Madras to the Khyber Pass, a route of nearly two thousand miles. Elizabeth kept a diary of their Indian travels; she said it was for her friend Minna Chapman. Elizabeth noted the exotic sights and colors of the country: "Women's skirts and *saris* glowing reds and blues. Anklets of brass half way up the leg like a stocking"; "great fields of lovely pink opium poppies"; houses nearly covered with bougainvillea vine; water palaces and "a marvel of balconies, gratings, balustrades, domes and minarets"; "hundreds of savage bristling boars" being fed with corn to fatten them for the Maharaja's hunting pleasure; elephants and "great peacocks the size of life." Diamonds

and rubies were seemingly everywhere. Even a trip to the armory was impressive: the swords were gold and encrusted with extravagant jewels.

By March the heat was becoming oppressive, and Elizabeth, whose fragile health was always a concern, was growing weary. She and Margaret retreated to Calcutta. There they received a cable from their sister in New York with shocking news: *Minna Chapman was dead.* After giving birth to her third son, Conrad, on the day before Christmas 1896, Minna developed a blood clot. Though bedridden, she seemed to be improving; but on the evening of January 25, 1897, while Jack was reading aloud to her, Minna suddenly sat upright and then collapsed, dead. She was thirty-five years old. Jack's three children—the youngest an infant, the oldest only six years old—were now motherless. Elizabeth knew how that felt. As soon as she got the news on March 3, 1897, she wrote Jack:

> God help you—And help us all for the light has gone out of the world. We are coming home. . . . I want to stay close to everybody I love forever more—Those children—and you—How can this world go on—Darling Jack

Jack insisted that she stay in India, that he would be all right. Elizabeth couldn't be stopped. Over Margaret's objections, they crossed the Indian continent to Bombay (present-day Mumbai) and caught the fastest steamer available. The sisters arrived in New York on April 7, and Elizabeth raced to Jack's side.

According to late Victorian convention, Jack would remain in "deep mourning" for a year after Minna's death. He'd have to dress in black with a mourning band on his hat—the so-called widower's "weed" that would indicate his status to the world at large. Social calls, theater, and other amusements were off limits for at least six months, and a romantic attachment—at least one openly displayed—would be scandalous within a year's time. If he conformed to a "perfectly formal line of con-

duct," in Elizabeth's words, Jack couldn't remarry for at least two years. Those were the rules.

Elizabeth and Jack secretly shared a correspondence of the grandest, most heated, and forbidden passion. She kept all of his letters locked up at Rokeby so that her siblings wouldn't find them. She told Jack to tell her when he received each one of her letters lest it was unaccounted for and fell into the wrong hands. In the summer of 1897, Chapman brought his children to the seashore on the main coast of Rhode Island—close enough to Newport, where Elizabeth would be staying, so that the pair could meet. Conanicut Island in Narragansett Bay, reachable by steam ferry, was the perfect midpoint. Elizabeth could slip away for the day and no one would know (though she feared that her sister Alida was already beginning to get suspicious about her relationship with Jack). Four hours alone on Conanicut. Such joy!

Jack teased her about her enjoyment of all the "mystery and clandestine meetings. . . . You shall have all the fun of it. I'll wear a cloak and give the countersign, evade the eyes of hotel clerks, pass you in public, and leap through your casement to the sound of twangling instruments." It was all very romantic, but brief encounters and letters were not enough to sustain her. Sitting beneath a tree on a breezy August morning in Newport, Elizabeth wrote passionately, "I crave more <u>habit</u> of you Jack—I need the close waking & sleeping intercourse of every moment of life. . . . And this living apart in our bodies delays that day,—though it must be going to make it more perfect when it comes. . . ."

In New York they met surreptitiously in out-of-the-way places like the Paulist Roman Catholic church on Tenth Avenue. Surely, no one would recognize them there. But on one occasion, Elizabeth dared to rendezvous with Jack at Grace Episcopal on lower Broadway, a religious outpost for their own social set. Jack had been writing poetry of late and

he read some to her in church. She was so enthralled by his presence—
"these blessed visions of your bodily nearness"—she could barely hear
the poems. Their being together was all that mattered—"It was less than
two hours, but it held days of fulfillment & verification. . . . For when I
am away from you my own, all joy & peace seem prophesies of our meet-
ing. And so they are." She was transported with love, "my soul all full
of you." Elizabeth wrote this in New York City just before setting off
for Rokeby, where she was to spend the fall, but she assured Jack that
"every field & wood & brook will shine with you! Bless you, bless you
my treasure—God keep us. . . ."

It was essential that Elizabeth go to Rokeby, but she couldn't tell Jack
why. A family scandal was brewing. The Chanler siblings were hunkered
down, bound together with a secret only they knew. Though Jack was in
the dark, he sensed something was wrong and asked about it in a letter.
She refused to tell him. While away in India, Elizabeth and Margaret's
oldest sibling, Archie, had been placed against his will into Bloomingdale
Asylum, a mental institution in White Plains. Two of his brothers had
signed the commitment papers. Stanford White, Archie's friend, helped
lure him unsuspectingly to New York City. Family friend Theodore Roo-
sevelt, then police commissioner of the city, helped lay the trap. Archie
was arrested and clapped into the asylum, with a diagnosis that would
keep him there permanently. The family put out a story that Archie was
out of the country and so far no one had divined the truth.

Madness ran in the Astor line, beginning with the family patriarch's
eldest son, John Jacob Astor II, who had been afflicted with debilitat-
ing mental illness and referred to as an "imbecile." Archie was certainly
eccentric—among other things he believed that he could turn his face
into the death mask of Napoleon, and that he had psychic powers from his
so-called "X-Faculty." Nonetheless, he was highly functional. He was
putting the finishing touches on a mill town called Roanoke Rapids that
he had created in the middle of the wilderness in North Carolina. Stan-
ford White designed the textile factory and workers' houses; he was also

an investor in the enterprise, as were all the siblings. And there was the rub. Archie was spending money recklessly on the project, and the family's Manhattan property, the bedrock of their fortune, was being mortgaged to the hilt to create a potential textile empire. The project was way over budget, and Archie was showing signs of mania. Not an unusual trait in a Chanler—they were all manic to some degree, and several of the brothers could easily have been deemed "insane"—but money was involved, family money, and lots of it. The brothers lost patience. Archie was locked away, and the textile project basically abandoned and written off as a loss (though the industrial town later became hugely successful, proving Archie's prescience).

Elizabeth learned of her thirty-four-year-old brother's plight when she arrived home from India. She went to see him in Bloomingdale Asylum. It was a genteel establishment for the rich—the grounds were lush and campus-like, tea was served every afternoon from a monogrammed sterling silver tea service—but, as Archie pointed out to Elizabeth, there were *bars* on the windows. He was imprisoned. As a trained lawyer, he knew his rights and said the law had been bent to suit his siblings. By the end of their meeting, Archie became convinced that even sweet, loving Elizabeth—as yet, the only sibling to visit—was part of the cabal against him. He sent her away and told her never to return. She was crushed, but felt she had to trust the judgment of her brothers who'd had Archie committed.

Elizabeth retreated to Rokeby with her own romantic secret. She was completely preoccupied with Jack. She wrote longingly to him that upon walking into the house it had "a honeymoon fragrance that makes me feel you by me at every turn." The very smell of Rokeby summoned up "the vision of half forgotten things . . . all throbbing with life." While her bathwater was being drawn, Elizabeth wandered into the billiard room where she and Jack had spent time alone the previous spring. Three happy weeks he'd been at Rokeby. Just walking into the billiard room brought it all back—it felt "like a great wedding chest holding a dense

condensation of every hour we have spent there—It was almost an over powering outburst . . . like hanging on a precipice in heaven."

She waited anxiously for his daily letter that seemed to her like a "Christmas stocking" that left her "guessing what's inside before daylight." She was sleepless thinking of him, and wrote him long, yearning letters. She wanted to visit him in the city, but there were unnamed people coming to Rokeby who might prevent her leaving. Perhaps it was the family lawyers.

Word about Archie had hit the headlines. A *New York Times* reporter—a morphine addict confined to Bloomingdale Asylum—had the professional good fortune to cross paths with Archie in the hospital. Archie was only too happy to narrate his story, and he asked the journalist to smuggle out a letter laying out his pitiful situation. What a scoop! Once released from the hospital, the reporter broke the news of the Astor scion's whereabouts. A headline in the October 14, 1897, edition of the *Times* read:

MR. CHANLER NEEDS REST
CAUSE OF THE WELL-KNOWN NEW YORK
CLUBMAN'S COMMITMENT TO BLOOMINGDALE.

SOME QUEER HALLUCINATIONS
THE FORMER HUSBAND OF AMÉLIE RIVES
BREAKS DOWN MENTALLY AND
IS PLACED IN AN ASYLUM BY HIS NEAREST FRIENDS.

Archie had been locked up at Bloomingdale for seven months. The article quoted brother Willie, the egocentric African explorer, who tried to put the best spin on the situation: "[Archie] has a splendid constitution, and there is every reason to expect that with rest he will cease to suffer from the nervous exhaustion which has been his trouble." In an attempt to contain the situation, Willie warned his sisters not to speak about it.

But the *Times* reporter had Archie's side of the story and that was juicy enough. He detailed Archie's vehement legal objections to his institutionalization; he also provided an insider's view of Archie's peculiar room at Bloomingdale—among the furnishings were two portraits of Napoleon and a miniature roulette wheel. (Archie claimed that he'd figured out a way to beat the house at Monte Carlo.) And then there was the sordid business of Archie's earlier misbegotten marriage to the scandalous bestselling novelist Amélie Rives, their subsequent divorce, and other public embarrassments, all of which the journalist rehearsed yet again. It was all very titillating and extremely embarrassing for the Astor clan, who were very concerned about the family's image. (That being said, the Chanlers were not the only branch of the family to flout social mores. The entire line of Astors begat one delicious marital scandal after the next, leading cousin Daisy White to opine that "the Astor blood seems morally unsteady in the matrimonial line.")

The news leak about Archie was bad enough, but rumors had also begun to circulate about Jack and Elizabeth's relationship. The siblings confronted her. How could the saintly Elizabeth have put herself into such a bad light? Her brother Wintie accused her of acting as if she and Jack had been secretly married. Elizabeth wrote to Jack and told him of Wintie's accusation. (Years later she scribbled an addendum to the letter in pencil: "This implies that we had been living together, which is of course not the case. But we had had many secret meetings, & unequivocal love making, & this amounted to marriage in my eyes.") Wintie threw up his hands: do what you like, he told her, but either marry him, and the public be damned, or stop seeing him. Margaret, the most sensible but most judgmental of all the siblings, served as an emissary from the family. She was going to meet with Jack and thrash it all out. Elizabeth begged Jack to be diplomatic: "I only ask one thing about your talk with Margaret & that is that you don't horrify her with any revelations of the past that would be more than she can stand." Apparently they came to an understanding.

Elizabeth and Jack married quietly on April 24, 1898, in the parlor of Margaret's townhouse. Only a few family members were in attendance, and, as it turned out, no one in New York took much notice. The newspapers referred to it as a "war wedding," as war had just been declared between the United States and the Spanish in Cuba. Clubmen throughout the city were signing up for the action, making the quick wedding seem a part of the race to go to war. Wintie described the wedding to his absent wife: the nervous bride carrying orange blossoms, the men with lilies of the valley in their buttonholes. The bride and groom were overwhelmed—"Bess was simply going to pieces and Jack looked like an undertaker." After the ceremony there was a luncheon and toasts to good health—and lots of talk about war. Elizabeth's brother Willie and her brother-in-law Temple Emmet came to the wedding directly from the recruiting office; Margaret spent a good deal of time on the telephone trying to arrange a boat to Key West with the Red Cross (she eventually got as far as Puerto Rico, where she tended to the wounded).

To everyone's amazement, and fright, Elizabeth got pregnant. All believed she would never survive childbirth, but it was Jack who faced disaster. In March 1901, a matter of weeks before she was to give birth, Jack had a complete mental and physical breakdown.

At age thirty-nine, Jack was one of the country's great intellects, a prolific literary critic, and a political gadfly. He detested the corruption of the political process by money and, to fight it, he became a leader of the Independent Party. When his old friend Theodore Roosevelt ran for governor of New York in 1900 on the Republican ticket, Chapman felt betrayed. He took potshots at Roosevelt; in turn, Roosevelt memorably referred to Chapman as residing "on the lunatic fringe." The former allies didn't speak again for nearly two decades. The intensity of Chapman's life—bitter political infighting; nonstop lecturing, writing, and lawyering; anxiety over his wife's condition and concern for his three young sons—all became too much for him. His mind abruptly stopped working. While giving a talk in a small town near Philadelphia he could no

longer comprehend the questions being asked by the audience. "The crisis came with a crash," he later reported. He was helpless. He believed he couldn't walk. He suffered harrowing hallucinations. The Chanlers resorted to putting him in a darkened room at Rokeby, in the mansion's tower, which rose above William B. Astor's grand octagonal library and boasted a magnificent view of the Hudson and the distant Catskill Mountains beyond. Chapman didn't see a thing. The blinds were tightly drawn because even a sliver of light pained him.

Elizabeth gave birth to a son, Chanler Armstrong Chapman, on April 26, 1901, in New York City. "Armstrong" was in honor of her mad brother Archie—née John Armstrong—who had been left to molder in the insane asylum. As soon as Elizabeth was permitted to travel, she hurried to Rokeby with the infant. Elizabeth now had three stepsons—eleven-year-old Victor Emmanuel, seven-year-old John Jay Jr., and four-year-old Conrad—a new baby, and a deranged husband. The infant was christened at Rokeby. Jack was carried downstairs for the event, though he may have been unaware of what was taking place, and then whisked back up to his personal asylum. He remained immobile, curled up in the fetal position, unable to feed, bathe, or dress himself. This went on for nearly a year, until he began to crawl around on all fours. A trained nurse tended to his every need. The family shrank from the idea of institutionalizing Jack, considering it too cruel. (The Chanlers hadn't been so magnanimous with Archie, but money was at stake that time.) All could see that Jack was not sane, but one brother-in-law made light of his condition, saying that the patient was merely "imaginative." Jack later described his hellish existence and how he felt like the prisoner in Edgar Allan Poe's "The Pit and the Pendulum," who was strapped to a board and had a lethal scythe above him, swinging back and forth, moving ever closer. Jack believed he had to lie perfectly still to avoid annihilation.

Elizabeth understood confinement and pain only too well. During Jack's prolonged infant-like state, she remained even-keeled and

compassionate and stood by patiently. She prayed for his recovery. When her prayers went unanswered, she turned to a Christian Science healer—a short, redheaded woman named Emma Curtis Hopkins who invariably wore a black satin dress and a matching hat or veil. Elizabeth's sister Margaret described Hopkins as a "a mystic to whom this world and the next were one." Elizabeth paid the healer a salary and expenses. She also promised her a lifelong annuity if she could cure Jack. What real affect Hopkins's businesslike commands had on Jack is uncertain, but Jack slowly emerged from his illness, and the healer earned her annuity.

When Jack could finally abide sunlight, Elizabeth had him carried outside to the garden where she'd sit with him for hours, holding his hand. She had his legs regularly massaged, and eventually he began to walk on crutches. A small carriage with a wicker seat was fitted out with a mule named Clara Barton, after the founder of the Red Cross, so that Jack could take short drives around the estate. Elizabeth thought a change would do him good, so on one occasion they ventured as far as the Catskills, spending several nights in a house atop a mountain. When he was called from his room to witness a magnificent sunset, he was overcome by its beauty.

In the fall of 1902, Elizabeth arranged a trip abroad, reasoning that such a "jounce" might awaken Jack fully. They traveled with a large entourage—in addition to Jack and Elizabeth and the four children, there were five servants, including a tutor. Elizabeth thought that the beauty and culture of the Old World would revive Jack's spirits, but when she brought him into a magnificent Italian church he was overcome once more. He could scarcely control his emotions. As time passed Jack's moods stabilized, and after Christmas he was able to shed his nurse. His appetite for art returned. Come spring, Elizabeth and Jack amused themselves by collecting paintings and beautiful objects for the house they were planning to build next to Rokeby. They had expert advice in that regard, as they were spending much of their time in the company of their

friends Bernard Berenson, the most famous art connoisseur of the day, and Lionel Cust (later, Sir Lionel Cust), who was then the director of the National Portrait Gallery in London.

When the summer heat in Italy became oppressive, the Chapmans moved to an enchanting mountain valley in the Austrian Tyrol. "Absolute heaven," and "the most blessed place on earth," Jack declared. Though he was still on crutches, Jack took his two eldest sons, Victor and Jay, and their tutor, on an excursion to Römerbad, a spa town about ninety miles away. In letters to Elizabeth during early August 1903, Jack reported on their activities: They had enjoyed a concert set in a grove of trees; Jay, not quite ten years old, had gone bowling on the green with some Austrian friends. Jack had a particular soft spot for Jay—such a beautiful child, with a sweet disposition, and an artistic flair. Elizabeth, who planned to study the violin, wrote that she was thinking of buying a Stradivarius. Jack sent along some tongue-in-cheek advice, ending with, "How smart I am. I'm just the kind of man that always gets cheated."

The next news from Jack came in the form of a telegram: "Jay drowned this afternoon. Body not found. The Lord gave and the Lord hath taken away. Blessed be the name of the Lord." On August 13, the tutor had taken the two boys to a swimming hole fed by a river, and he had left them briefly to check on their bicycles. In an instant, young Jay had slipped into the rushing waters of the river and disappeared. It took two days before authorities recovered his body. Jack was inconsolable, but it was as if an electric shock had been administered to him. Jack threw away his crutches and told Elizabeth it was time to go home. He was cured. They made the sad journey back to the States. The trip seemed interminable, traveling as they were with Jay's body, and customs officials stopping them along the way. Young Jay was buried next to his mother, Minna, in St. Matthew's Episcopal churchyard in Bedford, New York.

Back home, Jack didn't want anyone to speak of Jay. The pain was too deep. For the next two winters Jack took refuge alone. He moved by himself into Edgewater, a temple-like, 1820s Greek Revival house on the

edge of the Hudson that was part of an estate and farm that he and Elizabeth had recently purchased next to Rokeby. (The Chapmans planned to build a new mansion on higher ground on the property, on a bluff above the river.) Though charming, Edgewater was a warm-weather retreat, unheated, and considered uninhabitable in the winter. The newly bearded Chapman, biblical in appearance, stayed by himself in the frigid house, swathed in furs like an Eskimo. Elizabeth and Chapman's son Victor would stop by regularly to check on him. Jack made acquaintance with local eccentrics, including an elderly man who lived on a houseboat nearby. Chapman, the erudite man of letters, visited the boat frequently. What on earth do you talk about? Elizabeth asked. "I don't talk to him," Jack said, "I just sit there." Then what do you *think* about? Elizabeth persisted. "Oh, I keep wondering whether the black things in his beard are melon-seeds or cockroaches."

While secluded, Jack studied music, immersed himself in philosophy and religion, and corresponded with Harvard philosopher William James. Elizabeth put up with her husband's antisocialness and shielded him from unwanted visitors. Over time he returned to his literary pursuits, while Elizabeth—an accomplished poet and artist whose work was little known beyond her circle of family and friends—took over the management of their new Georgian mansion above the Hudson. They named the house Sylvania and moved into it in 1905. Elizabeth ran the farm and household, tended to the children and their education, and kept a watchful eye over her troubled husband. Though she had recurring bouts of illness and increasing difficulty walking as the years went by, Elizabeth could never escape the role of maternal caretaker that she had inherited as a child. She remained the glue that kept her unstable husband intact.

In 1909, at the age of forty-three, Elizabeth became pregnant again. After a joyous pregnancy, Elizabeth delivered a stillborn daughter in August 1910. Buried amid the hundreds of letters that remain at Rokeby is a faded manila envelope. On the front of it, in fountain pen, an unidentified hand has written:

Letters of Condolence

received August 1910 . . .

for Elizabeth to glance at <u>before destroying</u>

Inside the envelope are letters and telegrams from fashionable addresses—
Pointe-au-Pic in Canada, Tuxedo Park, Lenox in Massachusetts, Long
Island, Bar Harbor in Maine, Wall Street, neighboring estates in the
Hudson Valley—with messages expressing grief over Elizabeth's latest
loss. Elizabeth would have no more children.

With Elizabeth providing ballast and much needed stability, Jack's lit-
erary career revived and brought him renown. A photograph taken on
June 21, 1916, shows two men remarkably similar in appearance: about
the same height and age, sporting full gray beards and mustaches, in aca-
demic caps and gowns. One man, however, is missing a left arm. The
photograph depicts John Singer Sargent and Jack Chapman after com-
mencement ceremonies at Yale. Sargent had just received an honorary
doctor of arts, and Chapman an honorary doctor of letters. It was a joy-
ous occasion. Jack wrote to his mother the following day, describing the
pomp and ceremony and the praise he received while being introduced to
the crowd: "I've been *discovered*, by Jove! . . . They had a mace as big as a
Lord Mayor's and gold chains and robes. John Sargent looked like Titian.
. . . It was all very noble."

The next day, back home at Sylvania, Jack was stopped by the head
farmer. A reporter from Poughkeepsie, hoping to elicit a comment for
a news story, had called the farmer and asked him to relay a message
to Chapman: Jack's eldest son, twenty-six-year-old Victor, a volunteer
airman fighting for France before the United States entered World War
I, had been killed behind enemy lines. Jack appeared so unfazed by the
news that it was as if he'd expected it. He went to the house and found

Elizabeth in the library. "Victor has been killed," he said matter-of-factly. His firstborn son was dead.

Victor, the first American aviator to die in World War I, became a national symbol of bravery and idealism. A member of the Lafayette Escadrille, Victor had shot down four enemy planes, and been downed himself a number of times. A photo of the young aviator taken just days before his death shows him next to his plane with his head bandaged. Despite the nasty head wound, Victor took off on an errand of mercy— flying oranges and chocolate to a sick comrade in a hospital not too far away. When he came unexpectedly upon a dogfight in which his fellow aviators were outnumbered by Germans, Victor dove into the action. A member of a reconnaissance plane later said he'd seen Chapman's plane get hit and that "it had dropped like a stone."

As the parents of the first martyred American, Elizabeth and Jack had to grieve publicly. There was a memorial service at Trinity Church in New York. All stood for the playing of "The Marseillaise." Letters poured in, among them one from Bernard Berenson, who wrote to Jack from Florence on July 3, 1916:

> I have just heard that your son Victor was killed a few days ago fighting for a cause he elected to make his own. I can not easily conceive a finer end. To die for one's own [country] is something, to die for another because it happens to be fighting for justice & freedom & humanity, is a thousand times more. I confess I feel vicariously sancified [sic] & saved by a death like his. . . . [F]or him at the bottom of my heart I have congratulations only. . . . [For you] there is no compensation, no consolation. I can give you my sympathy for what it is worth.

A pacifist in previous wars, Jack became apoplectic over U.S. neutrality and heaped a stream of abuse upon President Woodrow Wilson. He ranted in letters to the *New-York Tribune* and other newspapers, and con-

tributed an article to a pamphlet titled *The French Heroes*. When Wilson finally did declare war, Jack published the long poem, *Ode on the Sailing of Our Troops for France: Dedicated to President Wilson* in the November 1917 edition of the *North American Review*. Wilson, perhaps relieved that Jack's caustic pen was stilled, wrote a personal note to Chapman saying that he'd read the ode to his family not once, but twice, and they were delighted with it. Conrad—the only surviving son from Jack's first marriage—served in the Navy during the war. But Elizabeth and Jack refused to let seventeen-year-old Chanler sign up for duty.

When war with the Germans was finished, Jack began waging his own private wars. He harbored a particular hatred of Catholics, whom he deemed antidemocratic, so the rising New York Catholic politician Al Smith became a favorite target. Even Jack's alma mater came into his crosshairs. In 1920 when a Catholic was elected a Fellow of Harvard—a rich New York lawyer whom Jack described as "high up in the Cathedral gang"—Chapman was livid. He feared that the Roman Church was intent on controlling education, even at Harvard. Jack announced he would prefer being "nailed to the cross" to seeing "any line of connection between the Pope, Cardinal O'Connell, and the Harvard Board of Fellows." At times he focused his rage on the so-called "Jewish menace," and in a sonnet titled "Cape Cod, Rome, and Jerusalem" he managed to merge his fears about both religions. The poem was published in the Ku Klux Klan's *National Kourier*, surely a low point in Chapman's literary career. Jack's unhinged religious crusade blinded him to the evils of the KKK. (He was, after all, a proud descendant of abolitionists and a fierce opponent of lynching.) In 1925 he wrote to a British poet: "The K.K. are all right. They are the only healthy-minded people in the country and while they have the lamentable simplicity of mind that seems universal in America their lunacies seem to be confined to *foolish names*."

Elizabeth focused her attention and advice on their son, Chanler. He needed it. Like his father and his namesake Uncle Archie, he took delight

in outraging others. At St. Paul's exceedingly buttoned-down boarding school he organized prizefights for money, sold firearms, and was told by the schoolmasters he had "the wrong attitude." He used that phrase as the title of a memoir he later wrote about the school. Harvard came next. A cousin recalled that Chanler ran a gambling den with some partners, taking in hundreds of dollars a week. The booze ran freely, thanks to a bootlegger, and the prep-school types who frequented the place would stagger out in the middle of the night.

Elizabeth offered much counsel to her son, most of it useless. While he was taking wagers, she was speaking to him of poetry. Robert Browning had been her favorite poet as a young girl; she held him in "worshipful reverence," she wrote. "I hear, now, that the youth of the world sees nothing in him to admire, that his day is past, & that he never was a real poet anyway." She was concerned that Chanler was following the wrong poets, was set on the wrong path. "The analysis of my obsession is as follows: you, yourself have great trouble to express your own thought clearly. You have turgid maelstroms in your brain, like those storms in the Aeneid . . . I do want you to carry the thought of beauty & symmetry & rhythm in your dreams, waking & sleeping, for they are the qualities toward which you need to bend your gaze." Later her advice became more practical. He had given up drinking and carousing—at least temporarily—when she urged him to brighten up his room and make it "a bower, not a cell." With the letter she sent along fabric from India and Florence to festoon the walls, and also a check to buy new blankets. She warned him not to get red ones as they'd clash with the wall hangings. Beauty, she believed, was always a tonic.

Elizabeth didn't understand the new world of the 1920s and '30s. She and Jack were relics from a world of books and art and high culture. A niece later recalled making solo visits to Elizabeth, who discussed highbrow topics and read "Shakespeare and such stuff" aloud. The young girl was bored to tears. She hated those visits, but her mother, Margaret, insisted. Elizabeth, with her Old World manners and breeding, was

decidedly out of step with the next generation. She was a product of Miss Sewell's, not the current Jazz Age; modernism held no charm for her.

Elizabeth and Jack cocooned at Sylvania in summer, and headed south to Sanibel Island or Charleston for the winters. Elizabeth's health required it. Jack eventually grew tired of his religious crusades, and wrote instead of the ancient world and American culture, winning praise for his final books. The lion that had bellowed through life, quieted in old age. He died on November 4, 1933, several days after surgery for liver cancer. He was seventy-one years old. Elizabeth, at his bedside during his final days, heard him repeatedly murmur, "A soldier lay dying, a soldier lay dying." When she leaned closer she realized he was reciting the opening lines of the ballad "Bingen on the Rhine":

> *A soldier of the Legion lay dying in Algiers*
> *There was lack of woman's nursing, there was dearth of*
> *woman's tears . . .*

His voice brimming with emotion, Jack replaced the ballad's next line with one of his own, telling his devoted wife: "But there is lack of nothing here." After his death a card was found in his room. On the front was an image of a Fra Angelico angel. On the reverse, Jack had written: "Elizabeth came with a book in each hand. In her left hand she held the mind of the world and this book she gave first. In her right hand she held the heart of the world and that she gave me and the hand that held it." For all its tempests, their marriage was a merging of hearts and minds.

Not long before he died, Elizabeth and Jack had moved into a cottage they'd built on the property at Sylvania. They named the house Good Hap, and intended to spend their remaining days there. They turned the big house over to their son, Chanler, his wife Olivia (a grand niece of Henry James), and their children. Chanler was an ongoing trial to his mother, who despaired over his failure to settle on a career. He had

worked briefly as a police reporter for the *New York Times* but found that crime "bores the hell out of me." He yearned for adventure, but instead became a gentleman farmer at Sylvania, living off the inheritance his mother dispensed before her death.

Money fueled his eccentricity, and Chanler did his best to live up to the title bestowed on him as the "most eccentric man in America." Over the years he married three times, the final time to a psychiatrist, prompting one relative to say, "It's convenient for Chanler to have his own psychiatrist in the house." He published a local newspaper called the *Barrytown Explorer*, filled with just about anything that interested him. ("Opinions come out of me like Brussels sprouts," he once said.) The newspaper's motto was "When You Can't Smile, Quit," and head-lines included the memorable KINGSTON ATTACKED BY GIANT MALL. Chanler also used the paper to dispense such priceless advice as "Close the blinds at night and lower the chances of being shot to death in bed." Guns were something Chanler had in abundance and he would fire at just about anything that moved. He later became enamored of a slingshot and carried it with him at all times, shooting ball bearings at passing cars and denting them. In the 1950s he rented a house on the estate to future Nobel laureate Saul Bellow. Bellow hated Chanler and the two of them fought—sometimes physically—during drunken dinner parties. Bellow got his revenge by using Chanler as the model for the main character in *Henderson the Rain King*. In an interview with Philip Roth, Bellow said, "Chanler Chapman, the son of the famous John Jay Chapman, was the original of Eugene Henderson—the tragic or near-tragic comedian and the buffoon heir of a great name."

Fortunately, Elizabeth did not live to see or hear all of this. She died at Good Hap on June 5, 1937, for no apparent reason. She was seventy-one years old. According to the servant who'd lived in the household for years, Elizabeth just willed herself to death. After her husband's death, she'd spent several years assisting on a volume of his collected letters. Her

work on the project was now done. The book was published to positive reviews a few months after her death, generating a new wave of enthusiasm for Chapman's work.

Elizabeth's portrait had its own eventful story. Sargent was proud of the portrait and seemed eager to hang on to it as long as possible. Not long after he completed the work in 1893, he wrote to Margaret Chanler and asked if she would permit him to exhibit the painting at the Royal Academy of London in the spring of 1894. He promised to make all the necessary arrangements for insurance and other logistics. He also told her that he'd "ransacked London for an old frame" but couldn't find one that pleased him. He'd custom ordered a frame with a scallop shell motif that would be ready in several months' time. In a subsequent note, he wondered if he could just hold on to Elizabeth's portrait—let her "peacefully hang on my walls"—until the London show, which was many months in the future. He hated to think of the painting "staying in a box in the dark and emerging lemon colour with a crop of mushrooms," he wrote. But Margaret, anxious to take possession of the painting, opted instead to have the painting shipped back and forth across the Atlantic.

In 1894 the portrait was exhibited at both the Royal Academy in London and the National Academy of Design in New York. The painting garnered mixed reviews on both sides of the ocean: the London *Times* noted its "vigourous energy" and Elizabeth's "intense intellectual" expression; but the weekly *Spectator* complained that the portrait was "dull" and that the overall "vision seems to have lost its edge a little, and the execution . . . its magic." A contemporary American artist in New York dismissed the painting as "poorly, hastily conceived." Nonetheless, it made the rounds to other cities in subsequent years—to Philadelphia, Boston, Charleston, Washington, Pittsburgh. But as interest in Sargent waned,

and as modernist critics derided his work as hopelessly old-fashioned, the painting gathered dust at Rokeby and in New York.

That is, until the day in 1963 when Chanler walked into Rokeby unannounced, took the painting off the wall, put it in the back of a farm truck, and drove away. One family member, watching, was stupefied. But Chanler couldn't be stopped. He had the right. His Aunt Margaret, who died in March of that year, had given Chanler 50-percent ownership of the painting during her lifetime, with the understanding that it would remain in place until after she died. Then the portrait would be entirely his. Having claimed his prize, Chanler removed the portrait's elaborate scallop shell frame chosen by Sargent, which still bore exhibit labels from the 1890s on the back of it, and stored it in the attic at Sylvania. He hung the painting—now in its simple inner frame—on the mansion's dining room wall, where it remained when Sylvania was rented out. Chanler had gone through all his money, so in the 1970s he announced he was going to sell the family heirloom to the highest bidder. Naturally, some family members protested vehemently. Of course, that was part of the fun for Chanler. His half-brother Conrad, a more reasonable sort, was recruited to dissuade him. Conrad had an inspiration. Why sell it and have to pay taxes on the painting, he asked Chanler, when you can probably donate it to the Smithsonian and avoid paying income tax for the rest of your life? Gyp the government of taxes? Now there was an idea that appealed to Chanler, and he boasted about it ever after. And so, in 1980 he donated the painting to the Smithsonian American Art Museum, where it currently resides at the heart of their Gilded Age collection. The original scallop shell frame was eventually rescued from the attic and reunited with the painting. And Elizabeth's christening silver from her godmother, *the* Mrs. Astor, is exhibited next to the painting in sacramental splendor.

CHAPTER FOUR

The Collector

She is not a woman, she is a locomotive—with
a Pullman car attached.

—Henry James on Isabella Stewart Gardner

THIRTY-FOUR-YEAR-OLD Isabella "Belle" Stewart Gardner lay stretched out on a couch at the back of the *Ibis*, the boat her husband had hired for a trip up the Nile. It was Christmas Eve, 1874. Frankincense perfumed the air. Belle watched as the Egyptian helmsman bent his forehead to the deck in prayer; meanwhile, a child took charge of the boat. The day had been busy: going ashore at Fascna (such a "dear little village" she wrote in her travel diary), and visiting the ancient fortifications on the hills of El Haybee where fragments of mummies were scattered about. Those bits of preserved flesh and organs had unnerved Belle—but by evening her thoughts were as gentle as the river itself. The here and now seemed to vanish, and she even forgot it was Christmas Eve. The moonlit evening transported her back in time, creating, she wrote, "a fit path by which my thoughts went straight to Cleopatra."

Her idle reverie had more than a little justification. Cleopatra used to sail on the same river in a golden barge. Ruthless and resourceful, she

seduced both Julius Caesar and Marc Anthony to solidify her political power. Cleopatra was the very definition of ambition and beauty, and, in her lifetime, Belle was compared to her. A young American woman was once heard to say she had waited over an hour to see the notorious Belle come out of a theater because she's as "wicked as Cleopatra."

Belle was an imposing figure—and ambitious. Like Cleopatra she lived for drama, creating lots of it in her lifetime, taking pleasure in outraging the sensibilities of Puritan Boston, her adopted hometown. But Belle was not at all beautiful. She was short and plain. She had light-colored hair, such a pale complexion that she wore veils outdoors, piercing dark blue eyes that resembled "blue icicles" when angry, and a low theatrical voice with a "delicious caress" in it.

Belle carried herself like an empress. She loved beautiful things and swathed herself in the most expensive fabrics and jewels. As time went on, she also collected some of the world's greatest art, nurtured some of the world's most gifted artists—John Singer Sargent among them—and built arguably the most fascinating and eccentric house museum in America.

Belle's life seems to have the neat structure of a three-act play. Act 1: High-spirited young girl, reined in by conventional marriage and disapproving society, is nearly crushed by tragedy. Act 2: Seeking an escape, the heroine sets off on a series of adventures around the world and reinvents herself. Act 3: The heroine revels in her notoriety, breaks all the rules for how a proper Victorian woman should act, and becomes a media sensation. Against all odds, she creates a veritable cathedral to art that doubles as a home for herself and a gift to the world at large. Having risen from the ashes, she overcomes tragedy and emerges triumphant.

Of course, Belle's life wasn't quite that simple. Her mercurial temperament—vain and egotistical one moment, deeply religious and

generous the next—makes her a difficult subject to pin down. She left behind a long trail of letters and travel journals, but also selectively burned big chunks of her correspondence in the hope of controlling her image beyond the grave. This was a woman who demanded control. In another era she might have been a corporate CEO, admired for her decisiveness, grit, and personal flair. As a collector, she'd be spoken of in the same hushed tones as the plutocrats J. P. Morgan and Henry Clay Frick, who created house museums in New York—but with much more money than she had. Belle's outrageous personal behavior, the manner in which she gaily thumbed her nose at the grim blue-blood society she married into, has, at times, obscured her brilliance as an art patron and collector. It's impossible *not* to portray Belle as a larger-than-life, colorful "character." She was a character, and seemed to encourage the scandalous rumors that circulated about her, whether they were true or not. (Apparently, all publicity was good publicity, in Belle's view.) Yet she was extremely serious. An intellectual in an era when women were discouraged—if not banned—from intellectual pursuits, Belle became an incomparable aesthete and patron of the arts. Blessed with a large fortune, she used it to ferret out some of the world's most beautiful art and curiosities, an eclectic and personal collection that she housed in a Venetian palazzo of her design. The official architect, Willard Sears, hardly mattered. It was *her* vision, *her* decisions.

As her palace rose out of an empty swampland in Boston, it was like seeing a mirage appear amid desolation. The fortresslike exterior is largely unadorned and pedestrian. The interior is breathtaking. A colonnaded walkway circles a sunlit courtyard with balconies and windows transported from Renaissance palaces in Venice. The central space is filled with flowers—and, during Belle's lifetime, birds as well. There are three floors of art, and the placement of every single piece is fixed forever. According to Belle's ironclad will, absolutely nothing in the museum can be changed. If the curators move a piece of furniture or a canvas even a foot from its preordained spot, the entire collection will be put up to auc-

tion in Paris with the proceeds going to Harvard. The arrangement of the entire museum is sacrosanct. It's like an enormous jewel box or collage— all of it Belle's creation.

Born in New York City in 1840, the eldest child of four, Belle came from humble, but entrepreneurial stock. Her grandfather ran a bar in Brooklyn. Her father, David Stewart, a second-generation Scotsman, owned a lucrative linen import business until he began to sense other possibilities in the nineteenth-century industrial boom. New railroads and the Erie Canal expanded opportunities to ship goods to and from New York City. Stewart got into the mining business, establishing the Stewart Iron Company near Uniontown, Pennsylvania. He amassed a fortune—not Vanderbilt or Astor money, but rich by any other standard. Tales of the Gold Rush in California stirred Belle's imagination (she was a precocious nine-year-old when gold was discovered), so when her father visited there he got her five coins fashioned out of gold. Belle's first treasures, the coins were stowed away in her childhood pocketbook—the beginning of her collecting habit.

One of the great influences in Belle's early life was her paternal grandmother and namesake, Isabella Tod Stewart, a formidable character. A longtime widow, Grandmother Stewart lived on a large farm in Jamaica, Long Island, where Belle spent summers. The youngster ran away from the farm one day after she'd been told she couldn't attend the traveling circus in the nearby town. Her grandmother's tall black butler, a very dignified figure in Belle's memory, tracked her down and swooped her up just as she was crawling under the circus tent. She was dragged home, wailing, her will thwarted.

Belle's mother had less success than the butler in subduing the willful Belle. Her mother sought advice from a clergyman on how to handle her headstrong daughter. He supplied two Bible storybooks, both of which proved useless. One day Belle was spanked after she took off her

shoes and walked home in her stocking feet from the very grand, very high-society Grace Church on 10th Street and Broadway where the family worshipped. Belle's action was considered an unpardonable breach of decorum; the young girl couldn't care less.

The Stewarts lived in a three-story brick home on University Place that included a room dedicated to gymnastics. Belle was tutored in calisthenics and learned how to do cartwheels and handstands. The unfulfilled hope was that the calisthenics would stretch the young girl and make her taller. When she heard the sound of drums coming from around the corner at Washington Square Park, then called the Parade Grounds, she knew that the Seventh Regiment was marching. With or without her parents' permission, she'd dash over to see the splendid pageant. Young boys flocked to the edge of the grounds, mimicking their swashbuckling heroes. From an early age, Belle got the message that boys had more freedom, more fun.

Like other upper-class girls in New York, Belle was educated by private tutors and in the parlors of respectable women. She learned dancing from a Frenchman, and other refined skills such as piano playing and drawing. At sixteen her parents brought her to Paris for finishing school. There she could acquire the sheen of Old World sophistication, an important ingredient in attracting a suitable marriage partner. After Paris, Belle and her parents traveled to Italy, where Belle studied Italian and flirted shamelessly with her young teacher. In Milan she found inspiration in the Museo Poldi Pezzoli, a palace featuring a private art collection. She told a friend that if she ever acquired enough money, she would do the same, filling a house "with beautiful pictures & objects of Art, for people to come & enjoy."

The European interlude worked its magic. Shortly after her return to America, Belle became engaged to the brother of an American schoolmate she had in Paris. His name was John Lowell "Jack" Gardner Jr., scion of one of the wealthiest and most socially prominent families in Boston. Over six feet tall with a dark, drooping mustache, Jack was con-

sidered the most eligible bachelor in Boston. Young women all over Beacon Hill gnashed their teeth over the interloper from New York scooping up such a prize. They never forgave her.

Not having been born into their society, Belle would never be able to count herself a true Bostonian. When she was eighty-three years old and had lived in Boston for over sixty years a friend wrote to Belle in jest, "How do you like Boston anyway?" as if she were new to the place. The so-called Brahmin class in Boston—the WASP aristocracy that dated back to colonial times and whose lives centered around Harvard, a few choice clubs, and people who shared a handful of bloodlines—was extremely insular and considered themselves superior to even the richest New Yorkers. In their estimation, New York was all about money, excess, and ostentation. Boston, however, was the "Hub of the Solar System" (thus christened by the writer Oliver Wendell Holmes Sr.) and the "Athens of America."

The Proper Bostonians, Cleveland Amory's classic dissection of Brahmin society, opens with an illuminating story. Bank officials in Chicago, considering a young Bostonian as a possible employee, contacted the venerable investment firm of Lee, Higginson & Co. for a letter of recommendation. The Boston firm sent a glowing report, citing the young man's peerless lineage: his father a Cabot, his mother a Lowell, his bloodlines intertwined with Peabodys, Saltonstalls, Appletons, and other grand Boston families. The young man couldn't be better qualified. Not long after receiving the recommendation, the Chicago firm replied that they were grateful for the response, but that they were seeking a different sort of information in evaluating the prospective employee. After all, they wrote, "we were not contemplating using Mr.—for breeding purposes." That in a nutshell was Boston.

Even New Yorker Elizabeth Chanler Chapman, an Astor by birth, found Brahmin society slightly daunting and claustrophobic. In 1923, she wrote from ultrafashionable Prides Crossing on the North Shore, near one of the many Gardner houses:

Sweet Son—

Here we are in the heart of the New England nobility. Everybody related to everybody else. "Weave a circle round them thrice, to keep his holy stock in-bred" . . . In listening to their conversation one never hears a last name mentioned. It is always Aunt Fanny & Cousin George. As a result, we have in Boston as bona fide an aristocracy as exists anywhere in the world,—a definite Court Circle—. . . These people are an absolutely unmixed race. Their voices, glances, gestures, modes of thought resemble those of no other race in the world. And, my! aren't they distinguished! . . .

Others took a slightly dimmer view of the Brahmin set. Nineteenth-century novelist Constance Fenimore Woolson found herself surrounded by Bostonians in Venice and discovered that they had an "immense security about themselves" but that they were as a rule, "cold, cold, cold. . . . They are stiff. They never gush, and hate gush. They have an inborn belief that Boston 'ways' are by far the best in the world, and secretly they think all other ways vulgar."

On April 10, 1860, four days before her twentieth birthday, Belle married Jack and moved to Boston. Her mother gave her a copy of *A Lady's Guide to Perfect Gentility*, which Belle promptly ignored. As a wedding gift, her father bought the newlyweds a lot on Beacon Street and built them a house. Belle and Jack were pioneers in the trendy new neighborhood of Back Bay. At the time it was also the epicenter of construction and noise. The area, literally a tidal bay—hence its name—was still being filled in with gravel. All day long, railcar after railcar dumped rocks to create new real estate.

Belle's entrance into Boston society was chilly, to say the least. All the Brahmins gathered in the autumn of 1860 for a gala ball honoring the visit-

ing Prince of Wales. Belle, a wonderful dancer, was not shy about showing off her skill—or her sense of style. The day after the ball, a description of her outfit—a green moiré dress, a velvet headdress, and flashy diamond jewelry—appeared in a Boston newspaper. What would have been a coup in New York was social death in Boston. Drawing attention to oneself was considered very bad form in this New England culture.

The young New York bride was conspicuously *not* invited to join a single "sewing circle," a Brahmin version of an exclusive sorority—in this case, a group of women clustered around a particular debutante. The elect would gather to lunch and gossip, and maybe even sew a few stitches. (During the Civil War the sewing became more serious.) The hierarchy of sewing circles absolutely defined social status in Boston. The *New York Times* ran an article about that "peculiar social institution" in 1888, noting: "From time to time, as strangers come to town, by marriage or otherwise, they are, if judged worthy, admitted to the sewing circle which is deemed most appropriate to their age and standing. Not to be admitted to these mysterious coteries is a species of social ostracism of which the severity is perhaps fully appreciated only by the native-born Bostonian." Belle fell into the "unworthy" category, barred from entry.

Belle endured this social slight, despite the fact that the Gardner family boasted some of the bluest blood in the Hub. Jack's mother was a Peabody; his brother married a ninth-generation descendant of John Endecott (also spelled Endicott), the first governor of the Massachusetts Bay Colony. They were related or intermarried with some of the grandest names in Boston: Lowell, Russell, Loring, and Sears. The Gardner men, of course, all went to Harvard, though Jack didn't make it through, dropping out after his sophomore year. (Harvard belatedly conferred a BA degree upon him in 1898, forty years after he should have graduated.) The family shipping business owned a large fleet of sailing vessels with names like *Arabia* and *Nabob* that ventured to the East Indies, China, and Russia, returning with precious cargoes of tea, ginger, saltpeter, shellac, indigo, and cloth. Pepper from Sumatra was a particular specialty. The

Civil War, with its Union blockade and Confederate privateers, turned shipping into a risky business.

When President Lincoln called upon the young men of Boston to volunteer for the Union, neither Jack nor his two able-bodied brothers took up arms. Boston was a hotbed of abolitionism—not so in the Gardner household. Their business interests led the Gardners to take a rather conciliatory view of the South; they had been among the minority in Boston who opposed Lincoln during the presidential election. They had southern connections: Jack's grandfather had lived for a time in South Carolina; Jack's sister married Joseph Randolph Coolidge, a descendant of Thomas Jefferson. All three Gardner brothers managed to avoid the war even when a draft was put in place. An August 23, 1864, letter from Jack to his younger brother George notes the new enterprises the family was expanding into—railroads and manufacturing companies—and also assures George that the family had procured a substitute to fight in his place. He doesn't mention how much the mercenary cost (though a Gardner in-law recalled paying $785—about $15,000 in today's money—for the privilege of sitting out the war), but he assures George that his replacement "is safe on board the receiving ship." Avoiding the draft while other young Bostonians, including many Harvard men, were fighting and dying for their country put the Gardners in a rather awkward position. Belle, though in her twenties during the war, later claimed to have absolutely no memory of the conflict. Perhaps it was a case of selective memory.

The fact that the Gardners remained on the sidelines during the war certainly did not help Belle's social status. Shunned by the first families of Boston, the once-vibrant firebrand turned inward. But the woman who had once run off to the circus showed flashes of her old self—skating gracefully in the Public Garden, riding horseback at the Gardners' summer place in Brookline, and, on the rare social occasion, still attracting too much attention on the dance floor.

And then she became pregnant. On June 18, 1863, she gave birth to a son, John Lowell "Jackie" Gardner III. A photograph depicts a smiling Belle nuzzling the neck of nine-month-old Jackie. By November 1864, the proud mother boasted of her toddler's growing vocabulary and clear diction. Four months later, Jackie died of pneumonia; he was not quite two years old. Before he was buried, Belle dressed him for the last time and brushed his hair. A lock of Jackie's fair-colored hair was saved and kept with a miniature portrait of him, which was inscribed with the dates of his birth and death. As the years went by, Belle never mentioned her son, though she'd go into seclusion on the anniversary of his death. Within months of Jackie's death she became pregnant again, but miscarried.

Weighed down by a prolonged depression, Belle turned to her doctor for advice. Get away with Jack, he advised her. Try to forget. In the spring of 1867, Belle—still such an invalid that she was brought downstairs on her mattress—was transported to the dock by ambulance, and carried on board ship. New worlds now opened up for her.

Belle and Jack arrived in Germany on June 10, 1867, and then pressed on to Scandinavia, where they ventured north to the edge of the Arctic Ocean to see the midnight sun. On they went to St. Petersburg, Moscow, Vienna, and Paris. Two months in Paris transformed Belle's look, and also Belle. She found her way to 7 Rue de la Paix, the salon belonging to Charles Worth, the designer who virtually invented haute couture, the artisan whom Empress Eugénie dubbed "le tyran de la mode," the marketing genius who probably introduced designer labels on dresses. The most fashionable women in the world rushed to his doors in liveried coaches.

He was quite autocratic—"half merchant, half Venetian doge"—and would snub anyone he didn't fancy. Emerging from his workroom in a dressing gown, Worth took one look at Isabella, sized up her eager-to-please husband with his very deep pockets, and decided that she would make a fine client. She might be plain, but her figure was pleasing. He had a soft spot for American millionaires—he dressed Vanderbilts, Astors, Carnegies, and their ilk. They were, according to him, "the best customers he has—far better than queens. *They* ask the price; American women never do. They simply say, "Give me the best, the most beautiful, the most fashionable gown.'" One of his ball gowns could cost ten thousand dollars—and would be worn only once.

Returning to America, Belle now appeared around Boston in her new Worth creations. No more hoop skirts for her, though that cage-like costume, designed to hide the fact that there was even a body beneath it, was still in vogue in the Hub. Instead, Belle wore a shocking new walking suit that accentuated her figure, revealed six inches of leg, and showed off her handmade kid shoes and colored stockings. Boston matrons frowned. Tongues wagged over her provocative, low-cut gowns. One evening a staid old Brahmin crossed paths with Belle as he was leaving a party and she was arriving fashionably late to make a dramatic entrance. At the sight of her he reportedly blurted out, "Pray, who undressed you!" And she countered, "Worth. Didn't he do it well?" This was just the sort of conspicuous display of wealth—and flesh—that New York millionaires reveled in, and from which Boston Brahmins recoiled. If New England society didn't approve of her and the way she dressed, all the better in Belle's view. She became a fixture at social events and a favorite dance partner for eligible bachelors and not-so-eligible married men.

Jack's mother was impressed, if somewhat guardedly, by Belle's nonstop socializing. "She is every day and evening in Society," she wrote to another son, "[her] powers of endurance are beyond anything I imagined." Mrs. Gardner Sr. tried to put a good face on the rather shocking fact that Belle went to theater parties and other events in the presence of

young men—but without her husband: "I think it is a real blessing that J [Jack] is spared some of the demands upon his time and powers of digestion that Belle is required to perform." Indulging in such a frenetic social life would interfere with his business obligations. That sanguine view of Jack wasn't shared by onlookers, however. Belle surrounded herself with a group of young male aesthetes, most of them gay. One of them wrote of Jack as a kind of "subordinate, comic, errand-boy" for Belle. Though he was an important personage in his own business world, he and his wife's lives were quite separate, "like royal spouses occupying opposite wings in a palace, they had their own exits and entrances, their own hours and their own friends."

More travel beckoned. A trip abroad might last a year or more in the era of steamships. Though prone to seasickness on the open ocean, Belle willingly endured the weeks of shipboard misery. Jack on the other hand, savored the ocean crossing itself as a respite from business and other cares. To his brother he described cold, foggy weather—not much different from Boston in April—adding, "there has been no storm to interfere with my happiness." Perhaps he did not mean typhoons but the storms of his wife. With Belle sequestered in their stateroom, Jack enjoyed life on deck, reading, relaxing, chatting at dinner with the other passengers and the captain, who remembered his brother from a previous journey. Jack was almost disappointed as they approached landfall during one trip abroad, fearing "the best part of the fun is over."

For Belle the fun was just beginning. She loved the *sensation* of travel— the sights, the sounds, the colors, the fragrances; the religious ceremonies so different from the pallid church services in Boston; the native art, decoration, and costume; and the people themselves. She became a student of the world, creating elaborate journals of her travels—twenty-eight volumes of them, chronicling the various trips she took from 1867 until 1895.

In addition to her running text, the travel albums burst with illustrations and ephemera: beautiful watercolors Belle painted of papyrus reeds, lotus flowers, ancient Egyptian ruins, and sailing vessels on the Nile; commercial photographs of famous temples, sumo wrestlers, a tattooed man, geishas plying their trade, and a photograph from Texas of two men hanging from a gallows that she captioned "San Antonio Justice"; pressed flowers and leaves; menus, theater tickets, and pamphlets she picked up along the way. Everything was of interest to her. She had an insatiable impulse to explore life and to curate beauty.

Belle and Jack kept parallel journals of their four months in Egypt in 1874 and 1875. Jack, convivial but hardly a romantic, focused on such things as the distances they covered each day on their Nile travels and the troublesome fleas in their hotel in Cairo. He'd brought a camera but couldn't quite make it work. Belle, the romantic one, fell into enchantment with the land of Cleopatra—its dreamlike colors, its silent desert, its camels and donkeys, its storied past, and its people who seemed to have "stept out of the 'Arabian Nights.'"

"Oh the grace and beauty of the men and oh their gorgeous clothes!" she wrote. "From the Princes of Persia to the barber's son, what graceful languor and what perfect postures."

In mid-December Belle and Jack took a carriage to the Pyramids at Giza with three women travelers. To Belle's annoyance, additional carriage loads of mainly American tourists were at the site as well as an Arab guide. When they moved on to the nearby Sphinx, she separated herself from the crowd and found an isolated spot. Fully dressed in Victorian garb, Belle lay down on the sand to soak in the whole atmosphere. It was at that moment, she wrote, that "solemnity and mystery took possession and my heart went out to the Sphinx." She scooped up some sand and saved it. Afterward, she reported, they had lunch "with 40 centuries looking down upon us." She shared some of her food with the dogs and the begging children who trailed after them.

Belle craved excitement. Before departing on their Nile cruise, the

Gardners went to the Mosque of the Howling Dervishes in Cairo to witness members of that Muslim religious fraternity perform their ritualistic, ecstatic dancing. Belle described the whirling dancers who drove themselves "into a perfect frenzy," some nearly fainting, one foaming at the mouth. She'd never seen anything like it.

For their cruise, they hired and outfitted a *dahabeah*—a shallow-bottomed sailboat resembling a barge, the type of vessel used on the Nile since the time of the pharaohs. Their quarters included a parlor, dressing rooms, bathrooms, and a "sky parlour," which they sumptuously furnished with Turkish rugs, couches, awnings, and plants, where the rich Americans could survey the passing scene. (A fellow tourist noted that new furniture was an "incalculable" advantage in that climate "where vermin are not rare.") Belle waxed poetic over the sight of palm trees on the shore and the silhouette of camels plodding across the desert, but she also enjoyed spying on the crew members as they crouched in their colorful robes and turbans, making strong, sludgy *café turc* over an open fire, and chanting. She admired the great care they took with their turbans "always washing them, fingering them and helping each other to wind their heads up in them." The crew—"a very jolly set," in her words—loved to sing, sip coffee, and smoke hashish. But when the dry khamsin wind blew in from the desert, "filled with sand, the puffs coming as a fiery furnace," the mood changed among the men and a terrific fight broke out. The fighting overflowed onto the riverbank and the men dispersed; the captain and the dragoman, the Gardners' official tour guide, couldn't restore order until the evening cool descended. Tempers flared on another occasion between the crewmen of the *Ibis* and another boat and it was Belle who intervened then. "I was obliged to take away their weapons with my own hands," she wrote.

After months on board ship, the crew members became a kind of second family to Belle. She wrote in her diaries of her favorites: the sweet young "cookboy" from Nubia named Alee; the very handsome Abdul Mulee who was the master of all trades onboard ship; and the solitary

figure of "Rei," meaning "captain," who crouched all day and night on a corner of the deck in silence, wrapped in layers of cloaks. One day, however, he suddenly emerged from his somnolence, leaping up, and crying *temseh*—or crocodile. Belle then got her first look at that grotesque scaly creature as it slithered into the Nile.

A monkey, housed in a claret box and named "Coco" by the crew, was adopted by Belle during the trip. The pet wandered freely around the boat getting into mischief. One day Coco made off with one of Rei's precious cigars and tried to eat the old man's breakfast. "When she couldn't be satisfied by dipping her fingers into the dish, she sat in it and had to be slapped and tied up." A sheikh onboard one day, deep in conversation with the Gardners, was unaware that the monkey was carefully examining and peeling back layers of his skirts. Belle could barely contain her laughter, waiting at any moment for Coco to bite the sheikh's uncovered leg.

"Arab swells" entertained the Gardners when they stopped at various points along the river. Belle described a visit to a prominent sheikh whose retinue included two slaves. One slave had a "white napkin embroidered with gold" on his shoulder; the other carried a tray covered with a red velvet cloth "embroidered and fringed with gold." Beneath the velvet cover were glasses containing sherbet. Belle wrote of the serving protocol: "Slave no 1 handed me a glass, which I sipped; then the napkin for my lips—and on to the others. By and bye [sic] came coffee—same performance." The Gardners invited the sheikh and his friends back to the *Ibis*. "And we started, I between two Arabs, leading the procession, with guns, spikes, battle axes and poles."

Belle loved such pageantry, but she also commiserated with the havenots. (The poor in her own country did not trouble her quite so much.) The Egyptian government was, in her words, "tyrannous," toward the common people, with taxes "levied under the lash," and forced conscription into the military. During the Gardners' voyage it was "conscription time," and Egyptian agents scoured the countryside looking for men

to fill the ranks of the army. There was no set term of service; once drafted, a soldier was sent to far-off regions and likely separated from his loved ones forever. When agents approached villages, the population emptied as all the young men fled into the desert to hide. Fathers were arrested and tortured for information on the whereabouts of their sons. If they didn't tell the authorities, their soles were beaten—a type of torture called *bastinado*—and if they continued to resist, the fathers were paraded naked down the street. (In her diaries Belle took a particular interest in the exquisite forms of punishment meted out around the world, from hangings in the American West, whippings by policemen on the docks of Hong Kong, chaining criminals to ancient gates in China, and crucifying those condemned to death in Canton. Belle and Jack toured the "Execution Ground" there, saw crosses leaning up against a wall, and even met the executioner.)

While the *Ibis* was moored in Luxor, the ancient city of Thebes, conscription agents were prowling nearby. On their final day, the Gardners visited a temple and the home of the American Consul. Nubar Pasha, one of the most powerful politicians in Egypt (a few years later he became the country's first prime minister), was also a guest. Nubar and Belle fell into conversation on the balcony, each one charmed by the other. But when she and Jack returned to the *Ibis*, they witnessed the arbitrary cruelty of the government. Conscription agents were trying to force their way on to the boat to capture one of the sailors who was hidden below deck. In a dramatic moment, the Gardners' dragoman defied the authorities and prevented them from boarding the ship. The *Ibis* set sail immediately.

Belle imbibed everything around her: the people, the landscape, and all the sensory pleasures. Her Egyptian diary records sunsets softened by the haze of the desert sand; groves of palm trees "with the earth more green than it was ever painted elsewhere"; women walking gracefully with water jars atop their heads; naked or barely clad monks swimming up to the Gardners' boat ("I hope they were as innocent of sin as of clothes," she wrote). She gazed on Cleopatra and Caesarion, her son

by Julius Caesar, in relief portraits on the wall of the Hathor Temple at Dendera. Coming upon a crumbling grotto with Technicolor decorations dating back thousands of years, she sat with her diary and made a watercolor of one of the decorative patterns. "The Desert, the rocks and the air were exactly tuned to my nerves. It was the most delicious thing I ever felt. . . . And all the time the wonderful mirages, that were not less real than everything else; it actually seemed an enchanted country and . . . once I saw an Efreet [a supernatural creature in Arabic folklore] rise in the cloud of sand"; "we had truly 'come abroad and forgot ourselves.'"

Nights aboard ship were so quiet that "when the Muezzin's call to prayer was wailed through the air . . . the tears would come." Taking a small boat to the massive rock temples of Abu Simbel at night, she wandered through its inner passageways with lighted candles until "the moon rose directly opposite the Temple, in at the very door so that all the lights were put out and the great hall was the strangest thing I have ever seen with its shadows and ghostly light. . . . I felt our way into the inner room and seated on the knees of the stone gods watched the moon through the distant door of the Temple. . . . Then we went and I climbed onto the foot of one of the Colossi and we feasted our eyes once more on the wonderful place."

As the boat headed south into Nubia (now northern Sudan and southern Egypt), the voyage grew more dangerous. The calm waters turned swift, with narrow channels, rocky outcroppings and islets, and white water rapids, or cataracts. A group of *shellalee*, or cataract men, came on board. For generations—perhaps back to ancient times—this group had the monopoly on piloting boats through the tricky labyrinth. "The Shellalee were like the inmates of an insane asylum let loose," Belle wrote. As many as fifty of them crowded the deck of the *Ibis*, maneuvering the boat with ropes and cables in an incomprehensible manner, with "universal shrieking, howling, and cursing in choice Arabic." One day when the men were positioned on rocks, pulling the *Ibis* through treacherous waters, a fight broke out and they dropped the ropes controlling the boat.

The group leader restored order by jumping "up and down, waving a stick and shrieking." Somehow, the boat managed to stay upright.

The *shellalee* piloted tourist boats only when the river was low, generally from November to March. Inevitably, dahabeahs stacked up waiting their turn through the series of rapids. There were weather delays, wind delays, and delays due to status. The *Ibis* was shunted aside when Prince Arthur, Queen Victoria's third son, arrived with a fleet of boats and the waterway was cleared for the royal duke. There was also the problem of fickle hired help. Having passed the first "gate," or narrow point, the Gardners were stranded when their pilot jumped ship to work for a German prince.

Though some travelers were exasperated by the seemingly endless delays during their voyages, Belle found it liberating. The clock had stopped. "Strange to say one can't feel very actively impatient [when] there is such a delicious laziness in the atmosphere," she wrote. By day there were expeditions into the outback, and at night much socializing among the select group of American, English, and European aristocrats. Belle and Jack hosted the German prince who'd taken their pilot. The aristocrat was very apologetic. The Gardners also exchanged visits with an American eminence—George B. McClellan, the former Union commander and the Democratic presidential candidate who lost to Abraham Lincoln in the 1864 election, much to Belle and Jack's disappointment.

During one dinner aboard the *Ibis*, conversation came to a halt at the sound of piercing cries from the opposite bank of the river. At around ten o'clock that night, Belle and her companions went to investigate the screams. The father of their *shellalee* pilot had died. In the darkness, a single light shone upon a group of dancing women "who looked like witches—one arm, and shoulder bare, hair disheveled, heads and bodies covered with sand and dust—each with a long stick and dancing up and down, singing to the beating of a drum." And throughout their dance, "that fearful death cry" went on and on. The next day she and a few others attended the funeral, watched as the body was wrapped in

a red cashmere shawl and placed atop a bier. Howling dervishes rolling their heads surrounded the corpse. Relatives wandered about wailing and throwing dust on themselves. The widow, set apart from the others, performed a solo dance while dressed in her dead husband's fez and red coat. Belle and her companions went to a reception afterward at the family's home. Chairs were quickly brought out for the foreign visitors and coffee served while the mourning cries and dancing continued. The *shellalee* pilot, grateful to Belle for having come to the house, shook her hand and thanked her. Belle was struck by the extraordinary events she'd witnessed and in her diary entry the next day she wrote, "I mustn't forget a superb looking woman at the funeral, who leaned on a long sword and was a very Judith," the smoldering Old Testament widow who saved Israel by beheading their enemy's commanding general.

It took a month for the Gardners to navigate the cataracts and reach the southern end of their journey. On the day they were to turn around and make the reverse trip to Cairo, Belle and Jack woke before sunrise for a pilgrimage to Abouseer, a two-hundred-foot-high promontory looking out over Nubia and the cataracts and rock outcroppings of the Nile. They arrived at the base of the bluff and climbed to its summit. The rock walls were etched with names of tourists who'd preceded them; several of the names they found were friends of theirs. While Jack scratched "Gardner" into the wall to mark their visit, Belle was more pensive. "I had the top of the mountain all to myself," she wrote, "and there was nobody to laugh at me for being absolutely unhappy because our journey was over and our faces were to be turned to the north even in ½ an hour." Not long after their Nile voyage, Belle and Jack left Egypt with the purchases they had made—and with her vials of sand.

The Gardners continued on to the Holy Land, Greece, and Turkey. When they arrived at their hotel in Constantinople in mid-July 1875, several telegrams were waiting for them. Jack's older brother Joseph, a widower, had taken his own life (he "blew his brains out," in Henry Adams's description), and left behind three sons—Joseph "Joe," four-

teen; Amory, eleven; and Augustus "Gus," nine. The Gardners made their way home, pausing in Paris long enough for Belle to buy some mourning gowns at Worth's.

Belle and Jack returned to Boston and took over the care of their three orphaned nephews, all of whom were "religious types" who had "inherited a supernormal sensitiveness of nervous structure." Belle raised them with a degree of seriousness and care that perhaps surprised even her most fervent critics in Boston. According to one of the boys' friends, she enforced a discipline and training "as one connects with the idea of a British nation." Belle taught her towheaded nephews how to ride bareback and survive a fall or two without turning fearful (after all, one had to get back on the horse in order to succeed); she went to all of their sporting events; she brought them to the symphony to encourage their interest in music; she read Dickens aloud to them. While the eldest was preparing for Harvard in 1879, she took the two younger nephews to England and France, for a summer of touring cathedrals—perhaps in deference to their religious leanings. Their tour was briefly interrupted by sporting events such as the Oxford-Cambridge cricket match and the Ascot races.

While overseeing the education of her nephews, Belle grew interested in filling in the gaps in her own knowledge. She yearned to understand more about the Old World and its treasures. Drawing on the brainpower at Harvard, she turned her house on Beacon Street into a serious salon for intellectuals. In the late 1870s, Charles Eliot Norton, Harvard's first art history professor and its resident genius on Dante and Italian culture, became Belle's muse. She attended his lectures and was invited to join the Dante Circle that met privately in his study at "Shady Hill," his rambling Cambridge home. Norton greatly influenced Belle with his vast knowledge, as well as his aesthetic snobbery. (He was particularly enamored of the Gothic cathedrals of the Middle Ages, so the joke went around Harvard that upon entering heaven his response would be, "Oh! Oh! Oh! So Overdone! So garish! So Renaissance!")

Belle became a devotee of Dante—and her devotion to the medi-

eval Italian poet increased when a handsome young man named Francis Marion "Frank" Crawford arrived in Boston in late 1881. Raised in Italy, the newcomer shared Belle's passion for Dante. Crawford would read the poet's work aloud to her in her sitting room. Years later, as a gift for Belle, Crawford had their individual copies of Dante's *La Divina Comedia* interleaved. The book, bound in green leather, has two silver clasps inscribed with the words, "The two are one." The inner cover has a silver and enamel display of flowers and curling stems within a quatrefoil—a design created by Crawford and produced by Tiffany.

The six-foot-two unmarried Crawford was a gorgeous physical specimen, a terrific athlete, and a boxer—all of which added to his allure. Perfectly proportioned and vain about it, "he would pose before a mirror quite openly," according to a Boston cousin, "rejoicing in his strength and beauty like any other vigorous young animal." (Belle's husband, Jack, on the other hand had grown rather portly.) Though he was fourteen years younger than she was, Belle carried on a rather conspicuous flirtation with Crawford. Even the Boston newspapers reported that Belle was seen "chandeliering" with him on the dance floor—that is, making a spectacle of herself.

Crawford was at a crossroads in his life, and Belle encouraged him to write fiction. She read early drafts of his first novel, which was set in India, where Crawford had lived for a time editing a newspaper. He'd studied Sanskrit there and become fascinated by Buddhism. He told Belle about the wonders of Asia and before long the two began plotting a trip to the Far East—with Jack in tow to pay the bills. Rumors spread that Belle was having an affair with Crawford. In a sudden about-face, the young man left for Italy. The Gardners—armed with an itinerary largely drawn up by Crawford—departed for a yearlong trip to Asia in the spring of 1883.

Belle, as usual, sought out the most unusual—and at times, most dangerous—experiences during their travels. She attended a sumo wrestling match in Japan, walked atop the walls around Peking (present-day Beijing);

ate boiled sea slugs and ducks' feet in China, and peacock in Phnom Penh. She gained special permission to visit Canton (present-day Guangzhou), which was off-limits to travelers because the locals had just sacked the foreign quarter in response to the killings of two Chinese—one, a mere boy—by Westerners. Belle wandered about Canton's teeming, narrow streets, "the spice of fear" heightening the experience. Carried on sedan chairs by sixteen bearers, Belle, Jack, and their guide took an excursion from Canton to the monasteries atop the nearby White Cloud Mountains.

In Cambodia they traveled by boat, elephants (courtesy of the governor), and buffalo carts, to make their way through the jungle to Angkor Wat, the vast twelfth-century Hindu and Buddhist temple complex, and then on to Angkor Thom, the nearby ancient capital of the Khmer Empire. They nearly got trampled when one of the elephants went berserk. At an audience with the king of Cambodia, Belle tried to impress him with her "glitter" by wearing a diamond and pearl necklace, two white diamonds in her bonnet, and a yellow diamond on her dress. The king, similarly arrayed in diamonds, an emerald, and a sapphire ring, let her know he coveted Belle's yellow diamond.

Struck by the beauty of the hand-painted sarongs she saw everywhere in Java (an island of the Dutch East Indies, now Indonesia), Belle went to a mud-floored, bamboo house to watch women make them. Three days later she visited the emperor of Java, who sat on a sofa wearing a sarong, red slippers embroidered with gold, a diamond-studded jacket, and a handkerchief on his head. Squatting on the floor around him were his women attendants, each one holding something he might need—a cuspidor he could spit in, a sword, a shield, and a cane. A group of women dwarfs were also present, while an orchestra in the shadows played the "most strange music."

Then for three months, the Gardners crisscrossed the Indian subcontinent. Jack kept track of their daily expenses, while Belle collected jewels. When they heard that the nizam, or monarch, of the princely state of Hyderabad was to be officially installed as ruler, they ignored the advice

of local officials who warned that there were neither tickets for the event nor accommodations available, and also that, as Westerners, it would be too dangerous. Hyderabad was a "hot bed of Mohammedanism" and "at a time like this Fanaticism would be rampant." Those concerns seemed only to fuel the Gardners' desire to go, and Jack blandly remarked, "I have always found hitherto that money will provide something." Indeed, they found lodgings—a tent in the Public Garden—and secured their invitations. Belle was one of only twenty-five Western women at the royal palace to witness the nizam's installation by the viceroy of India. "And really I was staggered!" Belle wrote of the extravagant proceedings—elephants pulling artillery, princes covered in jewels prostrating themselves before the nizam and offering tribute, the streets packed with Indian noblemen and their colorful retinues, the monarch being carried about on a yellow and gold palanquin and then brought into his palace by women, "for no male may enter there!"

Throughout her travels Belle noted how the women lived. She took particular delight in encountering the practice of polyandry—women marrying multiple men—in the Himalayas of India. She wrote to a Boston friend, "[Polyandry] seems to have a glorious effect on the women. Such great strapping creatures, red cheeks, covered with silver and tourquoises and much painted, and as merry as larks. One splendid specimen sat, selling her wares, with four husbands in a row behind her." On the other hand, Belle was rather shocked by the reality of arranged marriages in India. During the spring "marrying season" she encountered a score of newlyweds on the street in a single day. The husbands, in yellow, walked ahead of the brides, who wore red; their long gowns were tied together. Though a seemingly sweet scene, Belle noted that some of the brides were "small enough to be carried."

The mystery and variety of religious experiences were running themes in her diaries. In a remote palm forest in Malaysia, Belle once came upon a chanting Buddhist priest dressed in yellow. "I crept up softly—no light but the moon and the service lamps and the burning

incense, and I stood behind the priest, who never heard or noticed me. It was exquisite—but *very* sad." She also witnessed scenes hard for the Westerner to fathom: thousands of Indians, their faces daubed with paint, in a frenzy as they approached a temple devoted to Kali, the goddess of death and destruction. The faithful came carrying young goats to be sacrificed to the deity. "The place was literally washed with blood," Belle wrote. "The heads were carried in and laid before the hideous Image [of Kali], black and with three eyes, and the worshipping Hindu trotted off, bedecked with flowers, smeared with lines of paint, singing and shouting, carrying the little headless body at his side, the blood of it rubbing on to his legs at each step. It was horrible." She also watched as dead human bodies were carried to a tributary of the Ganges: "Two corpses brought in on stretchers, toes sticking up cold and stiff." And she saw other people, near death, brought to the Ganges. "It seems that to die in the Ganges insures Paradise," she wrote. Corpses were placed so that their feet could continue to be washed by the holy water of the Ganges while waiting "for a disengaged funeral pyre." Flames consumed the corpses "with Pariahs watching them and now and again shouting to the Hindu God."

A noted Boston scientist who crossed paths with Belle in India pronounced her the "perfect traveler, incapable of fear or fatigue & wishing to see everything that ought to be seen." Her letters from abroad were so vivid that Thomas Jefferson Coolidge, a relative by marriage, couldn't understand why she wanted him to destroy them. "I destroy your letters in obedience to your commands but I do it with regret," he wrote. "[T]hey ought to be collated with all the others and published." Her extant letters and diaries reveal an exquisite sensitivity and appreciation of color, texture, ritual, and spiritual practice. She experienced the world as an artist might. "Goodbye to the country of men with tattooed legs and with skirts open down the front," she wrote upon leaving Burma in January 1884. She was struck by certain images as she departed: "the stirabout of rainbows on the wharf" and a "flash of fire up to heaven from

the Pagoda." But "one little picture stands out—a woman with a long soft pink silk skirt light about her shoulders, and hanging down her back. She is holding, like Titian's woman, a large silver bowl."

Leaving India in April 1884 and heading back to the West was bittersweet for Belle. "I was very low hearted," she wrote. As the boat pulled away, the land—and all the adventures they had—began to recede. With an air of resignation, Belle ended her diary: "But that is all over now and India is going down into the sea."

When Jack and Belle had set off for Asia in 1883, their nephews were nearly grown, their futures seemingly secure. All attended Harvard: Joe graduated in 1882, Amory graduated Phi Beta Kappa in 1884, and Gus two years later. At the end of their round-the-world trip, Belle and Jack met the newly graduated Amory in London. Amory was at the end of his own trip—a gentleman's tour of England and the continent with his classmate John Jay Chapman, future literary lion and husband of Elizabeth Chanler. Chapman later recalled that he and Amory "gambolled up the Rhine like puppies at play" but that fun was limited in Paris—where they could have gotten into lots of mischief—because "Amory had the conscience of an anchorite." Amory and his aunt and uncle sailed home at the end of July. According to novelist Henry James, Belle was "in despair at going back to Boston where she has neither friends nor lovers, nor entertainments, nor resources of any kind left."

Two summers later the Gardners were abroad once more—this time with their nephew Joe. Very likely the Gardners were trying to cheer up Joe, who had fallen into a depression. (Louise Hall Tharp, one of Belle's early biographers, speculates he might have been brokenhearted over a young woman; a more recent biographer, Douglass Shand-Tucci, suspects it was over a male lover.) The three of them proceeded to Paris where they joined up with Amory, who was visiting Germany. Joe then

abruptly disappears from the record—until October 17, 1886. On that date Jack Gardner noted in his pocket diary, "Rec'd telegram . . . of death of J. P. G." Joseph Peabody Gardner—deemed "the wittiest man of his epoch" by his contemporary and friend John Jay Chapman—took his own life at age twenty-five. The details of his death remain mysterious. No more references were made about him—or, if there were, those papers were destroyed. Only a single letter of condolence remains that notes how charming Joe was.

A new chapter of Belle's life opened almost immediately. Within weeks of receiving word about Joe's death, she met John Singer Sargent in London, where he now lived and worked. The once-rising star of the Parisian art world had fled that city in the wake of the critical lambasting he suffered over a single painting—his frankly erotic portrait of Madame Gautreau (*Madame X*), exhibited at the 1884 Paris Salon. Even sophisticated Parisians swooned after viewing the painting. The strap of her gown painted so provocatively off her shoulder, as if her dress might slip off entirely at any moment (Sargent later painted the strap back into place, but by then it was too late); her skin tone so unnatural and decadent. Critics and the public alike howled: "She looks decomposed."

Belle wanted to meet the controversial artist of the moment, so their mutual friend Henry James made the arrangements. "I am writing to Sargent to say to him that we will come & see Mme Gautereau on <u>Thursday</u> at about <u>3:15</u> . . . the time being short to prepare Sargent's mind & Mme Gautreau's body," James wrote her on October 26, 1886. "I only send a word in advance to give you a timely warning & let you know that the bolt is leveled at the susceptible young artist." Sargent was trying to build a new clientele and enhance his reputation after the near disaster of Paris. A rich American woman interested in his work? "It would be doing me a very great pleasure," Sargent wrote to her, urging her to visit his studio even though "my afternoon sittings are dreadfully in the way." Belle went to the studio and greatly admired his painting of *Madame X*—even if Gautreau's outraged husband had refused to pur-

chase it. Thus began a lifelong relationship between Belle and Sargent. She became his greatest patron, and—though she could be infuriating and demanding—she became one of his dearest friends.

Charismatic as she was, Belle shared neither Gautreau's exotic beauty nor her youth; nonetheless, she wanted Sargent to paint a similarly seductive portrait of her. This says something about Belle's need to create a stir, as well as her oversized ego. She commissioned Sargent to paint her when he was in Boston in January 1888. Forty-seven years old, she wears a daring, low-cut dress that exposes an amount of cleavage not considered appropriate for an aging Boston matron. The portrait seems tame by today's standards, but the painting electrified the French critic Paul Bourget who wrote, "Her body, rendered supple by exercise, is sheathed—you might say molded—in a tight-fitting black dress." Belle's extremely pale skin practically glows in contrast to her severe dark dress. Her arms are rounded, athletic, and reveal "firm hands, the thumb almost too long, which might guide four horses with the precision of an English coachman." The painting exudes strength and physicality—attributes that a French critic might find appealing, but that Bostonians found appalling.

Belle had to know that the painting would cause a storm. She wanted to expose herself and believed Sargent was the artist who could do it. She was married and she was not young, but the portrait celebrates her sexuality, her joy in her body. The portrait was meant for public display. It was almost an invitation to the city's young men to pay attention to her (which they did). As a realistic portrait of an actual woman—someone *known* in Boston—it was certainly a provocation. How did Belle think her husband would react? The French critic, who had no puritanical scruples, went on to say that this painting might as well be called "The American Idol," as it expresses the greatness of American civilization—"a faith in the human Will, absolute, unique, systematic, and indomitable. . . . This woman can do without being loved. She has no need of being loved." Yet, she is "an idol, for whose services man labors, which he has decked with the jewels of a queen . . ."

In the painting, her jewels are eccentrically placed. Rubies adorn her barely visible shoes. A string of pearls with a ruby pendant encircles her neck and Sargent draped two more strands of pearls around her waist to accentuate her hourglass figure. These were all priceless natural pearls. (Cultured pearls had not yet been invented.) Natural pearls were considered the very symbol of wealth and power. According to legend, Cleopatra once drank a dissolved pearl to win a bet. Here was Belle wearing pearls around her waist. It was almost an affront. She stands erect before a richly patterned piece of Renaissance velvet brocade. One art historian notes that the background creates an effect of "the nimbus of an eastern divinity." But the hint of Eastern religion did not sit well with a contemporary critic who wrote sarcastically that the backdrop was "as if in testimony of [Mrs. Gardner's] devotion to the fashionable Hindoo cult."

During her sittings Belle drove Sargent to distraction. She couldn't, or she wouldn't, keep still. She kept craning her neck to look out the window and watch the boats on the Charles River. Sargent grew so frustrated that he threatened to give up the painting altogether. At dinners with friends he vented about how impossible she was during the sittings and mimicked her voice to their great hilarity.

Eight times he painted her face and eight times he scraped it off. Belle, still an avid student of Dante, assured Sargent that the ninth time would do the trick, since nine was Dante's mystic number. And so it was. The ninth incarnation was the final version. Belle loved the painting and, ever after, tried to get Sargent to agree that it was his finest work. She ordered photographic copies of the portrait to give to friends, but she had the photo studio retouch her right eye. When Belle sent Sargent the photograph he wrote back, "Some parts of it came out wonderfully well, but I disclaim any connection with the appearance of your right eye."

The painting was unveiled as part of a Sargent exhibition—his first solo show—that opened on January 30, 1888, at the St. Botolph Club in Boston, a private men's club devoted to the arts and letters whose members included the elite of Boston society. Portraits of prominent local

women—including Lily Fairchild, Caroline Mudge Lawrence, and members of the Boit family (one painting of the mother, Mary Louisa Cushing Boit, and another of the Boits' four daughters ranging in age from four to fourteen)—were included in the show. According to a checklist reconstructed later, there were twenty-one oil paintings and one watercolor exhibited, but it was the portrait of Belle that created the biggest stir. The Boston correspondent for *The Critic* ("An Illustrated Review of Literature, Art and Life") admired Sargent's "brilliant and suggestive" work. Still, he singled out Belle's portrait as verging "on caricature, as . . . [her] pose reminds one of a Japanese doll hanging from a nail in the wall." Someone suggested that the painting should be titled *Woman: An Enigma*, perhaps because the sight of all that décolletage was incomprehensible in Boston. Sargent left Boston just before the opening and was not around to shield Belle from the critical reviews. "The newspapers do not disturb me. I have only seen one or two at any rate," he wrote to her from the Clarendon Hotel in New York. "Do you bear up?"

Disapproving Boston weighed in. Even author Julia Ward Howe, Belle's Beacon Street neighbor and friend and a progressive women's rights advocate, noted that although the portrait had "great artistic merit," it also suffered from "great faults of taste." Jack—who paid three thousand dollars for the portrait—was blunter. "It looks like hell but it looks just like you," he reportedly said. A joke began circulating around the men's clubs in Boston that made reference to the earlier scandal involving Belle and Frank Crawford. Bostonians had a very long memory for indiscretions, and Sargent's portrait of her, with that plunging neckline, offered an opportunity to ridicule Belle. The joke went round that "Sargent had painted Mrs. Gardner all the way down to Crawford's Notch," a snide merging of her supposed lover and the popular New Hampshire mountain resort. When Jack overheard the joke, he was livid. He demanded that the portrait be removed from the exhibition at the St. Botolph Club and never shown publicly again during his lifetime. Belle followed his

wishes. When Sargent asked if he could exhibit the painting the following year at the Paris Salon, the Gardners refused.

Years later, after she built her Fenway Court museum, Belle hung the shocking portrait in a prominent spot in the "Gothic Room"—a space filled with sacred art. The room contains stained-glass windows, choir stalls, an altar panel by Giotto depicting Jesus as an infant being presented at the temple, and a fourteenth-century Italian Madonna and child. Nearby is Belle flaunting her décolletage. The rebel in a room full of saints. A former curator at the Gardner wrote that the Gothic Room, carefully constructed by Belle, "is in some ways the inner sanctum of Fenway Court"—the very heart of her creation; yet the visiting public was not allowed into the room until after she died.

In reality, the painting was nothing compared with Belle's own behavior, which grew more and more outrageous over time. She flirted shamelessly, danced with every handsome man in Boston, and attracted a coterie of young men who formed a kind of royal court around her. Belle made good copy. Even *Town Topics*, a New York society gossip sheet that was the *People* magazine of its day, followed her antics. In December 1887 it reported:

> "*Mrs. Jack*," as she is familiarly called, is easily the brightest, breeziest woman in Boston. Though hardly beautiful in the fleshly sense of the word, she is the idol of the men and the envy of the women. She throws out her lariat and drags after her chariot the brightest men in town, young and old, married and single. She dazzles them by her sparkling wit, her charming coquetry and her no end of polite accomplishments.

In a later edition the magazine covered a dancing party at the Gardners' that was described as "gay, brilliant, magnificent"—just like the hostess. "The beaux were out in full force, of course. *Mrs. Jack* always attracts all

the festive stags, including those who are bored to death with everybody else's dancing parties."

In a town where ostentation of any sort was frowned upon—a deep strain of Puritanism being the ruling ethos—Belle made a point of being noticed. She had a butler at home, and two liveried footmen accompanied her about town. This sort of display was unheard of in Boston. Her carriages were made in Paris and—at her insistence—her horses galloped through the streets at high speed. She made her own rules. After an enormous winter storm, she was determined to visit her friend Dr. William Sturgis Bigelow—a wealthy Boston Brahmin who shared her love of art and her interest in the Far East—despite a huge bank of snow that completely blocked his sidewalk and prevented her from getting to his door. Undeterred, she commanded her coachman to drive her horse-drawn sleigh onto the sidewalk and up to the doorway, thereby blocking pedestrian traffic. Her chutzpah was matched only by her charm. Dr. Bigelow wrote to her in an undated letter:

> My Dear Mrs. Gardner
> I am thinking of having a little medal made for you, as the "Champion All-Round Samaritan."—As a gloom-dispeller, corpse-reviver, & general chirker-up, you are as unrivalled in the fragrance of your flowers as in the sunshine of your presence. . . . I wish you would stop in again when you have a minute to spare, and exhilarate me some more.—I did not have to take any champagne the last time you came.

Belle loved sports of all kinds, including spectator sports not generally favored by women. She went to see the world-famous Sandow, the so-called perfect man who could balance three horses atop a plank that rested on his chest. It was not enough for Belle to watch such a feat. She insisted on feeling his muscles. Belle's love of prizefighters was well-known. When her carriage was stopped one day by an angry crowd of

strikers in South Boston, she leaned out the window to find out what the trouble was. John L. Sullivan, the reigning American heavyweight boxing champion known as "The Boston Strong Boy," was in the crowd and recognized Belle. Stepping forward, he told her not to be afraid, and he shepherded her carriage out from the mayhem.

Belle shared her passion for strong men with prim Boston society. One afternoon she entertained some women friends while a barely clad prizefighter posed behind a translucent screen. As legend has it, the women demanded that the fighter come out from behind the screen and flex his muscles for them. (Because of such escapades, Grace Minot and other blue bloods were forbidden to attend Belle's parties.) On another occasion, Belle orchestrated a boxing match for women spectators only. The bout took place in an artist's studio. The women cheered lustily when either fighter landed a solid punch. The bout went seventeen ferocious rounds, replete with knockdowns and blood. The losing fighter, an Irishman from Belfast, broke his hand.

Boston found itself alternately "charmed, scandalized and greatly preoccupied" with Belle. And why not? Her "unscrupulous flirtations" were the talk of the town, as was her outlandish manner of dressing. One night she "fairly stopped one's heartbeat" when she arrived at a costume party tightly wrapped in layers of gold-embroidered gauze that she had purchased in Egypt. *Town Topics* reported that on another gala evening she "was conspicuously elegant . . . in a Renaissance costume cut extremely décolleté back and front." The pink dress, accessorized with her most lavish diamonds and pearls, had a long train that was carried by an African attendant. To add a further touch of theatricality to her entrance (as well as a distressing bit of racism) she made the black servant dress in a sarong. A white poodle completed the entourage—though she would have preferred a panther.

The more exotic and wild the animal, the better, as far as Belle was concerned. She frequented the zoo in Boston, and in November 1896 she persuaded the zookeeper to let her take a pair of six-week-old lion cubs

in her carriage—doubtless, for all of Boston to see—so that she could play with them for the afternoon at her house. She preferred one cub to the other, and tied a red ribbon around the neck of her favorite. The zookeeper, who clearly loved the publicity, left the ribbon on "to let the world know it was a society lion." On another occasion, pandemonium broke out among visitors to the zoo when Belle strolled down the main hallway, holding a full-grown lion by its mane. (It was an old, toothless lion according to one cynical reporter.)

A contemporary wrote that Belle "stood out in vivid contrast to the people among whom she lived, and seemed to belong to another age and clime, where passions burned brighter, pleasures were more sumptuous, and repentances more dramatic than in sober Beacon Street." Passion, pleasure, repentance. Belle specialized in those subjects.

Her piety was as flamboyant—and as public—as her extravagances. She wore black on Ash Wednesday in an act of penance, a pair of rosary beads hanging from her waist. She and two women from the Altar Society—dressed in tight-fitting blue dresses that Belle had designed, along with veils and Franciscan scandals—washed the altar and steps of the Church of the Advent with palm fronds during a Maundy Thursday service. These ancient rites touched a deep religious chord within her. Belle loved the power and mystery of ritual, the scent of incense. To the horror of the Boston elite, she had a private audience with the Pope (during which he admired her pearls) and, at her request, he allowed her to attend Mass in his private chapel. She was deeply moved by the experience, and rumors spread that she had converted to Catholicism, a practically unthinkable violation in her circle.

Belle's antics and the colorful stories about her—some apocryphal, others not—tend to diminish her importance as one of the greatest art collectors and museum builders in America. She's dismissed as a

lightweight dilettante, not taken as seriously as the other millionaires (almost all of them male, with their own foibles) with whom she competed in the art market. Collecting art and antiquities was a blood sport in the Gilded Age, part stealth, part thievery—and she often got the best of her much wealthier competitors. Robber barons were looting Europe and Asia with abandon—literally dismantling crumbling villas whose owners could no longer afford them; buying at bargain prices masterworks from churches and temples; making off with Renaissance paintings from mansion walls.

Belle pursued paintings, antiquities, manuscripts, rare illustrated books, religious relics, textiles, tapestries, furniture, ceramics, glassware, and all manner of other curiosities with an unparalleled flair and passion. She wasn't doing it for investment purposes (though her collection turned out to be an investment bonanza), but for love. She adored art and artists, and she collected Old Masters as avidly as she encouraged contemporary painters like Sargent and Anders Zorn, and promising young musicians like eighteen-year-old George Proctor, whom she sent to Vienna and supported for years. Handsome and appealing as he was, Proctor had neither the ambition nor the capacity for the hard work necessary to reach the heights that Belle expected of him.

In contrast to the rather indolent Proctor, Sargent couldn't stop working and seemed constitutionally unable to turn down a commission. Because he had to support his family, part of his ambition may have been fueled by the need for money and the freelancer's eternal fear that assignments might evaporate at any moment. Even more, at bottom, he was a workaholic, content only when wielding a brush.

Sargent had a passion for the theater and theatrical characters (perhaps part of his attraction to Belle). As a respite from his commissioned portraits of stuffy dowagers and countesses, Sargent sought out actresses and dancers as subjects. While in New York in 1890, Sargent became obsessed with a temperamental Spanish dancer named Carmencita, who was then performing before delirious crowds at Koster and Bial's music

hall on 23rd Street. The theater was packed every night to watch her "tor-sal shivers and upheavals," as *Town Topics* described her movements.

Sargent saw Carmencita perform at the music hall and at a private party, where she danced sensuously until nearly 3 a.m. The artist accompanied her home that night and asked if he could paint her. She was twenty-two, illiterate, and spoke broken English; but she had a perfect grasp of money and her own worth. Thus, she was making a small fortune during her stay in the city. She earned $150 per week (about $4,000 in today's currency) for her evening and matinee performances, and raked in additional cash by giving dance lessons in the mornings to the daughters of some of the richest families in town. Indefatigable, she moonlighted after the curtain fell and performed at private parties.

The dancer agreed to sit for Sargent at his studio, but it came at a cost. The entire process required an ongoing seduction by jewelry. The artist first bought her several hundred dollars worth of bracelets. Her demands escalated and Sargent later admitted that it cost upwards of three thousand dollars to pay for her pearl necklaces and other extravagances. Sally Fairchild recounted that at one of the parties where Carmencita performed, some of the delighted women guests threw their own jewels at her feet. The dancer happily scooped them up, and Sargent had to buy them back from her.

During her portrait sittings, Carmencita was petulant and childish—bored and sulking one moment, angry the next. If the mood struck her, she'd walk away while he was in midcomposition. To catch her attention Sargent painted his nose red. When all else failed, he ate his cigar, which pleased her to no end. Sargent painted by daylight, so his work time was limited. He was juggling a number of other portraits simultaneously—*paying* portraits commissioned by New York plutocrats. The Carmencita portrait was costing him time and money. He felt he needed to sell the painting to recoup his investment.

Belle came immediately to mind. She greatly admired another Spanish-inspired work of his, the hypertheatrical *El Jaleo* that he'd

painted in 1882. That massive canvas portrayed a flamenco dancer in midperformance. Owned by Thomas Jefferson Coolidge, the painting had been exhibited at St. Botolph's Club in 1888 along with Belle's portrait—and for years thereafter, Belle had pestered Coolidge about buying *El Jaleo*. Sargent felt sure another Spanish dancer would appeal to Belle. "You must come to the studio on Tuesday at any time and see the figure I am doing of the bewildering superb creature," he wrote to Belle from New York in March of 1890. To heighten her interest in the painting, he wanted Belle to see Carmencita in real life—to witness her wonderfully untamed spirit, which would surely appeal to her.

Sargent set up the arrangements. His own studio wouldn't do, as it didn't have enough light. His artist friend William Merritt Chase agreed to provide his 10th Street studio. Belle insisted on paying for Carmencita's fee ($120 for her and two guitarists) as well as dinner from Delmonico's. Sargent was doubtless relieved at not having to cover the cost of dinner, as he'd been thinking more along the line of sandwiches rather than a feast from a fancy restaurant.

The setting for the party was perfect: a high-ceiled studio, dimly lit to accentuate the stage, with paintings along the walls, potted ferns, fans, porcelain, and other bric-a-brac artfully placed around the room. But the evening was nearly a disaster. The guests were high-society figures from Boston and New York, two different breeds, most of whom had never met before. The rather stiff atmosphere was not aided by the arrival of the star. She appeared around midnight with her hair a frazzled mess and her face over-made-up with powder and cosmetics. She didn't look a thing like her portrait. Sargent tried to straighten her hair with a wet brush and to rub off her makeup. Carmencita was enraged. She had to be calmed down and talked into performing. Lit dramatically from below, Carmencita strutted across the stage, casting dark shadows on the walls, and glaring angrily. Sargent, sitting on the floor, cringed as the tempestuous dancer took it out on Belle, the person he was most trying to impress. Carmencita plucked a flower from her hair, threw it in Belle's

face and made "a rude gesture." A gentleman nearby graciously picked up the flower, pretended it was meant for him, put it in his buttonhole, and profusely thanked the dancer. The crisis was defused. The mercurial dancer's mood changed and she proceeded to perform with graceful, sinuous movements. But Belle failed to bite; she passed on the painting.

In 1891, Belle's father died and left her $1.6 million tax-free dollars. She wanted to spend it on art, and her husband, Jack, eager to keep her happy—and probably away from mischief—agreed. She went on a spree, buying, among other things, Venetian antiques, a fifteenth-century painting of a naked Adam and Eve certain to make Bostonians cringe, and the unconventionally beautiful, nearly abstract *Harmony in Blue and Silver: Trouville* by her friend James MacNeill Whistler. Belle more or less wrested the canvas from him. According to one story, Belle grew so impatient over Whistler's reluctance to part with the painting—even though he'd already agreed to sell it to her—that she brought a friend with her to Whistler's studio and had him pluck it off the wall. As her friend carried the canvas down the steep stairs to their waiting carriage, Belle blocked Whistler, who was following and protesting all the while. He claimed the painting wasn't even finished; it lacked his signature butterfly. Come to lunch at my hotel then, and sign it there, Belle told him.

The same year Belle scored an even greater coup. Without benefit of any art experts whispering advice in her ear, she zeroed in on a painting at a Paris auction. *The Concert*, an enigmatic masterpiece by Johannes Vermeer painted about 1665, depicts two women at a piano—one woman playing, the other singing—with a man seated between them, his back to the viewer. Not wanting to arouse suspicion that she had an interest in the painting, Belle used a surrogate to bid on her behalf. She sat in the room with a handkerchief to her face the entire time—her signal to keep bidding. Both the Louvre and the National Gallery were pursuing the painting as well, but gave up in the middle of the auction when they thought they were competing against each other. They were shocked to discover

that an outsider had managed to best them. Within a decade, the value of the painting had risen exponentially.

The painting's worth today is incalculable, but alas, its whereabouts is unknown. *The Concert* was one of thirteen works of art—among them masterpieces by Rembrandt, Edgar Degas, and Édouard Manet—stolen from the Isabella Stewart Gardner Museum in 1990. The frames for the paintings sit empty at the museum, a haunting reminder of their loss. Curators at the museum note that the theft of the Vermeer was the cruelest blow of all. Only about three-dozen paintings can be attributed to Vermeer, making this canvas perhaps the most valuable stolen art object in the world. Theater and opera director Peter Sellars describes the Vermeer painting, now vanished, as "utterly impenetrable. I think of the characters in the painting as prisoners in some mysterious world. And now I think of the stolen painting itself as a prisoner in some vault."

"How much do you want a Botticelli?" the brash twenty-nine-year-old art connoisseur Bernhard Berenson wrote to Belle in August 1894. He was in London trying to jumpstart a career in the art business, which involved keeping his ear to the ground for rumors of fortunes in decline that would benefit from infusions of American cash. The fifth earl of Ashburnham was in just such a fix, and he happened to have one of the great works by the Florentine master Sandro Botticelli: *The Tragedy of Lucretia*, painted about 1500. "I understand that, although the noble lord is not keen about selling it, a handsome offer would not insult him," Berenson wrote in a conspiratorial tone. "I should think it would have to be about £3000. If you cared about it, I could, I dare say, help you in getting the best terms." As it turned out, Belle—who was then soaking in spa waters in Germany—wanted the Botticelli very badly and was willing to pay more than she ever had for a work of art. In December of

that year, she bought the work for £3200, about $16,000 at that time—
and more than twice the cost of the Vermeer. It was the first Botticelli to
come to America.

This purchase was a watershed moment. It marked the beginning of
Belle's collaboration with Berenson. This partnership would make his
career and her museum. Berenson offered his professional expertise to
Belle for financial gain, but it was also a way to pay tribute to her for her
past generosity. After all, Berenson probably wouldn't even be in London
in 1894 if not for her. "It would be a pleasure to me," he wrote when he
first approached her about the Botticelli, "to repay you for your kindness
on an occasion when I needed help."

Belle had met Berenson when he was an undergraduate at Har-
vard and still known as "Bernhard." (He dropped the Germanic *h* in his
first name during World War I.) Belle probably crossed paths with him
through their mutual teacher, Professor Norton. A poor Jewish Lithu-
anian émigré, Berenson was a rare breed in the Brahmin precincts of
Harvard, though he tried his best to fit in. His Jewishness was one strike
against him (perhaps one reason he converted to Episcopalianism during
his second year at Harvard), and his family's lowly status was another.
Bernhard's father was a tin peddler—he scavenged scrap metal and went
door-to-door selling tin goods that he carried in a backpack.

During his senior year Berenson asked Professor Norton to recom-
mend him for a traveling fellowship abroad. Norton refused, later tell-
ing a colleague, "Berenson has more ambition than ability." Instead it
was Belle who helped launch the fledgling aesthete, when she and several
others privately funded Berenson's postgraduate studies in Europe and
England. In 1889, Berenson wrote to Belle that when he returned home,
"I shall be quite picture wise then," and might even be able "to turn an
honest penny."

Berenson developed into the era's greatest connoisseur of Italian
Renaissance art, able to assess the value of a painting and correctly iden-
tify who painted it. This was no small matter given the legions of skill-

ful Italian art forgers and the fact that most Renaissance paintings were unsigned. To complicate matters, many artworks were executed by a school of artists in service to a master rather than by a single painter. Berenson had a prodigious memory and would examine the tiniest details of a painting and compare them with other works. He would also look for evidence of retouching and other changes made to a painting over the centuries. This method of minute examination was a new mode of connoisseurship. Art attribution up until that time relied on more subjective criteria, such as the overall effect and quality of a work. Professor Norton preferred that old-fashioned method and dismissively characterized the new, quasi-scientific approach adopted by Berenson and others as the "ear and toenail" school of connoisseurship.

There was a great deal of money to be made in the authentication business in the late nineteenth century. American millionaires were stockpiling art and needed professionals like Berenson to help them ferret out masterworks and certify them as real. His stamp of authenticity added tremendous value to the work. In the hypercompetitive art world, judging a painting or an artifact sometimes led down the slippery slope of shilling for something that might not be altogether as splendid as advertised—or worse yet, might not be the real thing at all. Prices were rising at such a preposterous rate that unethical art dealing was common. There were pressures from every side—the down-on-his-luck owner frantic to liquidate his family's Old World treasures; the art dealer, a super salesman eager to empty his warehouse and top the prices of his last sale; and the collector, equally anxious to be convinced that she has just acquired the most important work in Christendom. Caught in the middle of all of this was the art connoisseur, whose commission depended on the size of the deal.

Berenson's success in the art world was based entirely on his reputation, so he was certainly not in the business of willfully misidentifying work. In fact, his attributions have stood up remarkably well over the decades. But he was also willing to invent details about how he came

upon a painting, to occasionally press Belle to buy second-rate pictures, and, at all times, to flatter her enormous ego. When he and Belle first began their dealings in 1894, Berenson was still very much a neophyte in the marketplace. Sensing an opportunity to work with her on a large scale, he covertly allied himself with the Colnaghi art dealers in London. Berenson would regale Belle with a romantic tale of how he had discovered a particular masterpiece in a threadbare mansion, when, in fact, the painting was already owned by the Colnaghi firm, and the price already substantially marked up. Berenson took a 5 percent commission from Belle that was quite modest. He failed to mention, however, that he was also getting a hefty commission from Colnaghi. In one instance he had a financial investment of his own in a piece of artwork, which Belle knew nothing about, but which, naturally, factored into the inflated price.

This came back to haunt Berenson in 1898 when word of his secret arrangements with Colnaghi leaked out. Jack Gardner was furious, and Berenson was panic-stricken that he might lose his deep-pocketed client. Richard Norton, Professor Norton's son, then tracking down ancient sculpture for Belle, bluntly accused Berenson of duplicity. "He is dishonest," Norton wrote in a September 1898 letter. "He is as you must know a dealer. Well, there are only one or two honest Fine Art dealers in the world & Berenson is not one of those." As for his own dealings with Belle, he swore "I have never . . . made one single <u>centismo</u> in the business. On the contrary the work is an expense—an expensive luxury." He concluded the letter with, "You may find it hard to believe that I have written this letter with disinterested motives but such is the case. I tell you so on my honour & the Norton honour is, I believe, so far unsullied." (Some time later, it was rumored that Richard Norton, too, secretly accepted money from dealers.)

The art world was a murky one at best, as huge amounts of money were being spent and everyone had his hand out. Belle had already made it clear to Berenson that she wanted nothing to do with the Colnaghis. So when Berenson arranged the purchase of a pair of portraits by Hans Holbein the

Younger, and she discovered that he was once again surreptitiously front-ing for the London art dealers, she threatened a lawsuit. "I am sure the end has come," she wrote him in May 1899. "It looks as if it might be a ques-tion of the Law Courts." Somehow the two of them managed to patch it up and continue their art quest. They were an odd pair. As one art critic put it, "They tormented each other unmercifully, two vain individualists caught in a curious relationship of affection and annoyance."

Berenson craved her approval but he also referred to her as the "Ser-pent of the Charles [River]." He played to her vanity by seeking out any painting with a connection to Queen Isabella—or any Isabella for that matter. "Cable immediately," he'd write, trying to force a quick decision on a painting. This work is "simply unsurpassable," it will "enchant you. So be prepared with a pure heart and—a full purse." There are others in line, he'd warn. As an old man, even he admitted that he might have over-done his sales pitch at times. "I had to put on the praise of the works of art, as Disraeli said of Queen Victoria, 'not with a trowel, but with a shovel.'"

Belle had a mind of her own and was not always swayed by Berenson's gushing recommendations. On one occasion, however, she purchased a Rembrandt just to please him, later admitting that "the Rembrandt left me cold, and it was only because you seemed so anxious about it, that I wired to get it." (As it turned out, that particular painting, *Landscape with Obelisk*, was not a Rembrandt at all. In the 1980s, experts ascertained that the painting was by Govaert Flinck, one of Rembrandt's pupils—and in 1990 the work was stolen along with the other Gardner treasures.) But together Berenson and Belle assembled some of the great masterworks in her collection—paintings by Rembrandt (genuine ones), Raphael, Bot-ticelli, Giotto, Fra Angelico, and Rubens—and in later years, Chinese antiquities and Islamic miniatures.

In his memoir, *Sketch for a Self-Portrait*, written toward the end of his life, Berenson wrestled with his conscience over his role as *the* art arbiter for the ultrarich. Turning art into commerce gnawed at him. The once-poor émigré was eager for the money, but equally appalled by it.

Berenson, nonetheless, emulated his Gilded Age patrons, renting and then buying a property outside Florence, Villa I Tatti, which had begun life as a sixteenth-century farmhouse. Set atop a hillside with spectacular vistas, the house and grounds were transformed by Berenson into a Renaissance-style villa with a magnificent formal garden. His work and life merged in his hilltop villa, as he filled it with his own impressive collection of art and books. Bequeathed to Harvard, the estate now serves as the university's Center for Italian Renaissance Studies.

Belle had Berenson and other agents, including Sargent, in the field seeking out treasures; they were her knights in shining armor, ready to do battle to secure a prize for her. ("Do you want to see or buy a magnificent Persian rug of the finest design and period, worth all the pictures ever painted?" Sargent wrote her in 1894.) Belle loved the thrill of the chase and hated being outmaneuvered. In 1897 a Florentine art dealer told her he didn't think he'd be able to get a fifteenth-century terra-cotta sculpture out of the country (authorities were cracking down on the wholesale looting of the country's art treasures). Jack thought it was a ruse and that the dealer just wanted to sell the sculpture to someone else, probably at a higher price. Belle was competing against the J. P. Morgans of the world who, with their limitless funds, were scooping up everything in sight. "Please *grab*" the terra-cotta from the dealer, Belle instructed Berenson in a November 1897 letter from Paris. "Don't let any one else have it, and if it really can't be got out of Italy, take it away from him and have it put somewhere in *greatest secrecy* for the present. Tell no one and *let no one see it*—please." That painted sculpture, *The Deposition of Christ*, is currently displayed in a hallway on the third floor of the Isabella Stewart Gardner Museum—exactly where she placed it.

Secrecy, an integral part of the game, added a cloak-and-dagger element to the quest. In 1898 when Richard Norton came upon a sculpture from the studio of Praxiteles, the renowned fourth-century BCE Athenian sculptor, he wrote Belle, "Don't mention it to a soul or the game is up." He needed her go-ahead immediately. A few months later in London he was

shown a Raphael—"Don't gasp. It is true"—that had been spirited out of Italy without the government's knowledge. It "is beyond words to praise & all I beg of you is not to waste a moment. . . . But, good Lord, just think of it a <u>real</u>, <u>unquestionable</u>, <u>perfect</u> portrait by Raphael."

Another time, Norton wrote to her from Rome that she should just wire two words—"Yes relief"—if she wanted an ancient marble throne he'd been bargaining for. Other cryptic one-word responses he recommended included "Patrizzi," "Door," and "Drapery." When a small Rembrandt came within Norton's range he warned her not to use the artist's name in a telegram. "'Ditch' will serve as a synonym." He also pointed out that the painting was only "about 24 inches square—just a nice size to put in a trunk!" Furiously telegraphed messages in code, art smuggled out of countries. It was the high drama that Belle loved.

Fooling customs officials became an art in itself. Joseph Lindon Smith, an artist and friend of Belle's, purchased her a terra cotta Madonna and child and covered it in watercolor to obscure its antiquity—and its worth. "When therefore, this lovely thing reaches you," he wrote, "it will not be at all lovely, until the deceit has been taken off." On another occasion, the ever-resourceful Smith covered four marble Arab capitals with plaster and paint that was removable after being soaked in water. Better yet, he talked the dealer he bought the columns from in Seville into creating a fake invoice so Belle would pay less on duty tax. Smith advised her to destroy his letter to keep their deception secret.

Belle didn't always get away with this sort of subterfuge. In 1904 she had to pay $200,000 in custom duties for art and statuary that had been imported in 1898 under what government officials considered false pretenses. (She claimed it was for a museum; they disagreed.) When a friend brought her art from Europe in 1908 under the guise of "household effects," Belle was caught and fined $150,000—for art valued at roughly $82,000. "My life is as usual," she wrote to a friend that year, "music, people & constant persecution from our government." The Boston press, not usually an ally, weighed in on Belle's side in this cause célèbre. An

editorial in the *Evening Transcript*—aimed sarcastically at the custom laws—suggested that Belle should import dogs instead. "A snarling, blear-eyed bulldog of uncertain walk and disagreeable temper, valued at $10,000 can be imported free of duty. A yelping, howling, snapping poodle of no earthly good to himself or humanity but valued at $8,000 can be imported duty free. . . . But any millionaire who tries to import works of Titian, Rubens or Turner is lucky if he escapes jail."

In fact, when Belle imported those heavily fined works in 1898, she had already decided to create a museum. Berenson had secured two Old Masters for her in 1896: Titian's monumental *Europa*—deemed by Rubens the greatest painting ever made—and a self-portrait by Rembrandt. They would be the cornerstones of a collection that she could see expanding upon, with no end in sight. Belle was hooked. "I suppose the picture-habit (which I seem to have) is as bad as the morphine or whiskey one—and it does cost," she wrote Berenson in 1896. Belle had already gone through her own inheritance (supplemented by the winnings of a racehorse she owned) and Jack was ready to call a halt to her spending. "I have not one cent and Mr. Gardner (who has a New England conscience) won't let me borrow even one more! I have borrowed so much already."

But Jack didn't stand a chance if Belle wanted something. Within a month of writing that pitiful letter to Berenson, Titian's *Europa* arrived and Belle was in raptures—and also making plans for her museum. "I am breathless about the *Europa*, even yet!" she wrote Berenson on September 19, 1896. "I am back . . . after a two days' orgy. The orgy was drinking my self drunk with *Europa* and then sitting for hours in my Italian Garden at Brookline, thinking and dreaming about her." Belle took absolute pleasure in the work: "Every inch of paint in the picture seems full of joy." She invited a number of friends and painters to view the rather shock-

ing canvas that depicts the mythological story of the princess Europa in a moment of terror/ecstasy after having been raped by the god Jupiter. Disguising himself as a tame white bull, Jupiter ravished the unsuspecting princess. "Many came with 'grave doubts'; many came to scoff; but all wallowed at her feet," Belle wrote. "One painter, a general skeptic, couldn't speak for the tears! all of joy!!!" Yes, she would have her museum. That month Belle commissioned the architect Willard Sears to redesign and enlarge their double house on Beacon Street in order to accommodate her growing art collection. She and Jack would live in private quarters above the museum. Belle swore Sears to secrecy about the project.

Art and Venice merged in Belle's imagination. The city's very geography—a myriad of islands in a lagoon set in the Adriatic Sea—was like a one-of-a-kind art installation. Venice was drenched in romance and mystery. Water lapped against the front steps of the palaces, many of them brightly colored, which lined the canals that crisscross the islands. The so-called "City of Water" or "Floating City" was just that—a sensual dream world rising out of water. Isolated and cast off in its lagoon, beset by mosquitoes and occasional outbreaks of cholera (especially among the poor), oppressively humid with no dry season, Venice was decomposing as one watched. By the late thirteenth century Venice was the richest city in Europe, a great commercial empire that dominated Mediterranean trade with the Byzantine and Islamic worlds. Over the course of five centuries, the city's merchant princes built palaces—one more magnificent than the next—resplendent with commissioned paintings and frescoes from the greatest artists of the day. Eventually the economic tide turned, and Venice lost its preeminent place in international commerce.

By the late nineteenth century the old Venetian aristocrats, then penniless, tried to keep up appearances as their palazzos crumbled around them. Yet despite the ravages of age, the palaces presented an extraordi-

nary spectacle: "The wind and the weather have had much to say," Henry James wrote, "but disfigured and dishonored as they are, with the bruises of their marbles and the patience of their ruin, there is nothing like them in the world."

The past was present and palpable in Venice. The air of decay amid grandeur—even the poor, barefoot children who roamed the alleyways—held a picturesque appeal to the rich expatriate Americans who settled in Venice, many of them Bostonians, some of whom were fleeing scandal back home. This was a place of refuge. Exiled royalty, among them Empress Frederick of Germany and Don Carlos of Spain, were in Venice at that time. The city "wouldn't know herself without her *rois en exil*," James wrote. But the melancholy of exile was more than compensated for with joy: the seemingly endless processions and feast days, regattas in the Venetian Lagoon, evenings filled with song and fireworks, barges and gondolas illuminated with colored lamps jostling for space on the busy canals, the surprise and delight of secret interior gardens.

Conventional rules were bent or ignored in Venice, and sexual mores were relaxed in that languorous, sultry atmosphere. Aesthetes like Henry James—widely considered a repressed homosexual—regularly took refuge in Venice. Whether he ever acted upon his longings is unknown. Sargent loved exploring and painting the city's waterways and back alleys, and perhaps he let his guard down and enjoyed the sexual freedom the city offered. One friend reportedly claimed Sargent had a "positively scandalous" sex life in Venice. And an Englishwoman painted by Sargent confided to a niece that he was "only interested in Venetian gondoliers."

The Gardners—Belle, at least—fell instantly in love with Venice when they first went there in 1884, and, thereafter, they made semiannual treks to the city. The vivid colors, the quality of the light, the semitropical climate, the astonishing art everywhere, the sexual freedom, and the unabashed homosexual activity—nothing could be further from Boston. Belle's own rebellious spirit seemed at home in this world.

When in Venice, the Gardners generally stayed at the opulent Palazzo

Barbaro on the Grand Canal, a fifteenth-century palace owned by the Curtis family, expatriate friends from Boston. According to legend, the Curtis family—Daniel Sargent Curtis (a cousin of John's), his wife, Ariana Wormley Curtis, and their artist son, Ralph—fled Boston in the 1880s in the wake of some unpleasantness on a local train. Daniel got into an argument over a fellow commuter's luggage taking up too much space. Words were exchanged, and when Daniel was accused of not being a gentleman, he responded by twisting his foe's nose, which precipitated a fistfight. Daniel's combatant happened to be a prominent lawyer. Curtis was convicted of assault and sentenced to two months in prison. Despite the judge's offering him the opportunity to apologize and drop the whole matter, and practically all of Brahmin Boston—including Jack Gardner, the president of Harvard, and the usual assortment of Lowells, Higginsons, Saltonstalls, and other eminences—weighing in with a petition to the governor for a pardon, Curtis refused on principal, and served his two months. But the incident soured him on Boston society. Eight years later he left the city for good.

The Gardners were sometimes guests at the Palazzo Barbaro; on other occasions they rented it for themselves. Belle was in her element there, orchestrating grand dinners and nocturnal boat rides, and taking full advantage of the circle of writers, artists, and musicians the Curtises attracted to the house. When the Gardners were in residence, there could never be too many people. Belle was the engine of all the frivolity. Jack meanwhile chatted about business to anyone who might be interested (not many of those about) and busied himself keeping an account of their expenses. "I don't much wonder she likes other company in the house most of the time," one visitor wrote. "Mr. Jack is a comfortable sort of a body but come to think of it I guess pretty stupid as a constant companion." That being said, the visitor had to admit, "they are quite a devoted pair."

On at least one occasion Belle overbooked the enormous palace. There were no bedrooms available when Henry James came to visit in the

summer of 1892, so Belle arranged for a four-poster bed, surrounded by netting to keep the mosquitoes at bay, to be placed in the elegant upstairs library. Lying on the bed James could gaze through the netting at the fabulous frescoed ceiling. Dazzled by its seductive beauty, James used the Palazzo Barbaro as the backdrop for his novel *The Wings of the Dove*; its main character, an American heiress named Milly Theale, bears an uncanny resemblance to Belle.

Photographs from Venice depict Isabella and her friends leaning back in flat-bottomed gondolas guided by handsome gondoliers wearing broad-brimmed straw hats at a jaunty angle, and dashing white sailor suits cinched around the waist with long sashes. The athletic and sunburned gondoliers skillfully navigated the waterways and were idolized. Belle ogled them. Sargent painted them. The artist brought an Italian named Nicola d'Inverno to work in his studio in London. Visitors assumed the muscular young man was a gondolier from Venice, although in reality he was an amateur boxer from an Italian enclave in working-class London. D'Inverno worked for Sargent and traveled widely with him—to Palestine, Italy, and the United States, staying with him for over twenty years. D'Inverno left Sargent's employ in 1918, forced to do so for legal reasons—and perhaps to prevent a scandal for the artist—after he got into a brawl at the grand Hotel Vendome in Boston. His portrait, in which he could be mistaken for a Venetian gondolier, remained in Sargent's Tite Street studio until the artist's death.

Having settled on their plan for a museum, the Gardners' 1897 trip to Venice turned into a sustained, omnivorous adventure in acquisition. By this time, Jack had actually warmed to the museum idea and he helped Belle select treasures of every kind: furniture, paintings and wall panels, sumptuous fabrics, a pair of stone lions, and large architectural details— entire columns, frescoes, balconies, reliefs, fountains, an iron gate, and carved molding from the fourteenth century. Most of the architectural pieces in the interior courtyard of her Fenway Court museum were purchased during this trip. The buying continued in Rome and Sicily and

Paris, where Belle hired a large storeroom to house her purchases and wait for a "more favorable time to bring them into the country than the present"—undoubtedly a plan designed to circumvent government officials and fees.

Between entertaining guests and nonstop bargaining, the frenetic activity took its toll on the fifty-seven-year-old. On August 29 she was in great pain, couldn't stand up straight, and was convinced she was having a heart attack. But the Festa of the Madonna of San Stefano was taking place that day, a spectacle she could not miss. Belle prayed to the Madonna and when the statue passed by, the pain miraculously vanished, as she and her maid told Belle's first biographer, Morris Carter. The next day she hired a boat, had a piano carried on board, and had her guests—the composer Clayton Johns and the well-known singer Theodore Byard—perform for her as they floated along the canal. Like Cleopatra on her barge.

Back in Boston, Belle received a steady stream of "gondola gossip" from Ralph Curtis at the Palazzo Barbaro. He also kept his eyes and ears open for treasures she might want. Writing from a yacht off the coast of Naples he addressed an April 1894 note to "My dear Queen Isabella," mentioning a fifteenth-century Persian carpet she might like. As for news from Venice, he added, "The Crown Princess of Sweden wants the Barbaro but she can't have it now," and ended with, "Ever your faithful slave." And then a "P.S."—"These boys want us to go in the boat to the coronation of the Tsar—!??" Such was expatriate life at the top of the food chain. Small wonder that Belle eventually decided to recreate the Palazzo Barbaro in gloomy Boston.

The year 1898 began badly and ended even worse for the Gardners. In February, Belle broke her leg, an event that made headlines in the *New York Tribune*: "Boston Society Leader Breaks Leg but Won't Tell How." Even her doctor was sworn to secrecy. F. Marion Crawford, her former

inamorato, wrote to offer his sympathy that she should be "laid on the shelf like a plaster cast of the Venus of Medici." Though much of Boston society heaved a sigh of relief that she might be out of commission for a while, she surprised them all, venturing out in a wheelchair in midwinter and taking in a performance of *Lohengrin* from the stage wings. *Town Topics* reported that within two months of her injury, the nearly sixty-year-old Belle was seen making a dramatic entrance into another theater performance. As she intended, all eyes were drawn to her entourage. A footman in livery preceded her with a cushion for her foot. Then the star attraction, Belle, dressed in black with a "water-melon pink toque," walked down the aisle leaning heavily on the arm of her escort, a handsome man half her age. It was George Proctor, the former prodigy she'd been supporting for years. Though he never developed into the world-class pianist she expected, he more than fulfilled his role and continued to receive ample checks from her. He fawned over Belle and fed her vanity. She needed flirtatious young men around her as much as she needed her art.

The art treasures Belle was continuing to collect gathered dust in warehouses in various corners of the globe, awaiting the creation of her showplace. But what form should the museum take? Belle and Jack disagreed over that question. Belle wanted to follow through with the plan their architect, Willard Sears, had drawn up to replace their home on Beacon Street. But Jack thought the street, with its row of houses cheek by jowl, was too crowded for such a new structure. He preferred the idea of a freestanding building in an open space where light could stream through the windows on all sides. Apparently, Jack and Belle had just looked at a parcel of land that might serve that purpose—it was in a deserted area known as the Fens, a marshy backwater then being drained and filled in. During a dinner at the Gardners' house in the early fall of 1898, twenty-two-year-old Corinne Putnam (soon to be married to the Boston artist Joseph Lindon Smith) witnessed her hosts bickering about where the museum should be sited. Belle told Jack that if light was the problem, she might just "invent a new system of lighting." Corinne had never met

Belle before, and she was so taken by her hostess's self-assurance and determination that anything seemed possible.

Two months later, on December 10, 1898, Jack suffered a stroke at the Exchange Club on Milk Street. Carried back to their home on Beacon Street, he died that night at the age of sixty-one. Belle covered his coffin with a purple pall she had bought in Italy and had a cross of violets, grown in her own greenhouse, laid atop it.

Belle inherited over two million dollars from Jack in two separate trusts from which she drew a sizable yearly income. With the larger trust she also had the right to draw upon the principal. Conservative Bostonians shook their heads in disbelief: allowing an extravagant woman like Belle to draw upon the principal? She'd surely blow through her entire fortune. But she didn't. This was, after all, a rather large fortune in those days (not robber baron quality, but substantial nonetheless). Belle also still received income from her father's bequest. And she was very shrewd.

Jack had actively encouraged Belle's collecting obsession. He paid the bills, but he also provided ballast in her life. She seemed to outrage everyone in Boston except her husband. There was no stopping her, so perhaps he just tried to stay out of her way—and not to overhear the gossip about her. Belle burned many of her personal papers, so there's no written record of her grief. As happened after the deaths of her son and her nephew, she suffered her loss in a deep silence. She withdrew from the public for an extended time period and in a manner that exceeded traditional mourning customs. She stopped inviting close friends to her home for dinner. Her seclusion became such a source of concern that one acquaintance organized a concert at Belle's home—with only Belle in attendance. When she finally did emerge in public, she covered her face with a veil that fell nearly to the ground. Deemed "Boston's most interesting widow," a February 1899 newspaper article reported that Belle had been seen "enveloped in the heaviest crêpe from head to foot, in a Russian sleigh hung with sable robes and with coachman and footman in irreproachable mourning livery."

Rumors spread that she'd suffered a nervous breakdown. It wasn't true. With laser-like focus she turned her attention to her museum. In fact, within weeks of her husband's death she summoned her architect, Willard Sears, requested minor revisions for the new museum building that was to replace her Beacon Street house, and directed him to proceed with the construction as soon as possible. The following day she summoned him back. Scrap the plans, she told him; she'd just purchased a plot of land in the Fens, honoring Jack's wish.

Belle had a new world to conquer. The Fens was a vast stretch of empty landfill where she could create whatever she fancied. Her ego—once described as "cosmic and insatiable"—demanded an outsized, exuberant project. She turned her back on the counting house coldness of Back Bay mansions, an architectural aesthetic that was so very smug, so very parochial, so very Boston. It was an aesthetic that prided itself on restraint and avoiding ostentation (no matter what it might cost to attain that pinched look).

In the process of creating her vision, she drove her architect nearly mad. Sears was less the architect than the draftsman revising one blueprint after the next to fulfill Belle's dream. While she wanted to create a palace based on the Palazzo Barbaro, she wanted to build it in reverse. In Venice, the exteriors of palazzi are virtual wedding cakes of ornament and color. In contrast, the exterior of Belle's four-story museum, which she called Fenway Court, is constructed of austere dun-colored brick, with little detail except for the projecting chimney in the shape of a giant *Y* (for Isabella, or Ysabel, the fifteenth-century queen of Castile) that rises above the original entryway. It was as if she wanted to show Boston a face of humility—albeit a regal one with that *Y*.

The exterior does nothing to prepare one for what is inside. The original dark entryway opens up almost immediately into an unexpected burst

of light, color, and decoration. (A new entrance replicates the same experience.) Here is the heart of the museum: a central courtyard that is a lush oasis alive with tropical and seasonal flowers—orchids, poinsettias, jasmine, azaleas, hydrangeas, flowering nasturtium vines hanging twenty feet down the walls, palm trees, and ferns. It doesn't seem possible that some of these plants can even grow in Boston, and in midwinter, no less. Even on the gloomiest, snowiest day, light streams in from the skylight four stories above. It's a miracle. One is immediately transported to sultry, subtropical Venice and its overripe grandeur.

At the center of the courtyard, a mosaic floor from the second century, salvaged from a villa north of Rome, displays birds, flowers, and tendrils swirling around the face of Medusa, the monstrous and powerful female figure from Greek mythology. Here is Belle putting her stamp: This is a palace created by and for a woman. In Egypt, Belle had prostrated herself on the sands of Giza to ponder—to *feel*—the vastness of human time and the mystery of mortality and immortality. Her museum invites the visitor to enter into that ancient world and to experience classical beauty by being enveloped in it. Belle orchestrated every inch of the museum, deciding exactly where to position every single piece of artwork, every swath of fabric, every book, every manuscript page, each curious bit of ephemera. The arrangement is a unique piece of art in itself, a house museum unlike any other. Architectural historian Aline Saarinen describes Gardner's creation as having captured the "seductive siren" that is Venice. In contrast, she points to the masculine severity of the J. P. Morgan Library in New York, which has the "beauty of logic" but lacks the "captivation of caprice" that is at the heart of the Gardner Museum.

Belle often sat on a marble throne at the edge of the central mosaic. There she could savor her creation, her secret garden, and take in its sensual pleasures: the smell of the flowers, the color of the pink stucco walls that rose up all around her four stories high (during construction, Belle, then in her sixties, took up a brush and showed the workers how

to achieve the fading color of an ancient palazzo), the song of the finches that flew about the courtyard, and the soothing sound of water. On one wall of the atrium is a seventeenth-century Venetian fountain, with water flowing out of the mouths of stone dolphins. Water—omnipresent in Venice, its sound splashing against the stone steps of the palazzi along the city's canals—echoes in the Gardner courtyard as well. Above the fountain Belle placed an ancient relief sculpture of a maenad, one of the mythical devotees of Bacchus that danced themselves into states of orgasmic ecstasy. Even more sexually charged is a third-century marble sarcophagus on the edge of the courtyard. On it, naked maenads and naked satyrs caress one another as they gather grapes. This sarcophagus is considered one of the most important ancient works in America. Amid all this exuberant sensuality, Puritan Boston is erased.

Statues and sculptures from the pagan ancient world are carefully sited around the courtyard: a child's sarcophagus, which was placed in memory of Belle's child who died at two; a sensuous marble rendering of the Greek goddess Persephone; the granite *Horus Hawk*, an Egyptian deity, that dates back to the Ptolemaic dynasty; a Roman depiction of the Greek hero Odysseus—the figure shown creeping stealthily—that once served as the pediment for a building; a headless first-century marble of a Greek goddess purchased from the Sisters of San Giuseppe in Rome.

Arcaded cloisters offer shady walkways around the inner courtyard; balconies and balustrades—some removed from the exterior of Ca' d'Oro, one of the most famous Venetian palaces on the Grand Canal—overlook it. And this is just the beginning. Three floors of galleries rise up around the courtyard, each gallery featuring a particular era, artist, or type of art—among them are the Early Italian Room, the Raphael Room, the Dutch Room, the Veronese Room, the Titian Room, and the Gothic Room.

The museum houses roughly 320 paintings, the same number of prints and drawings, 400 pieces of furniture, 385 sculptures (not counting the many architectural elements embedded in the building itself), 340 textiles

of various kinds (tapestries; church vestments; embroidery; pieces of lace, velvet, and silk), and 230 ceramic or glass objects. In addition, there are rare books, illuminated manuscripts, Arabic miniatures, musical scores, and autographs, as well as countless bibelots, some worth a king's ransom, others holding a personal meaning for Belle alone: an eighteenth-century viola d'amore; a copy of Beethoven's death mask; locks of hair from Nathaniel Hawthorne, Franz Liszt, and others; a silk flag from a regiment of Napoleon's Imperial Guard; African arrows collected during the 1871 expedition led by Henry Stanley to find David Livingstone (the famous "Dr. Livingstone, I presume?"); Japanese and Venetian lanterns; a plaster cast of William Greenleaf Whittier's hand; an eighteenth-century Tibetan prayer wheel; and walking sticks that belonged to the artists James McNeill Whistler and John La Farge.

Like Belle herself, the museum is brazen. It breaks every rule of displaying art. Anyone expecting surgically lit gallery spaces with didactic wall captions will be disappointed. There are no captions or potted biographies of the artists on display. At the Gardner, one must encounter each work of art on its own; it is not mediated and deconstructed by curators. The art is what it is. Light in the gallery spaces is uneven at best, changing at various times of the day as the sun moves across the courtyard. This is a living, breathing house, and like any genuine Venetian palace, the rooms are large and shadowy. The interplay of dark and light lends the gallery spaces a nearly religious aura. One almost expects to smell incense while roaming from room to room, many of them stuffed with sacred art of every imaginable variety—altarpieces, church vestments with gold threads, Buddhas, and Madonnas. In fact, there is a chapel in the museum, where an annual high Mass is celebrated on the anniversary of Belle's death.

Every inch of the museum seems to hold an unexpected treasure or surprise. Art lovers grow giddy over the sheer number of masterpieces on display, all of them competing for attention. This museum is surely a democracy: Even Old Master paintings jostle for space. Titian's famous

Europa hangs above some Parisian silk, part of a ball gown once worn by Belle.

At Belle's insistence, the palace was built in the manner of a true Renaissance Venetian palazzo. The structure rests on piles driven more than ninety feet through filled-in marshland to bedrock. On the day the pile-driving began in June 1899, Belle emerged from her carriage and almost immediately spotted a four-leaf clover—the first one she'd ever seen. She put the clover in a crystal locket that remains in the museum.

Luck was in the air—but not so for the poor building inspector who had to do battle with Belle. Steel construction, which was the norm for such a large building, was out of the question according to Belle. She had already made Sears delete a steel frame and columns from his original plans. Marble columns would support the structure perfectly well, in her estimation. Renaissance palazzi in Venice—*still standing*, she pointed out—were built without steel. Back and forth the argument raged. There was some confusion as to whether the building was a public museum or a private residence (in fact, it was both), so Belle used the building's murky status to avoid turning over plans to the city in a timely fashion. As one newspaper noted, the inspector "never knows what is to be done next and waits upon the pleasure of the society leader."

Though a few columns had to be reinforced, Belle won the battle and steel construction was avoided. However, when she complained about the escalating cost of the project to the architect, he pointed out that it was impossible to put a price tag on what the house was going to cost when she was constantly changing her plans and violating the building codes. Sears warned her that she might "have to apply for special legislation or apply to the Board of Appeal" if she persisted in using building materials popular in the Renaissance. She was intransigent—which translated into more time, more money. But cost never got in Belle's way.

Feuds with the city officials continued throughout the construction— and on at least one occasion a convoy of inspectors was sent, perhaps in the vain hope that a show of force would change Belle's mind. She

remained indifferent to their concerns; she'd build it the way she wanted to. She felt she held the trump card: if the city refused to issue a permit when the building was finished, she wouldn't open the museum to the public.

Belle targeted not only the city officials but also the workmen. She was on-site supervising, complaining, giving orders. Staircases already in place had to be removed and reinstalled to her specifications. She told Sears to fire all the plasterers and hire new ones. She rejected all the plumbing fixtures. She spoke sharply to the men laying the floors, and told them to get to work. When they mimicked her sarcastically, she fired them. She rejected the stone that she had originally chosen and then accused the stonemason of not getting the new stone quickly enough. She called him a liar and the mason quit. Sears calmed him down and talked him out of abandoning the lucrative project. The architect had to play good cop to Belle's bad cop. She patrolled the construction site, risking life and limb as she climbed ladders and scaffolding. She wanted her ceiling beams hewed in a particular way, so she picked up a broad axe and showed the men how to do it. Alarmed at her fearlessness, Sears advised that an insurance policy be taken out on her; she refused, saying it was unnecessary.

Like a scene out of *Citizen Kane*, hundreds of enormous wooden crates from Europe lay in a storage warehouse waiting to be unpacked. Belle had a precise vision of how she wanted her museum to look and a method that went right down to the opening of the cases. In the warehouse she'd point to this crate and that one (inevitably ones at the very bottom of a large pile) and have them opened. She sought out the marble columns, capitals, and bases for her first-floor colonnade. She then arranged all of the columns in the warehouse in the *exact* way she wanted them placed in her museum.

Italian-born Teoboldi Travi, known simply as "Bolgi," supervised the transportation of the objects—from the warehouse, to the long holding sheds built near the mansion, and then into the museum. He earned Belle's

trust, although if a column accidentally broke in transit due to a workman's carelessness, Bolgi would stealthily cover up for the man, claiming that the column had arrived in that condition. (If not for Bolgi, a number of men would have been fired.) The Italian was not only diplomatic but he was also musical. He played the cornet, which Belle put to great use. As the construction proceeded, Bolgi accompanied her during the day, summoning the workers with his instrument. If she wanted the head mason, he'd give one blast of the cornet; two blasts brought the head pipe fitter; three, the head plumber; four, the master carpenter; five, the head plasterer; six, the top painter. Bolgi remained a devoted majordomo to Belle for the rest of her life. A 1904 photograph taken in the North Cloister shows the mustachioed Bolgi in a floor-length double-breasted overcoat, a cocked hat, and what looks like a scepter.

Belle was totally devoted to her museum. "I am building a new house on the Fenway," she wrote in 1901 to Frances Glessner, who lived in a magnificent Romanesque mansion in Chicago. "I made the plans myself and it has been and is a great pleasure and interest." But, she admitted, it required all of her days, and even some nights "to insure being on the spot early enough to guard against anything going wrong." Like one of the workmen, she carried her lunch pail every day, ate on-site, and contributed a dime to the fund that added oatmeal to the drinking water. (Exactly why oatmeal was needed is a mystery, though one Gardner biographer speculates it might have helped settle any mud in the drinking water.) Somehow Belle and the construction workers managed to coexist and the building was completed.

Though newspapers throughout the country speculated about the museum as it rose above the Fens, Belle swore everyone involved in the construction to secrecy. In late 1901 she moved into her fourth-floor quarters—much of it fashioned after her old home at 152 Beacon Street—and then spent an entire year overseeing the installation of the collection, arranging and rearranging it to her specifications, and buy-

ing bits and pieces to fill in the gaps. Last-minute purchases included eight Old Masters. The unveiling ceremonies were to include a concert by fifty members of the Boston Symphony. Belle needed to check the acoustics in the museum's Music Room in advance of opening night, but she didn't want anyone to actually *see* the place beforehand. Her solution? She invited the children from the Perkins Institution for the Blind to attend a private concert. It was a snowy day and the children arrived wearing galoshes. Each child placed his or her overshoes in a designated spot, but an overzealous servant, concerned about the clutter, moved all the rubbers into a big pile, creating chaos when none of the children could locate their galoshes afterward. The acoustics, however, passed muster.

All was in readiness. The curtain was about to rise on Belle's creation.

The opening gala was on New Year's night, 1903. Belle instructed her guests to arrive at nine in the evening—"Punctually," according to the engraved invitation. Physically set apart from the rest of Boston like its own duchy, the museum was ruled by Isabella, its undisputed queen. Even the name of her creation, Fenway Court, has a suitably royal ring to it. Belle welcomed her opening-night guests from a landing at the top of a curving stairway. She was a regal presence in black, slathered with jewels: a ruby, pearls (149 of them), and two enormous diamonds named "Rajah" and "Light of India," which she wore atop her head on gold spiral wires so that they'd bob and sparkle as she talked.

It was a frigid, clear night and there was a bottleneck at the entrance where Bolgi, attired in green velvet with gold trim, ushered in the guests, two by two so that everyone could ascend the staircase to greet Isabella personally. A long line of carriages waited outside, and the guests—bundled in sealskin and sable furs, top hats, and long white

gloves—awaited their turn to pay homage to the woman who many had so loved to sneer at. There was no sneering that night, just sheer envy. And awe.

The guests were seated. Live, glorious music by the Boston Symphony and singing by members of the Boston Cecilia society—a Bach chorale, the overture to Mozart's *The Magic Flute*, works by Schubert—encircled the guests. The critic for the Boston *Transcript* was enraptured: "Listening to music in such a hall, you feel as if you were inside of some musical instrument, indeed, such a hall is a musical instrument in itself." The concert ended at 10:15 and a mirrored doorway on one side of the Music Room was opened dramatically. Guests got their first glimpse of the courtyard: Venice in full bloom. Japanese lanterns and candlelight illuminated the brilliant array of flowers, ancient statuary, and water fountains. There was a stunned silence and then a growing buzz of approval. William James, the world-renowned psychologist from Harvard, later wrote to Belle, "The aesthetic perfection of all things . . . seemed to have a peculiar effect on the company, making them quiet and docile and self-forgetful and kind, as if they had become children." It was, he wrote, "Quite in the line of a Gospel miracle!"

Fenway Court became a vibrant art center. A series of concerts and experimental performances took place there. Ruth St. Denis, a pioneer of modern dance, performed "The Cobra, or Snake Charmer," as well as "Radha, a Hindoo Temple Dance," works inspired by eastern philosophies—and guaranteed to raise the hackles of most sensible Bostonians. Sargent informally played the piano for an assemblage of professional musicians one night. On another evening, guests ushered into the darkened courtyard were mesmerized by the sound of Gregorian chants descending from on high. Charles Martin Loeffler, a favor-

ite composer of Belle's (she lent him her priceless Stradivarius violin and eventually gave it to him), rescored his orchestral work *Pagan Poem* to take advantage of the unusual acoustics and geometry of the palace. The audience was seated in the Music Room as pianists onstage began the performance; suddenly trumpet blasts from windows high above the courtyard enveloped the room and joined the piano music. The result was an exhilarating performance piece, music coming from every direction.

Belle invited Sargent to stay and work at Fenway Court during his planned painting tour in the States in the winter and spring of 1903. Sargent wrote back that early on he'd have to stay at a hotel near the Boston Public Library where he'd be working "in my shirt-sleeves on scaffoldings" installing his most recent wall decorations, but that after that, "I would enjoy staying with you among the beautiful things whose fame has reached me."

Sargent's feelings toward Belle had softened considerably in the years since their initial skirmishing over the creation of her portrait. During Belle's frequent visits to London, he had invited her to his studio and to dinner. They had corresponded and shared many interests: "Venice misses you—" he ended one letter. Sargent had become a willing co-conspirator in her quest for art. He had bought Paul César Helleu's painting of the interior of the Abbey Church of St. Denis for her, and had recommended works by the Impressionists Claude Monet and Édouard Manet. Together they had schemed to convince the architects of the Boston Public Library to reconfigure the library plans to accommodate the "Peacock Room" created by Whistler. (They failed in that endeavor when the industrialist Charles Freer purchased the room.)

In January 1903, Belle, along with a few other trusted friends and artists, was invited to a private viewing of Sargent's decorations then being installed at the library. Before Sargent could take up Belle's invitation to

stay at Fenway Court, he had other pressing business: a trip to Washington, D.C., to paint President Theodore Roosevelt (who found it difficult to remain still), and to Philadelphia, where the artist received an honorary degree at the University of Pennsylvania. Sargent then returned to Boston and, preceded by tons of baggage, he took up residence that spring at Fenway Court—in the Macknight Room, Belle's private first-floor sanctum. Belle allowed him to paint in the Gothic Room, a space off-limits to the public during her lifetime. With his scandalous portrait of Belle looking over his shoulder from a corner in the room, the artist set up his easel and canvas and began to work. As Belle—and occasionally, her luncheon guests—looked on, Sargent produced an enormous painting of Mrs. Fiske Warren (Gretchen Osgood Warren) and her young daughter Rachel. The canvas is nearly the size of the artist. A series of photographs taken during the sitting shows Sargent in midcreation, palette in hand, applying finishing touches to the background, chewing on his paintbrush. Light comes into the room through fifteenth-century German and Flemish stained glass windows; an older Spanish window in the shape of a wheel, without glass and open to the elements, is covered with a dark cloth, presumably to block out too much direct light.

After his productive interlude as artist-in-residence at Belle's museum, Sargent typed a note of thanks to his hostess, saying that his thoughts, happily, "have taken permanent abode at Fenway Court." After his return to London, Belle sent him three dogwood trees— a species not native to England that he must have admired while in Boston. Sargent understood that it would be nothing short of miraculous if the dogwoods produced flowers in London; nonetheless, he was optimistic. He wrote to her of his plan to plant two of the trees in his garden and one in a pot. The potted tree might even appear in one of his paintings. And if the trees refused to flower in her honor? Well, then he'd paste paper flowers onto the branches. Belle remained devoted to Sargent's talent—and to their friendship—and she continued to purchase his latest watercolors.

The museum issued two hundred tickets and on February 23, 1903, the general public was allowed inside the palazzo for the first time. Everyone was welcome—art connoisseurs to streetcar conductors—at one dollar per ticket. Belle delightedly milled about with the curiosity seekers, expounding on the beauties of the art she had collected to anyone who was interested. But in short order some of her small treasures, which were not protected by glass cases, began to vanish. One day she spotted a woman across the room carefully examining a tapestry. Thrilled that someone else shared her enthusiasm for this art form, Belle approached the visitor only to discover that the visitor had a pair of scissors in her hand and was about to cut off a corner of it. Belle continued to open her house to the public, but with increasing dread. She watched as inquisitive museum visitors poked and prodded at her collections until the proprietress would shout "Don't touch" in "a voice like a parrot," according to one observer. Pronouncing that the visitors "saw with . . . [their] fingers," Belle deputized some of her young friends to help patrol the museum and prevent the "patting" of her precious objects.

Praise for her museum came from every corner. "You are a creator and stand alone," Henry Adams wrote to her. "As long as such a work can be done I will not despair of our age, though I do not think anyone else could have done it." "You are simply improbable!" William Sturgis Bigelow chimed in. The New York art dealer Henry Duveen expressed his deep admiration for the "magnificent" art and also his shock "that a lady should have made such a collection." Richard Watson Gilder, editor of *The Century Magazine* and one of New York's premier tastemakers, secured tickets for himself, his wife, and the impressionist artist Cecilia Beaux. "Tis surely the greatest fun this side of the ocean," he wrote after visiting the museum. "It wipes out the ocean, in fact. We three pilgrims were . . . knocked flat." The esteemed New York critic Mariana Gris-

wold Van Rensselaer pronounced herself "dazed" by Fenway Court and expressed surprise that Belle could "sleep at night for the pride & joy of thinking about it." Ethnographer Charles Fletcher Lummis, a leading figure in the Western art scene, wrote from Los Angeles that Fenway Court was "the only palace I ever saw that is Home." And as for those people who don't care about the notion of home? Lummis declared that if he were tsar, he'd have them "boiled."

Frank Crawford penned a long note from a castle in Kent to his beloved Belle, to say that her "Palazzo di Venezia" made him feel transported to Italy. He was struck by "the sobriety of taste that distinguishes your work from that of some professionals. . . . Nothing really noble can be anything but sober—and perhaps a little melancholy. . . . Your place is grave and calm. . . . It is so altogether yours, the form of your thought, that you and it are one—like light and air."

Gretchen Osgood Warren, who'd been painted by Sargent in the museum, wrote Belle that Fenway Court "is not 'a collection but a unity'. . . . It is alive & an organic wonderful whole—with uniqueness which is the mark of every great living thing." Evenings in the courtyard, she said, were especially powerful, "full of shadows tall & spired like cypresses" and full of "voices & echoes" from the past. In an addendum on the same letter, Gretchen's mother wrote, "I nearly wept over the beauty I saw yesterday—it is not like crude America—America owes you everything."

The rich and famous begged for an invitation to visit Belle's palace: actresses such as Sarah Bernhardt and Ethel Barrymore ("I am . . . breathless—for the intense joy you were good enough to let me experience. I didn't imagine that I should ever see so much beauty"); an English duchess and a marchioness; a knighted explorer who'd led an expedition to Tibet; the governor of Jerusalem; and Elsie de Wolfe, the reigning high priestess of interior decorating.

Even Brahmins, who never accepted Belle as one of their own (though they dared not ignore her), had to admit that her creation was sublime. In

his autobiography, George Santayana, the Harvard philosopher and man of letters, wrote that when Belle "became a widow and built her Venetian palace in The Fenway, as Egyptian monarchs built their tombs and went to live in them, she became an acknowledged public benefactor. Criticism was hushed: and there was something moving in beholding this old lady, whose pleasure it had been to shock, devoting herself . . . [to] her museum, to be left to the town . . . that had long looked at her askance, and that she was now endowing with all her treasures." Finally, stodgy old Boston acknowledged Belle's brilliance and her generosity. Her victory seemed complete.

Belle continued to add to her collection and recast her museum to accommodate new treasures. Spanish, Islamic, and Chinese art became an obsession. In 1914 she reconfigured the entire east wing of the museum. As part of the renovations she created a Spanish cloister to feature an enormous painting that she didn't even own. It was Sargent's masterful *El Jaleo* (meaning "The Ruckus"), which depicts a gypsy dancer moving across the floor of a taverna in Spain, one hand holding up her skirt, the other hand extended, snapping her fingers to the music; behind the dancer, in partial shadow, guitarists and other gypsy women rhythmically clap and sway to the performance. It is an enormous, cinematic work. Thomas Jefferson Coolidge, a relation to Belle by marriage, purchased the painting in 1882, and for decades she had badgered him to sell it to her. He refused. After the cloister was completed, Belle borrowed the work from Coolidge and invited him over to view it in its new setting. A Moorish arch frames the entire painting. Lit dramatically from below, the canvas comes alive. It appears as if a real performance is taking place on a stage set. Coolidge was bowled over by the effect. "If you really think it looks so much better here," Belle said slyly, "would it be right for you to take it away?" He gave her the painting. A few years later, Sargent, equally thrilled with Belle's installation of *El Jaleo*, presented Belle with an album of twenty-one sketches he had made in preparation for the painting.

But after that major reconfiguration, Belle's collecting slowed considerably. She feared that she wouldn't leave enough money behind to fund the museum in perpetuity. Her fabled tales of excess were now replaced with legends of her parsimony (though Belle did purchase an ambulance—named *Y* in her honor—for the Red Cross in France during World War I). She now instructed Bolgi to purchase only two oranges at a time; luncheon guests were served only toast with a few asparagus stalks. Bernard Berenson claimed that once when he and his wife stayed at Fenway Court there was so little food at dinner that by the middle of the night they were famished, and crept to the kitchen in search of a snack. They found only two dog biscuits.

During the Christmas cycle of festivities in 1919, Belle attended a dinner where Sargent was also a guest. After going to bed that night she suffered an embolism that left her paralyzed on the right side and she put out the story that she had the flu. Even Sargent, bearing a bouquet of violets—Belle's favorite—was not permitted to see her. The artist and his sister Emily, who was then in Boston with him, were finally invited to visit on February 24. She was badly diminished, but at nearly seventy-nine, she tried to make light of her condition as she was carried about on a Venetian gondola chair. She insisted that it was arthritis that had left her lame. Soon, of course, all of Boston knew her sorry state.

A series of strokes over the next several years left her without the use of her hands. She gave away her jewels to friends and relatives—even her beloved dancing diamonds, "Rajah" and the "Light of India," were of no use to her anymore. She directed her maid to conceal her lifeless hands and her withered body with yards of fabric. A veil, always white, covered her head and shoulders. Sargent visited Belle in September 1922. She looked like a vision of repose and calm—"a fleecy cloud from Heaven" enveloping her head, her face free of wrinkles, ageless. Sargent had long since grown to detest portraiture—to him, it had become a tiresome exercise in flattering his clients. But now he had a request. There's only one

woman in Boston I want to paint, he told her: You. "There isn't a woman on earth who would refuse to let you paint her portrait," she told him.

On September 14, 1922, Sargent painted eighty-two-year-old Belle in the Macknight Room, her private first-floor sitting room, and the room where he had stayed. Named after Dodge Macknight, a New England watercolorist favored by Belle, the room is modest, the least ostentatious one in Belle's magnificent palace. (Today, it is not open to the public if there aren't enough guards on duty.) But late in life, Belle would sit in that room among her most personal treasures: a seemingly haphazard collection of objects, drawings, and artifacts that meant something to her. There were gifts from friends and assorted oddities she had collected—a bronze knocker in the shape of a dolphin, a crystal box emblazoned with a *Y*, an Aeolian harp designed to be played by the wind, sixteenth-century leather strips flanking the windows, and seven plaster studies for Sargent's massive wall decorations at the Boston Public Library.

Two glass bottles sit atop an elegant eighteenth-century Venetian chest of drawers on one side of the room. One is filled with sand collected near the Great Pyramid at Giza, the other with sand collected near the Sphinx. Belle had scooped up the sand in 1875 and kept it for the rest of her life—a keepsake of her first encounter with the ancient world, when she literally lay upon the sand in her attempt to fathom the mysteries of the Sphinx.

To paint Belle, Sargent decided to use watercolor. Its insubstantial, ethereal quality perfectly captures the ebbing away of one of the greatest spirits of the Gilded Age. Shrouded in white cloth, she sits on a couch propped up with cushions; her pale, expressionless face seems to be disappearing into the cloth, about ready to vanish. Swathed and hooded, she appears like some sort of Egyptian mummy or priestess. There is an air of otherworldliness, as she faces her final days. The artist's valedictory to his friend and patron depicts a frail, gentle soul with her body scarcely in sight.

Sargent created the watercolor in a day, as if without effort. In contrast, Belle's earlier, brash, flesh-revealing portrait—which was all *about* her body—required many, many sittings. The opening salvo between the artist and his patron had been a battle, but Sargent's final watercolor of Belle was a work of peace, a heartfelt tribute to the woman he'd grown to love and admire. The artist gave her the watercolor and signed it: "To my friend Mrs. Gardner / John S. Sargent." She placed it in the Macknight Room atop a bookcase so she could see it easily from her couch. It remains there, not far from the cabinet with the Egyptian sand. It seems an apt pairing—the beginning of time, and the end of Belle's life as she dissolves in watercolor. The *alpha* and the *omega*.

That was the last portrait ever made of Belle. She died on July 17, 1924. Among her final, detailed instructions: that Sargent serve as one of her honorary pallbearers. But that turned out to be impossible. Sargent had boarded a ship for England three days before her death. "Carry my coffin high," she directed her pallbearers, as if she might strike them down if they failed to do so. Even in death, the queenly Isabella was issuing commands.

The Curtain Closes

When Sargent reached London he received news of Belle's death and a full account of her funeral from a friend who had attended the service. The artist regretted that he had not been able "to pay her a last tribute of respect and affection" in person; but, in fact, he had done that with his final depiction of Belle.

Sargent had tried his best to free himself from portraits—or, "paughtraits," in his sarcastic spelling. "Ask me to paint your gates, your fences, your barns, which I should gladly do, but NOT THE HUMAN FACE," he wrote to Lady Radnor when she tried to commission him to paint one of her daughters. He'd had enough. He preferred landscapes, watercolors, and the murals he was completing for the Museum of Fine Arts, a commission he received after he'd finished his work at the Boston Public Library. The upper class still clamored for Sargent's formal portraits, but by the 1920s, modernist critics derided his work as "empty bravura passages of just paint."

Laying portraiture aside, Sargent regarded his murals, which he created in England and sent in pieces to Boston, as his most lasting and important work. After he finished the final panels and reliefs for the Museum of Fine Arts, he wrote detailed instructions for their installation,

and then supervised as they were crated and shipped. "Now the American things are done," he told a fellow artist, "and so, I suppose, I may die when I like."

Sargent arranged for a stateroom aboard the RMS *Baltic* ocean liner for a trip to America, so that he could watch as his work was permanently placed in the museum. The ship was to depart on Saturday, April 18, 1925, and his sister Emily arranged a small farewell party at her home on Tuesday of that week. The guests included some of his dearest friends, including the artist Peter Harrison. (The surviving accounts don't mention whether Harrison was accompanied by his mistress, Dos Palmer.) It was a jolly evening and Sargent decided to walk back to his Tite Street home. But it began to rain and one of the guests, passing him in a cab, had the driver pull over. His friend insisted that Sargent climb in, and the artist did so reluctantly. At his doorstep, Sargent turned and called out, "Au revoir; in six months."

Before going to bed, Sargent remembered he'd neglected to inform a gallery owner in New York about a painting that he'd shipped earlier in the month. A stickler for business details, the artist sat at the dining room table, wrote the letter, and went outside and posted it. Back in the house he pulled a volume of Voltaire's *Dictionnaire Philosophique* off his bookcase to read in bed. The next morning, when there was no answer at his bedroom door, the maid entered and found him dead of a heart attack. There he lay, his glasses pushed atop his head, the book lying open next to him.

By the morning of April 15, word had spread of Sargent's death. At midday the trustee of the National Gallery, Sir Philip Sassoon, arrived at Sargent's Tite Street home with a mourning wreath to honor the sixty-nine-year-old artist. Tributes poured in, and the *London Times* claimed Sargent as one of the country's own: "End of an Epoch in English Art" the headline read, despite Sargent's insistence that he was an American artist. He was buried in Brookwood Cemetery in Surrey. Above his name, the gravestone reads "LABORE EST ORARE" ("TO WORK IS TO PRAY").

ACKNOWLEDGMENTS

Sometimes it takes a village to write a book, and in this case it took many villages, many experts, scholars, and friends. Author and friend Caroline Preston first suggested the idea for *Sargent's Women*, which set in motion years of research and writing.

Among those I am most indebted to is J. Winthrop "Wint" Aldrich, grandnephew of Elizabeth Chanler Chapman, who supplied me with family anecdotes, photographs, and access to the rich collection of private papers at Rokeby, the ancestral Astor/Chanler estate in the Hudson Valley. My friend Jane Stewart Humiston, owner of Castle Hill outside Charlottesville, Virginia, generously shared with me a soulful portrait of Elizabeth Chanler that was part of the original collections at the estate. (She also shared much wine and laughter.) I am extremely grateful to Vic King, local historian from the Isle of Wight, who gave me a tour of Bonchurch and brought me to the stone house, once a private school, where Elizabeth spent her formative years. Thanks also to playwright and actor John Goodwin and his wife, Linda, who live near the former school and helped track down local periodicals for me.

Chris Rollins, the current owner of Lucia Fairchild Fuller's house, graciously gave me transcriptions he had made of some of her correspondence. Lucia Miller also made key transcriptions of Lucia's diaries. Michael A. Varet and Elizabeth R. Varet kindly invited me to their home and provided me with critical insights on the Fairchild family. Nancy Norwalk, associate

director of the Philip Read Memorial Library in Plainfield, New Hampshire, not only offered expert archival assistance on Lucia and the Cornish Colony, but also unlocked the local town hall so that I could see Maxfield Parrish's magnificent theatrical backdrop. Henry J. Duffy, curator of the Saint-Gaudens National Historic Site, showed me Lucia's drawings, photographs, and other material that was crucial in establishing Lucia Fairchild Fuller's role in the Cornish Colony. Art expert James Godfrey and Lisa Cavanaugh, managing director, Midwest Regional Office, at Christie's, helped me locate Sally Fairchild's portrait. And Stanley Ellis Cushing, curator of rare books and manuscripts at the Boston Athenaeum, ferreted out the uncatalogued scrapbook devoted to John Sargent that includes photos of the artist on the beach in Nahant with the Fairchild family.

While in England following Sargent's footsteps, I was graciously hosted in both London and in the Cotswolds (in the village of Upper Slaughter, a name right out of an English detective story) by my friends James Morrison and Lee Marshall. To them, my sincere thanks. The proprietors of the Lygon Arms—the hotel in Broadway, England, where the Fairchilds stayed one summer—kindly allowed me to wander freely through the property. Elsie Palmer's story brought me to Ightham Mote in Kent, where Philip Stott provided me with a fine history of the American family's stay in that medieval manor house. Tamsin Leigh, visitor experience manager at the mansion, was also very helpful.

In Colorado Springs, Leah Davis Witherow, the curator of history and archivist for the Colorado Springs Pioneers Museum, shared her deep knowledge of the Palmer family as well as transcripts of correspondence. Witherow organized the extensive collection of Palmer manuscript material that was donated to the museum in recent years, and she and I spent many hours discussing the dynamics of that interesting family, and of Elsie in particular. Stephanie Prochaska, assistant archivist, supplied me with copies of hundreds of documents. Jessy Randall, curator and archivist at Colorado College Special Collections, was also exceedingly knowledgeable and helpful, as were Joy Armstrong, Curator of Modern

NOTES

ix **"His quarry":** Evan Charteris, *John Sargent* (New York: Charles Scribner's Sons, 1927), 46.

INTRODUCTION

xiii **"Portrait painting":** Lucia Miller, "John Singer Sargent in the Diaries of Lucia Fairchild 1890 and 1891," *Archives of American Art Journal* 26, no. 4 (1986), 7.

xiv **During his lifetime Sargent created:** Accessed October 12, 2016, http://www.johnsingersargent.org/the-complete-works.html.

xvi **Elsie Palmer penned:** E. M. P., *Two Stories* (Glen Eyrie, 1883).

xvii **Distraught after losing a child:** Stanley Olson, *John Singer Sargent: His Portrait* (London: Macmillan, 1986), 1.

xvii **She also harbored artistic dreams:** Charles Merrill Mount, *John Singer Sargent: A Biography* (London: Cresset Press, 1957), 11–12. (There are two editions of this book, one published in 1955, and another in 1957. The text varies, so hereafter the notes will include the date of the edition.)

xvii **His first memory:** Ibid., 4.

xvii **He'd later say:** Charles Merrill Mount, *John Singer Sargent: A Biography* (New York: Norton, 1955), 190.

xvii **Young Sargent and his family:** Olson, *John Singer Sargent*, 3–4, 6–7. Mount, *John Singer Sargent*, 1957 ed., 4, 6–7.

xviii **Business in England:** Sargent charges three times his usual fee, Mount, *John Singer Sargent*, 1957 ed., 104. Stanford White's influence, Richard Ormond and Elaine Kilmurray, *John Singer Sargent: The Early Portraits* (New Haven, CT: Yale University Press, 1998), 196.

xviii **On the wall:** Mount, *John Singer Sargent*, 1957 ed., 72, 78, 158.

xix **"Baby"**: Ormond and Kilmurray, *Early Portraits*, 98, Description of the portrait hanging in Sargent's dining room, 100.

xix **"not a marrying man"**: Mount, *John Singer Sargent*, 1957 ed., 181. In describing Sargent, Mount writes, "He was a large and strong man, with, if one knew him at all, enough indications of virility not to be taken for an example of the intellectualized homosexuality notable among the artists of London. Surely he could not say . . . that he was 'not a marrying man.' "

xix **"frenzied bugger"**: Elizabeth Anne McCauley et al., *Gondola Days: Isabella Stewart Gardner and the Palazzo Barbaro Circle* (Boston: Isabella Stewart Gardner Museum, 2004), 115. For a discussion of Sargent's relationship with Charlotte Louise Burkhardt as a possible love interest, see Olson, *John Singer Sargent*, 87–90. For more recent scholarship on Sargent's sexual leanings and his collection of nude male portraits, see Trevor Fairbrother, *John Singer Sargent: The Sensualist* (New Haven, CT: Yale University Press, 2000), 18–19, 154–55, and the "Album of Figure Studies" following 180.

xix **"seemed to protect himself"**: Charteris, *John Sargent*, 229. Discussion of his clothing and orderly life, Olson, *John Singer Sargent*, 201–3.

xix **"a lemon with a slit"**: Miller, "John Singer Sargent in the Diaries of Lucia Fairchild," 6.

CHAPTER ONE: THE PILGRIM

1 **"Here is no home"**: Elsie Palmer diary, October 2, 1894, Tim Nicholson Collection, Colorado Springs Pioneers Museum, Starsmore Center for Local History. In her transcription, Elsie misspelled "pilgrim" as "pilgram," and added a second "forth" before the exclamation point.

1 **"lifeless" . . . "hard" . . . "almost crazy"**: Ormond and Kilmurray, *Early Portraits*, 191.

1 *A Portrait*: Ibid., 259. The painting, currently owned by the Colorado Springs Fine Arts Center, now goes by the title *Portrait of Miss Elsie Palmer* or *A Lady in White:* Joy Armstrong, curator of Modern and Contemporary Art, Colorado Springs Fine Arts Center, e-mail message to author, January 16, 2017.

1 **"I sat sedately"**: Elsie Palmer diary, April 30, 1891. Tim Nicholson Collection.

2 **"marmorial and mute"**: Nigel Nicholson and Joanne Trautmann, eds., *The Letters of Virginia Woolf*, vol. 3 (New York: Harcourt Brace Jovanovich, 1977), 112.

2 **"merciless analysis"**: Ormond and Kilmurray, *Early Portraits*, 191.

3 **Elsie's mother had just visited:** Elsie Palmer diary, October 27, 1889. Tim Nicholson Collection.

3 **The ghost, Dame Dorothy:** Frances Metcalfe Wolcott, *Heritage of Years: Kalei-*

doscopic Memories (New York: Minton, Balch & Company, 1932), 254. General description of house and ghost, Nigel Nicholson and Adam Ford, *Ightham Mote*, rev. ed. (Warrington, UK: National Trust, 2005), 2–3, 12–13, 17.

4　**"co-maniacs":** Mount, *John Singer Sargent*, 1957 ed., 96.

4　**rumored relationship:** Mary C. Hampel DeHay, transcriber, *The Joyous Child: A Personality Sketch of Anna Held Heinrich* (self-published, 1992), 27–29, Special Collections and Archives, Tutt Library, Colorado College.

4　**"the scales of a serpent"** . . . **"soft chain armour":** Eve Adam, ed., *Mrs. J. Comyns Carr's Reminiscences* (London: Hutchison & Company, 1926), 211–12, for a full description of the dress.

4　**"magenta hair!":** John Singer Sargent to Isabella Stewart Gardner, January 1, 1889, Isabella Stewart Gardner Museum Archives.

5　**"the vision of Lady Macbeth"** . . . **"wonderful possibilities":** Cox Devon, *The Street of Wonderful Possibilities: Whistler, Wilde & Sargent in Tite Street* (London: Frances Lincoln, 2015), 138.

5　**The painting caused an enormous:** Richard Ormond and Elaine Kilmurray, *Sargent: Portraits of Artists and Friends* (London: National Portrait Gallery, 2015), 139.

5　**"I am tired":** Mount, *John Singer Sargent*, 1957 ed., 22.

6　**With the death of his father:** Olson, *John Singer Sargent*, 159–61. Financial situation in the wake of his father's death.

6　**The painter now inherited:** Mount, *John Singer Sargent*, 1957 ed., 13, 183. Discussion of Emily's debilitating illness and spinal deformity.

7　**"Castle" for her:** Black, *Queen of Glen Eyrie*, 22. From an August 7, 1869, letter from William J. Palmer to Queen Mellen.

7　**"where life would be poetry":** William J. Palmer to Queen Mellen, August 9, 1869. Elsie Queen Nicholson Collection, Colorado Springs Pioneers Museum, Starsmore Center for Local History.

7　**"I may as well get used to":** Black, *Queen of Glen Eyrie*, 18.

7　**The awestruck bride-to-be:** Ibid., 17.

8　**"lungers":** John Bessner Huber, *Consumption: Its Relation to Man and His Civilization, Its Prevention and Cure* (Philadelphia: Lippincott, 1906), 124.

8　**"all motionless and silent":** Jerry Camarillo Dunn Jr., *The Smithsonian Guide to Historic America: The Rocky Mountain States* (New York: Stewart, Tabori & Chang, 1998), 129.

8　**"Major Domo"** . . . **"Montezuma":** Black, *Queen of Glen Eyrie*, 42.

9　**"Our home is in Colorado":** Elsie Palmer to George MacDonald [1882]. Special Collections and Archives, Tutt Library, Colorado College.

9　**"dull-eyed and wan"** . . . **"little machine of her":** Black, *Queen of Glen Eyrie*,

80. Transcription of an April 26, 1882, letter from William J. Palmer to Queen Palmer.

10 **"I am perfectly enchanted":** Ibid., 81.

11 **The Mote is a giant puzzle:** For a thorough description of the house, Nigel Nicholson and Adam Ford, *Ightham Mote*, rev. ed. (Warrington, UK: National Trust, 2005).

11 **There was no electricity:** Adam, ed., *Mrs. J. Comyns Carr's Reminiscences*, 122.

12 **"a vile and papistical":** Nicholson and Ford, *Ightham Mote*, 22.

12 **"squint":** Ibid., 21.

12 **Elsie's own bedroom:** Elsie Palmer diary, March 29, 1890, Tim Nicholson Collection.

12 **"New Chapel":** Nicholson and Ford, *Ightham Mote*, 22–24.

13 **"who is a perfect beauty":** Elsie Palmer diary, September 3, 1889, Tim Nicholson Collection.

13 **"Mother wants to be very sure":** Queen Palmer to Elsie, Dorothy, and Marjorie Palmer, July 1886, Tim Nicholson Collection.

14 **"After supper at 8 o'clock":** Elsie Palmer to Queen Palmer, ca. 1886, Tim Nicholson Collection.

14 **"bewildering[ly] happy":** Elsie Palmer to Queen Palmer, October 5, 1889, Tim Nicholson Collection.

15 **"The good General Palmer":** Leon Edel, ed., *Henry James Letters, volume 3, 1883–1895* (Cambridge, MA: Belknap Press, 1980), 216.

15 **"drollest amalgam"** . . . **"characteristically Coloradoish"** . . . **"lean tenants"** . . . **"rustics":** Ibid.

15 **"now lives in a country boasting"** . . . **"a picturesque boatman":** Adam, ed., *Mrs. J. Comyns Carr's Reminiscences*, 123.

15 **"major-domo a helpless":** Edel, ed., *Henry James Letters, Volume 3*, 217.

15 **"a state of almost perilous decreptitude":** Ibid., 216.

15 **"Our spines were chilled":** Frances Metcalfe Wolcott, *Heritage of Years: Kaleidoscopic Memories* (New York: Minton, Balch & Company, 1932), 254–55.

16 **"fortunately the former remained":** Edel, ed., *Henry James Letters, Volume 3*, 216.

16 **The author added to the decidedly spooky:** Alice Strettell Carr, *J. Comyns Carr: Stray Memories* (London: Macmillan and Company, 1920), 134.

16 **"The children were always the frame":** Ibid., 135.

17 **"Always let her pursue":** Ibid.

17 **"like a nun":** Elsie Palmer diary, March 7, 1889, Tim Nicholson Collection. Carr, *J. Comyns Carr*, 134–35. Adam, ed., *Mrs. J. Comyns Carr's Reminiscences*, 126. George Meredith and Henry James helped teach the children at the Mote how to play a parlor game called "Definitions." One person would

write down a word that would be the "subject"; another would define it on a piece of paper, keeping the original word covered; a third person would then "recover" the meaning. Carr recounted one sample game: "Subject, *Soap*; Definition . . . *The Horror of the East-end multitude*; Recovery, *Jack the Ripper*," who was then terrorizing London.

17 **Dress-up was a major:** Adam, ed., *Mrs. J. Comyns Carr's Reminiscences*, 111, 123.

18 **Sargent needed activity:** Elsie Palmer diary, December 12, 1890, Tim Nicholson Collection.

18 **"Hardly doing any-thing":** Elsie Palmer diary, December 1, 1889, Tim Nicholson Collection.

18 **A full-length portrait:** Ormond and Kilmurray, *Early Portraits*, xxiii.

19 **"strange and weird":** Elsie Palmer diary, November 5, 1889, Tim Nicholson Collection.

19 **Elsie went up to London:** Ibid., December 1 and 7, 1889, Tim Nicholson Collection.

19 **Queen and Elsie had already spent months:** Ibid., August 10, 1889, and March 14, 1890, Tim Nicholson Collection.

19 **Leaving the Mote:** Elsie Palmer diary, March 26, 1890, Tim Nicholson Collection.

20 **"Tonight: this is the Mote":** Ibid., March 30, 1890, Tim Nicholson Collection.

20 **Mothers and daughters:** Ibid., March 31, 1890, and June 6, 1890, Tim Nicholson Collection.

20 **"Elsie Palmer's unfinished portrait":** Ormond and Kilmurray, *Early Portraits*, 191.

20 **"wonderful change":** Elsie Palmer diary, November 18, 1890, Tim Nicholson Collection.

21 **"Same spirit of rebellion":** Ibid., November 19, 1890, Tim Nicholson Collection.

21 **On other days they argued:** Ibid., November 21–22, 1890, Tim Nicholson Collection.

21 **By mid-December:** Ibid., December 11–13, 1890, Tim Nicholson Collection.

22 **"I can't express:"** Elsie Palmer diary, December 31, 1890–January 1, 1891, Tim Nicholson Collection.

22 **"There is not much to add":** Queen Palmer to Elsie Palmer, March 28, 1890, Tim Nicholson Collection. For the sake of clarity in this letter, a few dashes were changed to commas.

22 **Doctors in England:** William J. Palmer to Elsie Palmer, April 17, 1892, Tim Nicholson Collection.

22 **"My darling chick":** William J. Palmer to Elsie Palmer, February 21, 1891, Tim Nicholson Collection.

23 **Elsie knew her father:** Elsie Palmer to William J. Palmer, note folded into 1890–1892 diary volume, Tim Nicholson Collection.

24 **One winter day:** Elsie Palmer diary, February 26, 1891, Tim Nicholson Collection.

24 **"The end of the Gotterdammerung":** Ibid., March 22, 1891, Tim Nicholson Collection.

24 **"the most sacred spot":** Ibid., July 19, 1891, Tim Nicholson Collection.

24 **"great solemn silent pines!":** Ibid., July 9, 1891, Tim Nicholson Collection.

24 **"there is . . . a <u>something</u> strangely lacking":** Ibid., July 21, 1891, Tim Nicholson Collection.

25 **The General visited London:** William J. Palmer to Elsie Palmer, May 25, 1891, Tim Nicholson Collection.

25 **He and Elsie went:** Elsie Palmer diary, November 14, 1891, Tim Nicholson Collection. "My portrait looked very well in the right light," Elsie had written a month before her father arrived. She also noted that the studio had Sargent's "interesting Egyptian sketches for the Boston library."

25 **"I want to do something more":** John Singer Sargent to Elsie Palmer, December 1891, Tim Nicholson Collection. Sargent writing from Morgan Hall, Fairford, Gloucestershire, to Elsie Palmer at Oak Cottage, Frant, Sussex.

25 **"It is too difficult a task":** Elsie Palmer diary, June 7, 1892, Tim Nicholson Collection.

25 **Elsie wrote her assessment:** Thomas Garner and Arthur Stratton, *The Domestic Architecture of England during the Tudor Period*, vol. 1 (New York: Charles Scribner's Sons, 1929), 84.

25 **"like an ideal fairy-garden":** Ibid., June 7, 1892, Tim Nicholson Collection.

26 **"After having wandered":** Ibid., May 5, 1892, Tim Nicholson Collection.

26 **"Put it away in some nursery":** Ibid. Elsie and her husband Leo Myers eventually owned the painting. Ormond and Kilmurray, *Early Portraits*, 264.

26 **Helen Dunham remained:** Elsie Palmer diary, May 4–5 and 20, 1892, and June 16, 1892, Tim Nicholson Collection. "Helen's portrait quite finished and beautiful," Elsie writes on June 16.

27 **her fingers as "saignant":** Richard Ormond and Elaine Kilmurray, *John Singer Sargent: Portraits of the 1890s* (New Haven, CT: Yale University Press, 2002), 58. Further discussion of Lady Agnew, 66, and Helen Dunham portrait, 56–58.

27 **"a white finger appeared":** Elsie Palmer diary, May 13, 1892, Tim Nicholson Collection.

28 **"Poetess, who turns her back":** Ibid., June 12, 1892, Tim Nicholson Collection. The June 12 entry describes Elsie's entire stay at Box Hill, includ-

ing the birthday party that took place on June 10 and her departure on June 11.

29 **He had been dismayed to learn:** William J. Palmer to Elsie Palmer, April 17, 1892, Tim Nicholson Collection. The General, writing to Elsie from New York concerning his disappointment that she had given up her health regime, had one request: he begged Elsie to keep her younger sisters away from caffeine. "Then they will like milk & never find out that coffee or tea is essential to soothe shattered nerves or to drive away head aches &c because they will not know what nerves are to soothe & will be less likely to have head aches."

29 **Elsie was learning:** Elsie Palmer diary, June 12, 1892, Tim Nicholson Collection.

29 **Elsie's diaries reveal:** Ibid., June 16, 1892 and July 10, 1892, Tim Nicholson Collection.

29 **"Men and women of all kinds":** Elsie Palmer diary, July 5, 1892, Tim Nicholson Collection.

30 **"The very thing in this English climate":** Black, *Queen of Glen Eyrie*, 112–13.

31 **"There is some *music*":** Barbara Gately, "An Abiding Bond: The Friendship between Major Henry McAllister & William Jackson Palmer," in *Legends, Labors & Loves of William Jackson Palmer 1836–1909*, ed. Tim Blevins et al. (Colorado Springs: Pikes Peak Library District, 2009), 65.

31 **"And you my dear wife":** Chris Nicholl, "'My Darling Queenie . . .' A Love Story," in Blevins et al., *Legends, Labors & Loves*, 78.

31 **"Nomad":** Elsie Palmer diary, March 5, 1894, Tim Nicholson Collection.

31 **"Mrs. Carnegie's place":** Ibid., March 20, 1894, Tim Nicholson Collection.

31 **"George Vanderbilt's place":** Ibid., March 22, 1894.

32 **"stately little walks":** Ibid., March 28, 1894, Tim Nicholson Collection.

32 **"The green rock wall"** . . . **"in a silk dress":** Ibid., March 19, 1894, Tim Nicholson Collection.

32 **"Motherling's path":** Ibid., March 30, 1894, Tim Nicholson Collection.

32 **"chromatic scale bird":** Ibid., March 31, 1894, Tim Nicholson Collection.

32 **Visitors came and went:** Ibid., April 1–2 and 11, Tim Nicholson Collection.

32 **"Even what seems bad weather":** Judith K. Major, *Mariana Griswold van Rensselaer: A Landscape Critic in the Gilded Age* (Charlottesville: University of Virginia Press, 2013), 158.

32 **"barbaric place":** Ibid., 159.

32 **Only two days later:** Elsie Palmer diary, April 22, 1894, Tim Nicholson Collection.

33 **"Almost like a civil war":** Ibid., May 26, 1894, Tim Nicholson Collection.

Description of entire trip to and from California is from May 2 to June 8, 1894.

33 **Within six months Elsie:** Elsie Palmer diary, August 16, 1894, Tim Nicholson Collection. She described her trip to England as "going home!"

33 **"black shadows were assembling":** Elsie Palmer diary, October 1, 1894, Tim Nicholson Collection. Elsie is quoting Thomas Bailey Aldrich, prominent writer and editor, from his novel *The Queen of Sheba & My Cousin the Colonel.*

33 **"questionable letter":** Elsie Palmer diary, October 26, 1894, Tim Nicholson Collection.

34 **Peter cited "gentleman":** John Ashdown-Hill, *Last Days of Richard III and the Fate of His DNA* (Stroud, UK: History Press, 2013), xlvi.

34 **"looked sweetly interesting":** Elsie Palmer diary, December 19, 1890, Tim Nicholson Collection.

34 **"Juggernaut":** Peter Harrison to Elsie Palmer, November 4, 1903, Tim Nicholson Collection.

34 **"heaps of watercolours"** . . . **"all hopelessly clever":** Peter Harrison to Elsie Palmer, November 21, 1903, Tim Nicholson Collection.

34 **"creeping away into inner rooms"** . . . **"wiser and less exuberant":** Ibid., November 4, 1903, Tim Nicholson Collection.

34 **"be converted to think more of John":** Henry James to Peter Harrison, November 13, 1903, Tim Nicholson Collection.

34 **"strong man"** . . . **"& do-nothing":** Peter Harrison to Elsie Palmer, November 4, 1903, Tim Nicholson Collection. Peter Harrison also describes his feelings regarding Sargent in a November 9, 1903, letter to Elsie. He tells her that to be an artist it takes such a supreme effort that he doubts it's worth the trouble, unless you have the "vitality" or the "genius" of a Sargent. Harrison's depression and inability to work is described in a September 4, [1895] letter from Alma Strettell Harrison to Elsie Palmer.

35 **"asthmatic attack":** Elsie Palmer diary, December 15, 1894. Tim Nicholson Collection.

35 **"my own darling Motherling"** . . . **"We feel your presence":** Elsie Palmer to Queen Palmer, December 25, 1894, Tim Nicholson Collection.

35 **Elsie looked to Peter:** Elsie Palmer diary, December 29, 1894, Tim Nicholson Collection. She writes that she took "strength from Peter's presence."

35 **Peter gave Elsie a gift:** Elsie Palmer diary, March 2, 1895 and March 9, 1895, Tim Nicholson Collection. Elsie visits the Mote "in a daze," but Peter "understands it all—and holds one up to one's best."

35 **Sargent, from London:** Emily Sargent to Elsie Palmer, March 14, 1895, Tim Nicholson Collection.

36 **"looks like the end of the world":** Dorothy Comyns Carr diary, December 20, 1903, Tim Nicholson Collection.

36 **"Sky Garden":** Donald McGilchrist, "The Gardens of Glen Eyrie," in Blevins et al., *Legends, Labors & Loves*, 219.

37 **Close upon arrival, Elsie moved:** Elsie Palmer diary, April 13, 1895, Tim Nicholson Collection.

37 **"freckled and a little awkward":** John S. Fischer, *A Builder of the West: The Life of General William Jackson Palmer* (Caldwell, ID: Caxton, 1939), 283.

37 **"They would arrive with a town"** . . . **"little forlorner":** Dorothy Comyns Carr diary, December 19, 1902, Tim Nicholson Collection.

37 **"charming tyrant":** Chris Nicholl, "William Jackson Palmer: Living while Dying," in Blevins et al., *Legends, Labors & Loves*, 278.

38 **"loose or no undergarments":** Delores Gustafson, "General William Jackson Palmer & the Mellen & Clarke Families," in Blevins et al., *Legends, Labors & Loves*, 83.

38 **She pronounced that the mountains:** Dorothy Comyns Carr diary, January 13, 1903, Tim Nicholson Collection.

39 **"Infinite":** G. H. Bantock and L. H. Myers, *A Critical Study* (London: University College Leicester and Jonathan Cape, 1956), 139.

39 **Like a commanding general** . . . **"platoon":** Hamlin Garland, *Companions on the Trail: A Literary Chronicle* (New York: Macmillan, 1931), 82–84.

39 **Though raised in entirely different circumstances:** Trevor Hamilton, *Immortal Longings: FWH Myers and the Victorian Search for Life After Death* (Exeter, UK: Imprint Academic, 2009), 54–55. Leo doesn't want to be in the same room as his father and his mother tries to protect her son. Penelope Fitzgerald, Introduction to *The Root and the Flower* by L. H. Myers (New York: New York Review Books, 2001), vii. A "procession of mediums and 'sensitives' . . . came to the house."

40 **In two images titled:** http://www.npg.org.uk/collections/search/portrait/mw150346/Leopold-Hamilton-Myers-as-TheCompassionateCherub?set=2 47%3BPhotographs+by+Eveleen+Myers&wPage=0&search=ap&rNo=6.

41 **"Battleground"** . . . **"a war of boys":** Dorothy Comyns Carr diary, February 5, 1903, Tim Nicholson Collection.

41 **"probably 50 or 60"** . . . **"Only 2 years ago":** Ibid., March 2, 1903, Tim Nicholson Collection.

41 **One evening after dinner:** Ibid., March 6, 1903, Tim Nicholson Collection. In response to Doll's tears, "General Palmer [was] disappointed & thought us squeamish."

42 **"that burning time":** Peter Harrison to Elsie Palmer, December 20, 1903, Tim Nicholson Collection.

42 **"I touched the sky":** Ibid., November 19, 1903, Tim Nicholson Collection.

42 **What Elsie and Peter didn't know:** Dorothy Palmer to Marjory Palmer, November 29, 1902, Tim Nicholson Collection. "Tell me <u>everything</u>," she writes.

42 **A keen student of emotions:** Peter Harrison to Elsie Palmer, undated, Tim Nicholson Collection.

42 **"My Marje":** Dorothy Palmer to Marjory Palmer, November 29, 1902, Tim Nicholson Collection.

43 **"Oh! For a day":** Peter Harrison to Elsie Palmer, December 5, 1903, Tim Nicholson Collection. Peter often refers to Elsie in his letters as "Else," but for purposes of clarity I've changed it to "Elsie."

43 **"that very calm expression"** . . . **"I belong to you.":** Peter Harrison to Elsie Palmer, November 4, 1903, Tim Nicholson Collection.

44 **torrent of letters "is life to me":** Ibid., October 29, 1903, Tim Nicholson Collection.

44 **Yet at times Elsie wondered:** Ibid., November 19, 1903, and December 2, 1903, Tim Nicholson Collection. She has expressed "heavy doubts" in an earlier letter to him. Peter, fearing she will break off their relationship, writes, "No one comes anywhere near you. Else you mustn't leave me now. I couldn't bear it: you are in my bones."

44 **Increasingly brazen:** Peter Harrison to Elsie Palmer, November 23, 1903, Tim Nicholson Collection. He tells her about keeping photographs of her in open sight, and that one guest was "horrified . . . & wondered you allow them to be seen!"

44 **Dos knows about us:** Ibid., December 6, 1903, Tim Nicholson Collection.

44 **her beautiful voice (like a "meadowlark"):** Ibid., December 17, 1903, Tim Nicholson Collection.

44 **"Tell me of Dos: <u>always</u>":** Ibid., January 15, 1904, Tim Nicholson Collection.

44 **"For plain love":** Ibid., March 7, 1904, Tim Nicholson Collection.

44 **Can you imagine "that Dos"** . . . **"with your 'quiet way'":** Ibid., January 30, 1904, Tim Nicholson Collection.

45 **"I am walking on the clouds":** Ibid., in Paris, April 22, 1904, Tim Nicholson Collection.

45 **"poetess: for everything shared":** Ibid., April 28, 1904, Tim Nicholson Collection. After having visited Colorado, "Señor" was Peter's preferred signature to Elsie.

45 **twenty-three-year-old Dos as his "standard":** Peter Harrison to Elsie Palmer, May 11, 1904, Tim Nicholson Collection.

45 **Peter urged Elsie to send Dos:** Ibid., May 8, 1904, Tim Nicholson Collection. "I shall be sorely disappointed for her (and myself) if she doesn't come soon: You just ought to send her and risk it."

46 **"delicious lines of throat":** Peter Harrison to Elsie Palmer, July 2, 1904, Tim Nicholson Collection.

46 **In a way, Sargent put his stamp of approval:** Ormond and Kilmurray, *Sargent: Portraits of Artists*, 216.

47 **"It seems to be a sort of paradise":** Gustafson, "General William Jackson Palmer," in Blevins et al., *Legends, Labors & Loves*, 85. For descriptions of the newly renovated castle: McGilchrist, "The Gardens of Glen Eyrie," in Blevins et al., *Legends, Labors & Loves*, 226–27, 233; Black, *Queen of Glen Eyrie*, 123; Dorothy Comyns Carr diary, February 21, 1903, and May 10, 1903; http://www.fortcarsonmountaineer.com/2016/05/city-founders-castle-glen-eyrie/; and https://www.gleneyrie.org/Visit-The-Castle/GlenEyrie History/Glen-Eyrie-Castle.

47 **His idea of introducing adventure:** Elsie Palmer diary, September 1, 1895, Tim Nicholson Collection.

48 **The year ended tragically:** Nicholl, "William Jackson Palmer: Living while Dying," in Blevins et al., *Legends, Labors & Loves*, 273, 275–79.

48 **A battery of doctors:** Lynn A. Gilfillan-Morton, "General Jackson Palmer's Riding Accident, Palliative Care & Death, 1906 to 1909," in Blevins et al., *Legends, Labors & Loves*, 293, 297, 301, 305.

49 **He ordered a "Stanley Steamer":** Nicholl, "William Jackson Palmer: Living while Dying," in Blevins et al., *Legends, Labors & Loves*, 280–81. Description of his car being driven "at breakneck speed" in Wolcott, *Heritage of Years*, 157.

49 **"On this couch lay":** Garland, *Companions on the Trail*, 355–56.

49 **Like a duke of old:** Nicholl, "William Jackson Palmer: Living While Dying," in Blevins et al., *Legends, Labors & Loves*, 282–83. Photograph of reunion, Special Collections and Archives, Tutt Library, Colorado College.

50 **Out of the blue, Elsie announced:** Rowena Bell to Elsie Palmer, January 11, [1908], Tim Nicholson Collection. Rowena Bell, a friend, was so surprised she asked Elsie how long she had known Leo.

50 **One thing is certain: He was not after Elsie's money:** Fitzgerald, Introduction to Myers, *The Root*, viii.

50 **On the evening of January 20, 1908:** "Bride's Wrap of Bronze," *New York Times*, January 21, 1908, 1.

51 **"was like dew":** Peter Harrison to Elsie Palmer Myers, summer 1908, Tim Nicholson Collection.

51 **Under the headline:** "Not a $1,000,000 Baby," *New York Times*, December 26, 1908, 2.

51 **The *New York Times* immediately began:** "Gen. Palmer Dies Leaves $15,000,000," *New York Times*, March 14, 1909, 11. "$6,000,000 to Palmer Heirs," *New York Times*, March 15, 1909, 1.

51 **Peter wrote back saying:** Peter Harrison to Elsie Palmer Myers, March 15, 1909, Special Collections and Archives, Tutt Library, Colorado College.

52 **From Corfu, Greece:** John Singer Sargent to Elsie Palmer Myers, October 31, [1909], Tim Nicholson Collection.

53 **World War II Liberty Ship:** Lt-Colonel George H. Krause to Elsie Palmer Myers, December 11, 1943, Special Collections and Archives, Tutt Library, Colorado College.

53 **"a very over-rated pleasure":** Bantock, *L. H. Myers*, 152.

53 **She was helped in her final years:** 1949 photograph of Elsie Palmer Myers and "Harvey," the groom at Glen Eyrie, with a description by Tim Nicholson, Elsie's grandson. Special Collections and Archives, Tutt Library, Colorado College.

Chapter Two: The Sorcerer's Apprentice

54 **"greatest thing":** Lucia Fairchild Fuller to Harry Fuller (hereafter Lucia, Harry, respectively), June 18, [1898], Fairchild-Fuller Papers. Rauner Special Collections Library, Dartmouth.

54 **scrapbook:** Mary Newbold Patterson Hale, "The Sargent I Knew," published originally in *The World Today* (November, 1927). Hale described herself as Sargent's constant companion when he was in Boston between 1916 and 1925.

55 **The snapshots are . . . round:** The earliest version of the Kodak camera produced circular images.

55 **"ever-hospitable" . . . "wonderfully decent":** John LaFarge, S.J., *The Manner Is Ordinary* (New York: Harcourt Brace, 1954), 43–44.

56 **Years later, Sally Fairchild:** Mount, *John Singer Sargent*, 1957 ed., xii, 152–53.

56 **"legend":** Ormond and Kilmurray, *Early Portraits*, 206.

57 **"One look":** Interview with owner.

57 **Broadway:** While in Broadway during the summers of 1885–1886, Sargent painted his masterpiece *Carnation, Lily, Lily, Rose*, the dreamlike evocation of two young girls lighting Japanese lanterns amidst a garden of lilies and roses.

58 **Sally's memory:** Mount, *John Singer Sargent*, 1955 ed., 155–56.

59 **"knights of the quill":** *Boston Globe*, December 16, 1874.

59 **high-brow commune:** Blair Fuller, *Art in the Blood* (Berkeley, CA: Creative Arts Book, 2001), 168.

59 Fairchild built a house: Charles Fairchild to W. D. Howells, April 6, 1877, bMS Am 1784 (592). Houghton Library, Harvard University.

59 "fairy abode": Van Wyck Brooks, *Howells: His Life and World* (New York: E. P. Dutton & Company, 1959), 128.

61 "goddess of my childhood": Clippings 1910–1924, Fairchild-Fuller Papers.

61 "Things I must learn" . . . "Courage": Lucia Fairchild 1890 diary, Fairchild-Fuller Papers.

61 "He is so great": Miller, "John Singer Sargent in the Diaries of Lucia Fairchild," 4.

61 eccentric author: Maud Howe Elliott, *This Was My Newport* (Cambridge, MA: Mythology, 1944), 101. Ernest Mehew, ed., *Selected Letters of Robert Louis Stevenson* (New Haven, CT: Yale University Press, 1997), 344.

61 "very intense": Stevenson to Sidney Colvin, September 24, 1887, Mehew, *Selected Letters of Stevenson*, 345.

62 "salvation of your souls": Robert Louis Stevenson to Lily Fairchild, September 1890. Sidney Colvin, ed., *The Letters of Robert Louis Stevenson to His Family and Friends*, vol. II (New York: C. Scribner's Sons, 1907), 246.

62 published poetry: Fuller, *Art in the Blood*, 119.

62 father made a deal: Clara Fuller Taylor, "To all Lucia Fairchild Fuller's Grandchildren and Great-Grandchildren," 2. Fairchild-Fuller Papers.

62 "grand cubic chords" . . . "dreadfully morbid": Miller, "John Singer Sargent in the Diaries of Lucia Fairchild," 5.

63 "Very green, those trees": Ibid., 13.

63 inky silhouettes: Ibid., 5.

63 "Portrait painting" . . . "a dangerous thing": Ibid., 7.

63 "wonderfully handsome & tanned": Ibid., 11.

64 "*Terrific* love": Ibid., 13.

64 Henry Fuller: Fuller, *Art in the Blood*, 164–65.

64 "LEADING ARTIST": Ibid., 155.

65 Harry's talent: Ibid., 180–82.

65 kowtow to the rich: Ibid., 179.

65 "You are a God": Ibid., 183.

65 mural for the Woman's Building: Charlene G. Garfinkle, "Lucia Fairchild Fuller's 'Lost' Woman's Building Mural," *American Art* 7 (Winter 1993), 2.

66 "greatest gathering": *Augustus Saint-Gaudens 1848–1907: A Master of American Sculpture* (Toulouse, France: Musée des Augustins, 1999), 11.

66 simple wedding: Fuller, *Art in the Blood*, 190–91.

66 romantic plan: Taylor, "To all Lucia's Grandchildren," 1, Fairchild-Fuller Papers.

66 **Lucia sought refuge:** Lucia to Harry, August 30, 1894, Fairchild-Fuller Papers.

66 **"Luddy, you lazy girl":** Ibid.

67 **"fleshing up":** Ibid., September 10, 1894, Fairchild-Fuller Papers.

67 **"hob-goblins":** Ibid., August 31, 1894, Fairchild-Fuller Papers.

67 **"Dearest dearest Harry":** Ibid., August 29, 1894, Fairchild-Fuller Papers.

67 **She fretted:** Ibid., August 31, 1894, and September 9, 10, and 17, 1894, Fairchild-Fuller Papers.

67 **"Harry you make me so afraid":** Ibid., October 30, 1894, Fairchild-Fuller Papers.

67 **"It makes me respect you":** Ibid.

68 **"Dearest little Harry":** Ibid., October 1, 1894, Fairchild-Fuller Papers.

68 **she'd made a mistake:** Ibid., October 30, 1894, Fairchild-Fuller Papers.

68 **Lucia had an idea:** Ibid., September 9, 1894, Fairchild-Fuller Papers. A Mrs. Smith asked how much she'd charge for a miniature and Lucia said thirty-five dollars.

68 **ranging in size:** Kathryn Rawdon Senior thesis, Art History, Smith College, 1996, 12. Philip Read Memorial Library, Plainfield, New Hampshire.

68 **"a miniature brings":** Lucia Fairchild Fuller, "The Miniature as an Heirloom," [undated], 1. Fairchild-Fuller Papers.

68 **Producing a miniature:** Rawdon thesis, 12–13.

69 **"There she is"** ... **"I hope you find it pays":** Lucia to Harry, October 11, 1894, postmarked "Jefferson Hotel overlooking Union Square," Fairchild-Fuller Papers.

70 **"Release me":** Lucia to Harry, [October 1894], Fairchild-Fuller Papers.

70 **He wrote back:** Ibid., October 12, 1894, Fairchild-Fuller Papers.

70 **She gave birth:** Taylor, "To all Lucia's Grandchildren," 2, Fairchild-Fuller Papers. Clara was born March 17, 1895.

70 **The doctor warned her:** Ibid., 3. Charles was born January 11, 1897.

70 **"my arms ache to hold her":** Lucia to Harry, July 12, 1896, Fairchild-Fuller Papers.

70 **"the dear birds":** Ibid., [undated 1898, probably June 1898], Fairchild-Fuller Papers.

70 **"mama all gone":** Harry to Lucia, May 13, 1897, Fairchild-Fuller Papers.

70 **"very florid"** ... **"impious":** Ormond and Kilmurray, *Portraits of the 1890s*, 24.

71 **"economize":** Lucia to Harry, July 12, 1896, Fairchild-Fuller Papers.

71 **stand up to Dunham:** Harry to Lucia, July 16, 1896, Fairchild-Fuller Papers.

71 **"I don't like the way":** Lucia to Harry, June 17, 1898, Fairchild-Fuller Papers.

73 **"Huggins' Folly":** *A Circle of Friends: Art Colonies of Cornish and Dublin*, (Durham: University Art Galleries, University of New Hampshire, 1985), 33–34.

74 "state of mind": Fuller, *Art in the Blood*, 199.

74 "high thinking and perfection": Undated newspaper clipping, Fairchild-Fuller Papers.

74 "Geographically in Plainfield": Philip Zea and Nancy Walker, eds., *Choice White Pines and Good Land: A History of Plainfield and Meriden, New Hampshire*, 327. Philip Read Memorial Library, Plainfield, New Hampshire.

75 Lucia created the scenery: "Children Mummers of the Cornish Colony," *The Theatre* 8, (January 1907), 18, clipping in Fairchild-Fuller Papers.

75 Isadora Duncan: Virginia Reed Colby and James B. Atkinson, *Footprints of the Past: Images of Cornish, New Hampshire & The Cornish Colony* (Concord, NH: New Hampshire Historical Society, 1996), 187.

75 "Chickadees": *A Circle of Friends*, 50.

75 "Philistines" . . . "natives": Fuller, *Art in the Blood*, 206.

75 boys and girls to swim naked: Clara Fuller Taylor to her niece Jane Sage "Sagie" Fuller Cowles, May 5, 1967, Fairchild-Fuller Papers.

76 preferred bison: Zea and Walker, *Choice White Pines*, 334–35. For further descriptions of the Cornish Colony, Christine Ermenc, "Farmers and Aesthetes: A Social History of the Cornish Art Colony and Its Relationship with the Town of Cornish, New Hampshire, 1885–1930" (University of Delaware, Winterthur Program, MA, 1981).

76 "too small": Harry to Lucia, May 10, 1898, Fairchild-Fuller Papers.

77 Family members later blamed: Fuller, *Art in the Blood*, 220.

77 began a slow descent: Ibid., 196–97, 220.

77 "I will whisper": Lucia to Harry, May 23, 1898, Fairchild-Fuller Papers.

77 "Her movements" . . . "a rum sort of chap": Bertrand Russell, *The Autobiography of Bertrand Russell, 1872–1914* (Boston: Little Brown, 1967), 200–201.

78 Sally would later admit: Sally Fairchild (hereafter Sally) to Lucia, February 2, 1924, Fairchild-Fuller Papers.

78 One day Lucia jumped: Taylor, "To all Lucia's Grandchildren," 2, Fairchild-Fuller Papers.

78 "thought like a man": Ibid., 1.

79 "I am too weak": Lucia to Harry, May 23, 1898, Fairchild-Fuller Papers.

79 art lessons . . . unable to pay: Ibid., June 2 and 18, 1898, Fairchild-Fuller Papers.

79 "I have so little faith": Ibid., June 18, [1898], Fairchild-Fuller Papers.

80 renovations: Ibid., July 1898, Fairchild-Fuller Papers.

80 doctor in New York visited daily: Ibid., July 14, 1898, Fairchild-Fuller Papers.

80 "It is simply burning here": Ibid., July 5, 1898, Fairchild-Fuller Papers.

80 **"Artists have a more fortunate life":** Ibid., July 14, 1898, Fairchild-Fuller Papers.

81 **"the financial Moses":** Jean Strouse, *Morgan: American Financier* (New York: HarperCollins, 1999), ix. Quoting B. C. Forbes, founder of *Forbes* magazine.

81 **"financial bully":** Ibid., x. Quoting Senator Robert W. La Follette.

81 **Morgan's daughter-in-law:** Richard Ormond and Elaine Kilmurray, *John Singer Sargent: The Later Portraits* (New Haven CT: Yale University Press, 2003), 163–64.

82 **"cold roast Boston":** Strouse, *Morgan: American Financier*, 333.

82 **"barony" . . . Cragston was set:** Ibid., 147.

82 **Morgan had purchased:** Ibid., 147–48, 235; *New York Times*, July 1, 1894.

82 **L-shaped dock:** Strouse, *Morgan: American Financier*, 206.

82 *Corsair*: Ibid., 371–72.

82 **kind of clubhouse:** Ibid., 206.

83 **"charming and artistic":** *New York Times*, July 1, 1894.

83 **"one of the regular Deadly Bores" . . . "a discreet air":** Lucia to Harry, October 21, 1898, Fairchild-Fuller Papers.

84 **Charley advised Lucia:** Ibid., October 21, 1898, Fairchild-Fuller Papers.

84 **He urged Sargent:** Strouse, *Morgan: American Financier*, 649.

84 **fire started:** Colby and Atkinson, *Footprints of the Past*, 207. Taylor, "To all Lucia's Grandchildren," 3, Fairchild-Fuller Papers.

84 **Bells in the village rang:** Ibid., 3.

85 **The result: a pool:** Frances Duncan, "A Swimming Pool in Cornish," *Country Life in America* (July 1906), 303; Fern K. Meyers and James B. Atkinson, *Images of America: New Hampshire's Cornish Colony* (Portsmouth, NH: Arcadia, 2005), 95.

85 **"and the fit shall be as God wills":** Colby and Atkinson, *Footprints of the Past*, 135.

85 **"Mrs. Fuller!":** Taylor, "To all Lucia's Grandchildren," 1, Fairchild-Fuller Papers.

86 **"Drat it, Dash it":** Ibid., 1.

87 **next day he drowned:** Ibid., 5.

87 **his double life:** Laurence S. Cutler and Judy Goffman Cutler, *Maxfield Parrish: A Retrospective* (San Francisco: Pomegranate Communications, 1995), xi, 10–12.

87 **Gussie:** *Augustus Saint-Gaudens: A Master of American Sculpture*, 109, 122. By all accounts, Augusta was a prickly personality. Virtually deaf from the time she was a teenager, plagued by tinnitus and recurrent abdominal pains, she often avoided social gatherings and fretted constantly about her health. She and Augustus lived apart for long stretches of time. In an especially unflattering portrait, one of the sculptor's assistants at Aspet, Frances Grimes, described her as "unassimilated, with her extreme deafness, her barbaric

manners and temper, she was too difficult to get on with." Grimes, "Reminiscences" excerpted in *A Circle of Friends*, 70.

88 **"Now tell us all about this one":** Louise Hall Tharp, *Saint-Gaudens and the Gilded Era* (Boston: Little, Brown, 1969), 319.

88 **Rumors abounded:** Susan Hobbs, *The Art of Thomas Wilmer Dewing* (Washington, DC: Smithsonian Institution Press, 1996), 38.

88 **scathing letter:** Harry to Lucia, January 28, 1901, Fairchild-Fuller Papers; Hobbs, *Art of Thomas Wilmer Dewing*, 196; Fuller, *Art in the Blood*, 210–11.

88 **"You said that you must marry now":** Lucia to Harry, [undated, probably ca. 1901], Fairchild-Fuller Papers.

89 **ill and exhausted:** Lucia to Harry, June 27–28, 1900, Fairchild-Fuller Papers.

89 **191st commission:** Fuller, *Art in the Blood*, 211.

89 *Illusions: A Circle of Friends*, 87. William T. Evans, a prominent collector of American art, purchased *Illusions* for an unknown price and later donated the painting to the National Gallery of Art. It is currently displayed in the Smithsonian American Art Museum.

90 *Ivanhoe* . . . **"her salvation":** Meyers and Atkinson, *Images of America*, 112.

91 **Dr. Wadsworth:** Lucia to Harry, January 16, 1905, Fairchild-Fuller Papers.

91 **"animated, eccentric":** Colby and Atkinson, *Footprints of the Past*, 172.

91 **Christian Science:** Fuller, *Art in the Blood*, 214.

91 **Native American–style baskets:** Lucia to Harry, [January 1905] and January 25, 1905, Fairchild-Fuller Papers.

91 **an adventure:** Ibid., [January 1905], Fairchild-Fuller Papers.

91 **She was thrilled:** Taylor, "To all Lucia's Grandchildren," 3, Fairchild-Fuller Papers.

91 **"I feast my eyes":** Lucia to Harry, April 12, 1905, Fairchild-Fuller Papers.

91 **eyesight was so poor . . . piece of good news:** Ibid., April 14, 1905, Fairchild-Fuller Papers. Lucia complained that her work was constrained because she was "seeing so blobbily."

92 **"He's a very cross man":** Ibid., April 28, 1905, Fairchild-Fuller Papers.

92 **her tonsils removed:** Ibid., May 8, 1905, Fairchild-Fuller Papers.

92 **three-day stay:** Ibid., [May 1905], Fairchild-Fuller Papers.

92 **"You don't want" . . . "Clarky [Clara] got on the table":** Ibid., May 11, 1905, Fairchild-Fuller Papers.

93 **Harry had embraced Christian Science:** Fuller, *Art in the Blood*, 214.

93 **Harry began painting:** "A Gift to the Principia College," [undated], Fairchild-Fuller Papers.

94 **Ebba Bohm:** Fuller, *Art in the Blood*, 213.

94 **journalist noted sarcastically:** Unidentified newspaper clipping, Fairchild-Fuller Papers.

94 the work remained popular: Fuller, *Art in the Blood*, 214–15.

94 huge theatrical event: Lucia to Harry, April 16, 1905, Fairchild-Fuller Papers. Henry Duffy, *Celebrating Augustus Saint-Gaudens: The Pageants of 1905 & 2005* (Cornish, NH: Saint-Gaudens Memorial, 2009), 26, 30, 32, 34.

95 *A Masque of "Ours"*: Colby and Atkinson, *Footprints of the Past*, 423.

95 Maxfield Parrish created: James B. Atkinson, *A Masque of Ours: The Gods & the Golden Bowl, a Centennial Celebration* (Windsor, VT: Cornish Colony Museum, 2005), 9. Duffy, *Celebrating Augustus Saint-Gaudens*, 12.

96 "What people are these": Duffy, *Celebrating Augustus Saint-Gaudens*, 12, 19, 22, 27.

96 "Ah, now I begin to understand": Ibid., 31.

97 "The Gods are not" . . . "new Augustan Age": Ibid, 47, 49, 51.

97 An emotional Saint-Gaudens: Ibid., 18.

97 paint was still wet: Atkinson, *A Masque of Ours*, 10.

97 "As the play ended": Duffy, *Celebrating Augustus Saint-Gaudens*, 18. Members of the press were awed, as was everyone in attendance—all save Harry's mother, whose only memory of the event was that she'd left her umbrella behind. Henry Duffy, Museum Curator, Saint-Gaudens National Historic Site, interview with author, September 2010.

98 "plaquettes": Duffy, *Celebrating Augustus Saint-Gaudens*, 20. Colby and Atkinson, *Footprints of the Past*, 208.

98 parted amicably: Rawdon thesis, 23.

98 "Lucia firmly told us": Taylor, "To all Lucia's Grandchildren," 3, Fairchild-Fuller Papers.

99 "Whereas the pain": Fuller, *Art in the Blood*, 222–23.

99 "If you had a husband": Ibid., 196.

99 proposing a dinner: John S. Sargent to Isabella Stewart Gardner, [1894]. Gardner Museum Archives.

99 Lily confided: Fuller, *Art in the Blood*, 220.

100 shrewdly married . . . "an allowance": Ibid., 221–22.

100 "my angel sister!": Blair Fairchild to Lucia, 1899, Fairchild-Fuller Papers.

100 "its back to the world": Lily Fairchild, *Nelson Fairchild* (privately printed 1907), 4.

100 most incompetent of all . . . "[I'm] staying alert": Fuller, *Art in the Blood*, 219–20.

101 Lily collected the letters: Fairchild, *Nelson Fairchild*.

101 None of the brothers survived middle age: Miller, "John Singer Sargent in the Diaries of Lucia Fairchild," 4.

102 legal attaché: Gordon Fairchild obituary, *New York Times*, June 8, 1932.

102 Lucia visited her parents: Lucia to Harry, August 17, 1909, Fairchild-Fuller Papers.

102 **Lily, in need of money:** John S. Sargent to Mrs. Fairchild, May 2, 1910. Boston Athenaeum.

103 **"Change is relief":** William Dean Howells to Lily Fairchild, January 2, 1911. bMS Am 1784.1 (55). Houghton Library, Harvard University.

103 **"They are so clean":** Sally Fairchild to Lucia, October 16, [1911], Fairchild-Fuller Papers.

103 **"fork chooser" . . . "a lot of women and hermaphrodites":** Langdon Warner to Gordon Fairchild, May 20, [1912]. Autograph File, Houghton Library, Harvard University.

103 **Sally served as Gordon's hostess:** Lucia Taylor Miller, "Comments on the book, *Art in the Blood*," 6. Philip Read Memorial Library, Plainfield, NH.

104 **she helped found:** Guide to the Fairchild-Fuller Papers in the Dartmouth College Library, biographical information.

104 **Clara had been her model:** Taylor, "To all Lucia's Grandchildren," 4, Fairchild-Fuller Papers. "Madison Artist Doubly Famous," *Wisconsin State Journal*, May 15, 1924. "Clippings 1910–1924," Fairchild-Fuller Papers.

105 **She couldn't afford:** Fuller, *Art in the Blood*, 223–55.

105 **"I am going to beg you":** Lucia to Mrs. Fuller, April 25, 1914. Fairchild-Fuller Papers.

106 **"put the children to work":** Lucia to Fred [Higginson?], May 6, 1914. Archives of American Art, microfilm #3504. Fairchild-Fuller Papers, "Letters, undated & 1906–1924."

107 **Lucia yielded:** Taylor, "To all Lucia's Grandchildren," 3–4, Fairchild-Fuller Papers.

107 **her mother had died:** *New York Times*, January 18, 1924.

107 **"Mama looked so beautiful":** Sally to Lucia, January 16, 1924, Fairchild-Fuller Papers.

107 **She also put:** Ibid., February 2, 1924, Fairchild-Fuller Papers.

108 **"My whole inner life":** Ibid.

108 **"I sleep and eat just as usual":** Ibid.

109 **"This evening I had":** Lucia diary page, June 17 [probably 1920s], Fairchild-Fuller Papers.

109 **Lucia died:** *Boston Herald*, May 22, 1924. *Boston Evening Transcript*, May 22, 1924. "Clippings 1910–1924," Fairchild-Fuller Papers.

109 **"healing and blessed memories" . . . "adoring children":** Sally to Mary R. Jewett, July 7, 1924, bMS Am 1743 (343). Houghton Library, Harvard University.

110 **"hysterical gesture":** Taylor, "To all Lucia's Grandchildren," 4–5, Fairchild-Fuller Papers.

110 **Gordon, discovered:** Fuller, *Art in the Blood*, 221. They moved to 241 Beacon Street, a house formerly owned by Julia Ward Howe.

110 **contributions from brother Blair's wife:** Lucia to Mrs. Fuller, April 25, 1914, Fairchild-Fuller Papers.

110 **"his wanting to escape":** Miller, "John Singer Sargent in the Diaries of Lucia Fuller," 4.

111 **"Eat, drink, paint":** Lucia to Harry, September 17, 1894, Fairchild-Fuller Papers.

111 **Lucia was grateful:** Lucia to Harry, September 28, 1909, August 17, 1909, Fairchild-Fuller Papers. Lucia wrote, "Deerfield . . . has a charm, a beauty, a mystery, a divine poetic sense that I never felt so keenly in any other place. I am ever so glad that you are there."

111 **He established a studio:** Fuller, *Art in the Blood*, 229–31.

111 **"Was ever a man more suited":** Ibid., 232.

112 **Lady Duff Twysden:** Ibid., 232, 235.

112 **the fall of 1925:** Ibid., 239–43.

112 **"It is a life and death matter":** Ibid., 242.

112 **he met a young blond waitress:** Ibid., 246. Harry to Clarky Fairchild Taylor (hereafter Clarky or Clara), her husband, Warner Taylor, and Lucia, December 29, [1933], Fairchild-Fuller Papers.

113 **Harry got quite ill:** Fuller, *Art in the Blood*, 247.

113 **beneficiary:** Ibid.

113 **Debts were still following:** Harry to Clarky, Warner, and Lucia, December 29, [1933], Fairchild-Fuller Papers.

113 **"only a shell":** Ibid. Harry to Clara, January 18, 1934, Fairchild-Fuller Papers. He described a custom trailer fifteen feet long and six feet wide.

113 **a maid:** Harry to Clarky, Warner, and Lucia, December 29, [1933], Fairchild-Fuller Papers.

114 **"Trailering":** Harry to Clara, March 5 and 7, 1934, Fairchild-Fuller Papers.

114 **Dixie Tourist camp:** Ibid., March 20, 1934, Fairchild-Fuller Papers.

114 **waiting for inspiration:** Ibid., June 10, 1934, Fairchild-Fuller Papers. "It is like what horsemen do when lost, give rein to the animal to find its own way home," he wrote to Clara.

114 **As for income:** Harry to Clara, March 7, 1934, Fairchild-Fuller Papers.

114 **"make ourselves comfortable":** Ibid.

114 **died of cardiac arrest:** Fuller, *Art in the Blood*, 251.

115 **daunting, lordly personage:** Ibid., 198.

115 **Bertrand Russell:** Russell, *Autobiography*, 199.

115 **H. G. Wells:** Herbert George Wells, A. L. S. to Sally Fairchild from R. M. S. "Carmania" [undated, probably 1905], Autograph File, W, 1585–1973, Houghton Library, Harvard University.

115 **"If that young woman":** Fuller, *Art in the Blood*, 198. Miller, "John Singer Sargent in the Diaries of Lucia Fuller," 2.

115 **The man remained devoted:** Miller, "Comments," on *Art in the Blood*, 5. Philip Read Memorial Library, Plainfield, NH.

116 **"last laugh":** Taylor, "To all Lucia's Grandchildren," 5, Fairchild-Fuller Papers.

116 **"Lot 149A":** Ormond and Kilmurray, *Portraits of the 1890s*, 43.

117 **"Each time I turn a door knob" . . . "he is where he is":** Chris Rollins, e-mail message to author, November 1, 2011.

Chapter Three: The Madonna

118 **"The bud is so beautiful":** Margaret Chanler Aldrich, *Family Vista* (New York: The William-Frederick Press, 1958), 41.

118 **For half the year:** John Winthrop Aldrich, e-mail message to author, August 8, 2012.

119 **"the face of the Madonna":** http://americanart.si.edu/collections/search/artwork/?id=21621.

119 **Over her shoulder:** Ormond and Kilmurray, *Portraits of the 1890s*, 68. Description of the painting, and that her dress and jewelry were old-fashioned.

119 **"restless" pillow:** http://americanart.si.edu/collections/insight/tours/sargent/index2.html ="restless" pillow.

119 **She limped just as:** Mount, *John Singer Sargent*, 1957 ed., 13.

120 **At six years old:** Lately Thomas, *The Astor Orphans: A Pride of Lions* (Albany, NY: Washington Park Press, 1999), 13–14. (There are two editions of this book, one published in 1971, and another in 1999. The text varies, so hereafter the notes will include the date of the edition.)

120 **The grief-stricken father:** John Winthrop Aldrich, e-mail message to author, October 22, 2016. John Winthrop Chanler was never known by his first name. He signed his name J. Winthrop Chanler and was addressed by friends and family as Winthrop or Wint.

120 **"formidable" . . . "grim in every sense":** Aldrich, *Family Vista*, 17. Thomas, *Astor Orphans*, 1999 ed., 24. Thomas describes the intense competitiveness among the children.

120 **The household featured:** Aldrich, *Family Vista*, 19–20. Lately Thomas, *The Astor Orphans: Pride of Lions; the Chanler Chronicle* (New York: William Morrow & Company, 1971), 34–35.

121 **Poor Marshall:** Thomas, *Astor Orphans*, 1999 ed., photograph insert following 16.

121 **"Dear Boys":** Elizabeth Chanler to John Armstrong "Archie" [J. A.] Chanler

and Winthrop Astor "Wintie" Chanler, January 12, 1876, Elizabeth Chanler Chapman and John Jay Chapman Papers, Rokeby. Winthrop Chanler was nicknamed "Wintie" as a child, but as an adult the spelling was frequently "Winty." To avoid confusion, I've used the childhood variant of the spelling throughout the text.

121 **She wrote dutifully:** Ibid., February 3, 1876, March 3 and 31, 1876. Chapman Papers, Rokeby.

122 **"Nanie and Mary":** Ibid., March 9, 1876.

122 **"The children at home are very well":** Elizabeth Chanler to John Winthrop [J. W.] Chanler, [undated 1876?], Chapman Papers, Rokeby. Letter was addressed to their Manhattan residence at 192 Madison Avenue.

122 **"I would have gone to meet you":** Elizabeth Chanler to J. W. Chanler, [undated 1876?], Chapman Papers, Rokeby. This letter was written on mourning stationery.

122 **But many of the rooms were frigid . . . kerosene lamps:** Aldrich, *Family Vista*, 11, 14.

123 **"Old Black Jane":** Thomas, *Astor Orphans*, 1971 ed., 38–39.

123 **"death cold" . . . a guest experienced:** Aldrich, *Family Vista*, 31.

123 **Besides Cousin Mary:** Ibid., 22. Thomas, *Astor Orphans*, 1999 ed., 23–24.

123 **In a letter to her brother . . . announced the arrival:** Elizabeth Chanler to J. A. Chanler, [undated 1876?], Chapman Papers, Rokeby.

123 **"like an empress":** Aldrich, *Family Vista*, 23. Thomas, *Astor Orphans*, 1999 ed., 23, and photo insert after 16.

123 **The majority of the servants were Irish:** Thomas, *Astor Orphans*, 1999 ed., 23–24 and 1971 ed., 41. Aldrich, *Family Vista*, 23.

124 **Unsettling spirits hover:** Thomas, *Astor Orphans*, 1999 ed., 23.

124 **In 1968, *Life* magazine featured:** "America's 'Grandes Dames'," *Life*, January 26, 1968.

125 **"Lead from a king":** Aldrich, *Family Vista*, 24. Learned French, music, and drawing from governesses, 2.

125 **"Books, books, books" . . . "persuaded to stop looking":** Aldrich, *Family Vista*, 28.

126 **"family home" . . . "aunts":** Mrs. Hugh Fraser, *A Diplomatists's Wife in Many Lands*, vol. 1 (New York: Dodd, Mead, 1911), 223.

126 **"prison sofa":** Ibid., 222.

126 **Chanler seemed to have second thoughts:** J. W. Chanler to Mrs. Lewis Morris Rutherfurd, April 22, 1877, Margaret Chanler Aldrich Papers, Rokeby.

126 **Elizabeth was still playing with dolls:** Elizabeth Chanler to J. W. Chanler, August 7, 1877, Chapman Papers, Rokeby.

126 **Elizabeth's mother had expressed an interest . . . "a perfect haven of rest"**: Mary Rutherfurd Stuyvesant to Elizabeth Chanler, November 12, 1877, Chapman Papers, Rokeby. Mary Rutherfurd Stuyvesant, a member of the guardians who oversaw the children, wrote to Elizabeth, "You are just where your dear mother wished you to be."

126 **Chanler made the necessary arrangements**: Emily Hawtrey to J. W. Chanler, June 29, 1877, Chanler Aldrich Papers, Rokeby. Hawtry was writing from Nursling Rectory near Southampton, England, to J. W. Chanler in London. Elizabeth was staying at the rectory under the care of Hawtry until proper arrangements could be made at Miss Sewell's School.

127 **"What horses have you taken" . . . "Please come soon"**: Elizabeth Chanler to J. W. Chanler, August 7, 1877, Chapman Papers, Rokeby. The Chanler summer home in Newport, Cliff Lawn, is currently a deluxe hotel called The Chanler at Cliff Walk.

127 **a telegram arrived at Ashcliff**: Thomas, *Astor Orphans*, 1971 ed., 28. Mary Rutherfurd Stuyvesant to Elizabeth Chanler, November 12, 1877, Chapman Papers, Rokeby.

127 **"My dear sweet little Bessie"**: Bettina White to Elizabeth Chanler, October 27, 1877, Chapman Papers, Rokeby.

127 **"Mother Bess" . . . "learn all you can"**: Mary Rutherfurd Stuyvesant to Elizabeth Chanler, November 12, 1877, Chapman Papers, Rokeby.

128 **"heaven itself"**: Graham Bennett, comp., *Pages from the Past: A Look into Old Ventnor Guide Books* (Ventnor, UK: Ventnor and District Local Historical Society, 2005), 2. Further descriptions of Bonchurch, the Downs, and the Undercliff found in the following sources. Richard J. Hutchings, *Dickens on an Island* (Isle of Wight, UK: Hunnyhill, 2012), 14, 24. Michael Freeman, *A Winter Sanatorium: Ventnor as a Health Resort in the Victorian Era* (Ventnor, UK: Ventnor and District Local Historical Society, 2009), 1–7.

128 **The queen herself came**: Fraser, *A Diplomatist's Wife*, vol. 1, 230.

128 **The miraculous Undercliff boasted**: Freeman, *A Winter Sanatorium*, 10. Bennett, *Pages from the Past*, 1. John Goodwin, comp., "Flora and Fauna," in *Bonchurch from A to Z* (Bonchurch, UK: Bonchurch Trading, 1992), unpaginated.

129 **"While I breathe I hope"**: Michael Freeman, *Ventnor, Isle of Wight: The English Mediterranean* (Ventnor, UK: Ventnor and District Local History Society, 2010), 26, 33, 35. Freeman, *A Winter Sanatorium*, 2, 11. http://www.ventnortowncouncil.org.uk/about-famous.php notes the death of Karl Marx.

129 **"perpetual shower-bath"**: Frederic G. Kitton, *The Dickens Country* (London: Adam and Charles Black, 1905), 108.

129 **He exulted in the sea air . . . theatricals:** Hutchings, *Dickens on an Island*, 47.
 Goodwin, "Dickens," in *Bonchurch from A to Z* , unpaginated.

129 **his boisterous and rather blunt manner:** Hutchings, *Dickens on an Island*, 48,
 28–29.

129 **"did not go into society":** Eleanor L. Sewell, ed., *The Autobiography of Eliza-
 beth M. Sewell* (London: Longmans, Green, and Co., 1907), 46, 94.

129 **"irreligious society" . . . "entirely out of their thoughts":** Ibid., 52.

130 **"I am quite convinced":** Frederic G. Kitton, *Charles Dickens: His Life,
 Writings, and Personality* (London: T. C. & E. C. Jack, 1902), 178. Hutch-
 ings, *Dickens on an Island*, 35. Discussion of Dickens growing increasingly
 depressed.

130 **"congestion of the brain":** Hutchings, *Dickens on an Island*, 42–44.

130 **"In that little world there was never any doubt:"** Fraser, *Diplomatist's Wife*
 vol. 1, 221.

130 **"The religion was Anglican and thorough":** Ibid.

130 **"I will leave this out":** Ibid., 226.

131 **"devouring the forbidden page":** Ibid., 227.

131 **"Very good" . . . "foul disgrace!":** Ibid., 222.

131 **The school was a bastion:** Ibid., 228. The aunts hated French ideas, consider-
 ing them "flippant and demoralising." Empress Eugénie may have been beau-
 tiful, Aunt Ellen once advised a student, but she could not be "virtuous or a
 lady—I am told she has worn a bright red ball-gown!"

131 **Photographs from the era show the Sewells:** Mountague Charles Owen, *The
 Sewells of the Isle of Wight* (Manchester, UK: *Manchester Courier*, 1906), photo
 following p. 28.

131 **After their father died leaving huge debts:** Ibid., 31–32.

131 **Soon word spread among the wellborn:** Fraser, *Diplomatist's Wife*, vol. 1,
 223.

132 **Scores of novels:** Owen, *Sewells of the Isle of Wight*, 33–38. Fifty-seven works
 by Elizabeth Sewell are listed.

132 **The school boasted a rigorous curriculum:** Owen, *Sewells of the Isle of Wight*,
 32. Aldrich, *Family Vista*, 47. Fraser, *Diplomatist's Wife*, vol. 1, 222, 224,
 226.

132 **"rigid third person":** Fraser, *Diplomatist's Wife*, vol. 1, 224.

132 **"Be willowy, young ladies":** Ibid., 225.

132 **"the highest of high teas":** Ibid. Description of the daily schedule, 225–26.
 Owen, *Sewells of the Isle of Wight*, 32. Aunt Ellen Sewell playing the piano
 every evening.

133 **"The child is a *homeless* wanderer":** E. M. Sewell and L. B. Urbino, *Dictation
 Exercises* (New York: Leypoldt & Holt, 1867), 36.

133 **Elizabeth spent her free time:** Mary Marshall to Elizabeth Chanler, December 13, 1878, Chapman Papers, Rokeby.

133 **"Poor dear Lady Jane":** Fraser, *Diplomatist's Wife*, vol. 1, 229.

133 **"green and purple sea":** J. C. Medland, *Shipwrecks of the Wight* (Isle of Wight, UK: Coach House, 1995), 29.

134 **The ship was the HMS *Eurydice*:** Ibid., 29–30. Peter Bray, *The Sinking of the Eurydice* (Ventnor, UK: Ventnor and District Local History Society), 1–2.

134 **Soon after 3:30 p.m. . . . two survived:** Medland, *Shipwrecks of the Wight*, 29–30. At 3:30 p.m. the Bonchurch coastguard station noted the ship "moving fast under all plain sail, studding sails on fore and main, bonnets and skyscrapers."

134 **Winston Churchill's memory:** Winston S. Churchill, *A Roving Commission: My Early Life* (New York: Charles Scribner's Sons, 1930), 6–7. "We saw a great splendid ship with all her sails set, passing the shore only a mile or two away," he wrote. But after the squall, "there was no splendid ship in full sail, but three black masts . . . sticking up out of the water in a stark way." The ship had to be raised, deep-sea divers had to collect the corpses. Churchill reported that some of the divers fainted at the sight of fish devouring the drowned men. Churchill remembered "corpses towed very slowly by boats one sunny day." A great number of people lined the cliff to watch, "and we all took off our hats in sorrow."

135 **"the spirit of God":** Clara Eliam Coode to Elizabeth Chanler, November 30, 1896, Chapman Papers, Rokeby.

135 **"she is so attractive":** Elizabeth Sewell to Margaret Stuyvesant Rutherfurd, June 8, [1878], Chapman Papers, Rokeby.

135 **"morbid, self-conscious":** Elizabeth M Sewell, *Letters on Daily Life* (New York: E. & J. B. Young, 1885), 328.

135 **"The shy unobtrusiveness" . . . "pretend to decide":** Ibid., 338. Aunt Elizabeth dedicated an entire chapter in her book to the differences between the bright young things from America and the duty-bound, self-sacrificing English girls. She wrote that in America, "Young people rule to an extent which is startling to an English mind, especially to one which has been brought up upon the old traditions of deference to the opinion of elders," 341. Perhaps it was all that sunlight in America, she mused, 328–29.

136 **"but not extravagant":** Guardian minutes, January 15, 1878. Aldrich Papers, Rokeby.

136 **"usual" Christmas presents . . . "good management":** Ibid., December 17, 1878.

136 **permissions were sought . . . "societies" for Archie:** Ibid., January 18, 1881, February 15, 1881, January 15, 1884, April 19, 1888, December 21, 1880.

137 **"My fear is that the Uncles" . . . "very small matter":** Elizabeth Sewell to Margaret Stuyvesant Rutherfurd, June 8, [1878], Chapman Papers, Rokeby.

137 **She packed Elizabeth off with lessons:** Letter from Elizabeth Sewell to Margaret Stuyvesant Rutherfurd, June 13, [1878], Chapman Papers, Rokeby. Miss Sewell sent Elizabeth off with a less-than-scintillating reading list: a German grammar book by Dr. Emil Otto, *Aunt Charlotte's Stories of French History*, and *The Pupils of St. John the Divine* "for Sunday reading." Miss Sewell also sent word to Mary Marshall that Elizabeth should not be allowed to "scribble" lest she fall into "an untidy way of writing."

137 **"Pride—Temper—Curiosity":** Elizabeth Sewell to Margaret Stuyvesant Rutherfurd, June 8, [1878], Chapman Papers, Rokeby.

138 **J. Winthrop Chanler had selected her:** John Winthrop Aldrich, e-mail message to author, December 23, 2004.

138 **Daisy had gone to Miss Sewell's . . . with their busy schedules:** Margaret Stuyvesant Rutherfurd to Lewis Morris Rutherfurd, July 31, 1878, Aldrich Papers, Rokeby.

138 **Then, as if by magic:** Thomas, *Astor Orphans*, 1971 ed., 45–47.

139 **One of the guardians advised her:** Letter from Margaret Rutherfurd White to Elizabeth Chanler, December 29, 1879, Chapman Papers, Rokeby. Margaret "Daisy" White sent a long list of dos and don'ts for Elizabeth while she was in France. It was imperative that Elizabeth be a good guest "so that when you leave I shall hear what a pleasure your visit has been & not what a trouble." She should be sure to give "good liberal tips" to the servants in the households where she was staying—though Elizabeth should also be wary about the help ("I never trust to maids to look after jewellry"). "I particularly want you dear to read music." "Take good care of yourself and don't walk too much. But on the other hand, get out every day for air—if need be, hire a cab. Don't stay up late. To bed by quarter to ten at the latest." "You are not strong now & all these things are of the greatest importance, as I am sure you do not wish to grow up to be a delicate woman."

139 **Elizabeth also had in hand a recommendation:** Dr. James Paget to Elizabeth Chanler, December 18, 1879, Chapman Papers, Rokeby.

139 **a baroness married to the Dutch envoy:** Harvey O'Connor, *The Astors* (New York: Knopf, 1941), 315–16. "De Steurs Divorce Case," *New York Times*, February 9, 1892. Edgar W. Nye, "Nye on Divorces. They Are Not What They Are Cracked Up to Be," *Johnston New York Daily Republican*, March 1892. "Divorced and Married. Baroness De Steurs's Grass-Widowhood Was of Brief Duration," *Los Angeles Herald*, March 8, 1892. "Fighting for Her Child. The Divorced Wife of Baron De Steurs Fighting the Courts," *Milwaukee Journal*, January 20, 1893. "De Steurs Children to Get $325,000 Each," *New York Times*,

February 18, 1914. The Baroness de Steurs provided the press with reams of salacious copy. Maggie de Steurs was the first Astor to file for divorce—and hers was particularly nasty. Her marriage to the baron dissolved on a summer day in 1890 after her maid informed her that the doors in the house had been locked and the baroness was about to be carted off to an insane asylum. The baroness escaped and eventually made her way to Sioux Falls, South Dakota, the haven for quickie divorces in the 1890s, with a handsome Polish count in tow. The baron testified that his wife was insane. In turn, she accused her husband of cruelty—of having spit in her face, and having screamed at her in public, "I wish I'd never married you!" (A satirical columnist noted that the warring couple had to stay in the same hotel in Sioux Falls since there was only one decent one in town. "There they mope around, waiting for their turn at court, and glare at each other across their fruit meringue.") The baroness got her divorce—and on the same day a marriage license to marry her count, a handsome polo player. (He eventually became a well-known race-car driver and died during a race in 1903 when he had to make a hairpin turn and his cuff-links were said to have caught in the car's hand throttle.) The newly minted countess won custody of her children, but the baron had the divorce annulled in The Hague and custody awarded to him. He spirited off one child to a convent in Paris. The couple battled for years. Eventually, the countess disinherited her two de Steurs children "for the reason that they have not shown me any of the love and respect due to a mother." Lawsuits went on for years after the count-ess's death, with the children claiming their mother had been a morphine addict, an alcoholic, and that she had "labored under queer hallucinations," believing she was in communication with the deceased count. They also claimed their mother had taken old photographs of them, smeared ink over them, and then sent the defaced images back to them. All this was avidly reported in the press.

139 "surgeon's fees": Guardian minutes, February 17, 1880, Aldrich Papers, Rokeby.

139 "strapped down in a machine": Thomas, *Astor Orphans*, 1971 ed., 47–48.

140 "Cousin Stuyve": Ibid., 47.

140 hunting game and bagging art: Stuart W. Pyhrr, *Of Arms and Men: Arms and Armor at the Metropolitan 1912–2012* (New York: Metropolitan Museum of Art, 2012), 6, 41. Rutherfurd "Stuyve" Stuyvesant eventually amassed around six hundred pieces for his personal armory, probably the largest collection in the country. Cousin Stuyve's Second Avenue household was exceedingly gloomy when Elizabeth came to stay, as he was in mourning. A year earlier he'd lost his infant son and wife while she was giving birth inside the mansion.

140 "What is best will be made plain": Mary Marshall to Elizabeth Chanler, May 1, 1881, Chapman Papers, Rokeby.

140 **Lengthy letters kept Elizabeth abreast:** Mary Marshall and Margaret Chanler to Elizabeth Chanler, January 22, 1881, February 17, 1881, April 26, 1881, Chapman Papers, Rokeby.

141 **"Queen Bess":** Thomas, *Astor Orphans*, 1971 ed., 47.

141 **"Your loving old school fellow" . . . "privation cheerfully":** Letter from Elizabeth Sewell and Helen Mary Hichens to Elizabeth Chanler, February 26, 1881, Chapman Papers, Rokeby.

141 **"dear little face again!":** Ellen Sewell to Elizabeth Chanler, July 29, 1882, Chapman Papers, Rokeby.

141 **how unchanged she was . . . "I hope my dear Bessie":** Ellen and Elizabeth Sewell to Elizabeth Chanler, July 25, 1884, Chapman Papers, Rokeby.

142 **"I am so afraid that you might suffer":** Mary Marshall to Elizabeth Chanler, February 12, 1883, Chapman Papers, Rokeby.

142 **Elizabeth came of age in 1887:** Thomas, *Astor Orphans*, 1971 ed., 97.

142 **Another sibling would settle up:** Ibid., 105.

142 **"To roam & see":** Robert Chanler to Elizabeth Chanler, January 13, 1893, Chapman Papers, Rokeby.

143 **Her symptoms indicate:** Dr. Thomas Osteen, orthopedic surgeon from Asheboro, North Carolina, telephone interview, June 2013.

143 **she had remade her rather lighthearted groom:** Allan Nevins, *Henry White: Thirty Years of American Diplomacy* (New York: Harper & Brothers, 1930), 35–36. Harry White became a prominent diplomat—"the most useful man in the entire diplomatic service," according to Theodore Roosevelt. White helped negotiate the Treaty of Versailles after World War I.

143 **She also helped launch Sargent:** Ormond and Kilmurray, *The Early Portraits*, 106.

144 **"Souls":** Jane Abdy and Charlotte Gere, *The Souls* (London: Sidgwick & Jackson, 1984), 181–84.

144 **"Ah Bah":** Nevins, *Henry White*, 80.

144 **Daisy herself was much too puritanical:** Ibid., 33.

144 **When a robber made off:** Ibid., 77.

144 **The Whites occasionally dined . . . "she thinks me very pretty!":** Ibid., 89–91. Dinner with Queen Victoria at Balmoral was at 8:45. Daisy wore a black brocade dress with tulle sleeves designed by the House of Worth in Paris, *the* design firm of the Gilded Age. To complete the outfit, Daisy wore a chain and a collar, both of them studded with diamonds and pearls; she also placed an aigrette, a headdress of jewels or feathers, in her hair. Daisy curtsied and kissed Queen Victoria's hand when she paused en route to the dining room. Indian servants, "splendid in gold and scarlet," accompanied the monarch. As for the queen: "She is tiny!" Daisy wrote, "but her dignity is wonderful." After dinner the queen discussed

golf and other subjects with Daisy. The queen didn't understand the game but thought it "looked very dull." JoAnne Olian, *The House of Worth: The Gilded Age 1860–1918* (New York: Museum of the City of New York, 1982), 7. A Worth gown might cost ten thousand dollars.

144 **Elizabeth wore the prescribed costume . . . touching the floor with her knee:** http://www.edwardianpromenade.com/etiquette/the-court-presentation/.

145 **"Hurry!":** Thomas, *Astor Orphans*, 1971 ed., 101–02. Discussion of Elizabeth's social gaffe during her presentation to the queen.

146 **The ceremony came off in such a rush:** Ibid., 142–144. The wedding was so rushed that Robert's sister Margaret missed the event by a day, and her brother Willie was off only-God-knew-where in the wilds of Africa. Ibid., 185. Around the time of the wedding, Elizabeth had a dream in which Willie told her he was dead. Awakening, she immediately scribbled the details of her nightmare on scraps of paper. She feared it was a portent. Willie did, in fact, survive the African trip. Barely.

146 **"old Fuzz Buzz":** John Armstrong Chanler to Stanford White, December 26, 1893, Stanford White Papers, New-York Historical Society.

146 **"like a Triton":** John Jay Chapman, "McKim, Mead and White: Especially Concerning the Influence of Stanford White on American Architecture," *Vanity Fair* (September 1919), 102. Author John Jay Chapman's second wife was Elizabeth Chanler.

146 **It is believed that she purchased:** http://www.nga.gov/collection/gallery/gg69/gg69-46428-prov.html. The museum's provenance for the painting comes from White's family.

147 **He truly believed this would be the capstone:** Olson, *John Singer Sargent*, 154–55.

147 **working in an oversized:** Mount, *John Singer Sargent*, 1957 ed., 162. The studio in Fairford was sixty-four feet long, forty feet wide, and twenty-five feet high.

147 **a glorious fifteenth-century church:** Reverend Canon Edward Keble, *St Mary's Church: Fairford Gloucestershire, Consecrated 1497* (Much Wenlock Shropshire, UK: Smith & Associates for St. Mary's Church, 2010), 5–22.

148 **Charming jumble of French furnishings . . . humming or whistling:** Olson, John Singer Sargent, 129–31. Description of Tite Street studio and his method of painting.

148 **mutual friend in Sally Fairchild:** Ormond and Kilmurray, *Portraits of the 1890s*, 68.

148 **"What an unpleasant American idea!":** Aldrich, *Family Vista*, 88. Description of the painting session.

148 **"talking hard":** Ormond and Kilmurray, *Portraits of the 1890s*, 68.

149 **"I have painted you *la penserosa*"**: Aldrich, *Family Vista*, 88.

149 **"you must have <u>flames</u>"**: Elizabeth Chanler to Chanler Chapman, January 16, 1922, Chapman Papers, Rokeby.

150 **"Be fearfully afraid"**: M. A. De Wolfe Howe, *John Jay Chapman and His Letters* (Cambridge, MA: Riverside Press, 1937), 105.

150 **"At that time I was rooming alone"**: Ibid., 59–60.

151 **"Please don't be scared"** . . . **"That is for you to find out"**: Ibid., 60–61.

151 **"Imagine my horror"**: Wolcott, *Heritage of Years*, 257. Howe, *John Jay Chapman*, 62, 64. Further description of Minna being sent away and cutting off her hair in devotion to Chapman.

152 **He became a staple at their dinner parties:** Jack Chapman to Elizabeth Chanler, October 18, 1895, January [no date], 1895. Elizabeth Chanler to Jack Chapman, December 22, [1894], Chapman Papers, Rokeby. Describes dinners and Minna being away from home.

152 **"I have played chess"**: Jack Chapman to Elizabeth Chanler, June 25, 1895, John Jay Chapman Papers, 1841–1940 (MS Am 1854), Houghton Library, Harvard University.

152 **"way down in Hades"** . . . **"There is a certain cut"**: Howe, *John Jay Chapman*, 104.

152 **"My dear Miss Chanler"**: Jack Chapman to Elizabeth Chanler, December 28, 1894. John Jay Chapman Papers, 1841–1940 (MS Am 1854), Houghton Library, Harvard University.

152 **"Elizabeth darling"**: Ibid., October 3, 1895, John Jay Chapman Papers, 1841–1940 (MS Am 1854). Houghton Library, Harvard University. This was the third letter Chapman wrote to Elizabeth that day. It was written in the evening from the Century Association on West 43rd Street.

152 **"my beautiful Elizabeth"**: Jack Chapman to Elizabeth Chanler, October 29, 1896, Chapman Papers, Rokeby.

152 **"I love you & am with you in spirit"**: Jack Chapman to Elizabeth Chanler, December 28, 1894, John Jay Chapman Papers, 1841–1940 (MS Am 1854), Houghton Library, Harvard University.

152 **"What is going to happen is this"**: Ibid., February 17, 1895, John Jay Chapman Papers, 1841–1940 (MS Am 1854), Houghton Library, Harvard University.

153 **"a sort of electric wire"**: Ibid., October 3, 1895, John Jay Chapman Papers, 1841–1940 (MS Am 1854). Houghton Library, Harvard University. One of three letters he wrote to her that day, this one was on letterhead from his law firm at 56 Wall Street.

153 **"The air is full of spirits"**: Jack Chapman to Elizabeth Chanler, March 20,

1895, John Jay Chapman Papers, 1841–1940 (MS Am 1854), Houghton Library, Harvard University.

153 "gasping for air": Ibid., October 3, 1895, John Jay Chapman Papers, 1841–1940 (MS Am 1854). Houghton Library, Harvard University. This is from the third letter he wrote to her that day, from the Century Association.

153 "blessedness" . . . "all the Light Life": Jack Chapman to Elizabeth Chanler, October 3, 1895. John Jay Chapman Papers, 1841–1940 (MS Am 1854). Houghton Library, Harvard University. This is the second letter written that day from Jack's Wall Street law firm.

154 "big letter with death in it" . . . "you have burnt them": Jack Chapman to Elizabeth Chanler, October 3, 1895. John Jay Chapman Papers, 1841–1940 (MS Am 1854). Houghton Library, Harvard University. Two letters Jack wrote from his Wall Street law firm.

154 "sounded like cracked china" . . . "a flighty shallow girl": Jack Chapman to Elizabeth Chanler, October 4, 1895. John Jay Chapman Papers, 1841–1940 (MS Am 1854). Houghton Library, Harvard University.

154 Jack wrote in care: Ibid., October 17, 1895. John Jay Chapman Papers, 1841–1940 (MS Am 1854). Houghton Library, Harvard University.

154 "How is it you dare to go off" . . . "I'll indulge in them?": Howe, *John Jay Chapman*, 103.

154 On October 27, 1896 . . . wedding archway: Thomas, *Astor Orphans*, 1971 ed., 195–96. Description of the wedding celebration.

155 "kind, gay pagan": O'Connor, *The Astors*, 298. Quote by Margaret Terry "Daisy" Chanler, wife of Elizabeth's brother Wintie.

155 Jack had written Elizabeth: Jack Chapman to Elizabeth Chanler, October 14, 1896. John Jay Chapman Papers, 1841–1940 (MS Am 1854), Houghton Library, Harvard University.

155 "crimson chiffon dinner gown": Bill from Mme. Macheret's shop to Elizabeth Chanler, October 31, 1896, Chapman Papers, Rokeby.

156 Margaret confronted her sister: Thomas, *Astor Orphans*, 1971 ed., 212–13. Description of trip.

156 Aboard the steamship . . . Buddha's tooth: Aldrich, *Family Vista*, 95.

156 "tree of enlightenment": http://whc.unesco.org/en/list/200. Description of the sacred city.

156 "Women's skirts and *saris*" . . . the swords were gold: Aldrich, *Family Vista*, 96–99.

157 After giving birth to her third son: Richard B. Hovey, *John Jay Chapman: An American Mind* (New York: Columbia University Press, 1959), 72. Description of Minna's death.

157 **"God help you—And help us all":** Elizabeth Chanler to Jack Chapman, March 3, 1897, John Jay Chapman Papers, 1841–1940 (MS Am 1854), Houghton Library, Harvard University.

157 **Jack insisted that she stay:** Thomas, *Astor Orphans*, 1971 ed., 213.

157 **"perfectly formal line of conduct":** Elizabeth Chanler to Jack Chapman, [October 1897], John Jay Chapman Papers, 1841–1940 (MS Am 1854), Houghton Library, Harvard University. http://www.victoriana.com/VictorianPeriod/mourning.htm. Mourning customs.

158 **Elizabeth and Jack secretly shared:** Elizabeth Chanler to Jack Chapman, September 17 and 21, 1897, John Jay Chapman Papers, 1841–1940 (MS Am 1854). Houghton Library, Harvard University. She kept his letters under "lock & key," and advised him to acknowledge receipt of every letter she wrote to him, lest one should "go astray."

158 **Elizabeth could slip away for the day:** Elizabeth Chanler to Jack Chapman, August 7, 1897, John Jay Chapman Papers, 1841–1940 (MS Am 1854). Houghton Library, Harvard University. Thirteen-page letter in which Elizabeth plans a rendezvous on Conanicut Island, despite the fact that Alida was somewhat suspicious.

158 **"mystery and clandestine meetings":** Howe, *John Jay Chapman*, 128–29.

158 **"I crave more habit of you":** Elizabeth Chanler to Jack Chapman, August 12, [1897], John Jay Chapman Papers, 1841–1940 (MS Am 1854), Houghton Library, Harvard University.

158 **In New York they met surreptitiously:** Howe, *John Jay Chapman*, 128. Meeting at a Paulist church.

159 **"these blessed visions of your bodily nearness" . . . "God keep us":** Elizabeth Chanler to Jack Chapman, September 17, 1897, John Jay Chapman Papers, 1841–1940 (MS Am 1854), Houghton Library, Harvard University.

159 **Though Jack was in the dark:** Jack Chapman to Elizabeth Chanler, May 5, 1897, John Jay Chapman Papers, 1841–1940 (MS Am 1854), Houghton Library, Harvard University. Jack writes to her, "These mysterious sorrows & worries of yours are very annoying & painful. . . ." In pencil on the top of the page, Elizabeth noted years later, "Written when Archie was at Bloomingdale & I had agreed not to speak of it to anyone on the ground that he might recover suddenly & come out before anyone knew he was there."

159 **"imbecile":** *New York Herald*, November 25, 1875, 3.

159 **Archie was certainly eccentric:** Thomas, *Astor Orphans*, 1999 ed., 103–07. Discussion of Archie's business dealings with his family, his eccentricities, and his commitment to Bloomingdale Asylum.

160 **Elizabeth learned of her thirty-four-year-old brother's plight:** Ibid., 109.

160 "a honeymoon fragrance" . . . "precipice in heaven": Elizabeth Chanler to Jack Chapman, September 17, 1897, John Jay Chapman Papers, 1841–1940 (MS Am 1854), Houghton Library, Harvard University.

161 "Christmas stocking": Ibid., October 9, 1897, John Jay Chapman Papers, 1841–1940 (MS Am 1854). Houghton Library, Harvard University.

161 unnamed people coming to Rokeby: Ibid., October 18, 1897, John Jay Chapman Papers, 1841–1940 (MS Am 1854). Houghton Library, Harvard University.

161 "[Archie] has a splendid constitution" . . . the journalist rehearsed yet again: New York Times, October 14, 1897.

162 "the Astor blood seems morally": Margaret Rutherfurd "Daisy" White to Elizabeth Chanler, February 13, 1898, Chapman Papers, Rokeby.

162 "This implies that we had been living together" . . . "more than she can stand": Elizabeth Chanler to Jack Chapman, [October 1897], John Jay Chapman Papers, 1841–1940 (MS Am 1854), Houghton Library, Harvard University.

163 "war wedding" . . . "an undertaker": Thomas, Astor Orphans, 1971 ed., 247.

163 "on the lunatic fringe": Paul Grondahl, I Rose Like a Rocket: The Political Education of Theodore Roosevelt (New York: Free Press, 2004), 290. Thomas, Astor Orphans, 1999 ed., 136–37. Howe, John Jay Chapman, 138–41. Discusses the nearly twenty-year estrangement between Chapman and Roosevelt.

164 "The crisis came with a crash": Hovey, John Jay Chapman, 89. Thomas, Astor Orphans, 1999 ed., 136–37. Discussion of Chapman's breakdown and his being placed in the tower room with the blinds drawn.

164 "imaginative" . . . to avoid annihilation: Howe, John Jay Chapman, 153–154. Chapman writes that his brother-in-law Temple Emmet pronounced him "perfectly sane though imaginative." Thomas, Astor Orphans, 1999 ed., 161–62. Describes Chapman's infant-like condition.

165 "a mystic to whom this world and the next were one": Aldrich, Family Vista, 157. Thomas, Astor Orphans, 1999 ed., 201.

165 When Jack could finally abide sunlight . . . overcome by its beauty: Howe, John Jay Chapman, 154. Thomas, Astor Orphans, 1999 ed., 162.

165 "jounce": Hovey, John Jay Chapman, 163.

166 "Absolute heaven" . . . "kind of man that always gets cheated": Ibid., 163.

166 "Jay drowned": Howe, John Jay Chapman, 155–56. Chapman's telegram, his abandoning his crutches, and then announcing, "Now we can go home."

167 "I don't talk to him": Howe, John Jay Chapman, 157. Hovey, John Jay Chapman, 164. Discussion of his deep depression over the loss of his son. John Zukowsky and Robbe Pierce Stimson, Hudson River Villas (New York: Riz-

zoli, 1985), 189. Description of Edgewater, where novelist Gore Vidal lived for nearly twenty years in the mid-twentieth century.

167 **While secluded, Jack studied music:** Howe, *John Jay Chapman*, 157–159, 185.

168 **"Letters of Condolence" . . . no more children:** Teresa Klein to Jack Chapman, August 31, 1910, Chapman Papers, Rokeby. Klein wrote that the Chapmans' crushing loss was especially unfair, for Elizabeth "is the personification of all that is sweet, true & noble." May Sedgwick to Elizabeth Chapman, September 5, 1910, Chapman Papers, Rokeby. May advised Elizabeth to take it easy and to avoid people so that she wouldn't have to endure "the nervous effort of talking, & of <u>listening</u>."

168 **"I've been *discovered*":** Howe, *John Jay Chapman*, 320–21.

169 **"Victor has been killed":** Ibid., 302.

169 **"it had dropped like a stone":** Aldrich, *Family Vista*, 159. Thomas, *Astor Orphans*, 1999 ed., 218–19. Howe, *John Jay Chapman*, 301–02. Hovey, *John Jay Chapman*, 228–29. Discussion of Victor Chapman's death and church service.

169 **"I have just heard that your son":** Bernard Berenson to John Jay Chapman, July 3, 1916, Chapman Papers, Rokeby.

169 **heaped a stream of abuse upon President Woodrow Wilson:** Howe, *John Jay Chapman*, 297. Chapman called Wilson a "mendacious coward," and a "hopeless jackass." Hovey, *John Jay Chapman*, 229–30, 363. In an October 1916 pamphlet titled *The French Heroes*, Chapman expounded on the heroism of the French who "know they are saving not only France, but the soul of the modern world." And in a Letter to the Editor in the *New York Tribune* on January 5, 1917, Chapman stated that the military should take over the U.S. government.

170 **"high up in the Cathedral gang":** Hovey, *John Jay Chapman*, 281.

170 **"nailed to the cross" . . . "Board of Fellows":** Howe, *John Jay Chapman*, 347.

170 **"Jewish menace":** Ibid., 340.

170 **"The K.K. are all right":** Hovey, *John Jay Chapman*, 287.

171 **"the wrong attitude" . . . The booze ran freely:** Accessed October 22, 2014, http://www.si.com/vault/1977/06/13/621837/step-in-and-enjoy-the-turmoil.

171 **"worshipful reverence" . . . "need to bend your gaze":** Elizabeth Chanler Chapman to Chanler Chapman, January 26, 1921, Chapman Papers, Rokeby.

171 **"a bower, not a cell":** Ibid., January 16, 1922, Chapman Papers, Rokeby.

171 **"Shakespeare and such stuff":** Thomas, *Astor Orphans*, 1999 ed., 247.

172 **"A soldier lay dying" . . . "But there is lack of nothing here":** Hovey, *John Jay Chapman*, 347.

172 "Elizabeth came with a book": Howe, *John Jay Chapman*, 462.

173 "bores the hell out of me": Accessed October 22, 2014, http://www.si.com/vault/1977/06/13/621837/step-in-and-enjoy-the-turmoil.

173 living off the inheritance: Thomas, *Astor Orphans*, 1999 ed., 307.

173 "most eccentric man in America" . . . "It's convenient for Chanler" . . . "Opinions come out of me" . . . "When You Can't Smile, Quit" . . . "Close the blinds at night": Accessed October 22, 2014, http://www.si.com/vault/1977/06/13/621837/step-in-and-enjoy-the-turmoil.

173 KINGSTON ATTACKED BY GIANT MALL: Accessed October 22, 2014, http://www.bard.edu/archives/voices/Kline-Education/Chapman.doc.

173 "Chanler Chapman, the son of the famous John Jay Chapman": Saul Bellow and Benjamin Taylor, eds., *There Is Simply Too Much to Think About: Collected Nonfiction* (New York: Viking, 2015), 494.

173 She died at Good Hap: Thomas, *Astor Orphans*, 1999 ed., 307–08.

174 "ransacked London": John Singer Sargent to Margaret Chanler, August 3, 1893, Aldrich Papers, Rokeby.

174 "peacefully hang": Ibid., October 17, 1893, Aldrich Papers, Rokeby.

174 "vigourous energy" . . . "intense intellectual": Ormond and Kilmurray, *Portraits of the 1890s*, 68.

174 "dull" . . . "vision seems to have lost": D.S.M., "Art. The Academy–I." *The Spectator*, May 12, 1894, 652.

174 "poorly, hastily conceived": Ormond and Kilmurray, *Portraits of the 1890s*, 68.

175 when Chanler walked into Rokeby . . . Gyp the government of taxes?: John Winthrop Aldrich, e-mail message to author, August 8, 2012 and October 22, 2016.

CHAPTER FOUR: THE COLLECTOR

176 "She is not a woman": Leon Edel, *Henry James: A Life* (New York: Harper & Row, 1985), 242.

176 "dear little village" . . . "straight to Cleopatra": Shana McKenna, trans., *Isabella Stewart Gardner's Egypt Travel Scrapbook and Diary 1874–75*, December 24, 1874. Isabella Stewart Gardner Museum Archives.

177 "wicked as Cleopatra": Ralph Curtis to Isabella Stewart [I. S.] Gardner, October 3, 1911. Gardner Museum Archives. There are several versions of the story—it was also said to have taken place in a Venetian train station, with an Italian girl saying that Belle was "more wicked than Cleopatra." Morris Carter, *Isabella Stewart Gardner and Fenway Court*, 3rd ed. (Boston: Isabella Stewart Gardner Museum, 1972), 165–66.

177 **"blue icicles":** Louise Hall Tharp, *Mrs. Jack* (Boston: Little, Brown, 1965), 345.

177 **"delicious caress":** Ernest Samuels, *Bernard Berenson: The Making of a Connoisseur* (Cambridge, MA: Belknap Press, 1979), 307. Letter from the art connoisseur Bernard Berenson to his wife Mary Berenson.

178 **According to Belle's ironclad will:** Lisa Feldmann, Isabella Stewart Gardner Museum, e-mail message to author, November 22, 2016. Any permanent change to the collections or the building requires the formal permission of the Massachusetts attorney general. The short-term loan of an item for an exhibition at another museum is occasionally permitted because Isabella did so herself. In addition, the piece's removal would roughly match the time it might take for a conservation treatment, so it is considered a temporary—and not a permanent—change to the collection. Museum officials will not permit a loan request if it is for too long a period or if it is deemed to detract too much from the visitor's experience of the Gardner Museum.

179 **Her grandfather:** Tharp, *Mrs. Jack*, 5, 12.

179 **early life:** Ibid., 6–11.

180 **private tutors:** Ibid., 10–16.

180 **"with beautiful pictures":** Ibid., 16. Ida Agassiz Higginson to I. S. Gardner, March 8, 1923, Gardner Museum Archives.

181 **"How do you like Boston anyway?":** John Jay Chapman to I. S. Gardner, May 19, 1923, Gardner Museum Archives. "You see you married into Boston," he wrote, but she was still not one of them.

181 *Proper Bostonians*: Cleveland Amory, *The Proper Bostonians* (New York: Dutton, 1955), 11.

182 **Sweet Son:** Elizabeth Chanler Chapman to Chanler Chapman, July 25, 1923, Rokeby Collection. She goes on to write: "A bit suppressive & conventional perhaps, taken en bloc. But one of them at a time in a drawing-room qualifies the whole atmosphere."

182 **"cold, cold, cold":** Elizabeth Anne McCauley et al., *Gondola Days: Isabella Stewart Gardner and the Palazzo Barbaro Circle* (Boston: Isabella Stewart Gardner Museum, 2004), 18.

182 *Lady's Guide*: Tharp, *Mrs. Jack*, 12.

183 **green moiré dress:** Ibid., 23–24.

183 *not* **invited:** Ibid., 29.

183 **"peculiar social institution":** "The Sewing Circles of Boston," *New York Times*, November 10, 1888.

183 **family shipping business:** Gardner Family Papers 1772–1915 and Gardner Family Papers II, 1655–1959. Account Books 1851–1857: January 25, 1853, pepper cargo; January 28, 1853, saltpeter cargo; June 14, 1854, shellac cargo; August [no date], 1854, tea cargo; March 25, 1856, indigo cargo; April 23,

1856, cloth cargo, Massachusetts Historical Society. Frank A. Gardner, comp., *The Gardner Memorial: A Biographical and Genealogical Record of the Descendants of Thomas Gardner, Planter, Cape Ann, 1624, Salem (Naumkeag), 1626–1674, through His Son Lieut. George Gardner* (Salem, MA: Newcomb & Gauss, 1933), 148–49, 190–91, Gardner Museum Archives.

184 **about $15,000:** http://www.davemanuel.com/inflation-calculator.php

184 **"safe on board":** Jack Gardner to George Gardner, August 23, 1864, Gardner Family Papers, 1772–1915.

184 **flashes of her old self:** Tharp, *Mrs. Jack*, 30–31.

185 **By November 1864:** Ibid., 35.

185 **Jackie died:** Ibid., 36–37. Carter, *Gardner and Fenway Court*, 27.

185 **Get away with Jack:** Tharp, *Mrs. Jack*, 38–39.

185 **"le tyran de la mode":** Olian, *The House of Worth*, 3.

186 **"half merchant, half Venetian doge":** Ibid., 4.

186 **Worth took one look:** Tharp, *Mrs. Jack*, 42.

186 **"the best customers he has":** Olian, *The House of Worth*, 7.

186 **"Pray, who undressed you!":** Tharp, *Mrs. Jack*, 43.

186 **"She is every day and evening in Society":** Catherine Peabody Gardner to George Gardner, January 22, 1872, Gardner Family Papers 1772–1915.

187 **interfere with his business:** Ibid., September 17, [no year]. Despite "an amount of dinners Balls etc. . . . that would frighten you," she wrote reassuringly, "John neglects no business duties."

187 **"subordinate, comic, errand-boy"** . . . **"like royal spouses":** George Santayana, *The Middle Span: Volume 2. Persons and Places* (New York: Charles Scribner's Sons, 1945), 123.

187 **prone to seasickness:** Alan Chong and Noriko Murai, eds., *Journeys East: Isabella Stewart Gardner and Asia* (Boston: Isabella Stewart Gardner Museum, 2009), 133. Writing to Anna Lyman Gray, a friend in Boston, she describes an excruciating trip from San Francisco to Japan during which "I was wretched as usual and Jack happy as a King. Never was mortal so glad to find foot on dry land as I—and then to have that land Japan . . . I am wild with excitement."

187 **"there has been no storm"** . . . **"fun is over":** Jack Gardner to George Gardner, June 17, 1883, Gardner Family Papers 1772–1915.

188 **"San Antonio Justice":** Chong and Murai, *Journeys East*, 21. http://www.gardnermuseum.org/microsites/travelalbums/album_index.html; http://www.gardnermuseum.org/microsites/travelalbums/index.html#/3/11/1/4.7/v_1_a_4_7020.

188 **"stept out of the 'Arabian Nights'"** . . . **"what perfect postures":** Gardner's Egypt Scrapbook, December 10, 1874, Gardner Museum Archives.

188 **"solemnity and mystery took possession":** Ibid., December 16, 1874.

189 **"into a perfect frenzy"**: Ibid., December 18, 1874. She wrote, "I have never seen anything so terrible."

189 **"sky parlour"**: Ibid., December 18, 1874.

189 **"incalculable" advantage**: George McClellan, "A Winter on the Nile," *Scribner's Monthly*, 13, no. 3 (January 1877): 370.

189 **silhouette of camels**: Gardner's Egypt Scrapbook, December 20, 1874.

189 **"always washing them"** . . . **"a very jolly set"**: Ibid., December 18, 1874.

189 **"filled with sand"**: Ibid., February 14, 1875.

189 **"I was obliged to take away"**: Ibid., February 16–19, 1875.

189 **"cookboy"**: Ibid., December 27, 1874.

190 **crocodile**: Ibid., January 24, 1875. She describes a "loathsome creature" that "slumped himself slowly into the river."

190 **"Coco"** . . . **"when she couldn't be satisfied"**: Ibid., January 30, 1875, and March 6, 1875.

190 **sheikh's uncovered leg**: Ibid., February 2, 1875.

190 **"Arab swells"** . . . **"battle axes and poles"**: Ibid., January 5, 1875.

190 **"tyrannous"**: Ibid., January 18, 1875.

190 **"conscription time"**: McClellan, "Winter on the Nile," 379.

191 **arrested and tortured**: Gardner's Egypt Scrapbook, January 18 and 21, 1875, Gardner Museum Archives.

191 **forms of punishment**: Chong and Murai, *Journeys East*, 201, 219, 224.

191 **American Consul**: Gardner's Egypt Scrapbook, January 17–18, 1875, and March 4, 1875, Gardner Museum Archives. Discovering that Belle loved to smoke, Pasha Nubar offered to have a servant fetch his hookah for her. Nubar found her irresistible—"enchanté, enchanté, Madame" he kept repeating. In turn, Belle found the politician "charming" and his very grand steam-driven *dahabeah* "a beauty." But as for the government's cruelty, she noted on February 22 that the *Ibis* gave refuge to another young boy "who fled from the conscription to us at Assouan."

191 **"with the earth more green"**: Ibid., December 21, 1874.

191 **"I hope they were as innocent"**: Ibid., December 26, 1874.

192 **"The Desert, the rocks and the air"**: Ibid., February 2–8, 1875, and March 8, 1875.

192 **"We had truly 'come abroad and forgot ourselves'"**: Ibid., December 10, 1874.

192 **"Muezzin's call'"**: Ibid., January 20, 1875.

192 **"the moon rose"**: Ibid., February 20, 1875.

192 **cataract men**: George B. McClellan, "Winter on the Nile. Second Paper," *Scribner's Monthly* 13, no. 4 (February, 1877), 453.

192 **"The Shellalee were like the inmates"**: Gardner's Egypt Scrapbook, February

11, [1875], Gardner Museum Archives. At the end of the day, when "the maniacs had left us, the stillness was so great and so sudden that I felt like fainting," Belle wrote as the *Ibis* glided gently past Philae, a picturesque island of dark granite covered with ancient ruins that rose out of the Nile.

192 **As many as fifty of them:** Ibid., March 4, [1875].

192 **"universal shrieking":** McClellan, "Winter on the Nile. Second Paper," 454.

193 **jumping "up and down, waving a stick":** Gardner's Egypt Scrapbook, February 11, [1875], Gardner Museum Archives.

193 **The *Ibis* was shunted . . . German prince:** Ibid., February 2–8 and 10, 1875.

193 **"such a delicious laziness":** Ibid., February 13, 1875.

193 **expeditions into the outback:** Ibid., January 28, 1875, and February 2–15, 1875.

193 **father of their *shellalee* pilot:** Ibid., March 1–3, 1875. Description of the grieving and subsequent funeral.

194 **"I had the top of the mountain":** Ibid., February 23, 1875.

194 **telegrams:** Ibid., July 16, 1875.

194 **"blew his brains out":** Shand-Tucci, *Crimson Letter*, 39.

195 **mourning gowns:** Tharp, *Mrs. Jack*, 58.

195 **"religious types" . . . "nervous structure":** Howe, *John Jay Chapman*, 35.

195 **"idea of a British nation":** Tharp, *Mrs. Jack*, 59–60. Discussion of their upbringing.

195 **a summer of touring cathedrals:** Ibid., 61–63. Carter, *Gardner and Fenway Court*, 49, 51.

195 **Charles Eliot Norton:** Carter, *Gardner and Fenway Court*, 93. Rollin Van N. Hadley, ed., *The Letters of Bernard Berenson and Isabella Stewart Gardner,* (Boston: Northeastern University Press, 1987), xix.

195 **"Oh! Oh! Oh! So Overdone!":** Rachel Cohen, *Bernard Berenson: A Life in the Picture Trade* (New Haven, CT: Yale University Press, 2013), 45.

196 **"The two are one":** Tharp, *Mrs. Jack*, 173. Alan Chong, Richard Lingner, and Carl Zahn, eds., *Eye of the Beholder: Masterpieces from the Isabella Stewart Gardner Museum* (Boston: Isabella Stewart Gardner Museum in association with Beacon Press, 2003), 72–73.

196 **"he would pose":** Maud Howe Elliott, *My Cousin F. Marion Crawford* (New York: Macmillan, 1934), 90.

196 **"chandeliering":** Tharp, *Mrs. Jack*, 74.

196 **his first novel . . . In a sudden about-face:** Chong and Murai, *Journeys East*, 15–16. Tharp, *Mrs. Jack*, 78. Crawford wrote to his mother on March 26, 1882, of "the slandering tongues of petty Boston."

196 **sought out the most unusual . . . White Cloud Mountains:** Chong and Murai, *Journeys East*, 155, 195, 208, 215, 227. After attending the sumo match she wrote to a friend, "I shall go to see the Missionaries . . . to atone."

197 one of the elephants: Ibid., 246–48.

197 "glitter": Ibid., 255. Admiring her yellow diamond, the king said he had nothing like it.

197 Struck by the beauty: Ibid., 259, 263–65.

197 "most strange music": Ibid., 265.

197 Gardners crisscrossed the Indian subcontinent: Ibid., 299, 313, 315, 378.

198 "a glorious effect on the women": Ibid., 308.

198 "marrying season": Ibid., 343.

198 "I crept up softly": Ibid., 286.

199 "literally washed with blood": Ibid., 306.

199 "Two corpses brought in": Ibid., 304.

199 "to die in the Ganges" . . . "disengaged funeral pyre": Ibid., 342, 304.

199 "with Pariahs watching": Ibid., 304.

199 "perfect traveler": Thomas Jefferson Coolidge to I. S. Gardner, April 26, 1884, Gardner Museum Archives. Coolidge reported that he'd just visited Alexander Agassiz, a well-known American scientist and mining engineer, who'd recently returned from India. There he had seen Belle, whom he considered the "perfect traveler."

199 "I destroy your letters": Ibid.

199 "Goodbye to the country of men with tattooed legs": Chong and Murai, *Journeys East*, 294.

200 "I was very low hearted": Ibid., 378.

200 nephews: Carter, *Gardner and Fenway Court*, 48. The three nephews were Joseph Peabody Gardner (1861–1886), William Amory Gardner ("Amory" or "WAG"; 1863–1931), and Augustus ("Gus") Peabody Gardner (1865–1918).

200 "gambolled": Howe, *John Jay Chapman*, 40.

200 "anchorite": Tharp, *Mrs. Jack*, 104.

200 "in despair": Ibid., 105.

201 "Rec'd telegram": Ibid., 120. Shand-Tucci, *Crimson Letter*, 108. Joe was brokenhearted over Logan Pearsall Smith and committed suicide. Cohen, *Berenson*, 280, note 6. The telegram informing the Gardners of Joe's death came from his reported male lover, Logan Pearsall Smith.

201 "the wittiest man of his epoch": Howe, *John Jay Chapman and His Letters*, 35.

201 met John Singer Sargent: Tharp, *Mrs. Jack*, 120–21.

201 "She looks decomposed": Ormond and Kilmurray, *Early Portraits*, 113.

201 "I am writing to Sargent": Henry James to I. S. Gardner, October 26, 1886, Gardner Museum Archives.

201 "a very great pleasure": Sargent to I. S. Gardner, [1886], Gardner Museum Archives.

202 **She commissioned Sargent:** Chong, Lingner, and Zahn, *Eye of the Beholder*, 204.

202 **"Her body" . . . "the jewels of a queen":** Paul Bourget, *Outre-Mer Impressions of America* (London: Fisher Unwin, 1895), 107–08.

203 **"the nimbus of an eastern divinity":** Trevor Fairbrother, *John Singer Sargent & America* (New York: Garland, 1986), 102, 111.

203 **"Hindoo cult":** Chong, Lingner, and Zahn, *Eye of the Beholder*, 204. Quoting *The Art Amateur*.

203 **Belle drove Sargent to distraction:** Mount, *John Singer Sargent*, 1957 ed., 111–12.

203 **ninth incarnation:** Carter, *Gardner and Fenway Court*, 104–05. Ormond, *Early Portraits*, 211.

203 **"I disclaim any connection":** Sargent to I. S. Gardner, November 1, 1889, Gardner Museum Archives.

204 **"brilliant and suggestive" . . . "nail in the wall":** William H. Rideing, "Boston Letter," in *The Critic: A Weekly Review of Literature and the Arts*, vol. 9 (New York: The Critic Company, 1888), 69.

204 ***Woman: An Enigma:*** Chong, Lingner, and Zahn, *Eye of the Beholder*, 204. Carter, *Gardner and Fenway Court*, 105.

204 **"The newspapers do not disturb me":** Sargent to I. S. Gardner, [undated], 1888, Gardner Museum Archives.

204 **"great artistic merit":** Nancy Whipple Grinnell, *Carrying the Torch: Maud Howe Elliott and the American Renaissance* (Hanover, NH: University Press of New England, 2014), 66.

204 **"It looks like hell but it looks just like you":** Ormond and Kilmurray, *Early Portraits*, 210. Quoting Theodore Robinson diaries, June 24, 1892. Original diary entry says "h..l".

204 **"Crawford's Notch":** Tharp, *Mrs. Jack*, 134.

205 **"inner sanctum":** Goldfarb, *Gardner Museum*, 135.

205 ***"Mrs. Jack":*** Tharp, *Mrs. Jack*, 109. Quoting *Town Topics*, December 1, 1887.

205 **"gay, brilliant, magnificent":** Ibid., 110. Quoting *Town Topics*, December 22, 1887.

206 **liveried footmen:** Carter, *Gardner and Fenway Court*, 52.

206 **"I am thinking of having a little medal made":** William Sturgis Bigelow to I. S. Gardner, [n.d.], Gardner Museum Archives.

206 **Sandow:** Carter, *Gardner and Fenway Court*, 139–40.

207 **John L. Sullivan:** Tharp, *Mrs. Jack*, 126.

207 **a barely clad prizefighter:** Ibid.

207 **Grace Minot and other blue bloods:** Mrs. Winthrop Chanler, *Roman Spring* (Boston: Little, Brown, 1935), 119.

207 **boxing match:** Tharp, *Mrs. Jack*, 125–26. Shand-Tucci, *Art of Scandal*, 104–05. Belle rooted for the American boxer, Tim Harrington of Cambridge, who was exceedingly handsome; but afterward she also "took pains to compliment" the loser, Knucksey Doherty of Donegal Square, Belfast.

207 **"charmed, scandalized"** . . . **"unscrupulous flirtations":** Chanler, *Roman Spring*, 118.

207 **"fairly stopped one's heartbeat":** Tharp, *Mrs. Jack*, 197.

207 **"conspicuously elegant"** . . . **preferred a panther:** Ibid., 142. Quoting from *Town Topics*.

208 **"to let the world know it was a society lion":** Carter, *Gardner and Fenway Court*, 161. Tharp, *Mrs. Jack*, 197–98. Belle walking with lion, albeit an old toothless one.

208 **"stood out in vivid contrast":** Chanler, *Roman Spring*, 119. Daisy Chanler was the half-sister of F. Marion Crawford.

208 **rosary beads:** Chanler, *Roman Spring*, 118.

208 **Altar Society:** Sand-Tucci, *Art of Scandal*, 32.

208 **audience with the Pope:** Tharp, *Mrs. Jack*, 184.

209 **blood sport in the Gilded Age:** Saarinen, *The Proud Possessors*, 46. A whole corps of artists specialized in creating copies of the masterworks being taken from the Old World so that fading aristocrats could keep up the pretense that they still owned the family treasures, while evading government officials who were trying to stop the wholesale exportation of their cultural heritage.

209 **George Proctor:** Tharp, *Mrs. Jack*, 159–60.

209 **Sargent couldn't stop working:** Burke Wilkinson, *Uncommon Clay: The Life and Works of Augustus Saint-Gaudens* (New York: Harcourt Brace Jovanovich, a Helen and Kurt Wolff Book, 1985), 190. "Without a brush in his hand he never seemed wholly at his ease," an acquaintance, Rose Nichols, said. "He was like a hungry man with a superb digestion, who need not be too particular what he eats," Sir William Rothstein, a fellow artist wrote. "Sargent's unappeased appetite for work allowed him to paint everything and anything, anywhere at any time," 307.

210 **"torsal shivers and upheavals":** *Town Topics* quoted in Ormond and Kilmurray, *Portraits of the 1890s*, 21, and Fairbrother, *Sargent & America*, 162. "On stage, the torsal shivers and upheavals indulged in by Carmencita might be allowed to pass for art, but in the privacy of a richly furnished room, with innocent eyes to view her, nothing but the fatal earthiness of the woman's performances could make any impression." Her twirling gyrations—which reveal a good deal of leg and petticoat—were captured in 1894 in a short black-and-white film using an Edison motion picture camera.

210 **illiterate:** "Dancing Carmencita Can't Read," *New York Times*, May 24, 1890.

"Carmencita Sues Kiralfy," *New York Times*, May 13, 1890, 4. She earns $150/week. Mount, *John Singer Sargent*, 1957 ed., 142.

210 **bracelets:** Mount, *John Singer Sargent*, 1957 ed., 141–42.

210 **Sally Fairchild:** Ormond and Kilmurray, *Portraits of the 1890s*, 21.

210 **petulant and childish:** Mount, *John Singer Sargent*, 1957 ed., 141. Charteris, *John Sargent*, 111.

210 *El Jaleo*: Ormond and Kilmurray, *Early Portraits*, 195. Mount, *John Singer Sargent*, 1957 ed., 143.

211 **"bewildering superb creature":** Sargent to I. S. Gardner, March 1890, Gardner Museum Archives.

211 **His own studio wouldn't do:** Mount, *John Singer Sargent*, 1957 ed., 144. Sargent wrote to William Merritt Chase, "The gas man tells me he cannot bring more light into the studio than the two little jets that are there. Would you be willing to lend your studio for the purpose and be our host? We would each of us invite some friends and Mrs. Gardner would provide the Carmencita and I the supper and whatever other expenses. " Sargent later wrote to Belle, "I will ask *very few people* and must keep extremely dark about it, as hundreds would want to come." Sargent to I. S. Gardner, [late March], 1890, Gardner Museum Archives.

212 **"rude gesture":** Corinna Lindon Smith, *Interesting People: Eighty Years with the Great and Near-Great* (Norman: University of Oklahoma Press, 1962), 118, and Tharp, *Mrs. Jack*, 144, recount Sargent's own recollection that Carmencita threw the flower in Gardner's face and Joseph Smith picked it up and put it in his buttonhole to deflate the tension. Charteris, *John Sargent*, 111–12, and Mount, *John Singer Sargent*, 1957 ed., 146, recount a different version: that the flower was thrown at Sargent, not Gardner, and he put it in his buttonhole.

212 **$1.6 million tax-free dollars:** Chong, Lingner, and Zahn, eds., *Eye of the Beholder*, x.

212 *Harmony in Blue and Silver*: Carter, *Gardner and Fenway Court*, 135. "This is my picture," she told Whistler, "you've told me many times that I can have it . . . and now I'm going to take it." Chong, Lingner, and Zahn, *Eye of the Beholder*, 198–99.

212 **surrogate:** Carter, *Gardner and Fenway Court*, 134–35.

213 **value of the painting:** Ralph Curtis to I. S. Gardner, August 12, [1901?], Gardner Museum Archives. An expert "says your Concert [which cost 29,000 francs] is now worth easily between 150 & 200 thousand! Tell Georgie [her nephew] he can't make investments like that in State Street!" Chong, Lingner, and Zahn, *Eye of the Beholder*, 149. The painting cost 29,000 francs.

213 **three-dozen:** There is some dispute about the number of surviving Vermeers; perhaps thirty-four or thirty-five can be reliably attributed to him.

213 **"utterly impenetrable"**: Chong, Lingner, and Zahn, *Eye of the Beholder*, 149. Quoting Sellars.

213 **"How much do you want a Botticelli?"** . . . **"getting the best terms"**: Hadley, *Letters of Berenson and Gardner*, 39–40.

213 **earl of Ashburnham**: Chong, Lingner, and Zahn, *Eye of the Beholder*, 69.

214 **£3200**: Cohen, *Berenson*, 119. Puts the price at £3200 or $16,000.

214 **"It would be a pleasure to me"**: Hadley, *Letters of Berenson and Gardner*, 39.

214 **undergraduate at Harvard**: Cohen, *Berenson*, 27, 37, 39. "Harvard was an anxious pinnacle of achievement" for the young Berenson, "bestowing on him a status he coveted while constantly threatening to take it away."

214 **"Berenson has more ambition"**: Ibid., 46–48.

214 **"I shall be quite picture wise then"**: Ibid., 69.

215 **Italian art forgers**: Barbara Strachey and Jayne Samuels, eds., *Mary Berenson: A Self-Portrait from Her Letters & Diaries* (London: Victor Gollancz, 1983), 82. Cohen, *Berenson*, 86–88.

215 **"ear and toenail"**: Cohen, *Berenson*, 68.

215 **pressures from every side**: Ibid., 116.

215 **his attributions have stood up**: Walter Kaiser, "The Passions of Bernard Berenson," *New York Review of Books*, November 21, 2013.

216 **enormous ego**: Saarinen, *Proud Possessors*, 26. Refers to Gardner's "cosmic and insatiable" ego.

216 **secret arrangements**: Chong, Lingner, and Zahn, *Eye of the Beholder*, xi–xii. Hadley, *Letters of Berenson and Gardner*, 36. Strachey and Samuels, *Mary Berenson*, 76. "Business complications with Mrs. Gardner—Bernhard was simply awfully worried and felt at times almost suicidal," Berenson's wife, Mary, wrote in her diary on June 23, 1898.

216 **"He is dishonest"**: Richard Norton to I. S. Gardner, September 14, 1898, Gardner Museum Archives.

217 **"Law Courts"**: Hadley, *Letters of Berenson and Gardner*, 177.

217 **"They tormented each other"**: Saarinen, *Proud Possessors*, 44.

217 **"Serpent of the Charles"**: Ibid., 43.

217 **"Cable immediately"**: Tharp, *Mrs. Jack*, 176–77.

217 **"unsurpassable"**: Chong, Lingner, and Zahn, *Eye of the Beholder*, 63.

217 **"I had to put on the praise"**: Ibid., 44.

217 **"Rembrandt left me cold"**: Ibid., 147.

217 **together Berenson and Belle**: Ibid., xi.

217 **Berenson wrestled with his conscience**: Bernard Berenson, *Sketch for a Self-Portrait* (New York: Pantheon, 1949), 38. "I cannot rid myself of the insistent inner voice that keeps whispering and at times hissing, 'You should not have . . . let yourself become that equivocal thing, an "expert." You should